EVERGLADES

UNIVERSITY PRESS OF FLORIDA

Florida A&M University, Tallahassee
Florida Atlantic University, Boca Raton
Florida Gulf Coast University, Ft. Myers
Florida International University, Miami
Florida State University, Tallahassee
New College of Florida, Sarasota
University of Central Florida, Orlando
University of Florida, Gainesville
University of North Florida, Jacksonville
University of South Florida, Tampa
University of West Florida, Pensacola

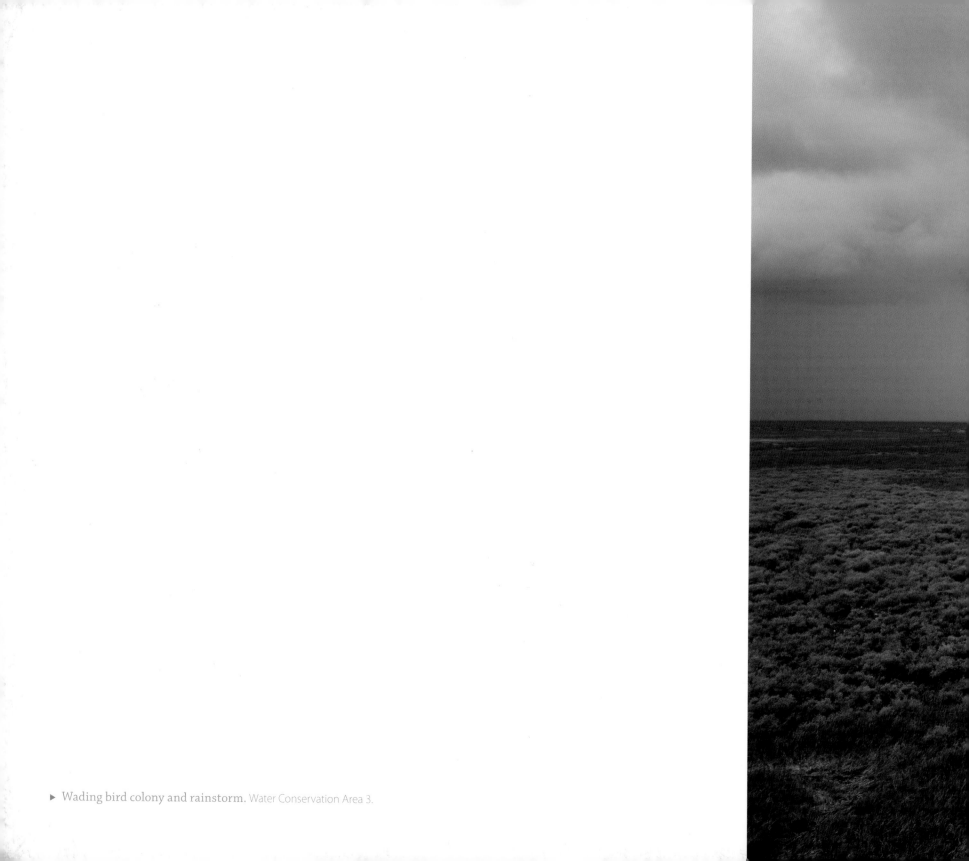

▶ Wading bird colony and rainstorm. Water Conservation Area 3.

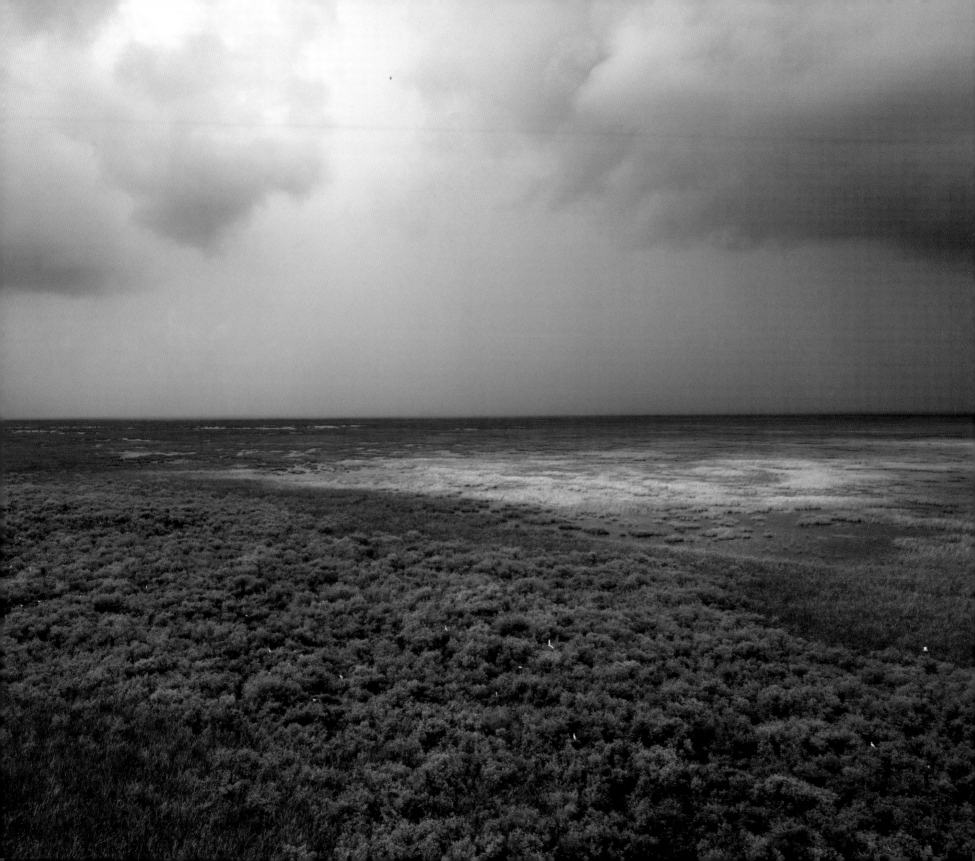

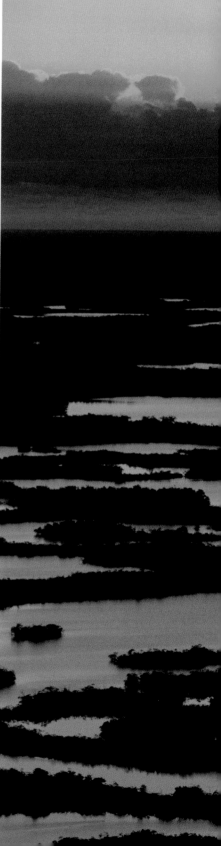

► **Sunrise over Hell's Bay.** Everglades National Park.

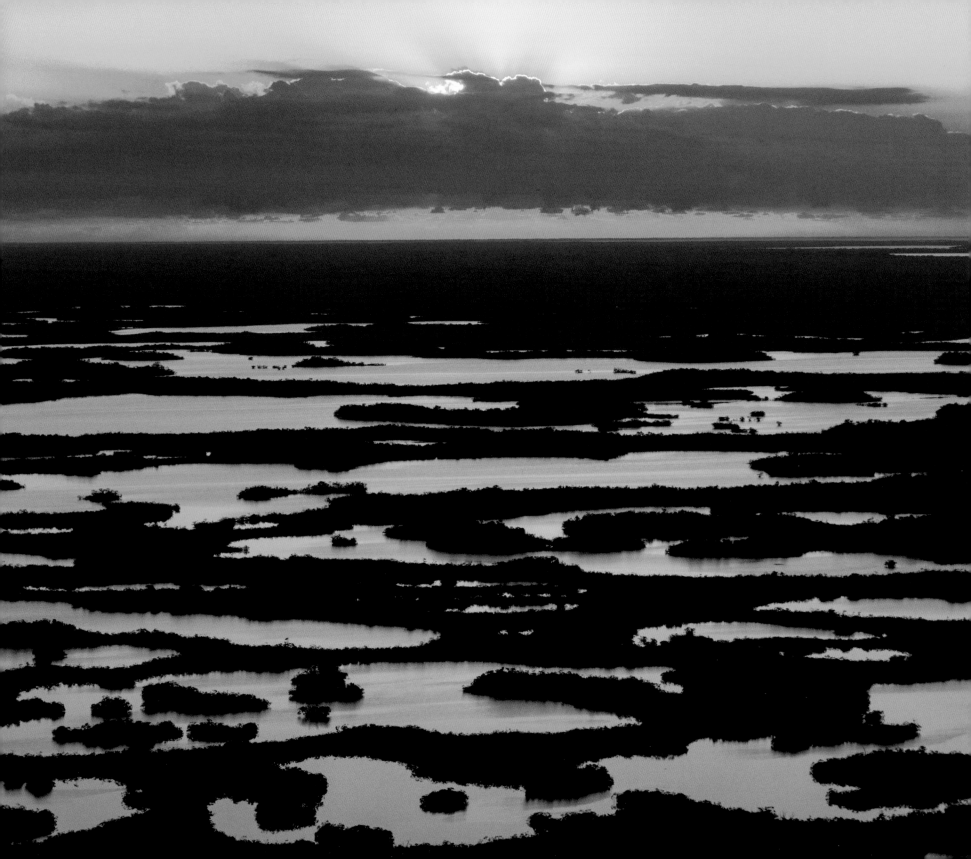

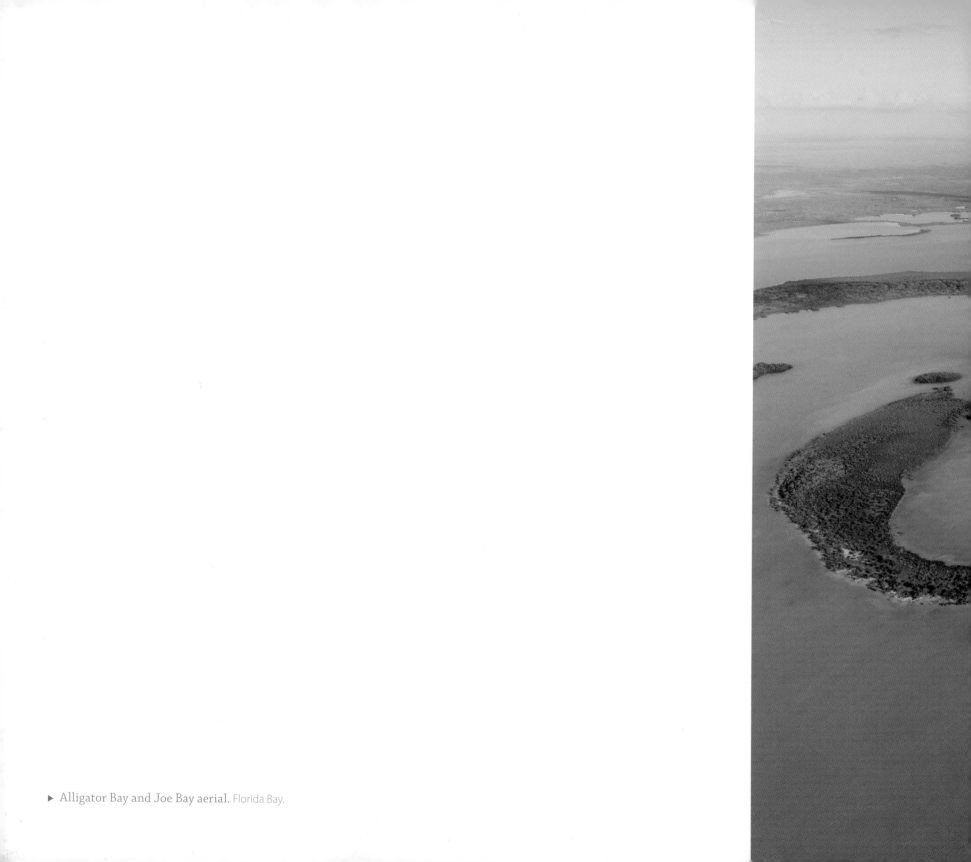

▶ Alligator Bay and Joe Bay aerial. Florida Bay.

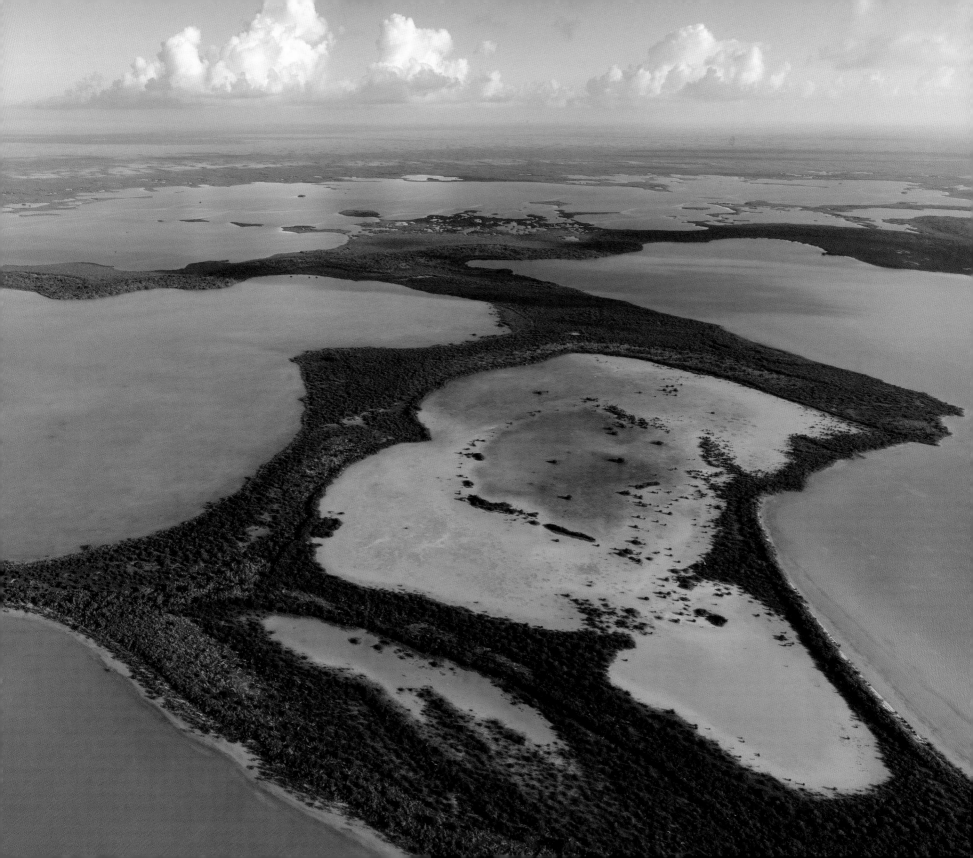

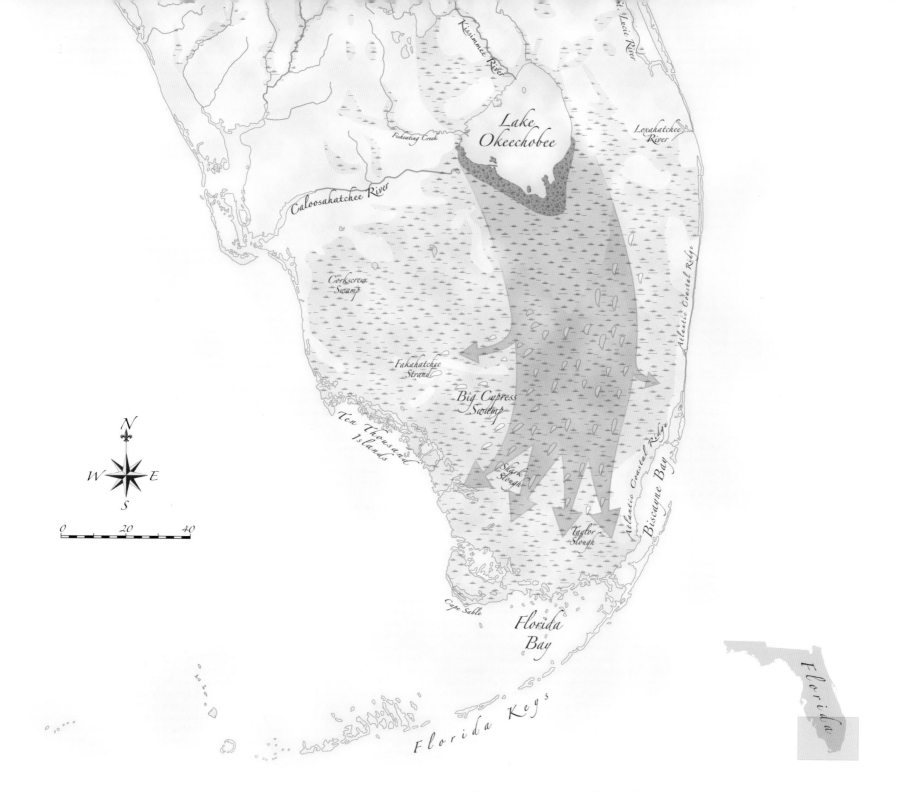

Lake
Okeechobee

Kissimmee River

St. Lucie River

Loxahatchee
River

Fisheating Creek

Caloosahatchee River

Corkscrew
Swamp

Atlantic Coastal Ridge

Fakahatchee
Strand

Big Cypress
Swamp

Ten Thousand
Islands

Shark
Slough

Taylor
Slough

Atlantic Coastal Ridge

Biscayne Bay

N
W E
S

0 20 40

Cape Sable

Florida
Bay

Florida Keys

Florida

▲ Representation of the Everglades watershed pre-development. Map by Gene Thorp.

EVERGLADES
AMERICA'S WETLAND

Mac Stone

Foreword by Michael Grunwald

University Press of Florida

Gainesville · Tallahassee · Tampa · Boca Raton

Pensacola · Orlando · Miami · Jacksonville · Ft. Myers · Sarasota

A Florida Quincentennial Book

Printed in China on acid-free paper
Book design by Mac Stone and Hannah Dillard

19 18 17 16 15 14 6 5 4 3 2 1

Library of Congress Control Number: 2014934184
ISBN 978-0-8130-4985-4

The University Press of Florida is the scholarly publishing agency for the State
University System of Florida, comprising Florida A&M University, Florida
Atlantic University, Florida Gulf Coast University, Florida International
University, Florida State University, New College of Florida, University of
Central Florida, University of Florida, University of North Florida, University
of South Florida, and University of West Florida.

University Press of Florida
15 Northwest 15th Street
Gainesville, FL 32611-2079
http://www.upf.com

▶ Roseate spoonbills in flight. Florida Bay.

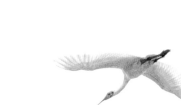

In loving memory of Larry Heaton and John Ogden

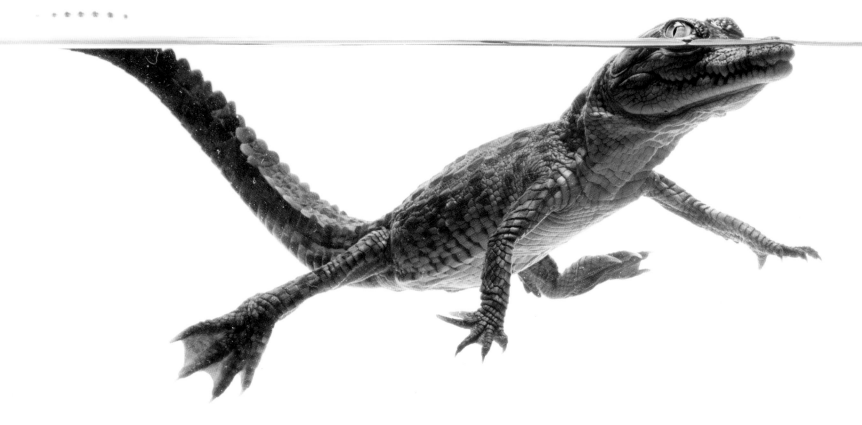

▲ American crocodile hatchling. Turkey Point.

CONTENTS

Foreword

Michael Grunwald

For the first 5,000 years the Everglades existed, people mostly avoided it. And the Americans who started exploring it in the nineteenth century mostly hated it.

They described it as an impenetrable, abominable, godforsaken morass, "suitable only for the haunt of noxious vermin or the resort of pestilential reptiles." They dreamed of "improving" it, "reclaiming" it, converting it from soggy wasteland into productive farmland, developing it from useless wilderness into subtropical paradise, draining its uninhabitable swamps to create an Empire of the Everglades. And eventually, their dreams came true. They transformed America's last frontier.

It took more than a century, but after all the visionary schemes and Florida swampland jokes, the ecosystem stretching from Walt Disney World down to the Keys now supports 7 million residents, 60 million annual tourists, and 400,000 acres of sugar farms. The eager beavers of the Army Corps of Engineers and South Florida Water Management District now control just about every drop of water that falls on the region. In the rainy season, they whisk excess floodwaters into the Everglades and its estuaries, ravaging the ecosystem; in the dry season, they essentially sink 7 million straws into the Everglades and Lake Okeechobee, creating structural droughts that also ravage the ecosystem. But even more than air conditioning, bug spray, or Social Security, it was their water management that made South Florida safe for one of the most spectacular development booms in human history.

The thing is, now that half the Everglades is gone, and the other half is an ecological mess, we've realized it was pretty amazing the way it used to be. We no longer think of wetlands as wastelands. So the United States has launched the largest environmental restoration project in the history of the planet to try to resuscitate the River of Grass. We've acknowledged our abusive relationship with nature in South Florida, and we're trying to make amends. It's a monumental task, and it will take time to complete. It's one thing to say the water of the Everglades ought to be clean; it's another thing to scrub it as clean as the natural Everglades, which was significantly cleaner than Evian. But today, no politician would dream of describing the Everglades as a pestilential hellhole that ought to be developed. Left-wingers, right-wingers, buffalo-wingers, you name it; everyone describes the Everglades as a national treasure that ought to be revived. It really has become America's wetland.

Environmentalists like to say that the Everglades is a test: If we pass, we may get to keep the planet. It's true. Everglades restoration has become the model for similarly massive plans to revive American ecosystems like the Great Lakes, the Chesapeake Bay, and Louisiana's coastal wetlands, as well as global ecosystems like the Pantanal, the Okavango Delta, and the Garden of Eden marshes of Iraq. In the twenty-first century, water will become more precious than oil, and if Miami-Dade and Broward Counties can't figure out how to share water, while leaving enough for the gators and otters, it's hard to imagine how Israel and Syria will manage. The Everglades is an ideal canvas for restoration, with plenty of science, plenty of rain, plenty of land in public hands, and plenty of money. It's got an amazing political commitment from federal and state governments. If we can't save the Everglades, what can we save?

So the world wants to know if sustainability can be more than a buzzword in South Florida. But those of us who live here have even more at stake in the answer. The economic health of Florida depends on the health of the Everglades, and not just because of the millions of fishermen, birdwatchers, hunters,

kayakers, and beachgoers who visit the ecosystem every year. The aquifers that store South Florida's drinking water sit underneath the Everglades, and they've been ravaged by sprawl—the same sprawl that's undermining the region's quality of life. With insanely congested highways, overcrowded schools and hospitals, and overstretched municipal services, paradise is starting to feel like the New Jersey Turnpike with better weather. Real estate development has been Florida's leading industry, but it's killing its golden goose; retirees are looking at less congested destinations that have retained their sense of place, while developers are worried that limits on new water and sewer connections will start limiting new subdivisions. It's no coincidence that the subprime crisis that nearly shattered the financial system began in overdeveloped exurbs at the fringes of the Everglades, like Homestead or Port St. Lucie; they turned out to be economically as well as ecologically unsustainable.

So the Everglades is important as a model for restoration, as a symbol of sustainability, and as an engine of economic growth. But it's also important as a very cool place. There's only one Everglades, and God isn't making more. It doesn't have glaciers or geysers or rolling hills or jagged cliffs; it's less ooh and aah than hmm. As those early explorers found out, it takes some time to understand and appreciate it. But it really is an extraordinary place—not only the gators and panthers and royal palms and ghost orchids that you see on the postcards, not only the majestic wading birds that once darkened the South Florida sky, but the sawgrass and algae and other seemingly prosaic flora and fauna that made the Everglades the Everglades.

That's why it's important to have photographers and communicators like Mac Stone. And that's why it's important to have books like this one, bearing witness to the Everglades that actually exists, its sawgrass marshes, cypress hammocks, and mangrove swamps as well as its sugar fields, feeder canals, and exurban subdivisions. The Everglades is not the Grand Canyon or Yosemite; even though we no longer think of it as a godforsaken morass, it doesn't routinely inspire awe. But it should inspire curiosity. It is a place that cries out for understanding as well as appreciation, and this book should help with both.

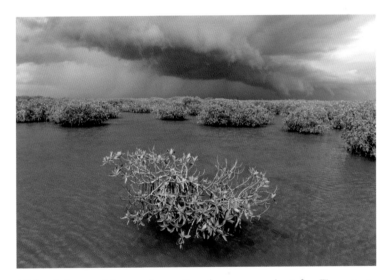

Michael Grunwald, a senior national correspondent for *Time* magazine, lives in Miami, Florida, and is the best-selling author of *The Swamp: The Everglades, Florida, and the Politics of Paradise* and *The New New Deal: The Hidden Story of Change in the Obama Era.*

▲ Storm clouds over mangrove flats. Joe Bay.

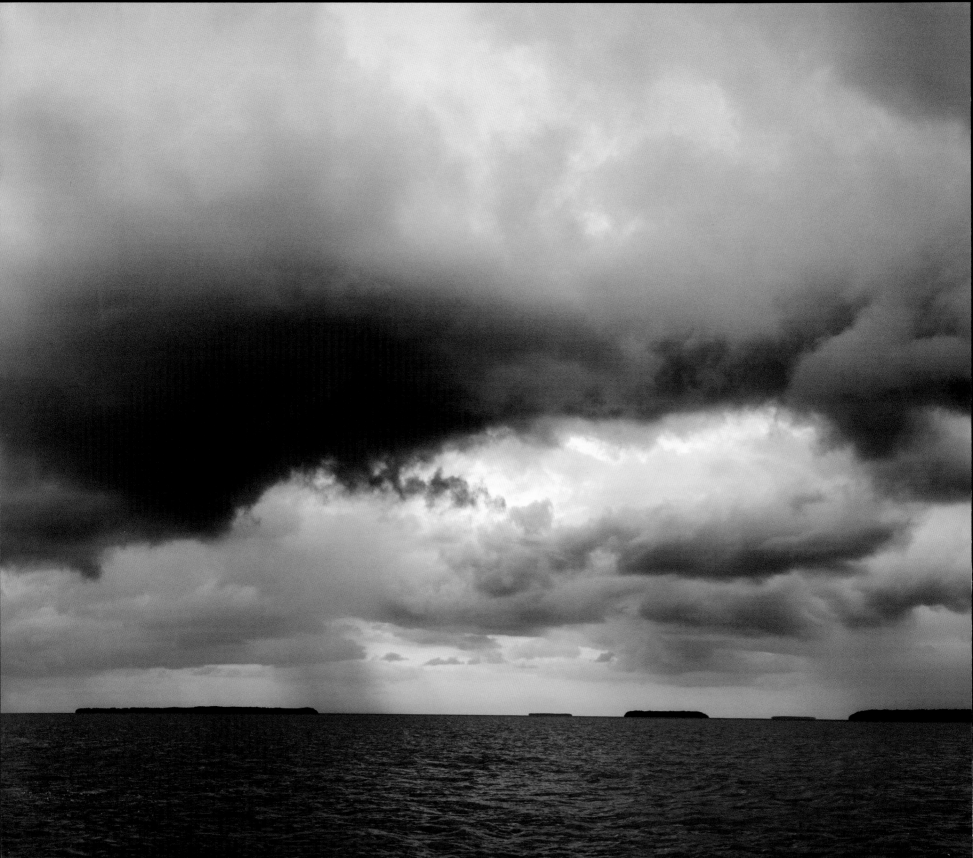

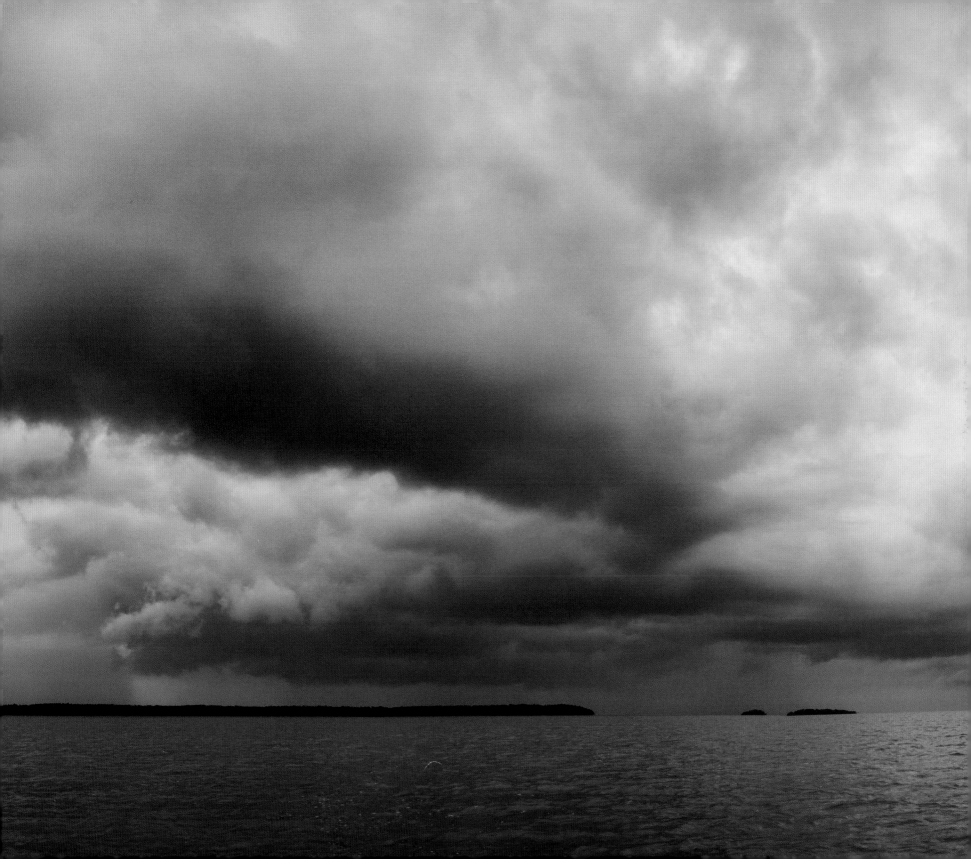

Preface

Bob Graham

I was introduced to the Everglades by my father Ernest R. Graham. He arrived in South Florida in 1921 at the age of 36 to start the Everglades sugar cane empire for the Pennsylvania Sugar Company (Pennsuco). This endeavor would challenge Cuba for dominance in the post–World War I United States sugar market. Even with my father's engineering training, mining experience, and service as a wartime captain in U.S. Army Corps of Engineers, Pennsuco could not overcome the floods, insects, hurricanes, and finally the great depression that crashed its dreams.

Dad stayed on to establish a dairy and cattle farm on parts of the former sugar cane fields.

Our coral rock home was on the western edge of the farm, an island in the Everglades. From the backyard, on a summer afternoon, I was mesmerized by the towering anvil thunderheads. From my second floor bedroom window at nighttime, I could see the drama of Everglades fires illuminating the black skies. With other farm boys I waded into the fringes of the Glades to shoot frogs with our bb guns.

Dad believed that nature and humans could live together if man would respect the natural order. Early in his life in the Glades, he implored the builders of the Tamiami Trail to install sufficient culverts to allow the north-to-south flow of the river of grass to be sustained. He was accused of standing in the way of progress but prevailed. Americans are still struggling to understand and adhere to nature's imperatives.

Dad taught by example that the Everglades could be cruel and unforgiving. During World War II, much of the transitional training of naval aviators took place at an air station east of the Everglades and adjacent to our farm. Frequently these young pilots or their aircraft would malfunction and crash in the Glades. As the person who knew the most about this region, Dad would frequently be asked to assist the navy in its search and rescue. I often accompanied him. My first experience seeing a man die was early in the war when a navy trainer crashed near our home, and the plane exploded in a fireball before the pilot could be reached by emergency crews.

As a mining engineer Dad learned what he didn't know about the Everglades. After the collapse of the sugar cane plantation, he thought salvation might be through open-pit mining of the Everglades rich peat soil—citing Ireland as an example of successfully using peat as an energy source. On further examination, he came to understand the critical contribution that peat made to the complex ecosystem of the Everglades. The mining project was abandoned. The necessity of consistently expanding our understanding of the Everglades and applying those lessons learned continues today.

Dad wasn't always so prescient. After the two hurricanes and the great flood of 1947, he was a prime advocate for engaging his beloved Corps of Engineers in a massive drainage project to protect properties adjacent to the Glades from future floods. This project led to the largest transformation of the earth by the United States since the building of the Panama Canal. Today we recognize that nature has provided an intricately sophisticated system for the Everglades, a system which serves the multiplicity of the needs of man, the teeming habitat of nature, and the Glades itself. The half century's effort to restore the Everglades is at its core—the return to nature's architecture.

As governor and later as a United States senator, these lessons from my father were the centerpiece of the plan for Everglades restoration. The goal was, to the extent possible, restore

◄◄ Summer storm. Florida Bay.

the Everglades to look and function more like it did a century earlier than when the effort was launched in 1981. This would be achieved by freeing nature from man's impingements. The state of Florida and the federal government would be equal partners in saving what would now be known as America's Everglades.

These lessons are applicable today—particularly today. As I record these thoughts, the potential of the collapse of the effort to restore the Everglades is greater than at any other time since the campaign to "Save the Everglades" commenced. Political support in Tallahassee and Washington wavers. Budget shortfalls have thrust Everglades restoration into competition with other state and federal priorities. The human and fiscal capacities of agencies responsible for restoration have been slashed. Old wars between sugar production and other water users have reignited.

The initial purpose of this compelling book is to introduce you to the Everglades and captivate you by its beauty and mysteries. The ultimate purpose is to recruit you to be one of the millions of Americans who are committed to the preservation of America's Everglades.

Bob Graham served two terms as governor of Florida, from 1979 to 1987, and eight terms as a U.S. senator for the state of Florida, from 1987 to 2003. President Barack Obama appointed Graham to serve as co-chair of the National Commission on the BP Deepwater Horizon Oil Spill and Offshore Drilling in 2010. Graham is also the founder of the Bob Graham Center for Public Service at the University of Florida and is the author of *America, The Owner's Manual: Making Government Work for You*.

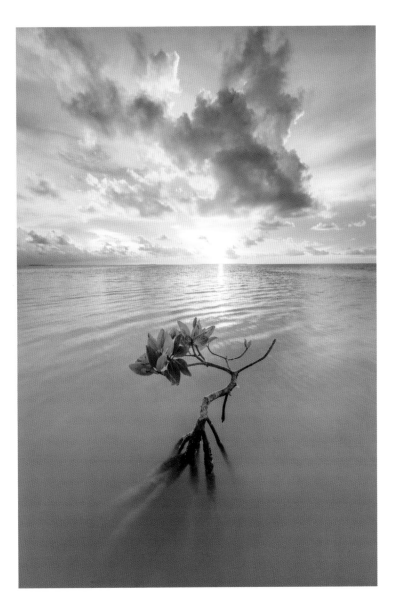

▲ Sunset on Florida Bay and red mangrove. Islamorada.

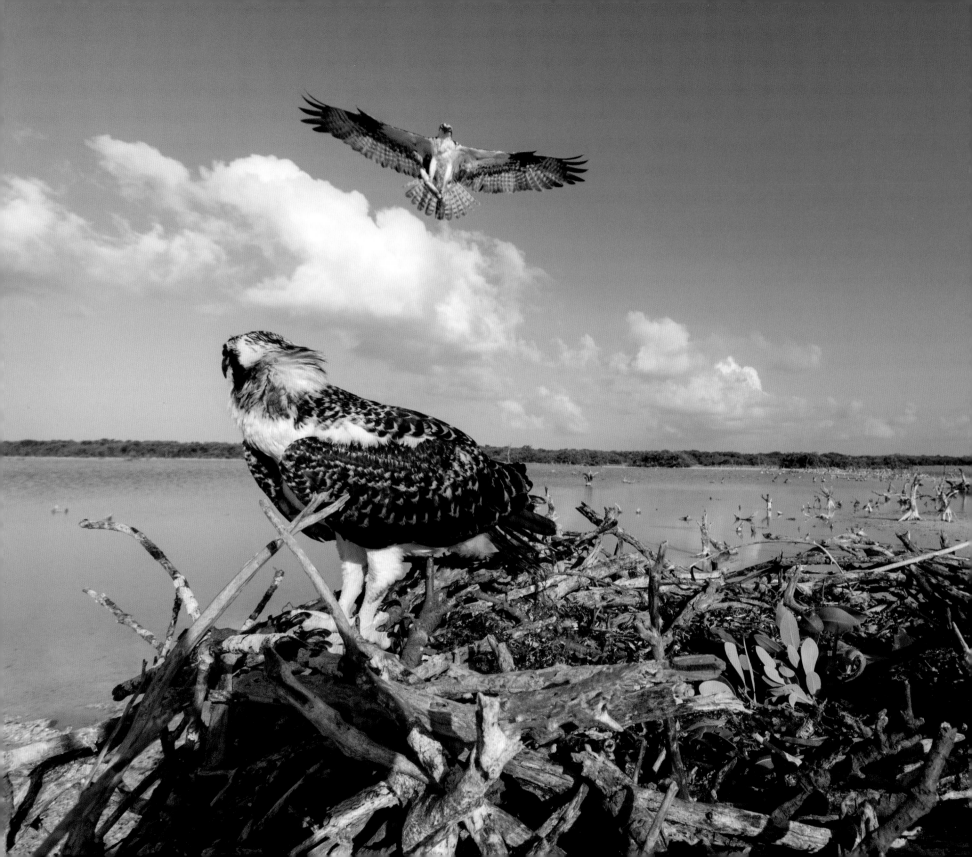

Introduction
Mac Stone

As a child of North Florida, even the whisper of its name would send my imagination reeling. Conjuring fanciful lands of verdant forests teeming with orchids, aviaries, predatory cats, and prehistoric reptiles, the Everglades seemed more like a dreamscape than an actual place in my home state.

By all measures, I was already surrounded by a bounty of natural wonders. Crystal clear springs, live oak canopies, wetland prairies, and freshwater lakes were only minutes from my doorstep in Gainesville. I spent the latter part of my childhood romping through the blackwater creeks and backwoods oases developing a deep bond with Florida's bottomlands. The humid swamps, full of spirit and verve, became my photographic training grounds and the foundation for a lifelong love affair.

Many people feel uncomfortable with the idea of wading into Florida's blackwater, but this is what I loved about growing up in the Sunshine State. For many of us, we live with a latent but very palpable fear that when we put our toes into the water there might be something much more ancient, much more adapted than we are. Knowing that you're not top dog is a welcomed discomfort, I think. It's not often in our modern urban age that we get the chance to feel vulnerable or consider that the world may not have been made for just us. So I sought out the areas where concrete yields to forest, and pines turn to cypress. I found refuge in the sodden landscapes and viewed the mosquitoes, reptiles, and various discomforts as the tangible affirmations that I had found true wilderness. And I embraced them wholly. As satisfied as I could be, there was something about South Florida—something about the subtropics in particular—that I longed for.

Perhaps it was the whimsical names that piqued my interest. Places like Fakahatchee Strand, Okeechobee, Loxahatchee, Corkscrew Swamp, and Big Cypress were a few among the many that tugged at my adolescent curiosity and beckoned exploration. For years I plotted and schemed ways of getting to the Everglades, my lowcountry mecca.

Finally, at fifteen years old, my dad and I ventured south to spend a week kayaking along the Wilderness Waterway in the Ten Thousand Islands. For five days, we paddled to remote chickees and camped on mangrove islands experiencing the coastal fringe of the western Everglades.

◄ A fledgling osprey awaits breakfast. Florida Bay.

I watched the dynamic skies bring thunderous storms and torrential rains across the Gulf of Mexico. I saw bottlenose dolphins corral mullet in the shallow basins and heard the whistling screams of ospreys when we paddled beneath their massive nests. At night, I ate ramen noodles by the fire. Large conch shells fortified its base like a glowing sea castle, blocking the wind, and I gazed upward into the starry night, imagining the world of discovery that still awaited me on the interior.

I will never forget those five days on the water. My introduction to the Everglades sowed deep the seeds of exploration and adventure, providing the momentum for more than a decade of expeditions with my camera to all corners of the Americas.

The further from home I traveled, however, the more I longed to be back in my Sunshine State among my beloved bottomlands. After four months of living within the world's largest stand of old growth cypress and tupelo trees, the Francis Beidler Forest, I was ready for the world's most famous swamp. Twelve years after my fateful handshake with the Everglades, I was back, and the reunion was better than I could have ever imagined. I remember it as if it were yesterday.

"Before you jump, make sure to check for alligators . . . I'll see you in a few hours," the pilot yelled over the thunderous blades of the helicopter. I stared into the murky water below, looked back at his bearded grin, took a deep breath, and jumped. The sediment came up to my chest

and the tepid water lapped at my chin as the chopper lifted off, and the low fading hum of the propeller was quickly replaced with the gnawing trill of mosquitoes. I was left with a small boat, one oar, a camera, and the blind faith that this wasn't just an elaborate joke. It was my first day on the job in the Everglades with National Audubon Society's Tavernier Science Center and the beginning of an adventure that would change my life.

Over the next three years I experienced the vast watershed in nearly every way imaginable. In vehicles from helicopters to airboats to kayaks and single-propeller airplanes, I tirelessly traversed the Everglades from Lake Okeechobee to Florida Bay. I accompanied biologists tagging endangered American crocodiles, searched for invasive Burmese pythons, conducted nest surveys of roseate spoonbills, and wrangled female alligators to count their eggs. On the weekends I would venture into the most remote sections of the backcountry in search of the very soul that makes the River of Grass unique. I lived and breathed the Everglades, and my childlike fascination with this wilderness never fully matured.

I am awed by the vibrant biodiversity and timelessness of this ecosystem. Thus, my immediate inclination as a natural history photographer is to celebrate its beauty and candor with every release of the shutter. But the more time I spent in South Florida, the more I realized that the Everglades is not simply a love story about flora and fauna, or

▲ Airboat ride through the northern Everglades. Water Conservation Area 3.

▲ American alligator along Loop Road. Big Cypress National Preserve.

magnificent vistas. Rather, for better or for worse, the Everglades narrative is intrinsically tied to the story of mankind and its ever-changing relationship with the natural world.

We have burned and dredged the Everglades in the name of progress, we have hunted its fauna to near extinction, we have contaminated its healing waters and redirected its historic flow, but we have also taken steps to rewrite this regrettable narrative. My aim is to document these complex relationships, which means I must not only capture the beauty, but also the disturbing scenes to help raise awareness of the need to restore this life-giving watershed. From the fishermen of Florida Bay to the farmers, and the millions of visitors and residents of South Florida, we are all tied to the fate of the River of Grass.

Within the following pages is the realization of a lifelong dream and the lessons I have learned from one of Mother Nature's most resilient ambassadors. On a journey through cypress cathedrals, alligator holes, wading bird colonies, and mangrove mazes, I reveal what I have come to regard as Florida's largest wilderness. The captions serve not only to provide context to the images but, I hope, to inspire you to use this book as a road map to start your own adventure exploring this incredible landscape. As the River of Grass flows ever so gently southward and westward, so does the content of this book. With the turning of each page, you gradually travel from Lake Okeechobee to Florida Bay, intersecting many unique ecosystems. Along the way, some of the top minds in Everglades conservation lend their decades of experience to help me tell this important story.

Throughout its history we have witnessed the tectonic shifts of public opinion toward the Everglades. After a century of abuse and neglect, what was once deemed a swampy wasteland is now a World Heritage Site and Wetland of International Importance. We have certainly come a long way, but we are far from escaping the consequences of our misguided predecessors. The Comprehensive Everglades Restoration Plan is good start, requiring both state and federal action, but as with any movement, it requires the hearts and minds of citizens to see it through. The steps that we take to heal the system will set a precedent for how we treat our natural resources on the world's stage for years to come. As my father did, I hope to one day bring my children to this verdant paradise and let them listen to the whispers of Old Florida.

The international spotlight is upon us in the Sunshine State; and though the Everglades lives in Florida, it belongs to everyone. It is America's wetland.

▲ Bay boat. Florida Bay.

▲ Sunset clouds. Snake Bight.

EVERGLADES

"One way to open your eyes is to ask yourself, 'What if I had never seen this before? What if I knew I would never see it again?'"

—Rachel Carson

▶ Red mangrove. Florida Bay.

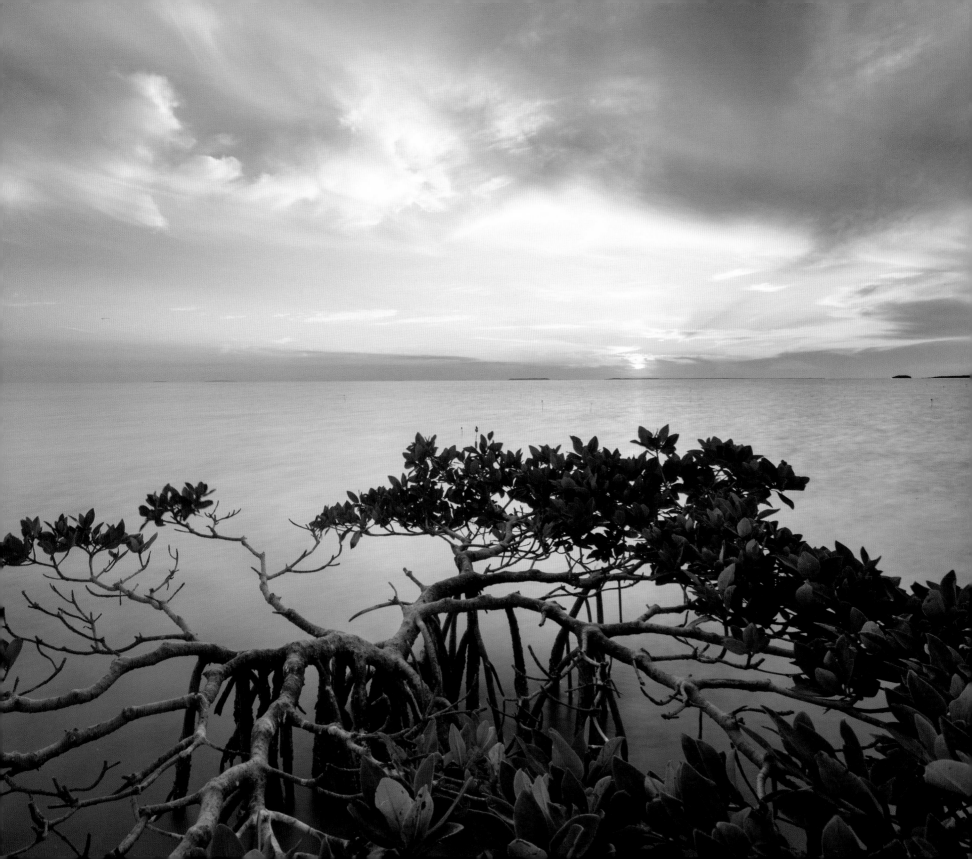

Schemes and Machines

Bill Loftus

Humans were witness to the formation of the greater Everglades ecosystem some six to seven thousand years ago; unfortunately, we also bear responsibility for the continued decline of America's signature wetland. Before 1900, this vast, trackless wilderness covered South Florida nearly from coast to coast. Combining temperate latitudes with a tropical climate created by warm water on all sides, the Everglades became the new home for an assemblage of flora and fauna found nowhere else in the continental United States.

Clean waters from rainfall and overflow from Lake Okeechobee moved from the immense plains of sawgrass south of the big lake through the sloughs and sawgrass ridges of the southern Everglades. Some water was lost to small rivers along the Atlantic coastal ridge while hydraulic pressure behind the ridge forced water through porous limestone to emerge as springs that supplied mariners on Biscayne Bay. The almost imperceptible slant of the landscape pulled the clear water ever southward into what is now Everglades National Park, where open glades supported large aquatic meadows of grasses and sedges dotted with floating mats of water lilies, bladderworts, and algae called periphyton. That mix of algae and decaying plant matter is the base of the food web that supports all life in the Everglades, from the tiniest invertebrates to mighty alligators and elegant wading birds.

When dry-season water depths concentrated millions of small fishes, the predators feasted on them to feed their young. As waters rose during the wet season, fishes and reptiles would disperse into the flooded expanses to search for mates to carry on this timeless cycle. The natural rhythms of the ecosystem were set by seasonal rainfall, the unimpeded flow of water following the gradual slope of the bedrock, and the development of plant, soil, and animal communities adapted to low nutrients. But those subtle routines were interrupted as this last frontier of the United States began to be settled around 1900. Those pioneers brought with them their schemes and their machines to change the Everglades into personal visions of productivity and prosperity. Dredges that gashed the peat landscape and cut through the coastal ridge began the process that ended the life of the original Everglades, that "worthless swamp."

Drainage meant more dry land for towns and the loss of huge areas of the sawgrass plains for agricultural development. Water levels no longer followed seasonal patterns; the deep central sloughs dried, giving rise to massive peat fires; and large areas of wetland were isolated by levees and canals. As the size of the system shrank, and freshwater was lost to flood control and water supply, humans used the wetland as a convenient sewer by pumping into it the nutrient-laden waters of agricultural and urban runoff; water quality declined dramatically. The low-nutrient system responded to this "fertilizer" with the loss of periphyton and sawgrass, and their replacement over thousands of hectares with almost impenetrable stands of cattails and shrubs of little use to fishes and wildlife. The future holds yet more uncertainty for the Everglades as the effects of global climate change begin to take hold.

Today, in this smaller, heavily managed system, it is still possible to escape the twenty-first century and experience the original Everglades in a few interior wetlands. Sadly, even these last refuges are threatened. There is much room for pessimism but also cause for optimism as the Everglades is a resilient ecosystem that still retains all of its biological pieces. Perhaps by experiencing these remaining natural outposts of the River of Grass, we will be inspired to take the steps needed to protect them for future generations.

William F. Loftus is a research ecologist formerly employed by the Department of Interior, having worked with the U.S. National Park Service and the U.S. Geological Survey for 32 years. He served as program manager for Everglades freshwater ecology studies and was the South Florida biology lead for USGS, developing restoration alternatives and monitoring for adaptive management for the Everglades. He has authored more than 60 technical and peer-reviewed publications across a wide array of subjects. Dr. Loftus now operates a biological consulting company performing aquatic research and science communication.

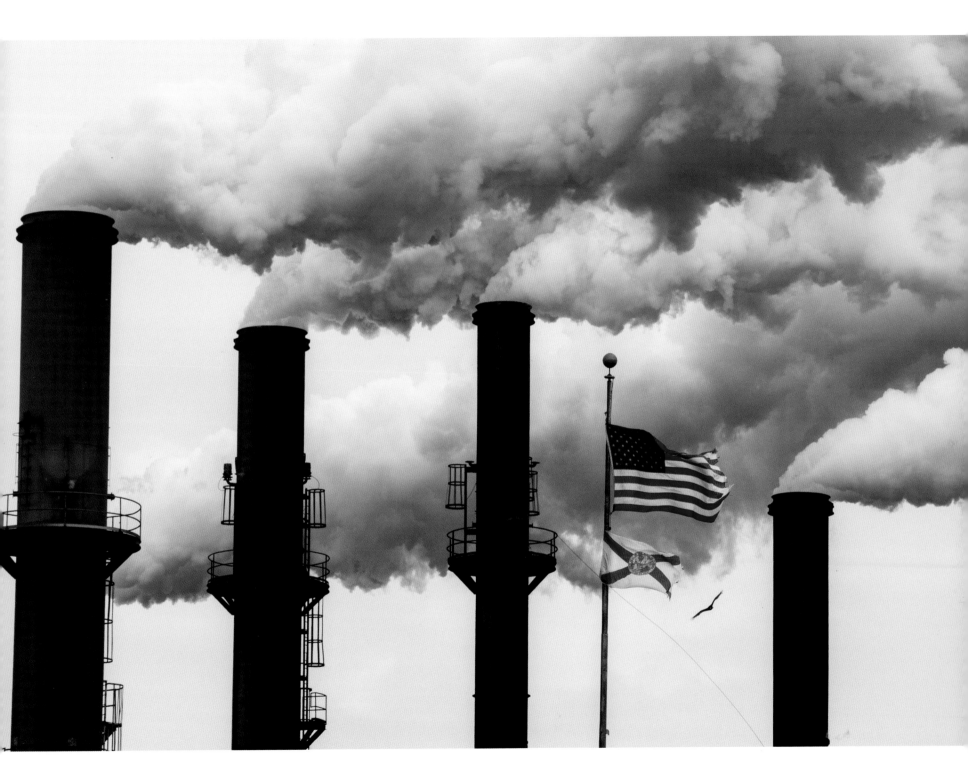

▲ Sugarcane factory. Belle Glade.

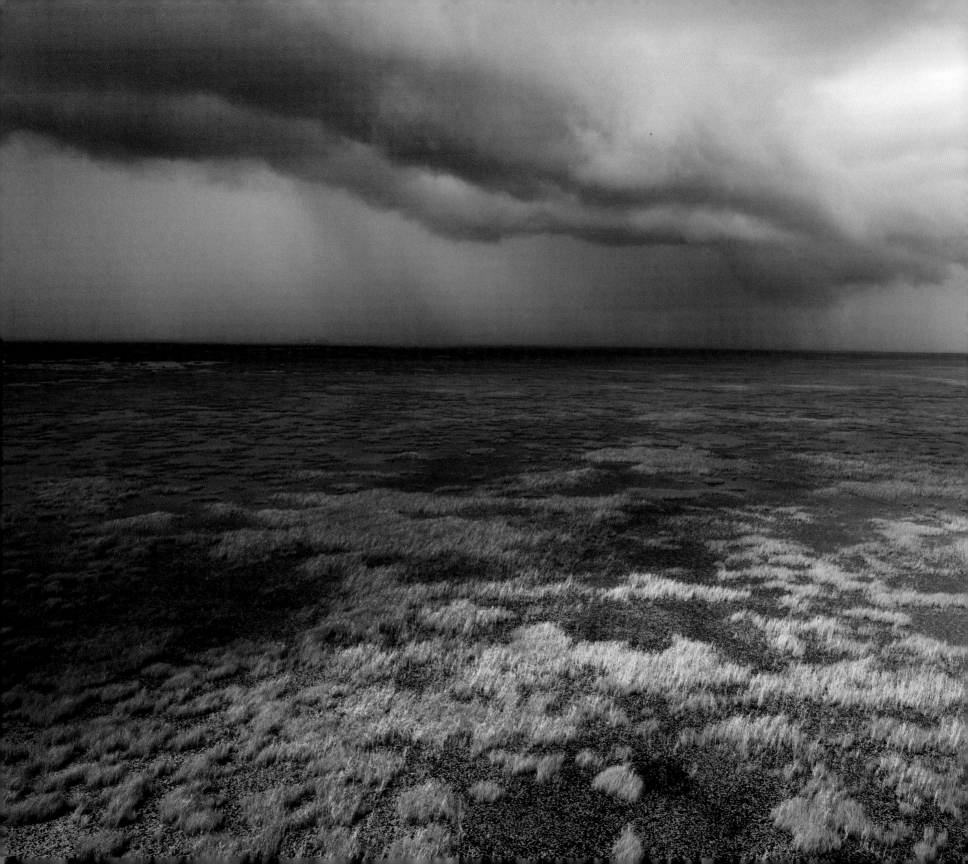

◄ Spring rains over sawgrass prairies. Water Conservation Area 3.

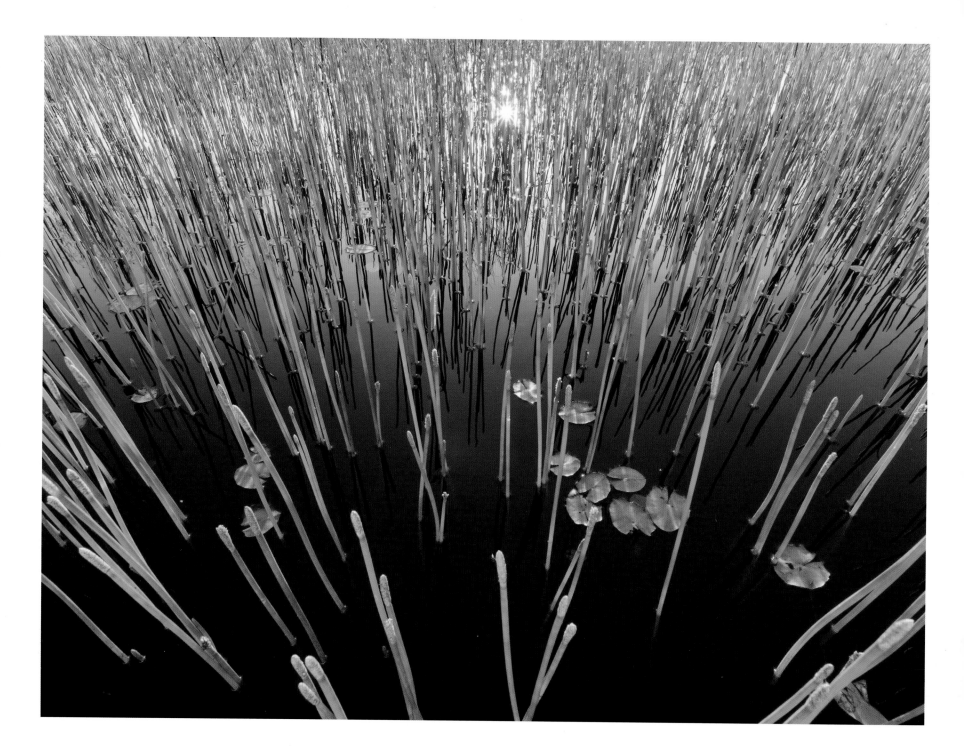

▲ Spikerush dominates shallow water providing food for waterfowl and habitat for fishes. Lake Okeechobee.

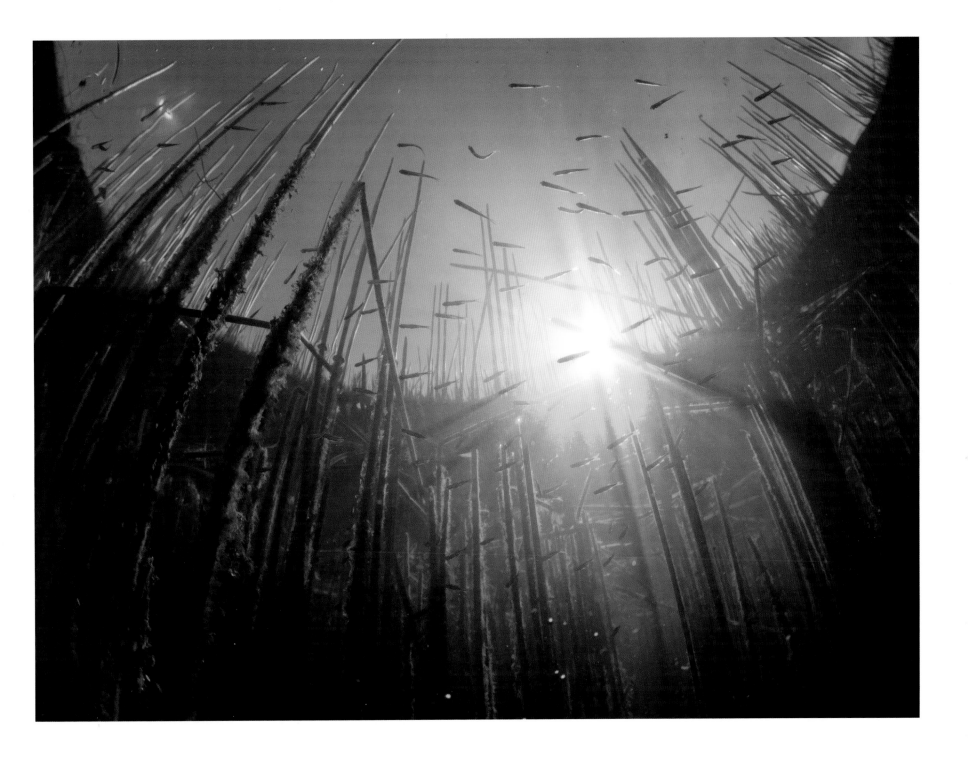

▲ Spikerush and silverside fish. Lake Okeechobee.

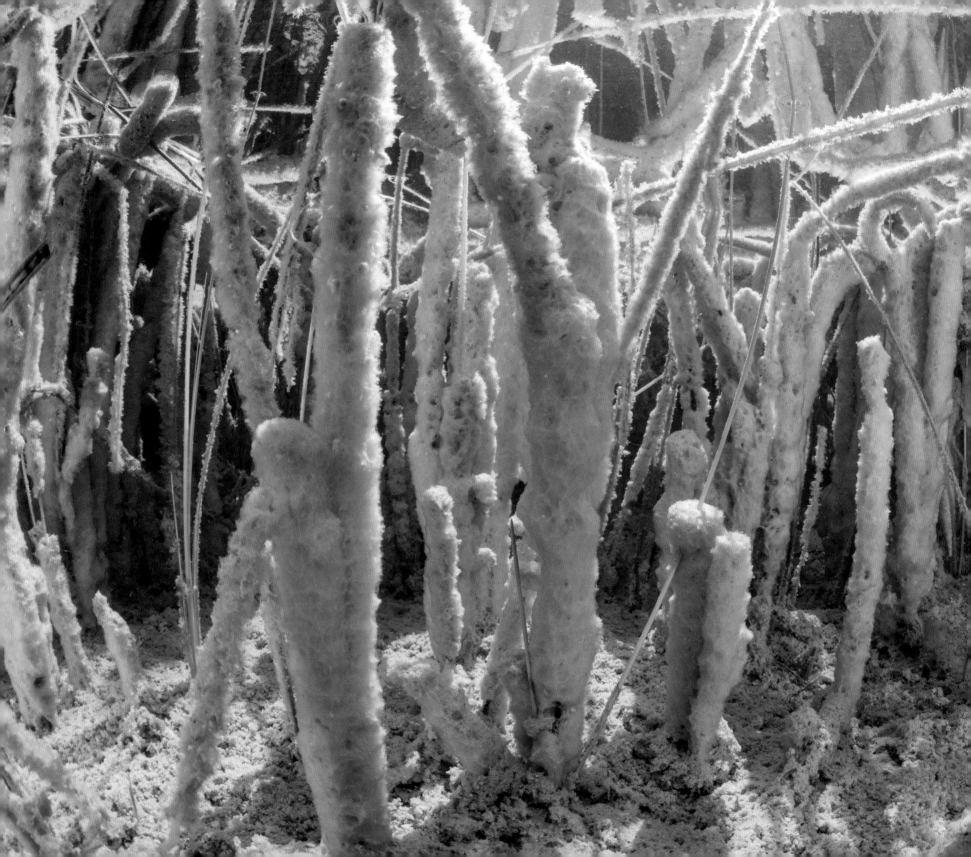

Periphyton is more than the audible squish between your toes when walking barefoot through freshwater habitats. Forming strange underwater formations and surface mats, the periphyton complex is considered an essential building block of the Everglades food web. An agglomeration of algae, cyanobacteria, fungi, and detritus, periphyton mats offer refuge and sustenance to small fishes and invertebrates. In wetlands with high dissolved carbonate levels, these mats deposit marl, which accumulates to form a major Everglades soil type. By processing small natural quantities of nitrogen and phosphorus for growth, periphyton also acts as a nutrient sink for waters moving southward to Florida Bay. In recent years, however, runoff laden with fertilizers from agricultural and livestock fields has led to the replacement of this essential complex by cattails and undesirable algae that thrive in higher nutrient areas.

◄ Periphyton clings to spikerush. Nine Mile Pond.

The Mother Lake

Nathaniel P. Reed

As a young teenager following the Second World War, I begged my father to take me to Lake Okeechobee. It was Christmas vacation and I remember stopping at Port Mayaca and climbing up to the top of the dike on a primitive set of steps. The great St. Lucie River gate and lock were below me, and an endless landscape of water stretched to the horizon. I was overwhelmed by my first sight of Lake Okeechobee, the Mother Lake of South Florida.

Nearly thirty miles wide and surrounded by the Hoover Dike, which stretched 140 miles, the lake was captured and tamed within its manmade boundary. I had never seen so much freshwater; it looked as if the ocean had moved inland. Thus began my love affair with Lake Okeechobee.

As my fascination with the lake increased, so did my visits. Over the following years I explored the headwaters: the Kissimmee River, Taylor Slough, and Fisheating Creek. I hunted ducks on the lake over decoys. I fished for giant black bass. I flew over the watershed by single engine plane and helicopter. I visited and explored the southern marsh system and I crisscrossed the great northern marshes in airboats. I spent many warm nights in primitive motels eating fried frog legs, catfish, alligator tail, crappie, bluegills, and even turtle. I have Lake Okeechobee in my system.

I logged weeks watching adult snail kites feed their young, encouraging them to fly by holding their sole food, the apple snail, in their mouths. Slowly, day after day the young birds flew further from their nests until that great moment when they lifted up into the air and accompanied their parents on a hunt for their own snails. Their grasping foot and eye coordination is incomparative. Snail shell tightly grasped, they land atop a perch and with their curved beak, pull out the resisting snail, and devour the contents. It was all so perfect.

Yet the demands on the lake as a water supply came on slowly as South Florida's population grew at unexpected rates. Cheap drinking water pumped from the shallow Biscayne Aquifer needed to be continually refreshed by discharges from the lake through multiple canal systems. Ironically, it was the abundant great lake that allowed the millions of new residents to move to South Florida, and thus, the degradation of an ecosystem.

Then, when Cuba nationalized sugarcane production, the sugar industry exploded south of the lake. The number of acres per year grew to the present 500,000 plus acres, and the demand for irrigation water increased far beyond any expectation or sustainability. Further, the sugar plantations discharged excess rainwater loaded with tons of nutrients and fertilizers into the lake and the Everglades system, changing the botanical makeup of the River of Grass.

In my lifetime I have seen Okeechobee go through many changes. I have seen the lake mismanaged as a private reservoir and have witnessed the deliberate drowning of the great 150,000-acre northern marshes. As a result, snail kite populations were decimated, and the abundant wading birds that lined its shores became a thing of the past. As the lake's ecosystems degraded and collapsed, so did the entire system in its wake.

But as the science caught up to the dredges, state and federal agencies began reevaluating the need to preserve this treasured resource. For once since man's intervention in South Florida, things started to improve for the Everglades. The thousands of wading birds are slowly returning and the kites are attempting a comeback from near extinction. The battle of years of massive inflows of nutrient laden water from the vast Okeechobee watershed may be finally addressed, but our task is not finished.

No one knows what the future of the lake will be. It depends on our ability to control our demands on the lake's precious water. It depends on vastly improving the quality of water flowing into the lake. It depends on managers who recognize that Lake Okeechobee is the heartbeat of the southern Everglades system and the key to every restoration effort.

Its surplus water must no longer be sent out to sea through the St. Lucie and Caloosahatchee Rivers: it must be cleansed of the nutrient load and allowed to flow south along the River of Grass, under Tamiami Trail through Everglades National Park and into Florida Bay via the natural flow ways carved out by thousands of years of nature's elegant design. We have the unique opportunity of restoring one of the world's unique areas. We cannot let the opportunity slip away.

Nathaniel P. Reed grew up on Jupiter Island and is currently vice chairman of the Everglades Foundation. He has served under seven Florida governors and was assistant secretary of the Interior for Fish and Wildlife and Parks in the Nixon and Ford administrations, helping to pass such milestone legislation as the Endangered Species, Clean Air, and Clean Water Acts.

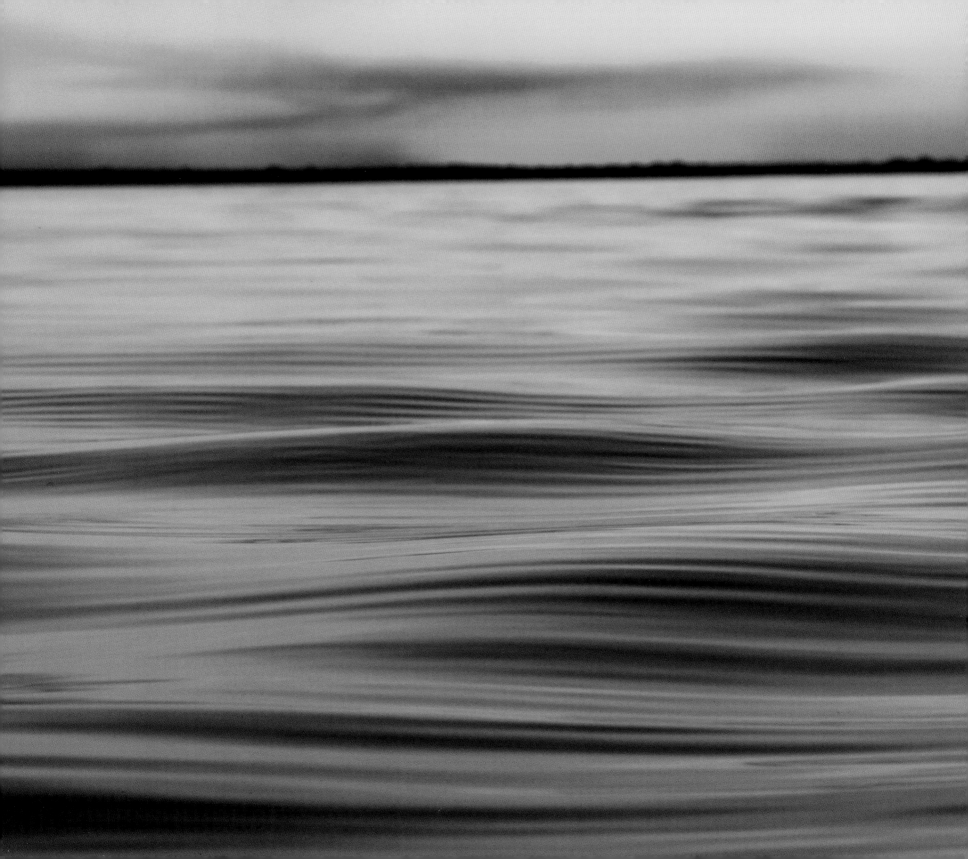

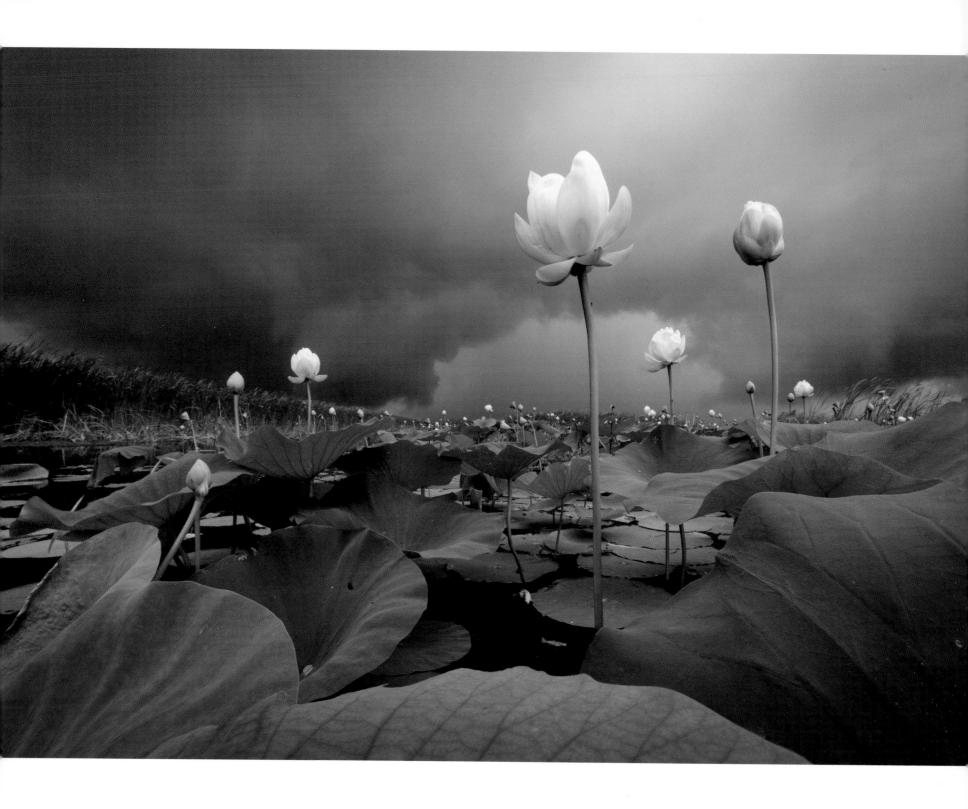

◄ American lotus and approaching storm. Lake Okeechobee.

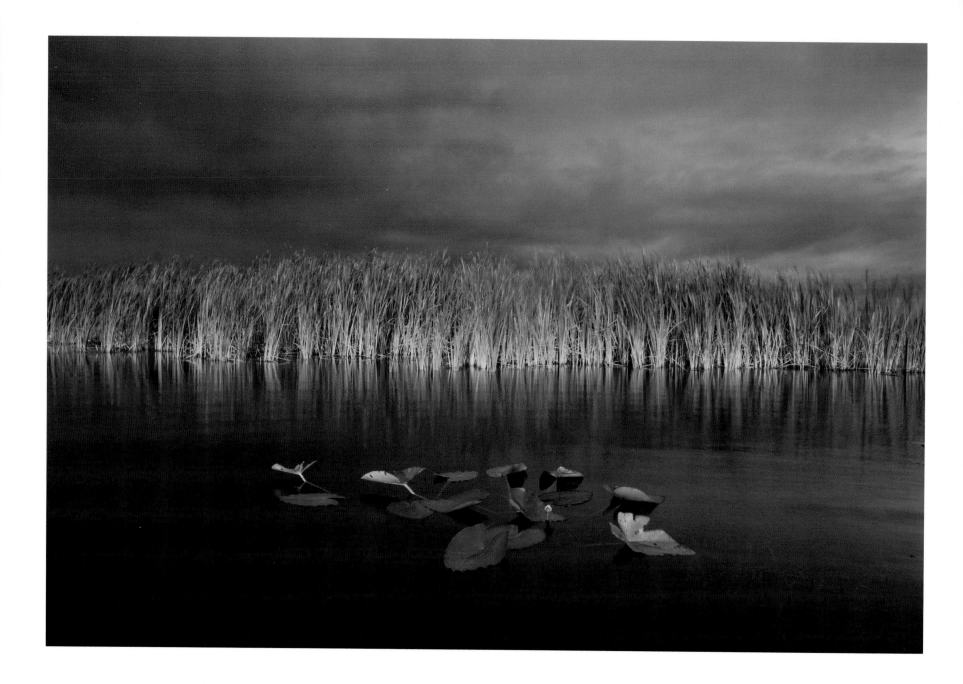

▲ Morning light on spadderdock and cattails in Eagle Bay marsh. Lake Okeechobee.

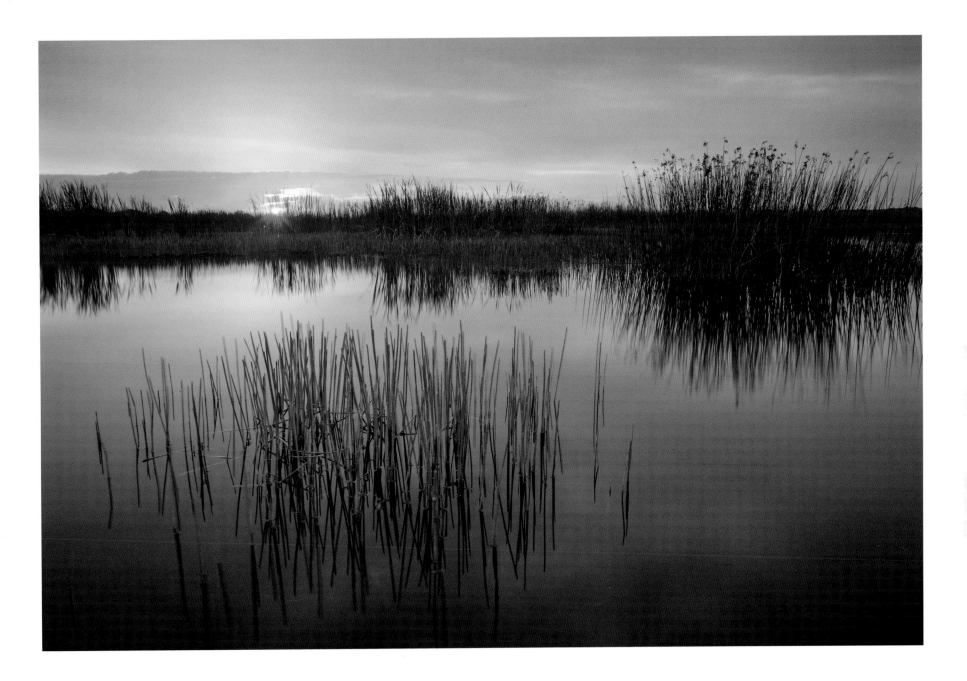

▲ Sunrise on restored wetland in Eagle Bay. Lake Okeechobee.

Everglades Snail Kite

In the northern Everglades, endangered snail kites soar low above the cattails and bulrush, scanning the endless maze of aquatic jungle for a needle in a haystack. The survival of these unique raptors depends entirely on their ability to locate their sole source of food: a camouflaged gastropod called an apple snail, about the size of a ping-pong ball. The evolutionary adaptations of these animals have allowed them to thrive in the Everglades watershed with boisterous populations until the last century.

Apple snails are perfectly adapted for the hydrological fluctuations of the Everglades. Equipped with both a gill and a lung they are able to endure the long rainy seasons submerged underwater and prolonged droughts by sealing their bodies from water loss behind a hard shell operculum. The apple snail, however, has an Achilles heel. It must periodically ascend the tall vegetation until reaching the water's surface to breathe through its air tube, as well as mate and lay eggs.

During the spring months from February to June, Everglades snail kites raise their young when the apple snails are most active. The raptors' wings are broad, which allow them to glide effortlessly over the wetland while locating prey. With pinpoint vision and long, curved talons, they miraculously identify and grasp the apple snails without submerging in the water. Flying to a nearby perch, the kites' sickle-shaped bill is the perfect tool for prying the stubborn snail from its shell. Over the last century, however, water quality worsened throughout the Everglades and water management schemes flooded or drained much of the snails' habitat. Apple snails became less abundant, causing a dramatic decline in snail kite populations, taking them to the brink of extinction. Today, restoration efforts hope to bring more stability to the region and give the Everglades snail kite a real chance at reestablishing itself as the iconic raptor of the River of Grass. Currently, there are an estimated 300 pairs nesting in Florida.

▶ A male Everglades snail kite swoops in to grasp an apple snail. Lake Okeechobee.

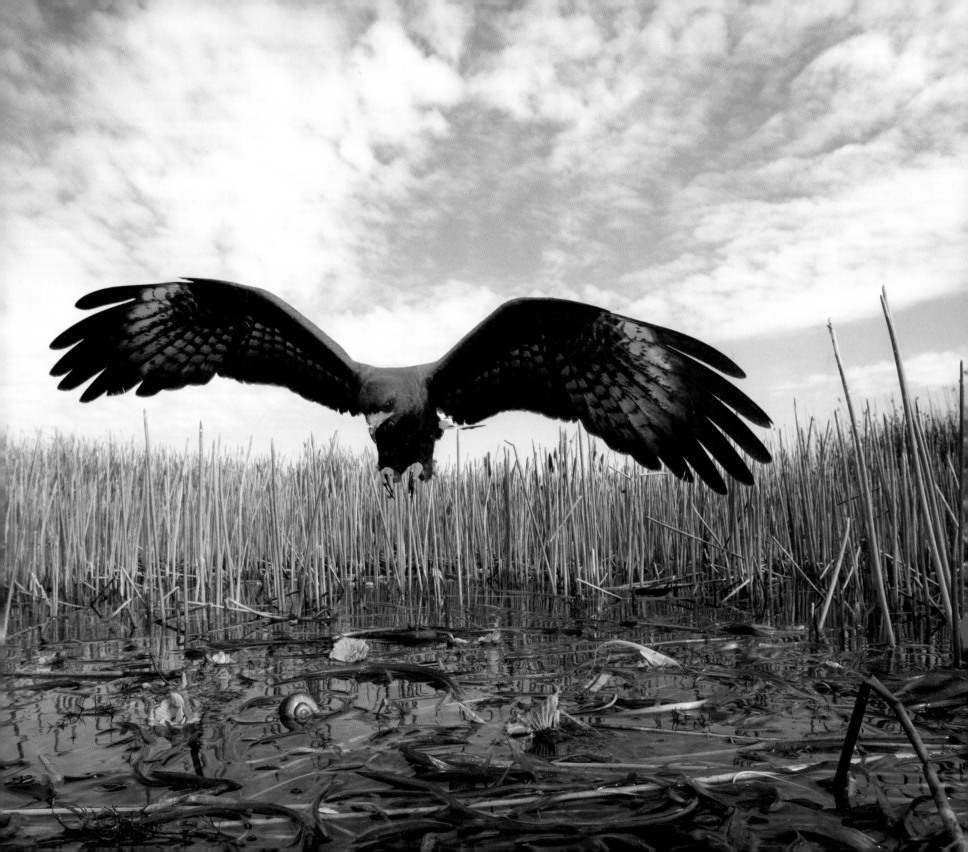

▶ Female snail kite and apple snail. Lake Okeechobee.

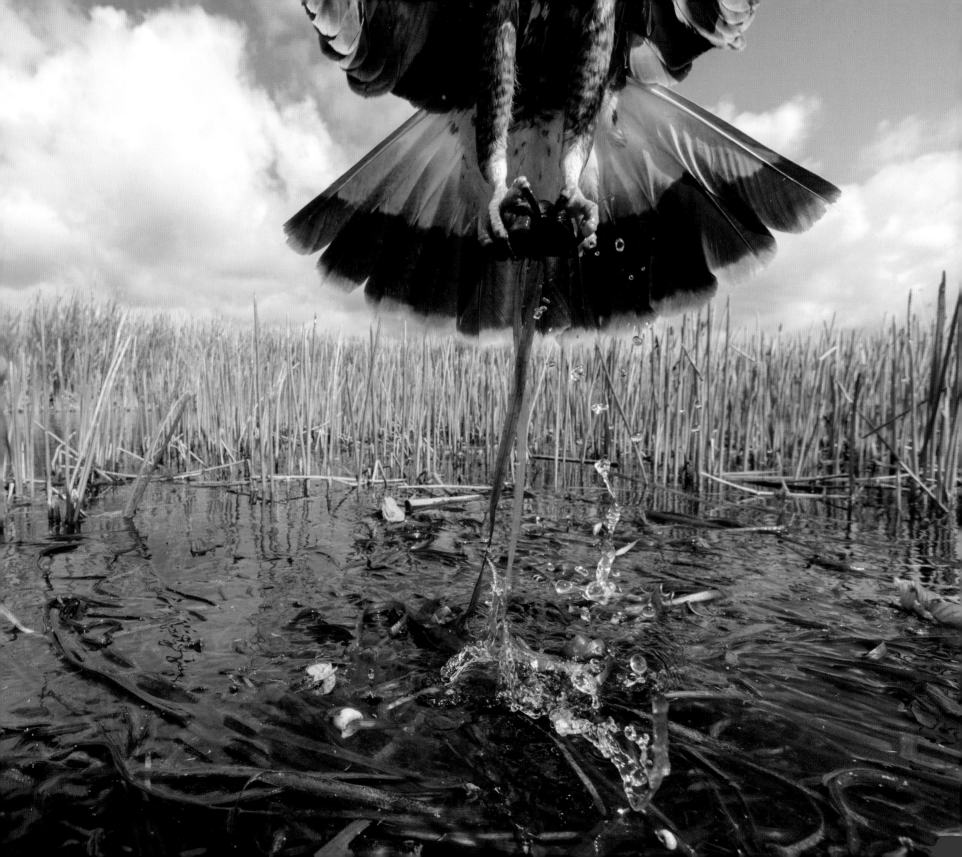

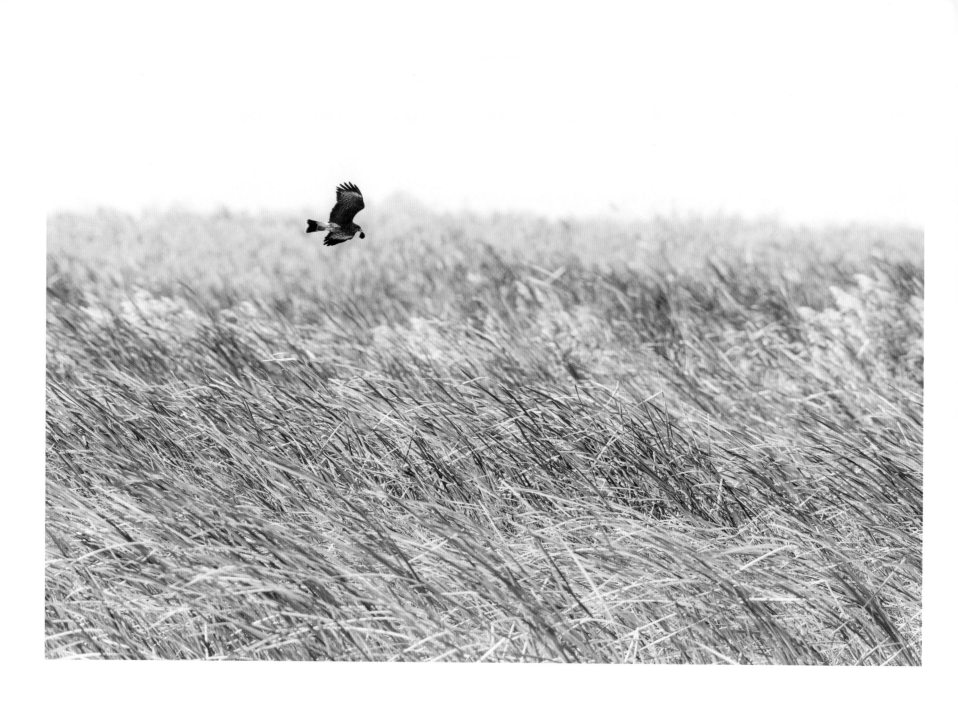

▲ A female snail kite returns to her nest with an apple snail. Lake Okeechobee.

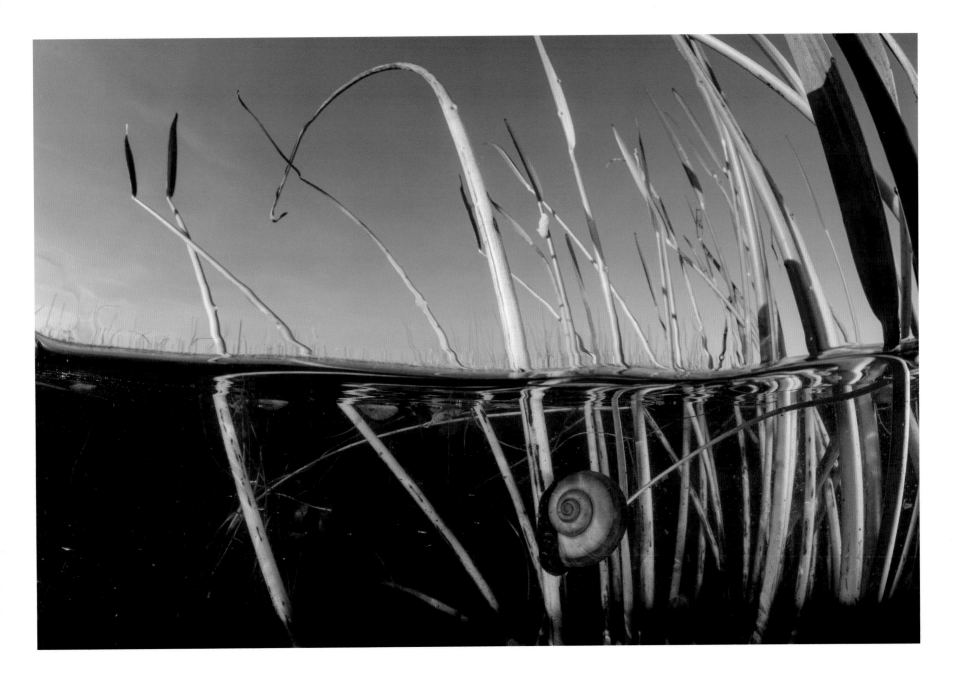

▲ A native apple snail scales the marsh vegetation. Lake Okeechobee.

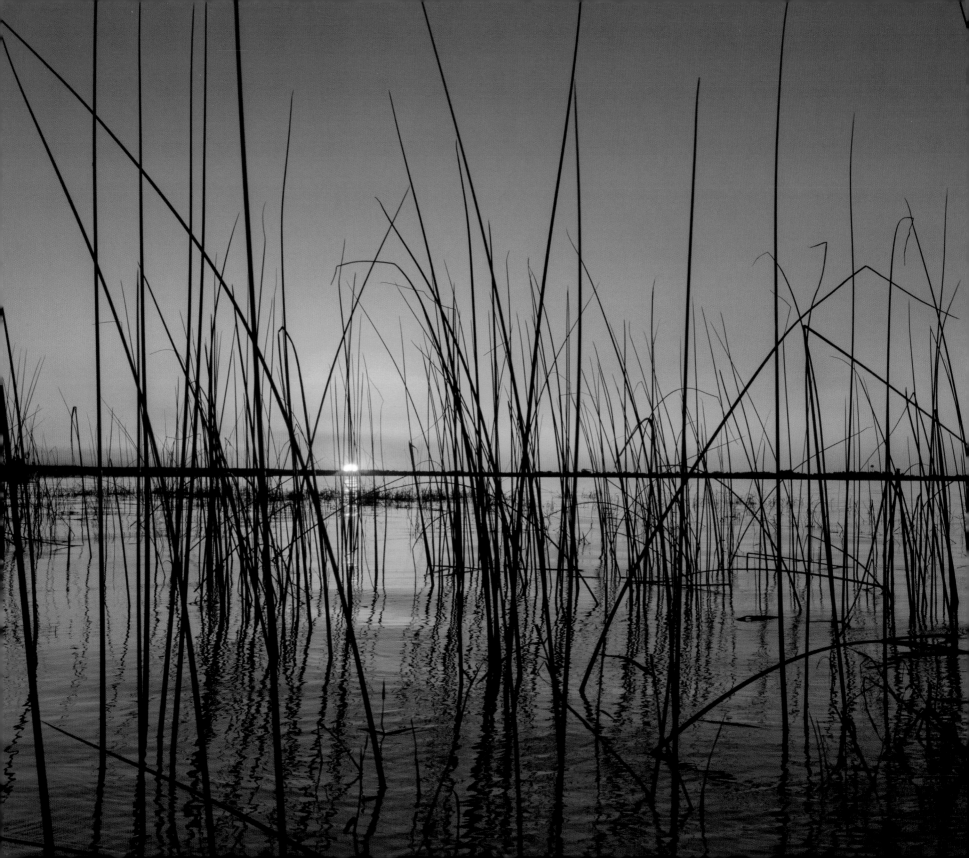

◄ Bulrush at dusk. Lake Okeechobee.

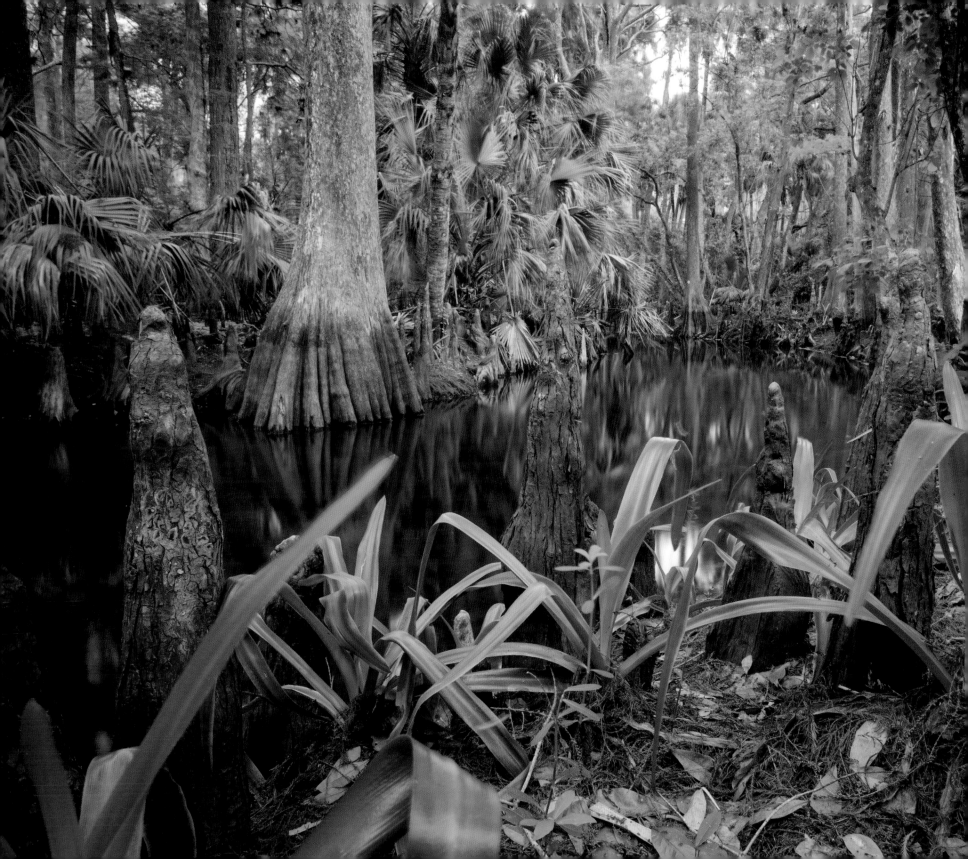

Fortunately, local organizations and citizens have fought hard to keep their slice of the Everglades in its natural state. Within these few oases, the waterways still bend and meander, delivering the precious lifeblood to its intended source. The Loxahatchee River and the Hobe Sound National Wildlife Refuge at its terminus are shining examples that collaborative conservation works.

◄ The Loxahatchee River. Jonathan Dickinson State Park.

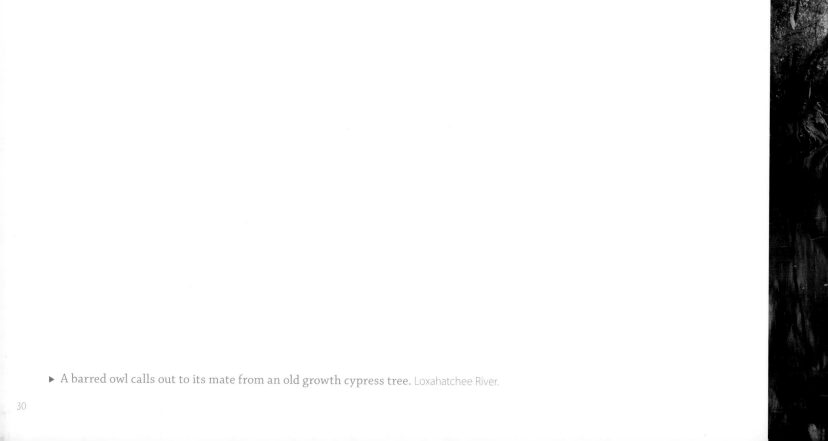

▶ A barred owl calls out to its mate from an old growth cypress tree. Loxahatchee River.

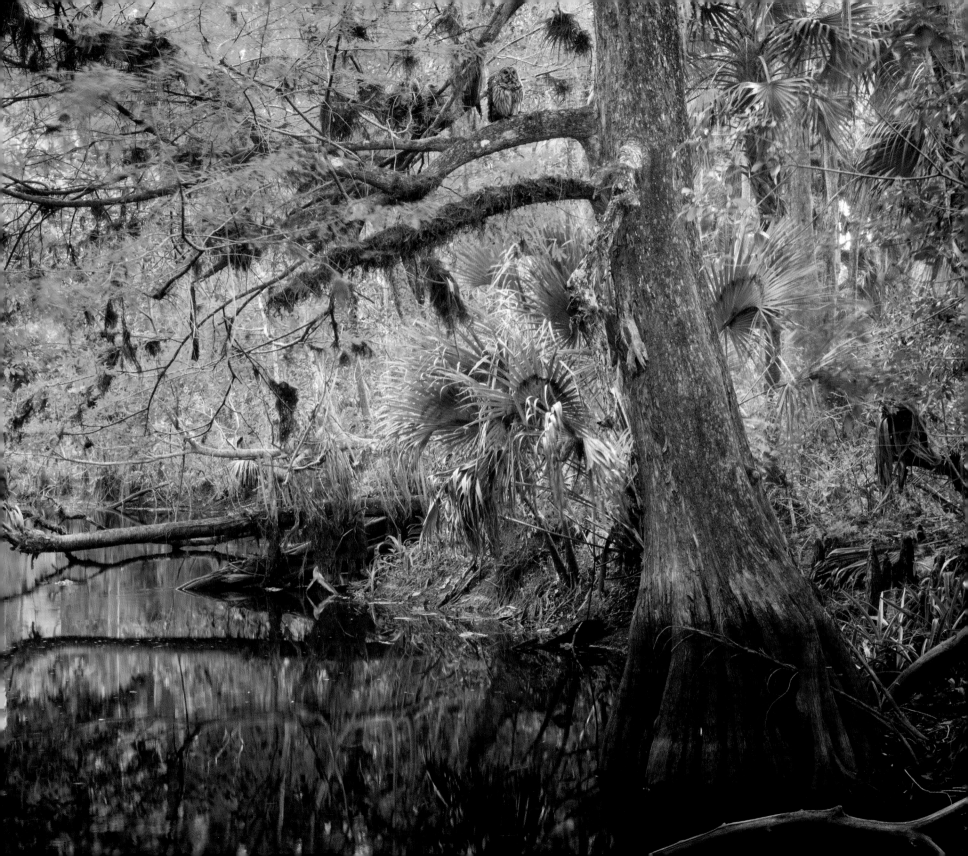

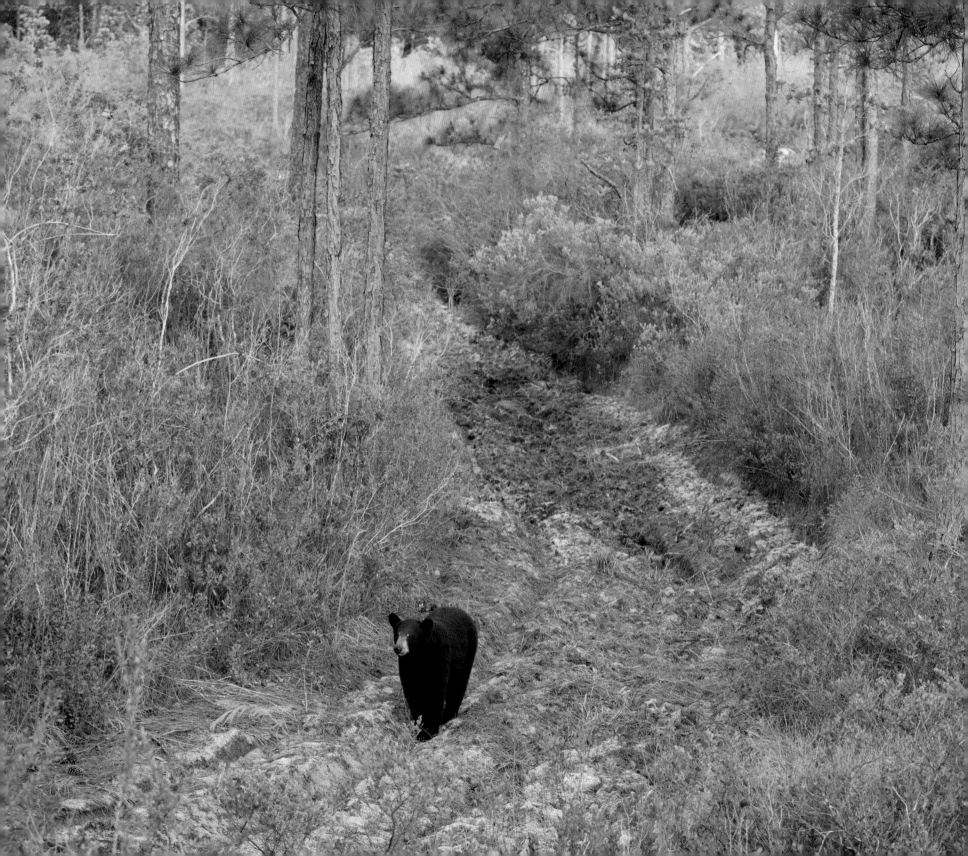

Florida black bears, the largest terrestrial mammals in the Everglades watershed, require vast tracts of land to successfully forage and breed. Over the years their populations have dwindled from rampant habitat loss to development and agriculture. Fortunately, within large private ranches in the northern Everglades, healthy populations exist and are given free range to roam the scrub, flatwoods, and cypress sloughs.

◀ A female Florida black bear pauses along a firebreak in the Hendry Ranch. Palmdale.

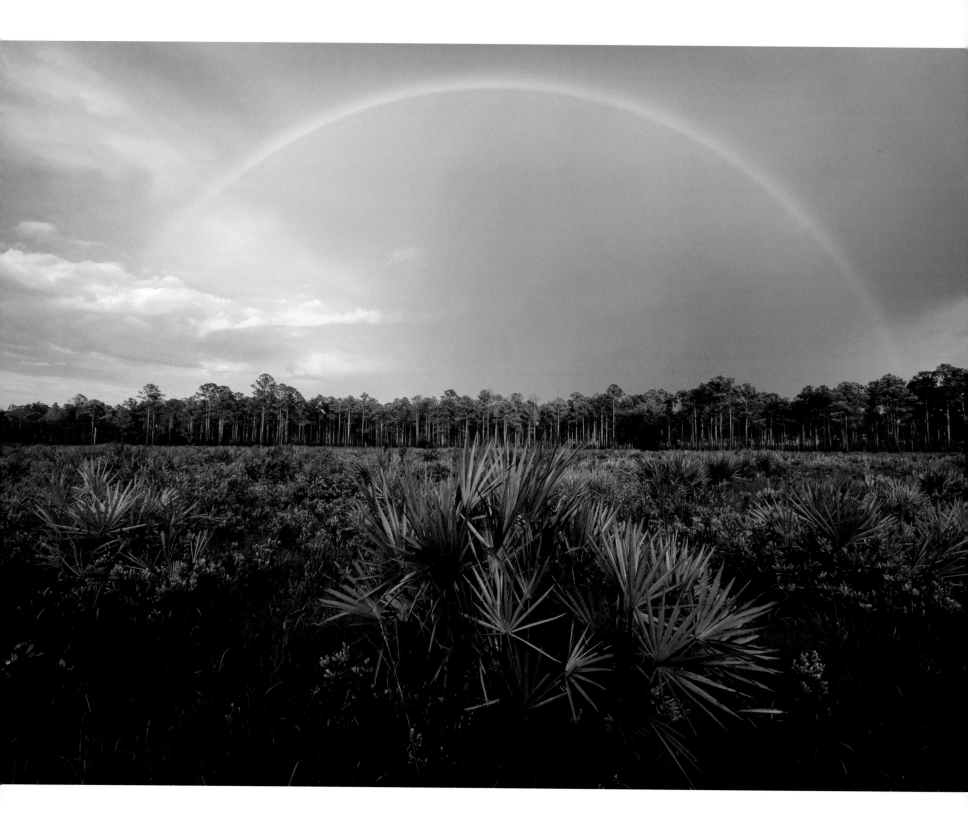

◀ Rainbow at last light over palmetto prairie. Smoak Ranch.

▶ **Pine flatwoods.** Smoak Ranch.

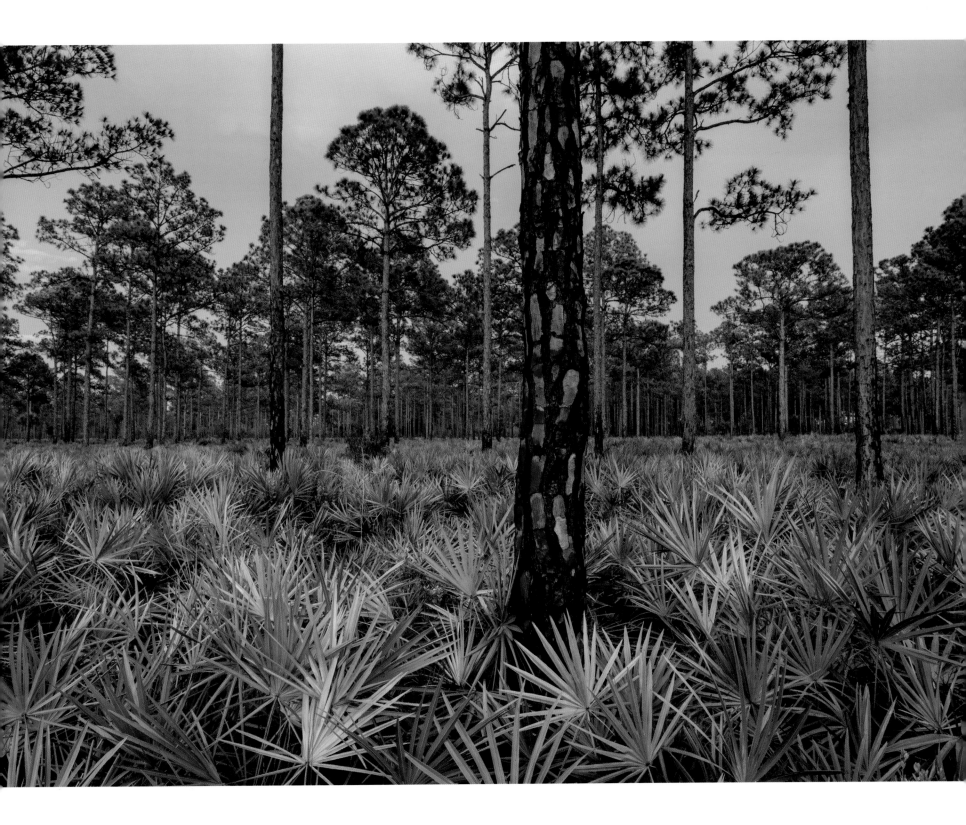

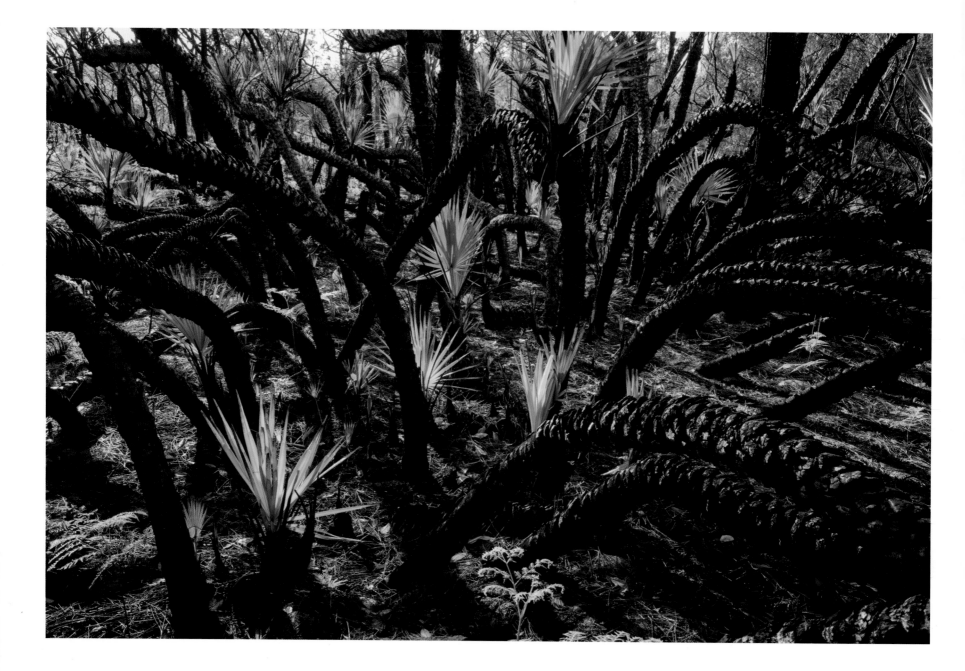

▲ Saw palmetto begins to sprout new growth and fruit only a month after a prescribed burn. Palmdale.

Fire serves an important role in the Everglades watershed. Historically, lightning strikes would cause natural fires across the River of Grass, scorching the earth and ravaging the scrub, flatwoods, and sawgrass habitats. Throughout the epochs plant and animal communities have evolved not only to survive these natural events but to thrive in them. Pinelands and prairies depend on fire to help abate succession from shrubs and other wetland trees, which compete for sunlight and minerals. After a fire, the nutrients previously locked within the burnt plant tissues are suddenly available to resistant trees and shrubs, sparking an explosion of new growth. Many plants like the saw palmetto bloom and fruit only after a fire, and their seeds are then eaten and dispersed by bears, birds, and other mammals. Today, land managers use prescribed burns to encourage the natural processes of the Everglades while ensuring the safety of South Florida's citizens on the periphery.

▲ Loblolly pine detail after a fire. Palmdale.

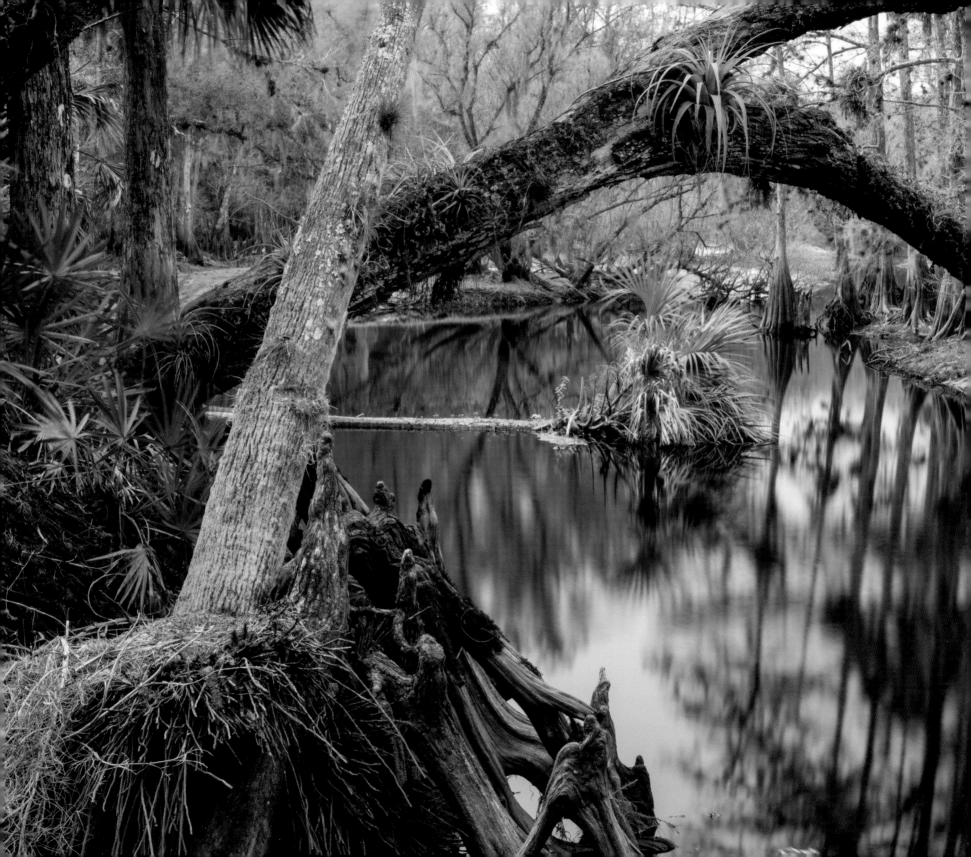

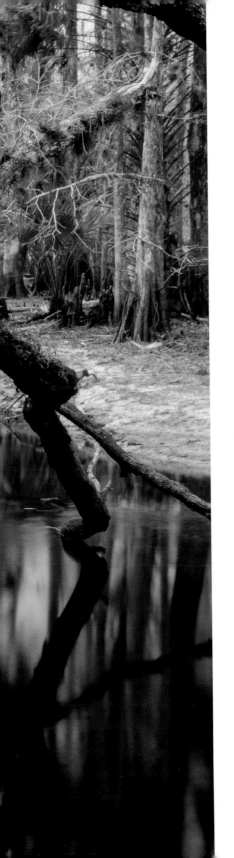

Fisheating Creek
Mac Stone

If Lake Okeechobee is the beating heart of the Everglades, then Fisheating Creek is one of the coronary arteries. The blackwater tributary runs the topographical gamut through prairies, flatwoods, upland hammocks, floodplain swamps, and freshwater marshes, supplying the lake with nearly a tenth of its water. For years I had been told it was one of the most scenic blueways in the state, a living testament to what South Florida once was. To this day, it remains the singular free-flowing waterway that feeds the big lake; a lone survivor of the dredges and dams from the Everglades draining blitzkrieg.

My fascination with Fisheating Creek, as with all memorable first impressions, is made more earnest by the circumstances under which we met. I arrived at the put-in with my kayak and hammock nearly two hours after dusk. A new moon offered no solace from the daunting task of paddling through this unknown wilderness at night. I followed the slow meandering water in hopes of finding a suitable campsite downstream.

My only light source was an LED headlamp, which barely served to illuminate my immediate surroundings. Careening through the night, I was afforded no further context than the dim flood of dying batteries. Reflections of arching limbs, flared buttresses, and gnarled cypress knees danced on the water. Countless alligator eyes glowed like luminaries from the dark abyss, marking my path ahead, then disappearing as I approached. Each bend, submerged log, and floating limb that brushed my hull came as a surprise, and I was overwhelmed with a hyperaware consciousness. Pupils dilated, nostrils flared, knuckles white, and steadily breathing a thin fog, my senses felt suddenly awakened as if having been dormant for years.

After an hour of paddling, I stopped at a large sandy bank and immediately built a fire. Looking across the stream, a massive bald cypress known as the Memorial Tree with knees taller than me stood prideful against the starry night, eerily lit by the campfire embers. At that moment, I knew exactly where I would spend the night.

Suspended high over the knobby spires of the cypress, I nodded off in my hammock, cocooned from the crisp winter air. The next morning I awoke in a thin layer of fog and set out with my camera to rediscover the magical waterway all over again.

◄ Low water in the dry season. Fisheating Creek.

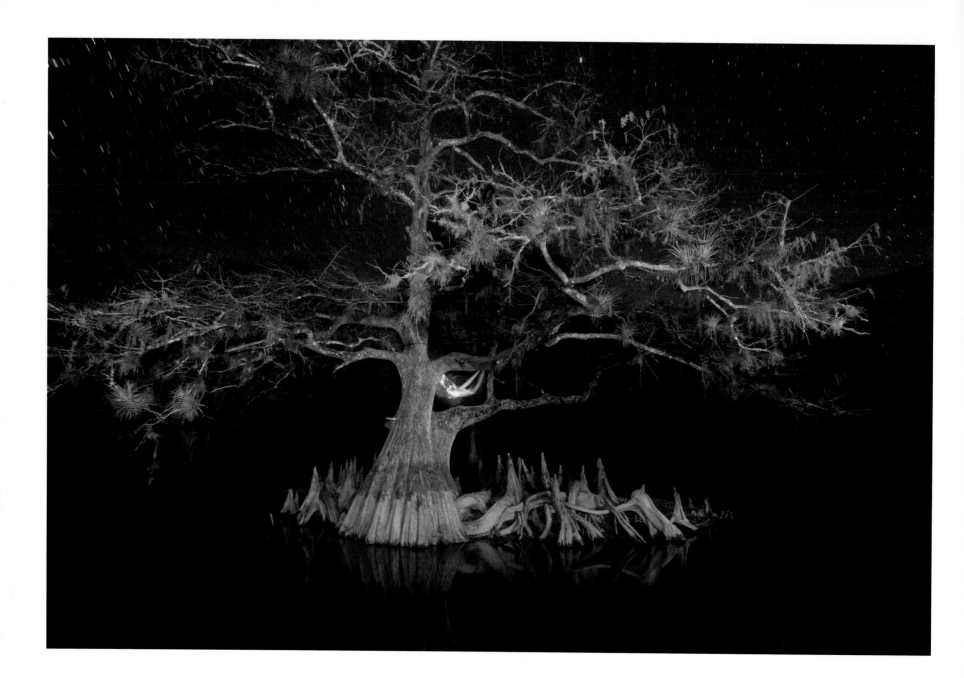

▲ Hammock camping in the northern Everglades. Fisheating Creek.

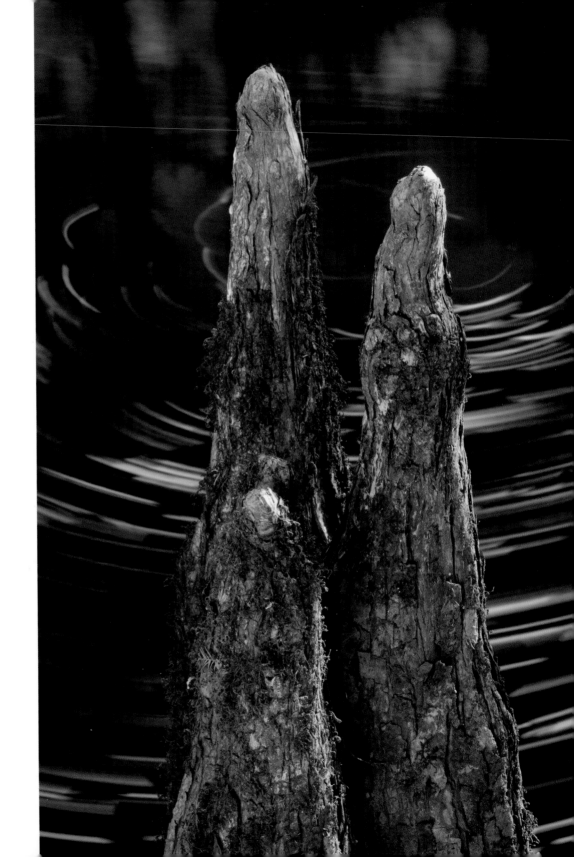

▶ Cypress knees and swirling red maple seeds. Fisheating Creek.

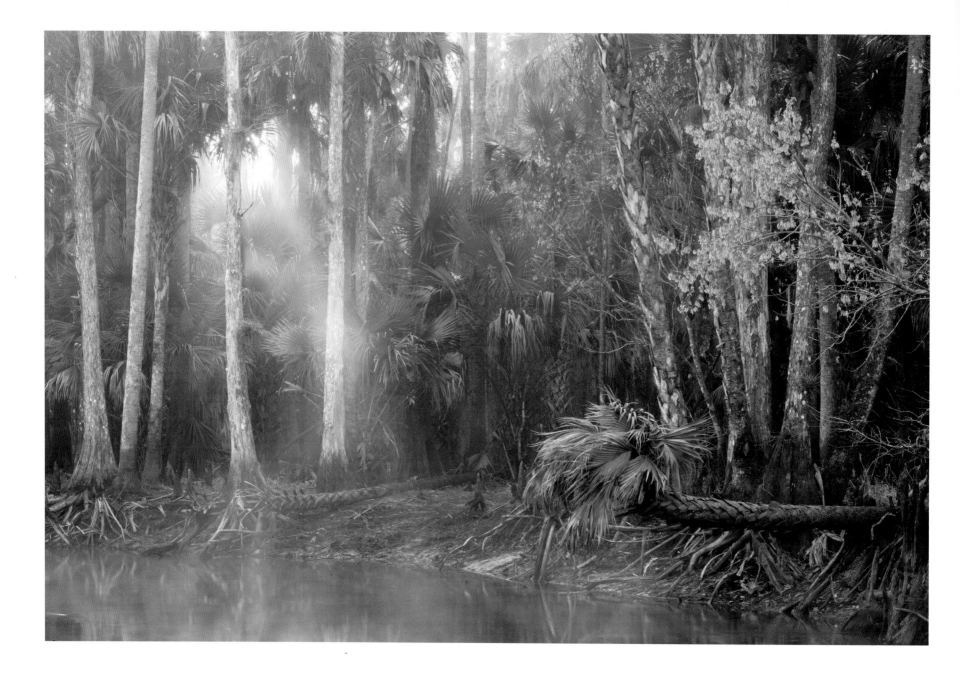

▲ **Morning light in autumn.** Fisheating Creek.

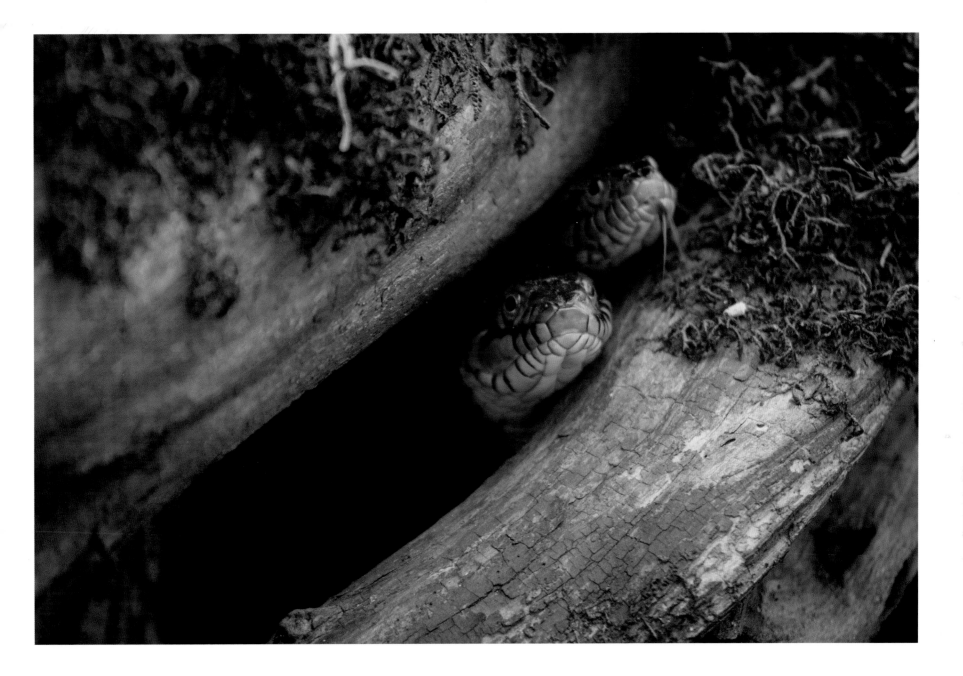

▲ Florida water snakes emerge from a cypress buttress after a brisk night. Fisheating Creek.

▶▶ Low water and polar fog. Fisheating Creek.

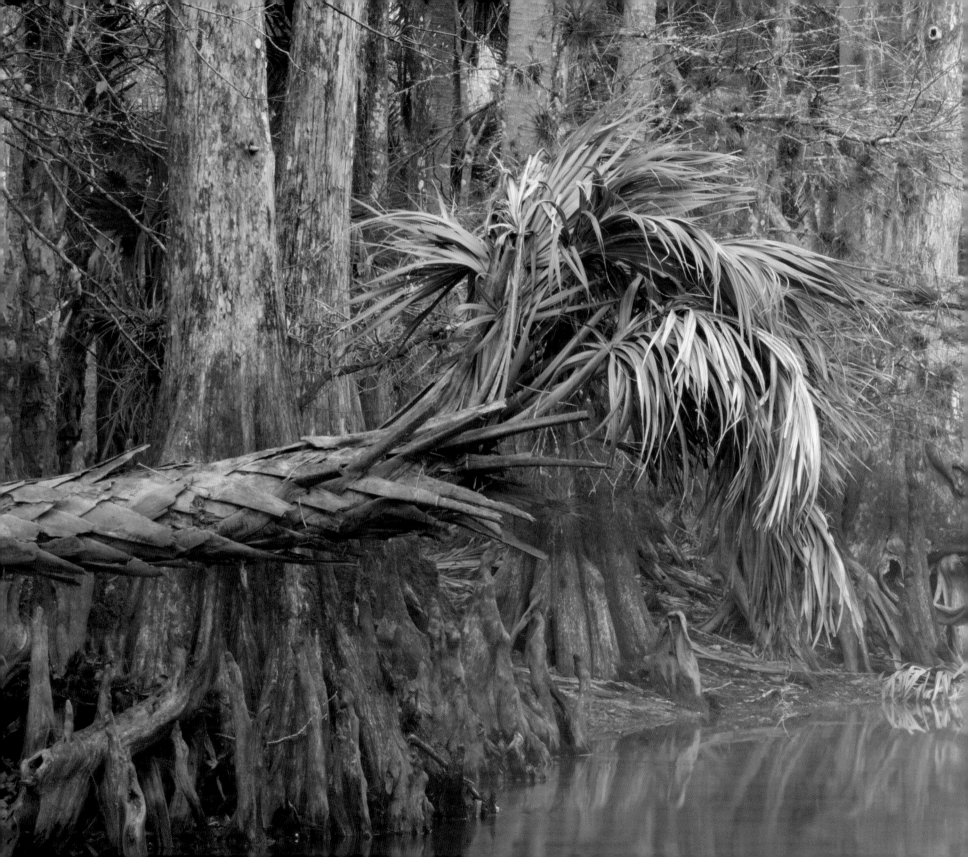

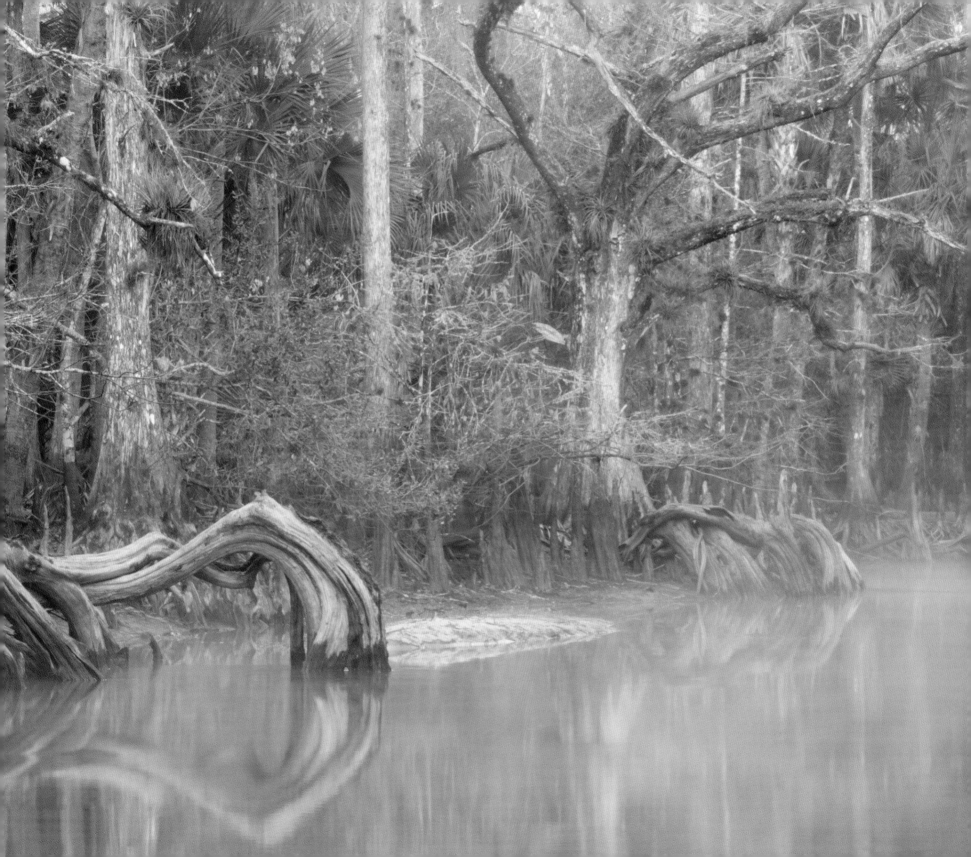

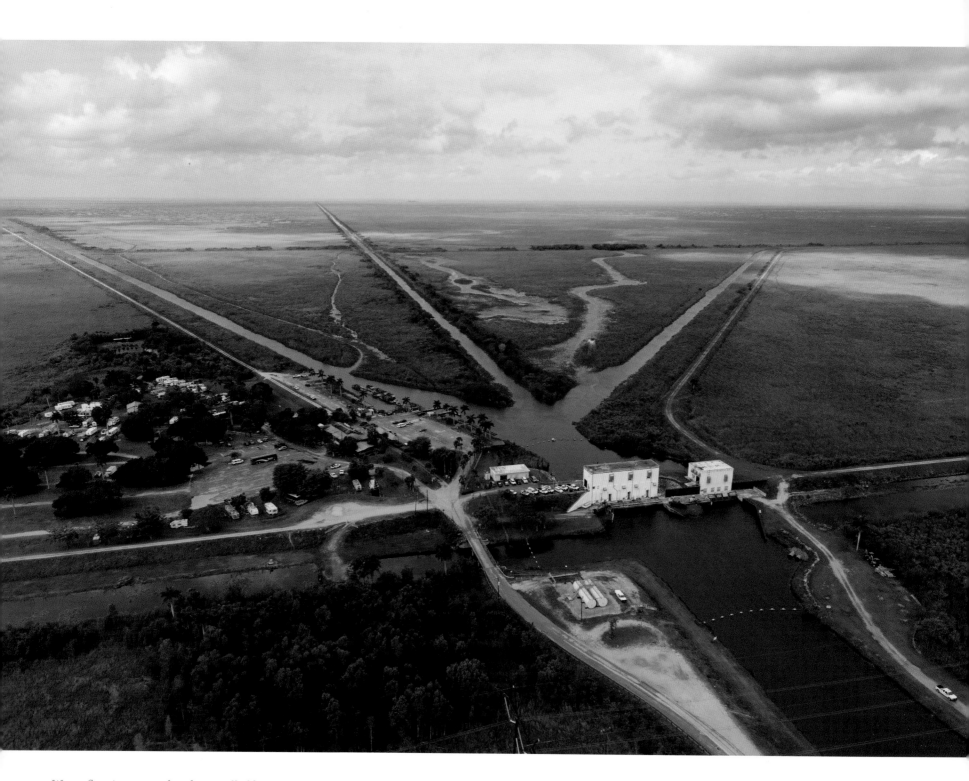

▲ Water flow is captured and controlled by a series of canals then released through pump stations. Pump Station S9, Water Conservation Area 3A.

Water Wars

Susan Bullock Sylvester

The Everglades is where the tragedy of the commons has intersected with the law of unintended consequences. Accounts of early explorers tell of an unparalleled natural world where lush wetland landscapes and abundant wildlife coexisted to the exclusion of all but the hardiest of Native Americans and pioneers. That world was permanently altered as trees were cut for timber, land drained for agriculture, and wildlife hunted almost to extinction for hides and feathers. Canals bisected the state, removing excess water from the land but creating an impossible dichotomy: drain the water and the land dries up; deliver too much water at the wrong time and the native plants and animals inevitably drown.

The fickle and tumultuous weather patterns of the subtropics confounded South Florida's early settlers. Massive flooding caused thousands of deaths in the 1920s and severe economic losses in the 1940s, resulting in an aggressive public campaign to tame the region's waters. Engineers stepped in and with federal funding, developed a complex management system to handle the needs of a growing population. As a result, the natural areas, which once expanded and contracted to hold the seasonal rains, now rigidly constrained the water and purged to sea most of the excess. The vast and historic watershed, which for millennia provided for such a profusion of life, was forever changed in a matter of decades.

The Everglades today could be described as a patient on life support. The scientists and engineers who manage the water attentively perform critical care. Pumps, valves, canals, and earthen

The Everglades today could be described as a patient on life support.

levees keep the water contained and delivered through a corridor roughly half the size of the original watershed. These mechanisms serve as the prosthetics for a once naturally free flowing system. It is not lost on me that as one of the engineers responsible for keeping the "patient" alive, I, too, live and benefit from the management of the Everglades: a dry home and an adequate supply of drinking water. However, water requirements for humans have often been met at the detriment of the natural world. It is critically important to continue to recover the watershed by gradually remodeling management strategies, building more storage, and restoring flexibility to allow the Everglades to reclaim its natural balance.

By leveraging technology, we have been able to keep up with the expanding population of South Florida while maintaining the remnants of our region's natural heritage. In the end, however, technology can only take us so far. Perhaps restoring the Everglades will instead depend more heavily on reviving the relationship between the ailing watershed and the seven million souls who call it home. I believe this personal connection with the wetland, above all, will be the key to finding sustainable solutions.

Susan Bullock Sylvester worked for the Corps of Engineers for 21 years until 2005 when she joined the South Florida Water Management District. As bureau chief of water operations control, she leads the team that monitors and operates the complex water management system.

▲ Engine detail at S-127 pump station. Lake Okeechobee.

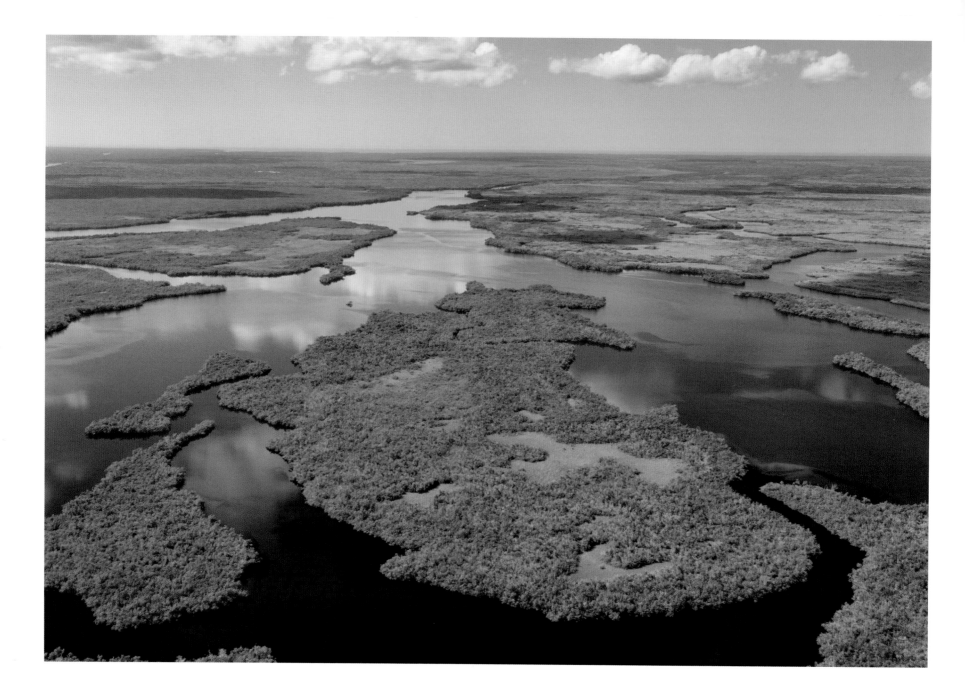

▲ Mangrove islands in Tarpon Bay. Everglades National Park.

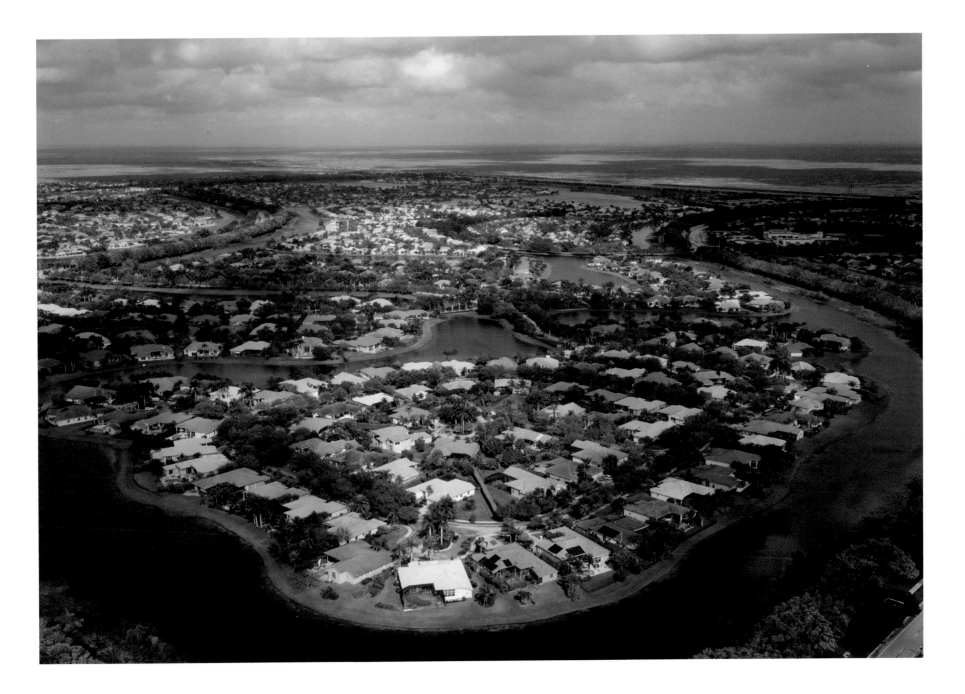

▲ A housing development offering waterfront properties within the historic Everglades watershed. West Palm Beach.

▶ Trucks pump water from the subterranean limestone shelf to irrigate tomato fields. Homestead.

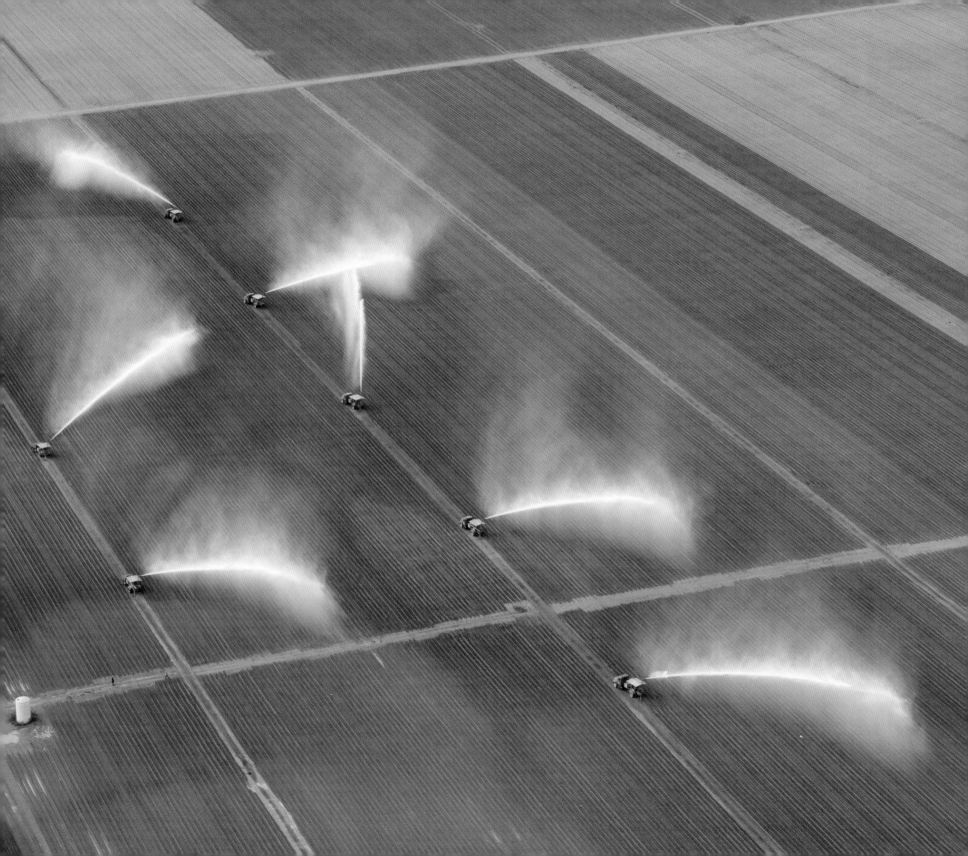

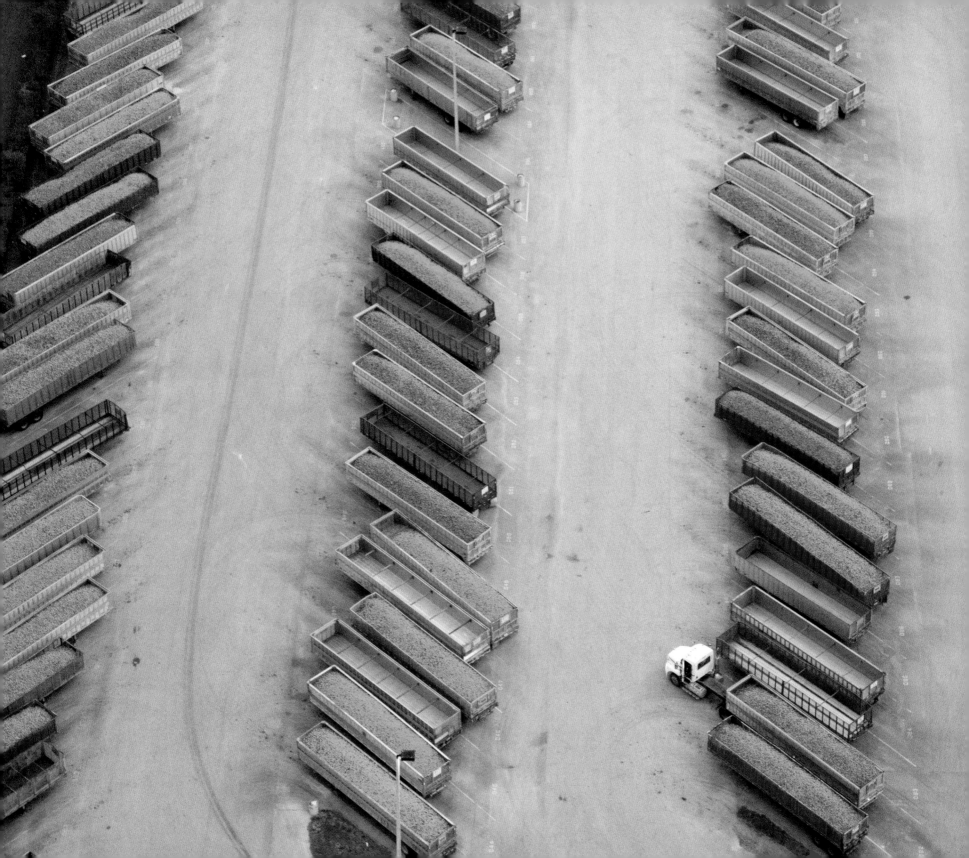

◄ Trucks full of oranges await transportation to the juicing factory. Indiantown.

White ibis and roseate spoonbills nest on large tree islands in the central Everglades. As early spring rains raise water levels in the water conservation areas, these birds will fly in all directions to search for optimal foraging grounds. Historically, colonies like this once hosted thousands of pairs of wading birds. High nutrient runoff from sugarcane and agricultural lands has greatly altered the landscape replacing the extensive sawgrass prairies with cattails, making access to shallow pools of fishes sparse. In combination with poorly timed releases of water as well as lack of freshwater, the carrying capacity for these colonies has diminished greatly. Still, the resilient birds continue to nest in South Florida, waiting for conditions to improve.

▶ Wading bird colony. Water Conservation Area 3.

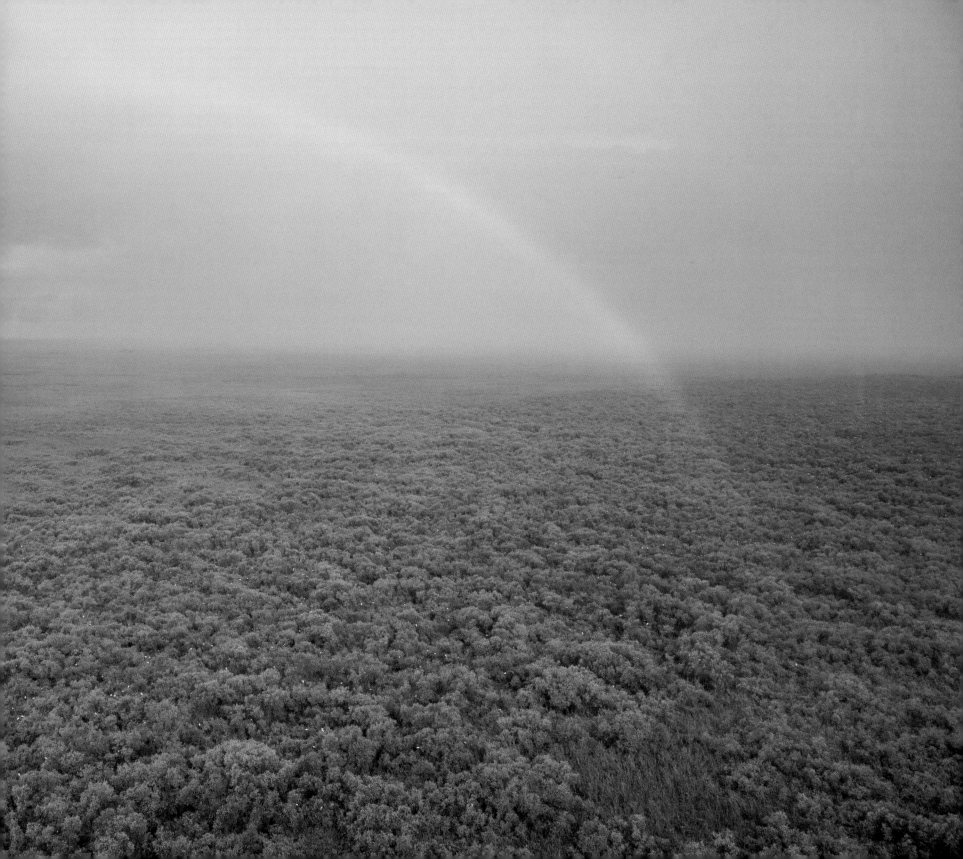

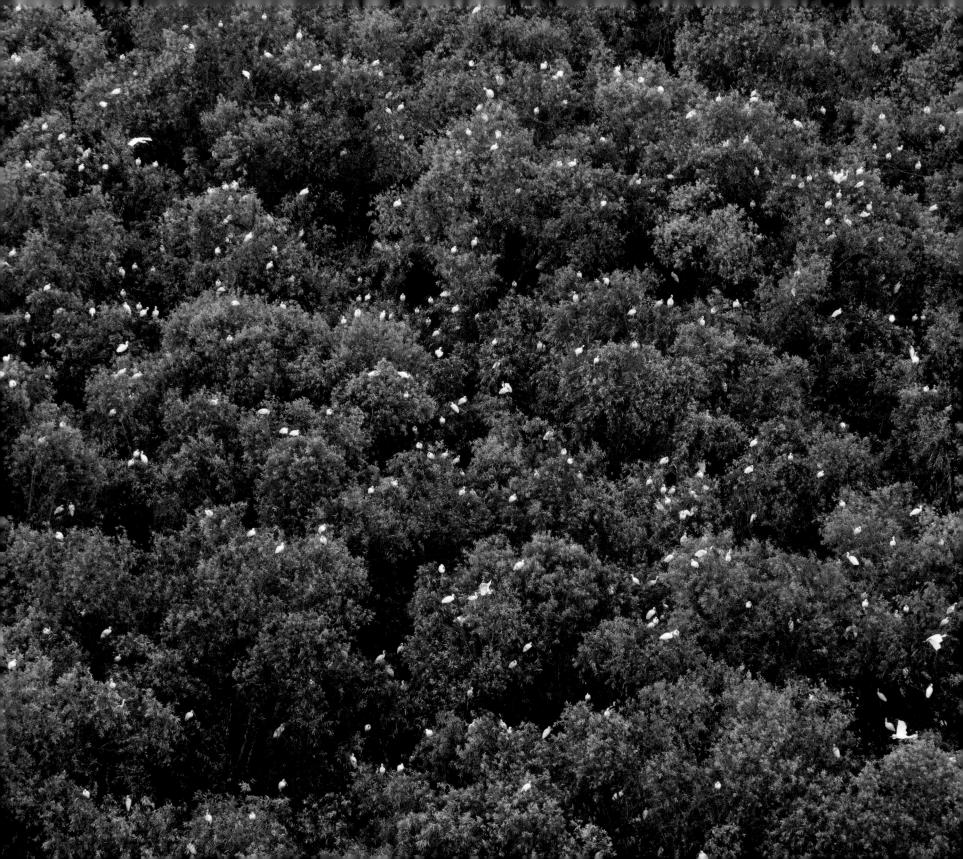

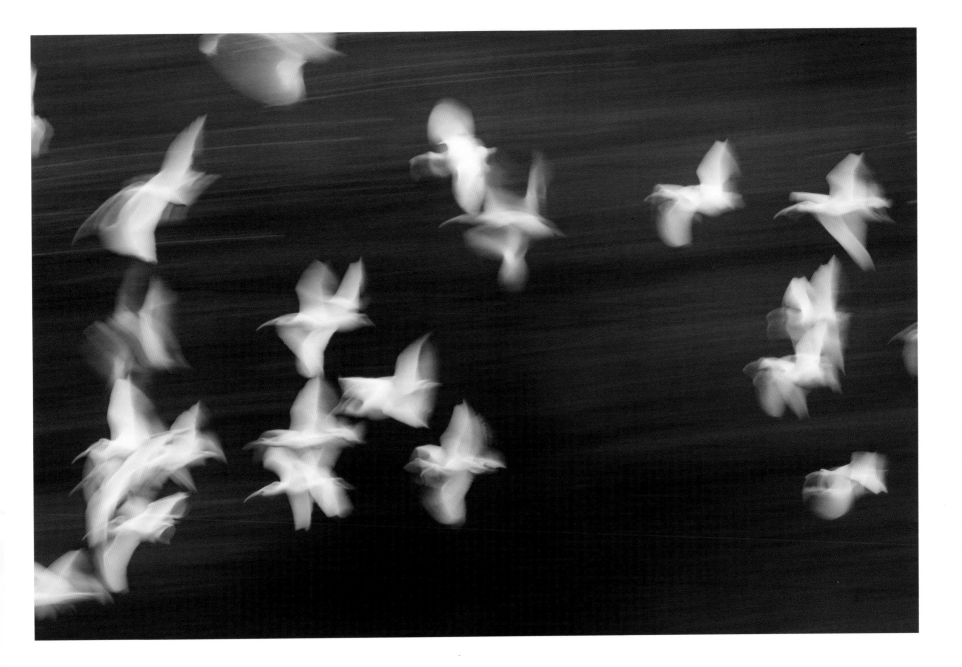

◀ White ibis colony. Everglades Water Conservation Area 3.

▲ White ibis return to roost at dusk. Everglades National Park.

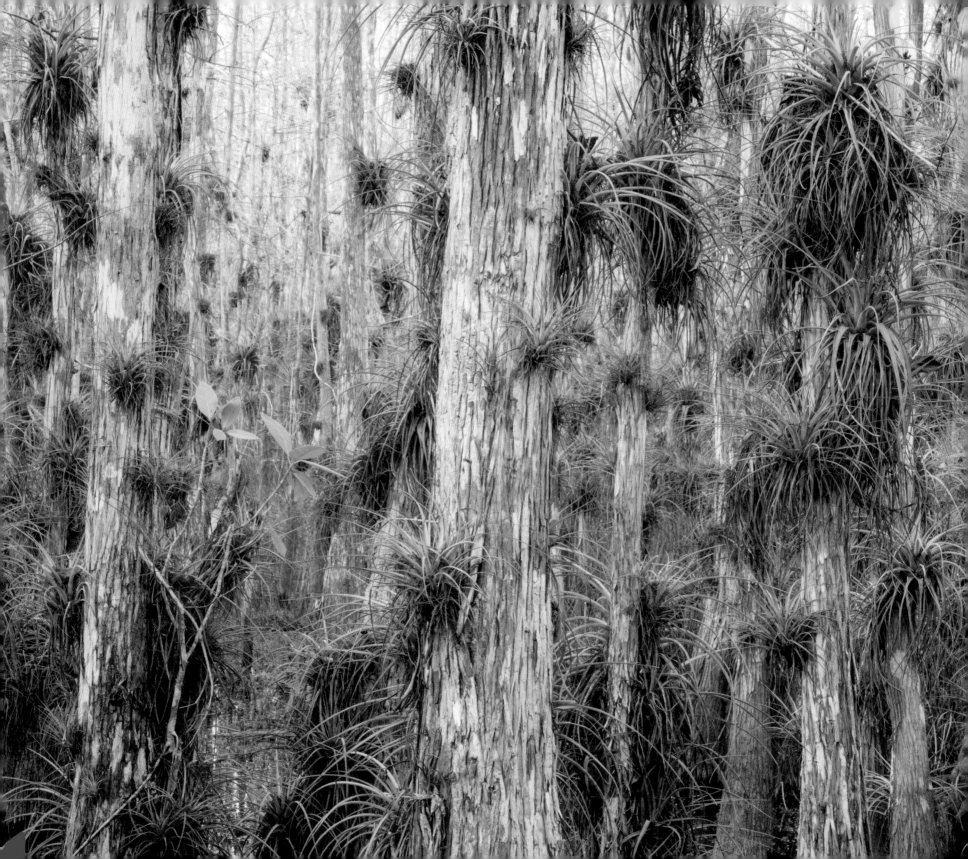

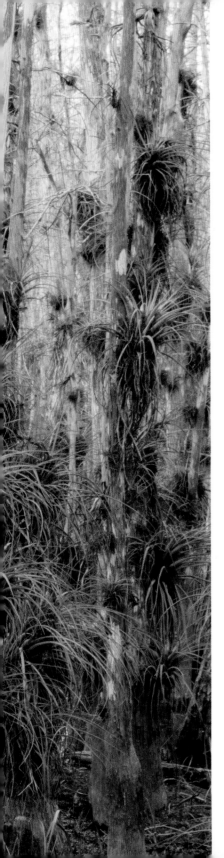

South of the water conservation areas the expanses of sawgrass gradually turn into braided creeks and sloughs of bald cypress trees in the central and western Everglades. Bald cypress trees are deciduous trees; their name originates from their denuded appearance during the winter months. Heavily logged during the early twentieth century for their water-, rot-, and insect-resistant qualities, cypress trees were the naturally occurring modern equivalent to pressure-treated wood. These ancient giants dominated the wetland canopy and gave name to the present day Big Cypress National Preserve. Today, younger cypress trees and pond apples are reclaiming the landscape, and the extensive backcountry forests within the Fakahatchee Strand Preserve State Park and Corkscrew Swamp offer a glimpse into a unique Everglades ecosystem where rare orchids, snakes, panthers, and black bears flourish.

◄ Tillandsia and cypress grove. Big Cypress National Preserve.

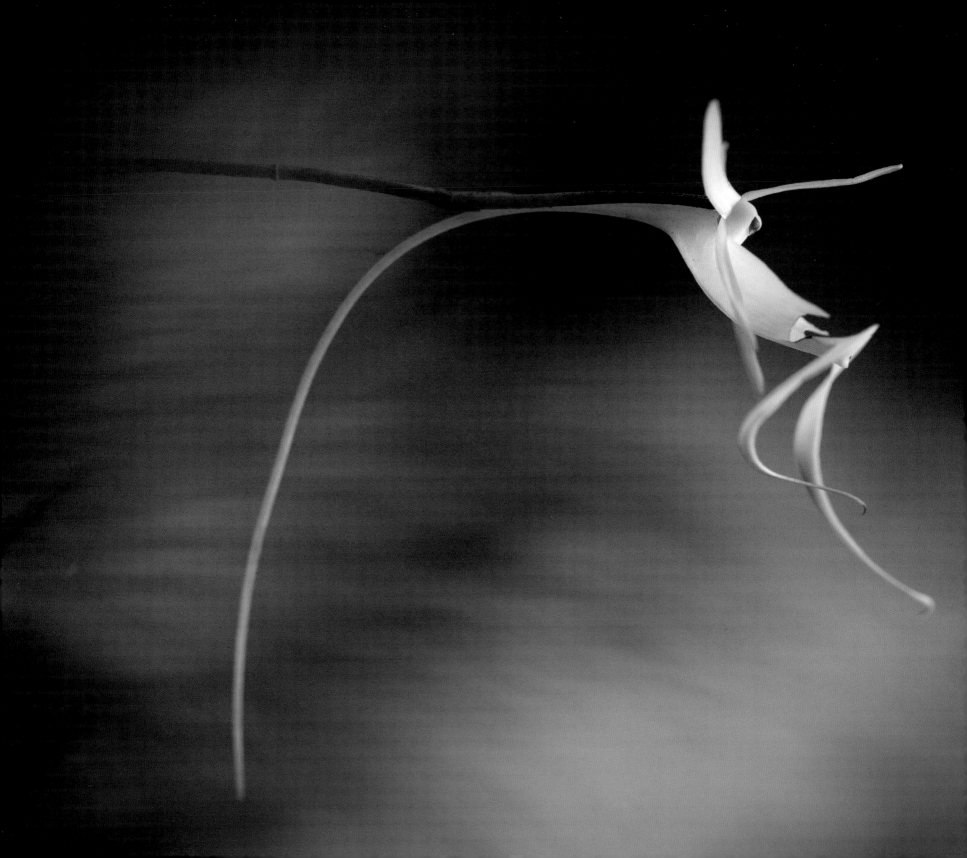

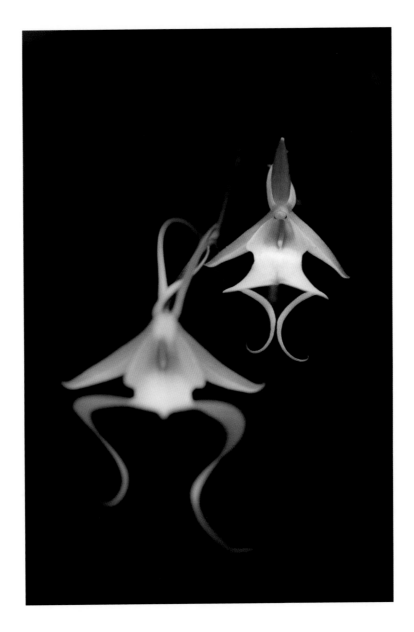

◄▲ Ghost orchid. Big Cypress National Preserve.

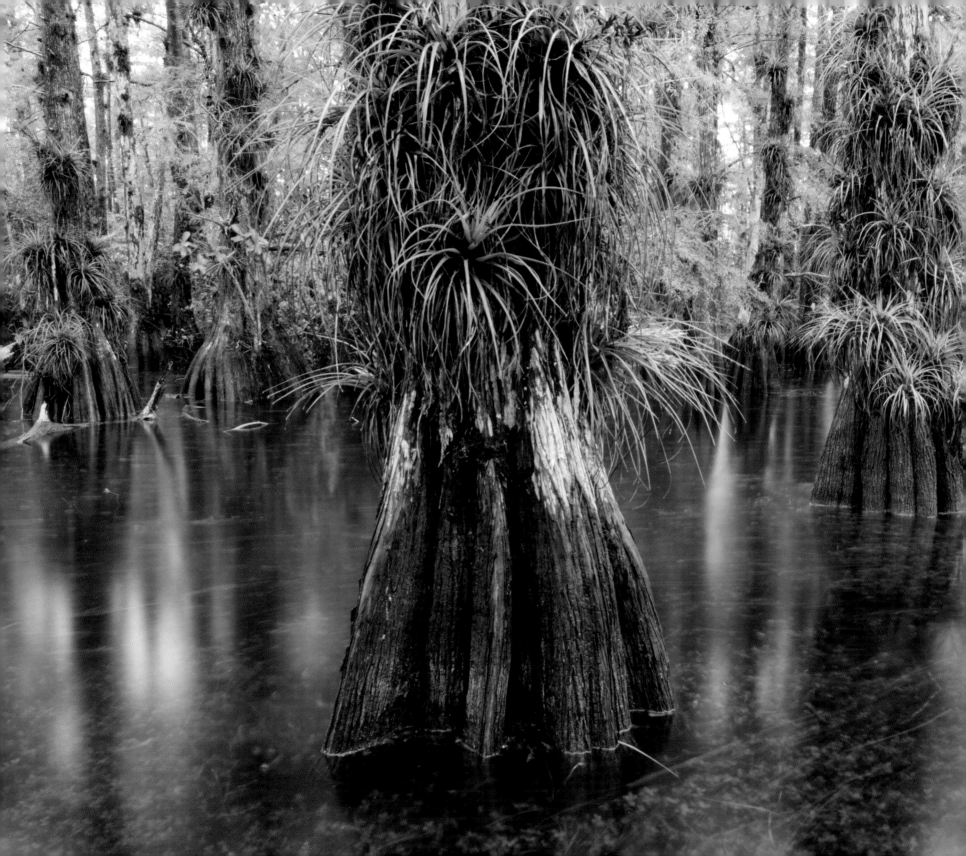

◄ Cypress trees in Gator Hook Swamp. Big Cypress National Preserve.

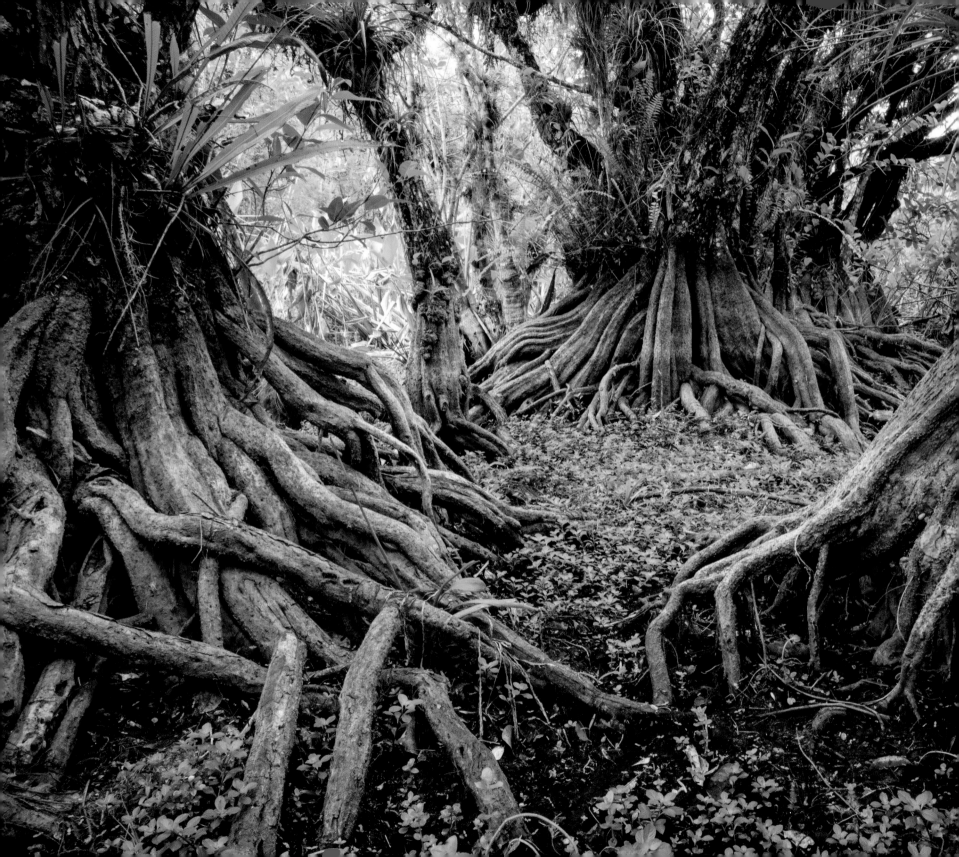

Ancient pond apple groves once stretched nearly fifty miles along the southern rim of Lake Okeechobee, providing refuge to species of orchids, ferns, and gourds found nowhere else on the planet. At the turn of the century, however, pioneers soon learned the peaty soils beneath the tangled canopies were some of the most fertile in the Everglades complex. Soon after, the great forests were slashed and burned making way for the agricultural areas of Belle Glade, Moore Haven, and Pahokee. Fragmented pockets of these majestic trees still exist throughout the Everglades, and they appear carved from the primordial block. Life teems from every crevasse and clings to every inch of organic real estate. Walking through the few remaining pond apple forests is eerily peaceful, resembling a prehistoric land.

◄ Pond apple trees in the dry season. Big Cypress National Preserve.

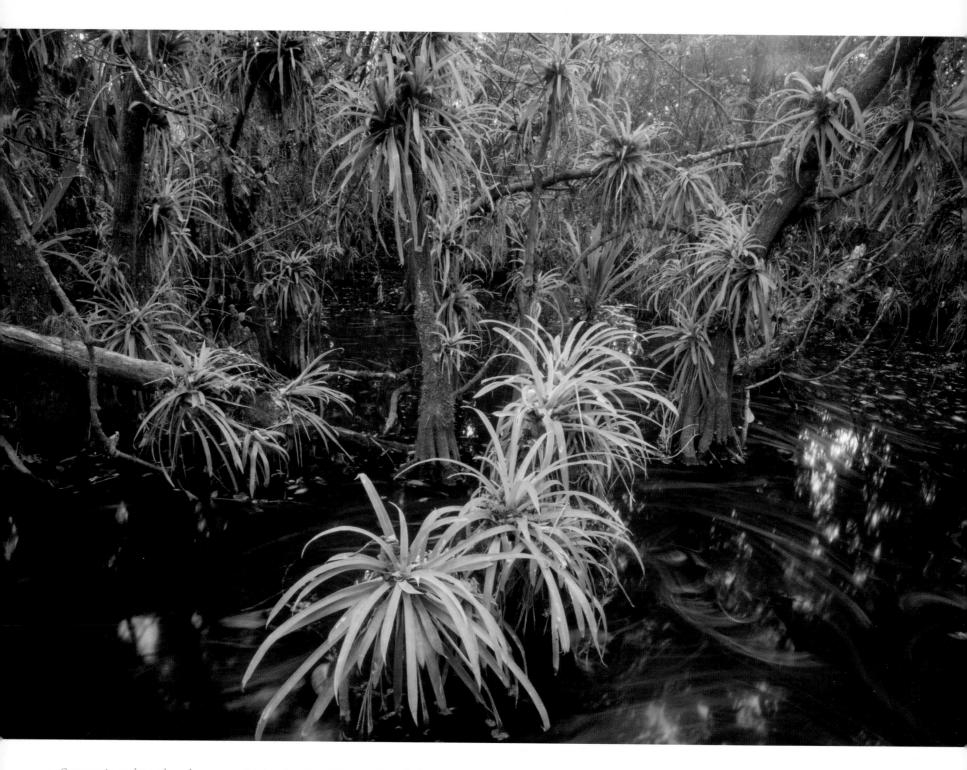

▲ Guzmania and pond apple swamp. Fakahatchee Strand Preserve State Park.

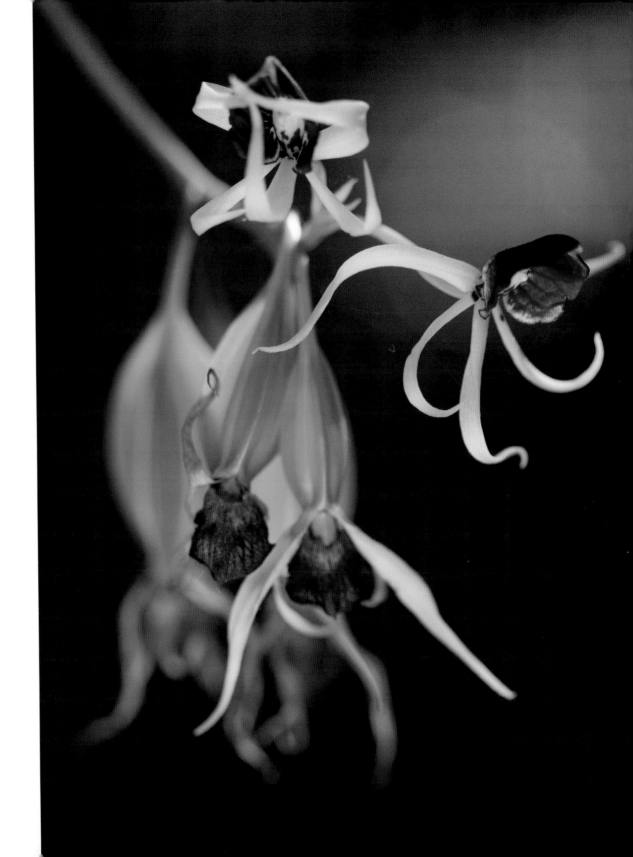

▶ Clamshell orchid. Fakahatchee Strand Preserve State Park.

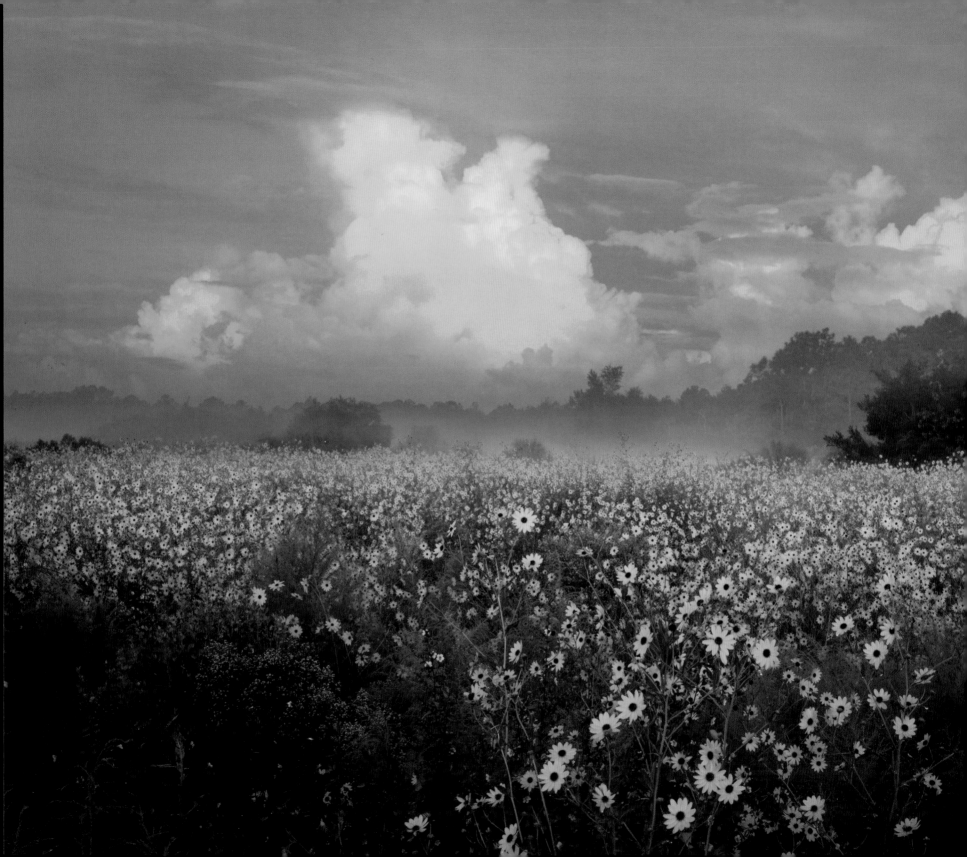

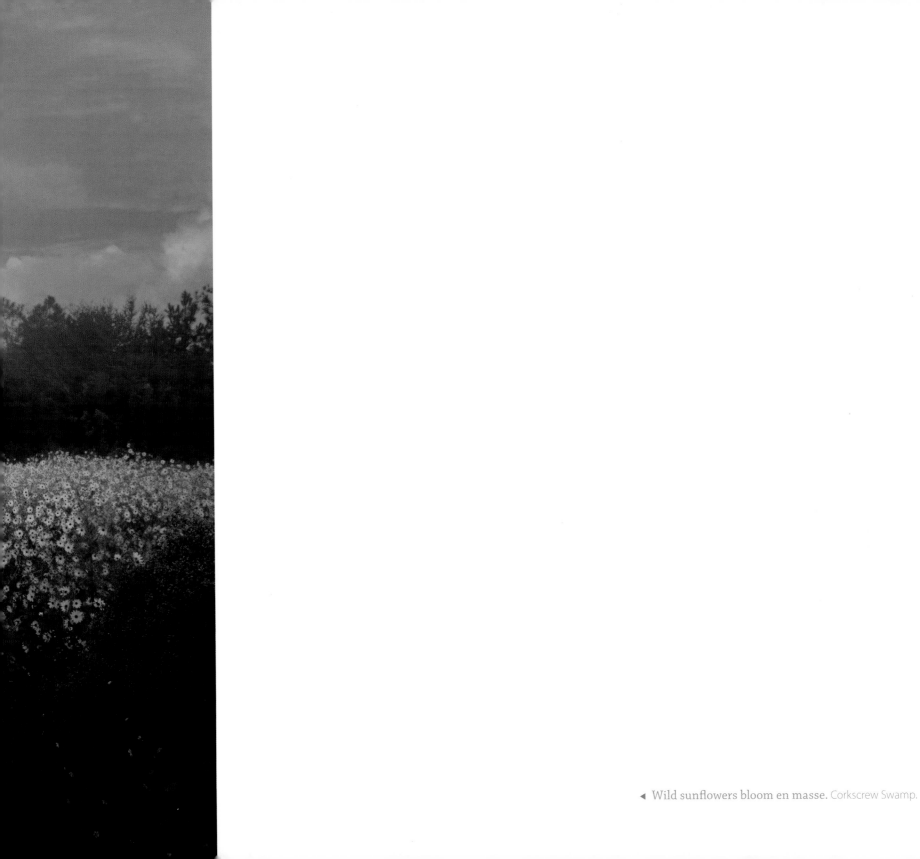

◄ Wild sunflowers bloom en masse. Corkscrew Swamp.

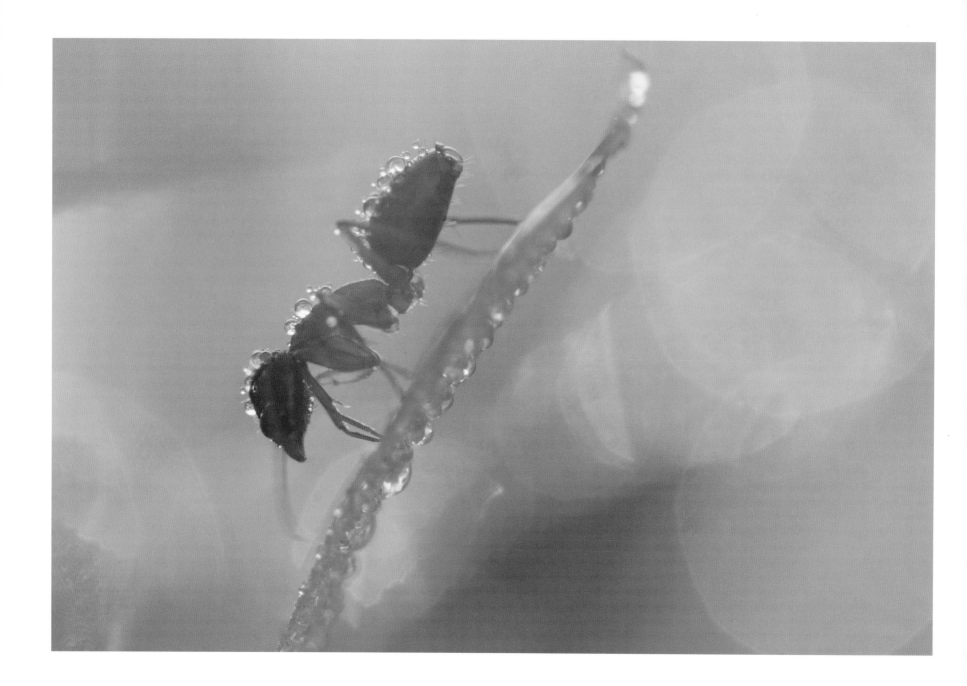

▲ **Morning dew on a red ant.** Corkscrew Swamp.

►► Morning light shines through wetland prairies. Corkscrew Swamp.

▲ Wetland prairies form the fringe around pond and bald cypress trees. Corkscrew Swamp.

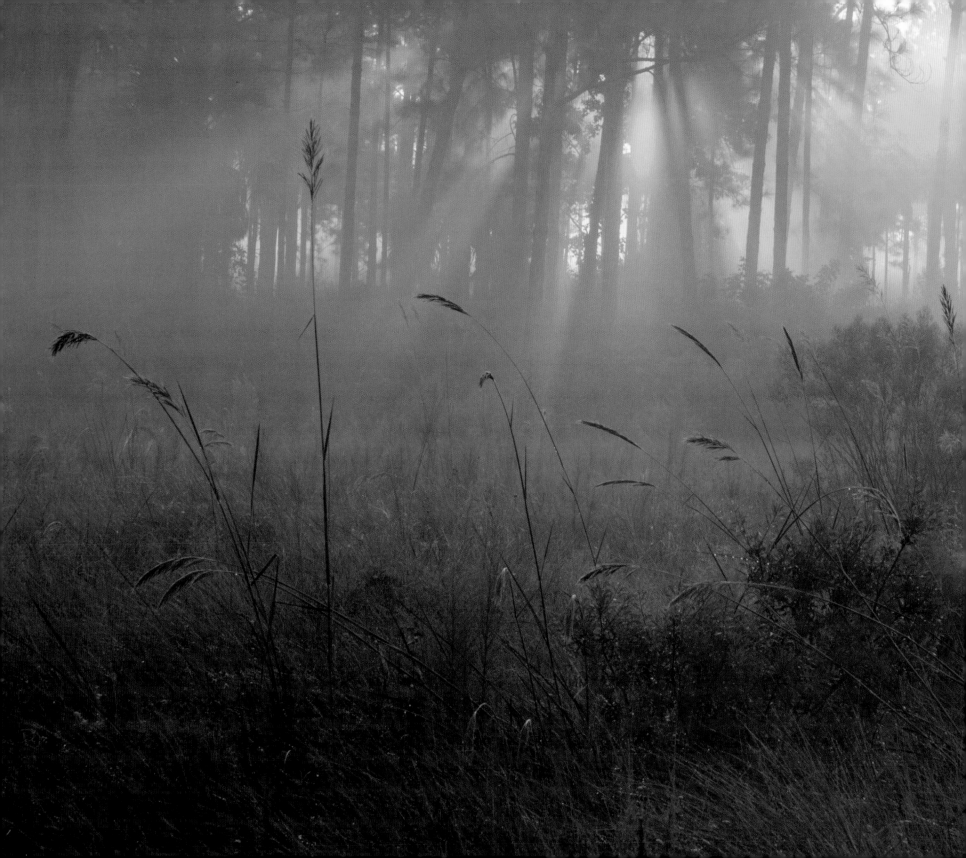

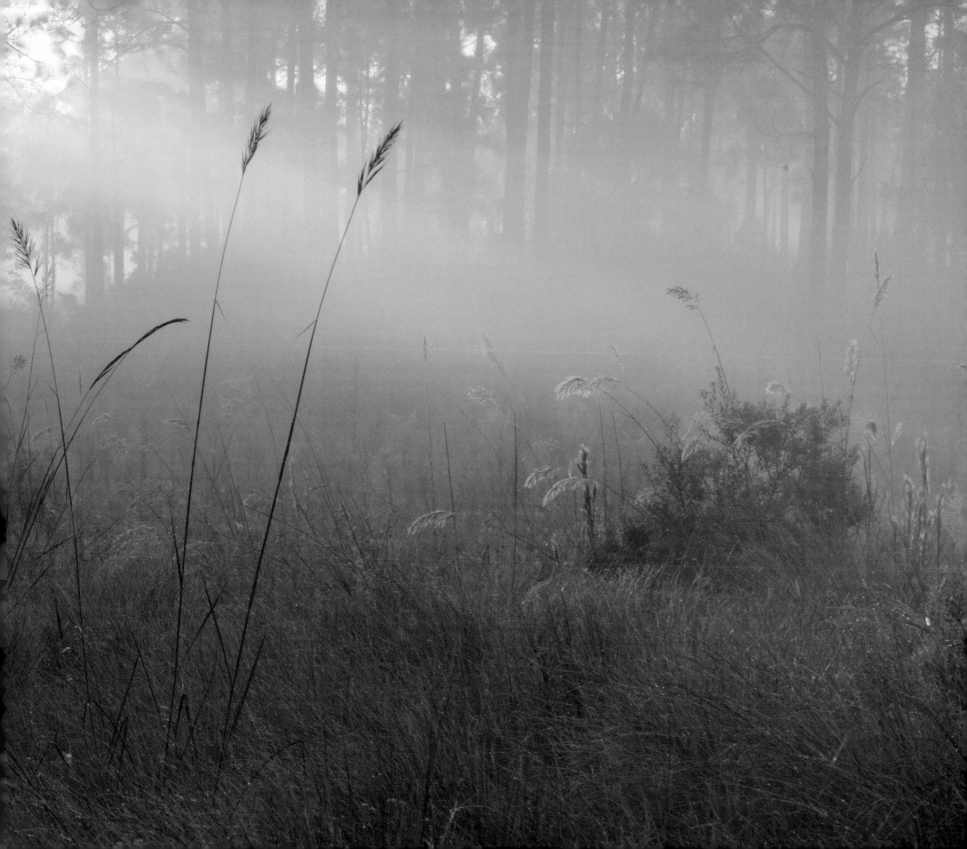

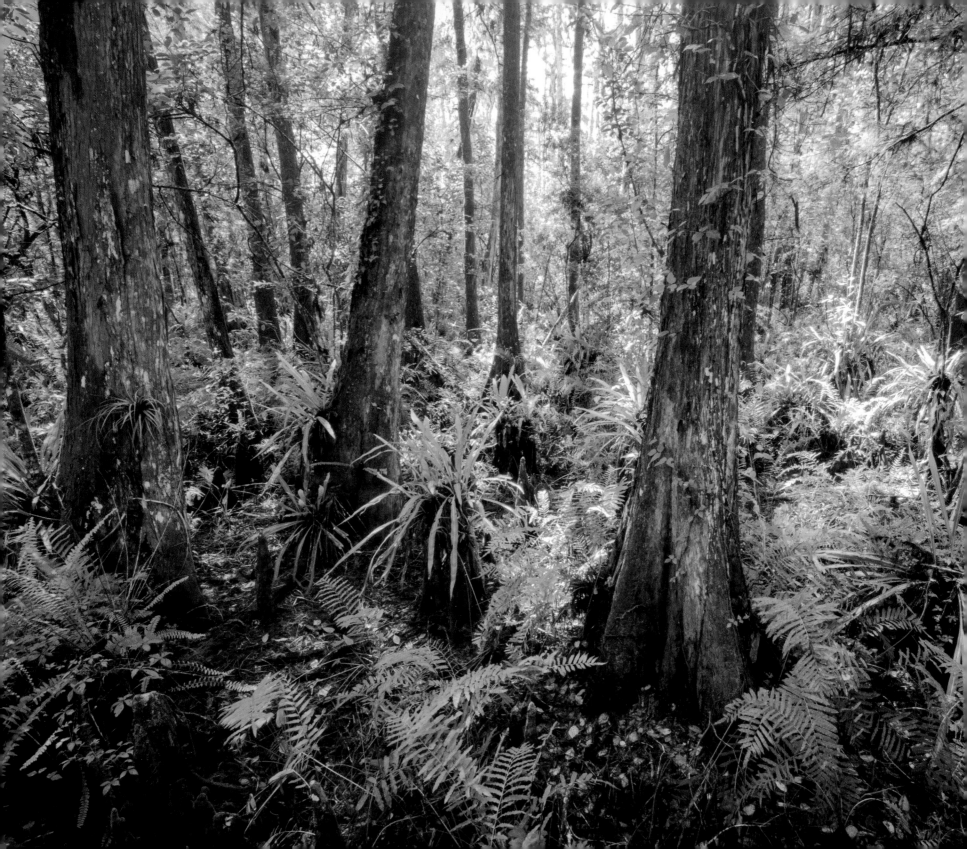

◄ The world's largest remaining stand of old growth bald cypress trees. Corkscrew Swamp.

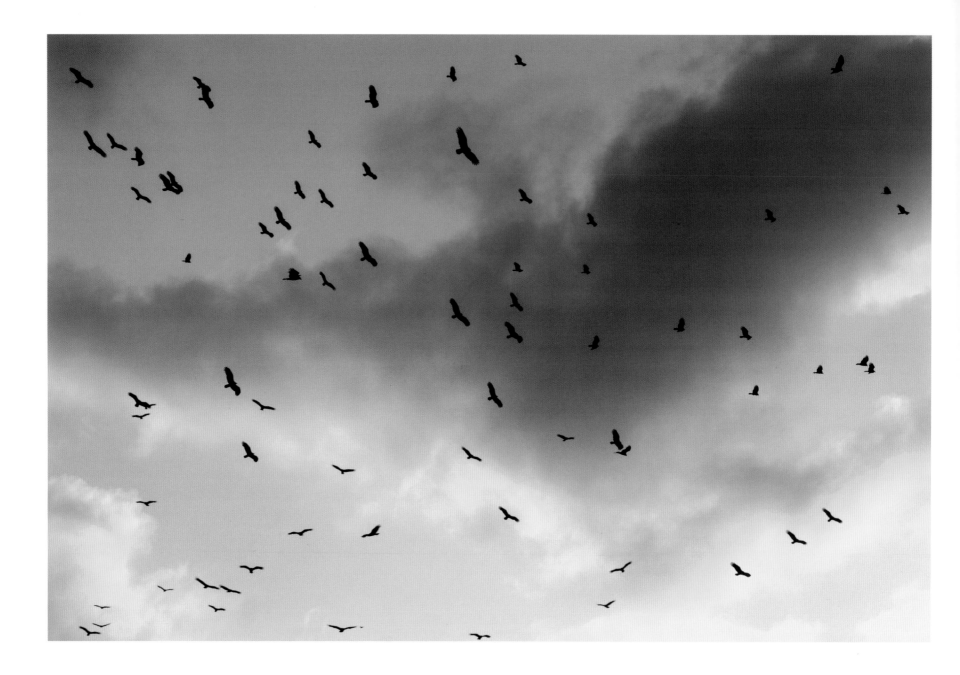

▲ Vultures soar above the central Everglades at dusk. Big Cypress National Preserve.

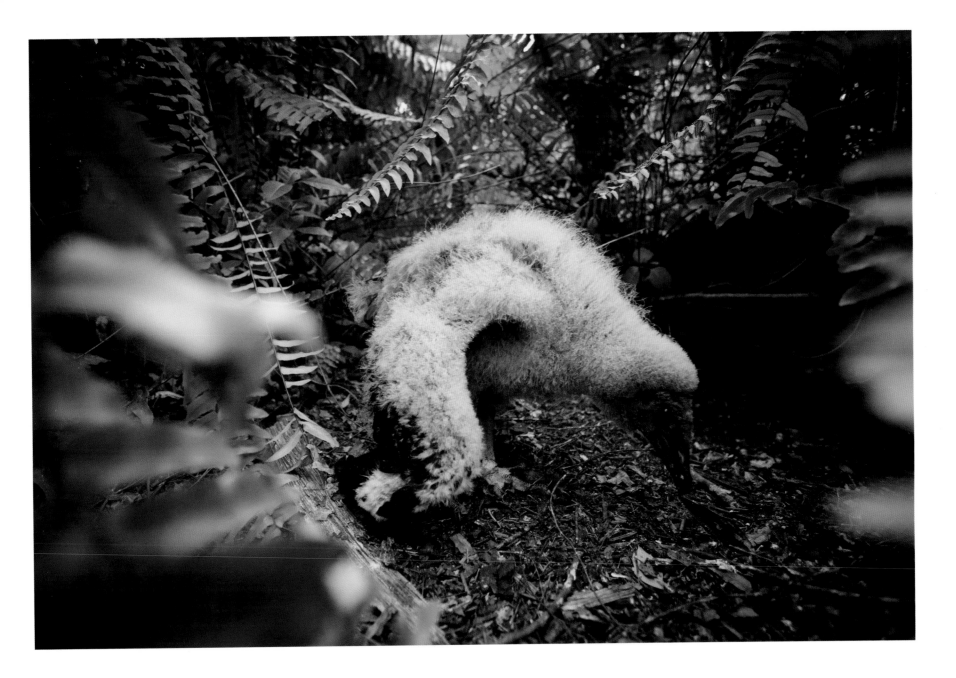

▲ An American black vulture chick waits for its mother to return to its ground nest. Fakahatchee Strand Preserve State Park.

The natural Everglades is a perfectly balanced system. It is profoundly nondiscriminating and yet, subtly forgiving.

▶ **Black vulture and alligator carcass.** Big Cypress National Preserve.

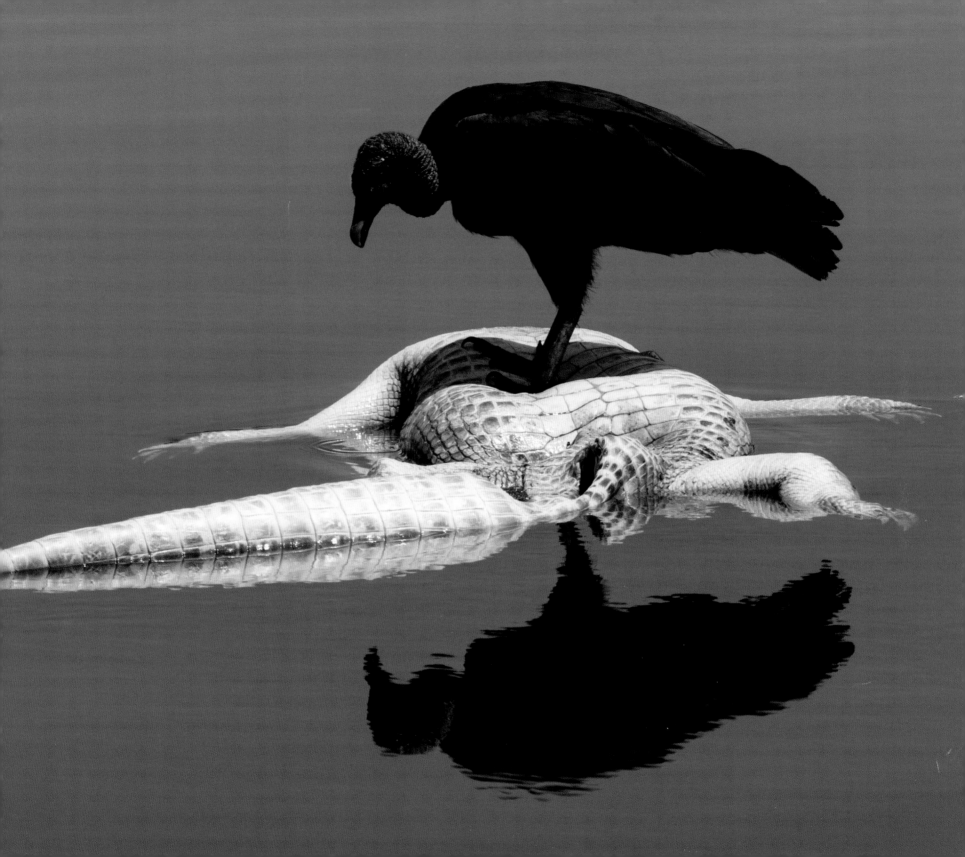

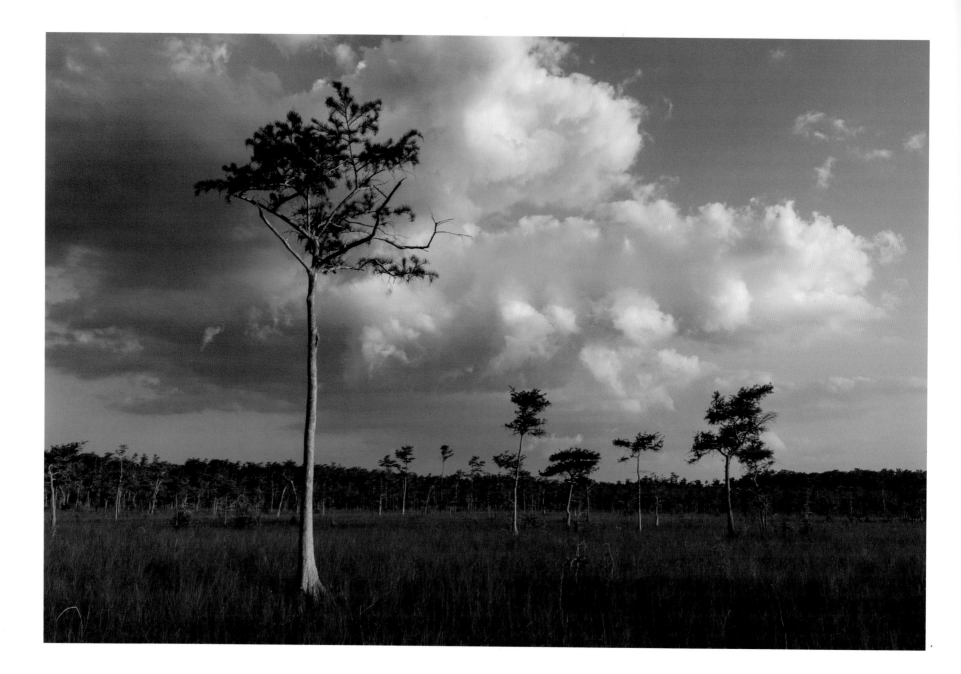

▲ Dwarf cypress prairie. Big Cypress National Preserve.

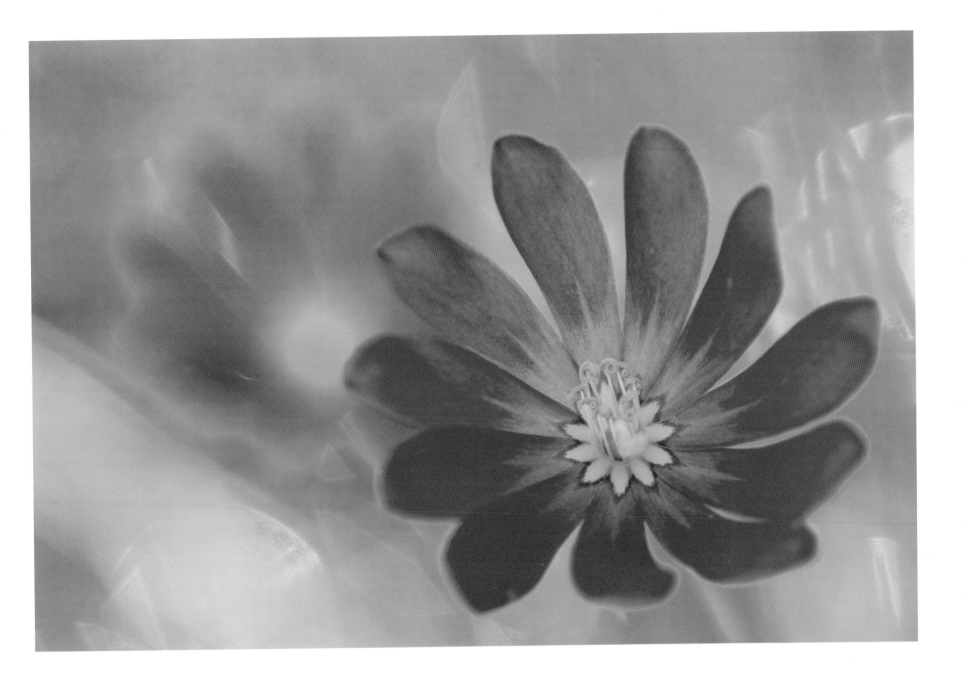

▲ Bartram's rosegentian flower detail. Big Cypress National Preserve.

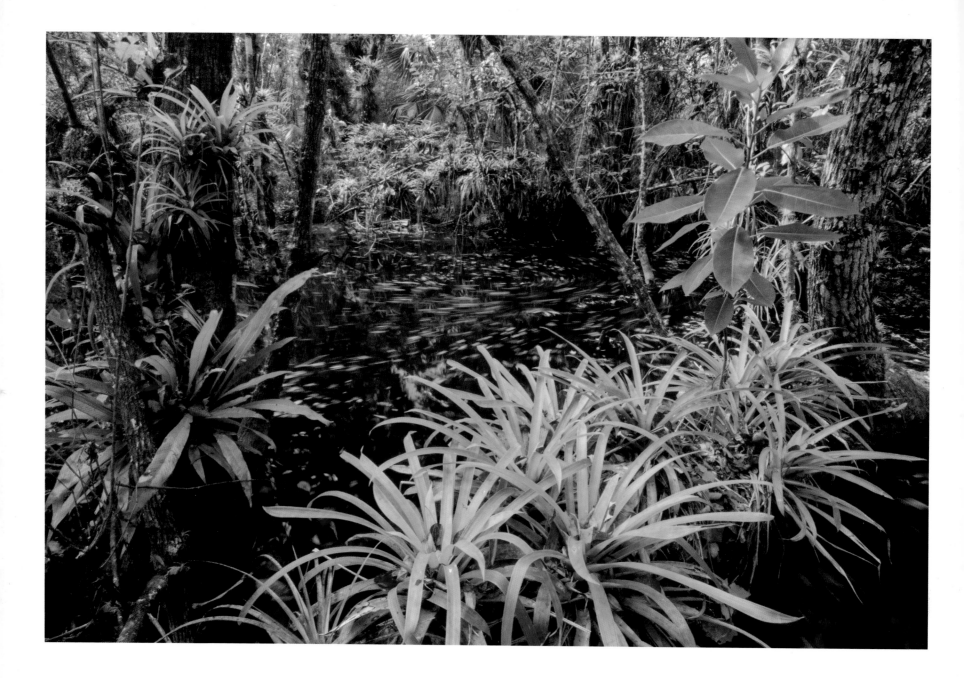

▲ Guzmania swamp. Fakahatchee Strand Preserve State Park.

▶ Tree snail and epiphyte detail. Fakahatchee Strand Preserve State Park.

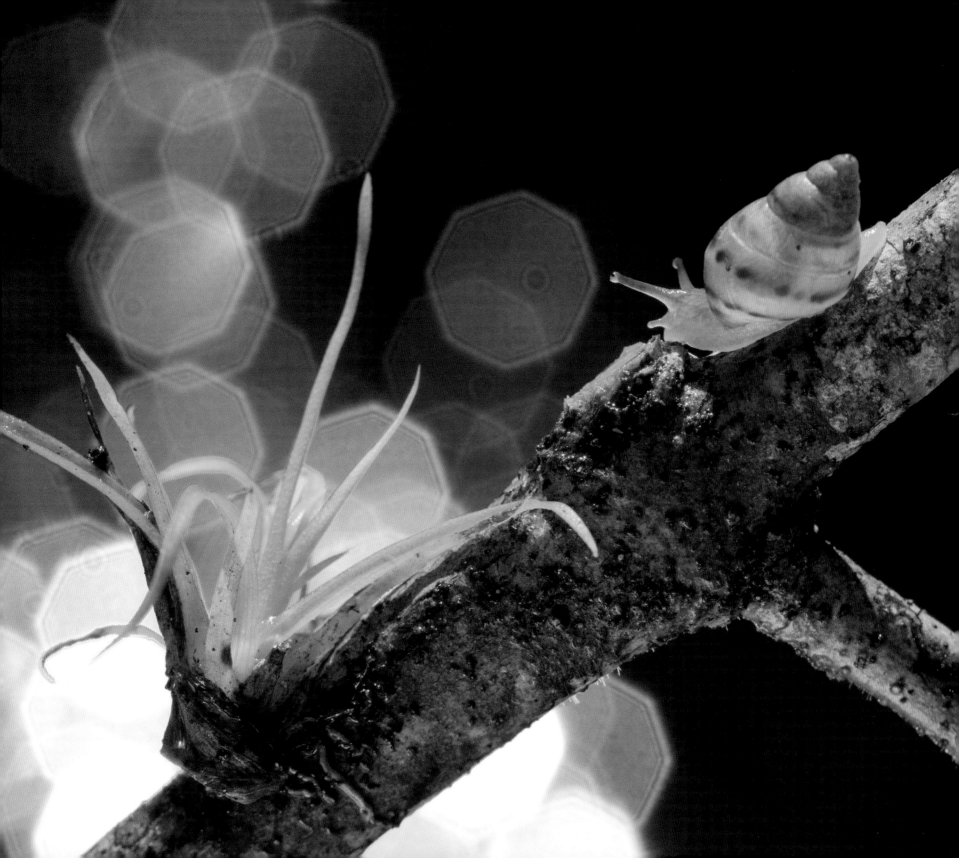

▶ Florida panther portrait (captive). Homestead.

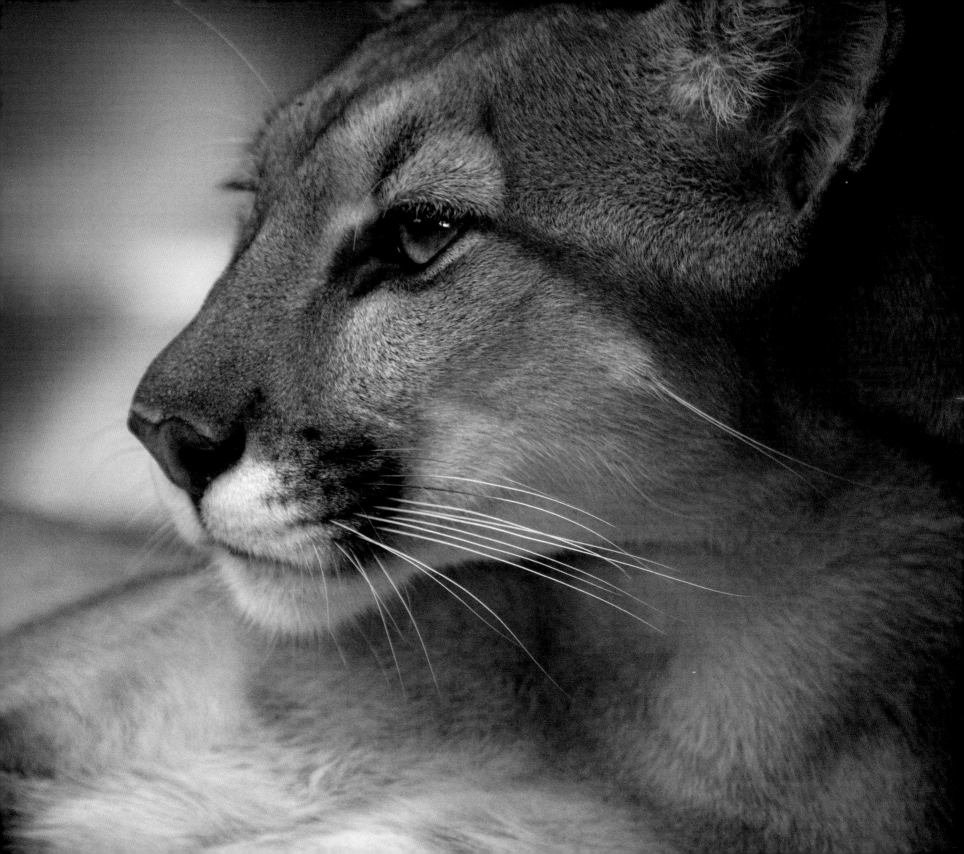

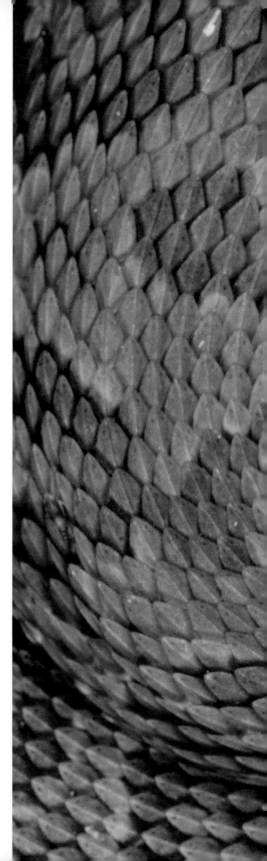

Each animal plays an equally vital role in maintaining the ecological balance of the Everglades. From the dainty roseate spoonbill to the scaly cottonmouth, every species takes its proper place in the complex web of life. Ever since Eve ate the proverbial apple, however, snakes have been culturally relegated as the deceitful bottom-feeders of the animal kingdom. In the late nineteenth century, a government report stated that the Everglades was "suitable only for the haunt of noxious vermin, or the resort of pestilential reptiles." At the time, Florida's brand of wilderness was not only uncouth, it was viewed as dangerous, especially for early settlers coming from the North. But these rumors were born of an acute behavioral misunderstanding. Snakes are secretive creatures, preferring a life far away from humans and are seldom seen. Of the 27 species of snakes in the Everglades, only four are venomous, and they each have their own way of thoughtfully warning potential predators—or photographers—when they're too close.

▶ The cottonmouth is aptly named for its unique gaping behavior. Big Cypress National Preserve.

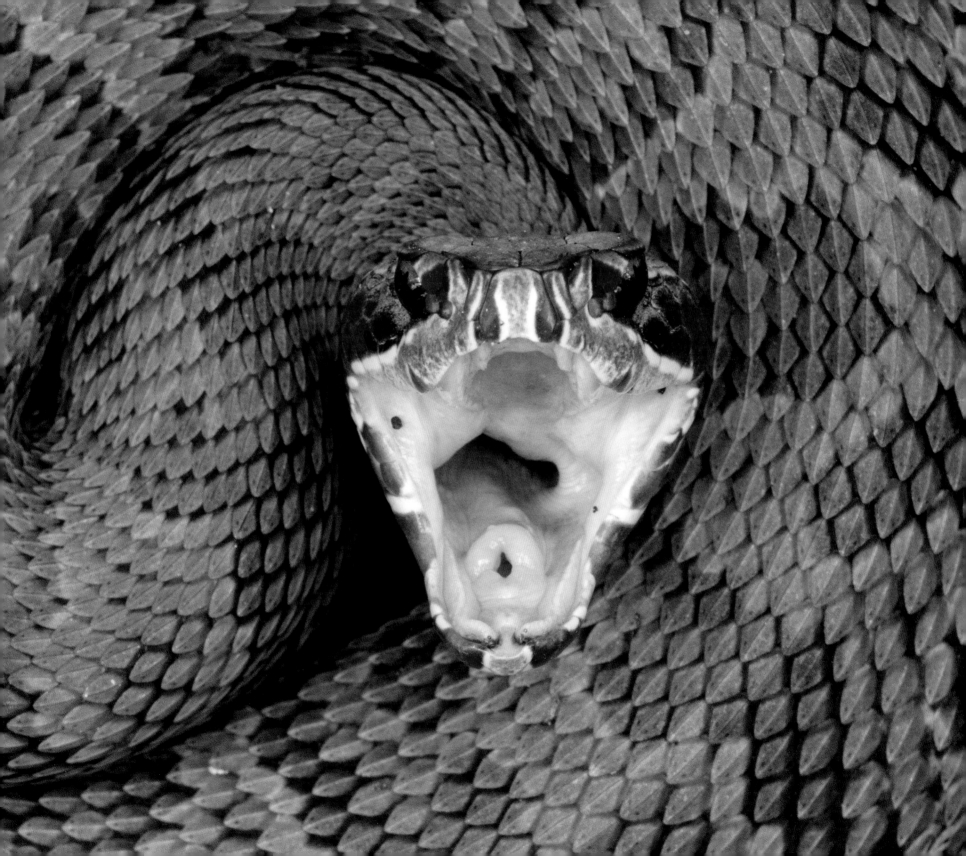

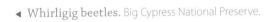

◄ **Whirligig beetles.** Big Cypress National Preserve.

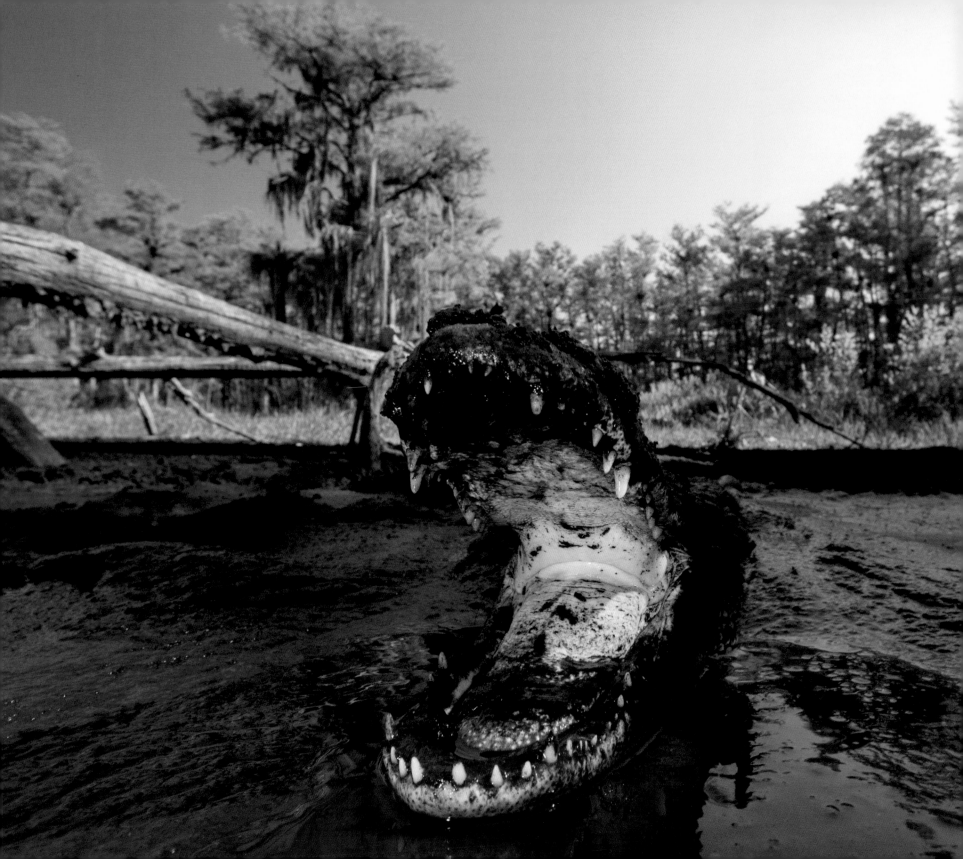

Architects of the Everglades
Mac Stone

The sun was blazing in the cloudless sky as I slogged through a remote section of Big Cypress National Preserve. Navigating the dried-up braided sloughs of bald cypress and pond apple groves, I was miles from any road and, except for my friend, Paul, not another soul was in sight. We had come to photograph morning light in the cypress domes but decided to press on into the backcountry, hoping to find wildlife. It was winter in the Everglades, and the lemony zest of exposed becopa plants filled the air with every crunching step. Two months prior, this area was submerged under three feet of water.

The deeper I trudged, the more the signal on my cell phone waned until eventually fading completely. I had been using it to navigate through the thick understory with live aerial maps to find a unique feature of the Everglades: alligator holes. Fortunately, I had a rough bearing and pressed on. Eventually, spotting a large opening in the canopy ahead, I came to the edge of the tree line and saw a lone alligator submerged in the dark mud. Staying moist and cool until the rains returned, the gator dug out one of the last remaining wetlands into a muddy mire. It hissed loudly as I approached, sending an audible warning to any intruder that this precious real estate was not for sale. This is why I came.

My parents always thought I had an unhealthy relationship with alligators. When I was in high school, they threatened to confiscate my camera several times after I returned home with full-frame close-ups of gators' scales and eyes. It was not lack of sensibility as much as an overwhelming curiosity that drew me to the prehistoric reptiles that conveniently inhabited my backyard.

Through the years not much changed with me, or my beloved crocodillians. In fact, their species have undergone little change in 65 million years. They were—and still are today—

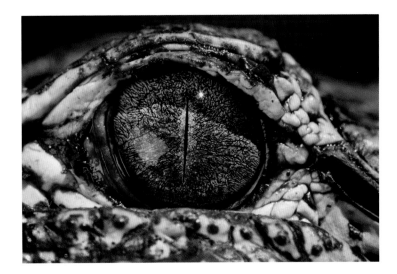

perfectly adapted to their environment. Their ancestors basked on the same shores where dinosaurs roamed, and at the end of the Cretaceous period, their bloodline survived whereas many others perished.

Despite enduring a catastrophic meteor event, crocodilians in the modern southern United States encountered a more formidable foe: humans. During the 1960s and 1970s American alligators were hunted to alarming levels. Combined with the effects of habitat loss, their populations faced near extinction. Fortunately, after federal and state intervention, in a short time their numbers steadily rebounded to the robust population of today; the recovery is often heralded as one of the greatest conservation achievements in modern history.

In the Everglades, the gradual comeback of alligators returned stability to the ecosystem. Their role as a keystone species is essential to the stasis of the entire watershed. Biologists in the park refer to them as the engineers of the Everglades.

◄ An American alligator defends its mud hole during the height of the dry season. Big Cypress National Preserve.

▲ American alligator eye detail. Fakahatchee Strand Preserve State Park.

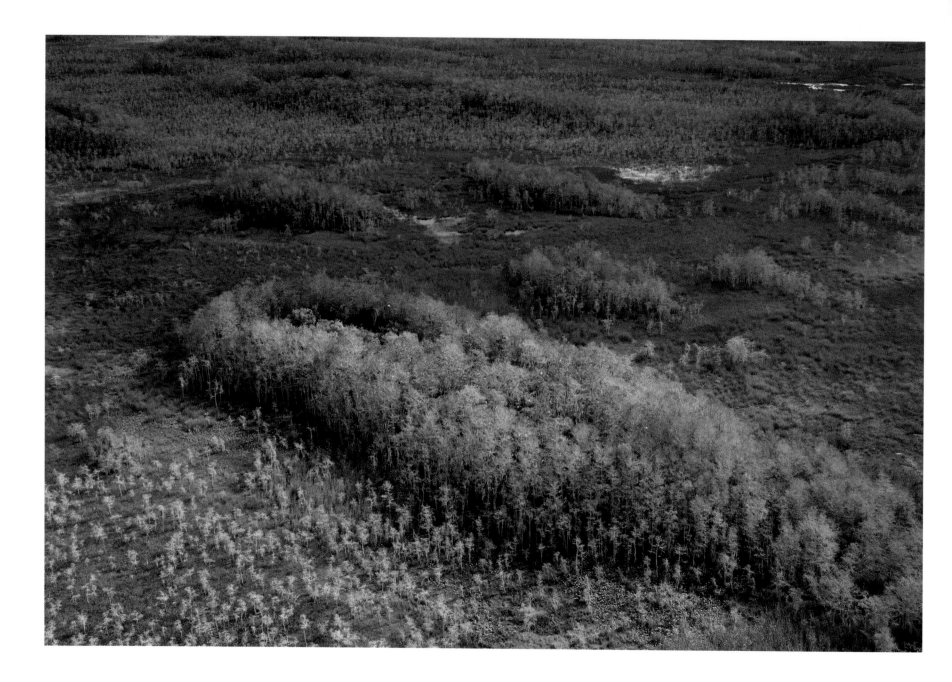

▲ Cypress dome with nesting egrets around an alligator hole. Big Cypress National Preserve.

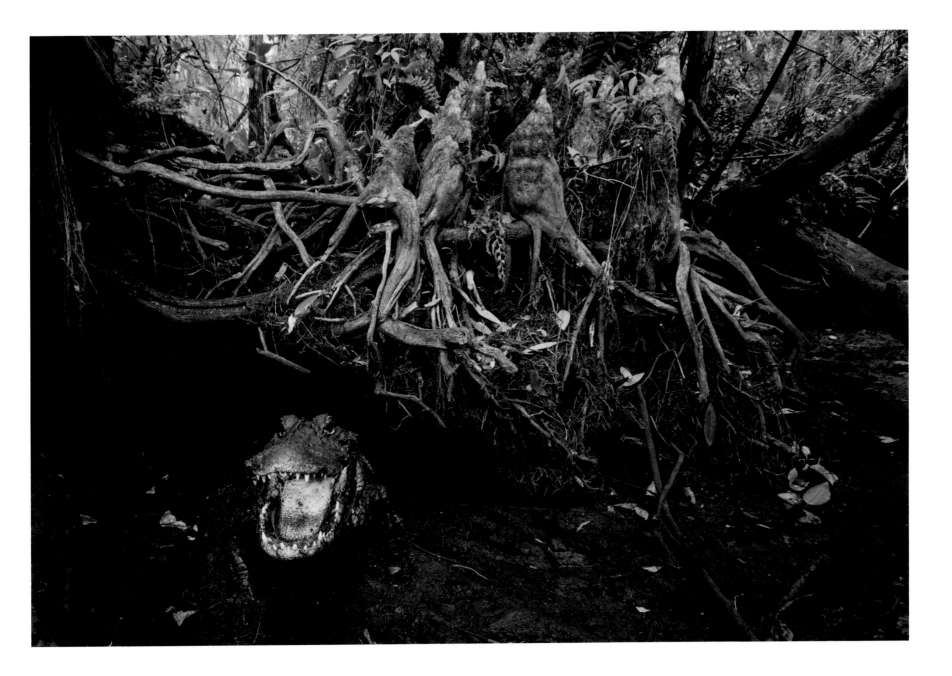

▲ American alligator defends her hatchlings beneath a hollow cypress root bank. Everglades National Park.

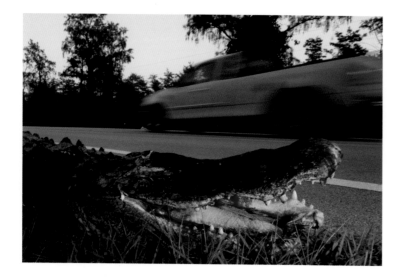

For thousands of years alligators in South Florida have physically altered the landscape to adapt to the seasonal ebb and flow of water. In turn, specific plant and animal communities have modified their own survival behaviors around the services that alligators provide.

For this reason, biologists believe them to be one of the main indicator species for the overall health of the ecosystem. Monitoring their populations and nesting success rates provides a gauge of whether water management policies are working. If the wrong amount of water is released from the central Everglades at the wrong time, alligator nests will flood, essentially drowning the eggs.

In the nesting season, deep within the flooded sawgrass prairies, alligators use their jaws and powerful hind legs to pile large mounds of vegetation above the water line. With their nests built high, they lay a clutch of eggs inside the moist sawgrass incubator. Oftentimes, turtles will sneak into the nest and lay their own eggs. Hatching before the alligator's clutch,

the turtles escape, having benefited from the security offered by their toothy watchdog.

As water levels drop during the dry season, alligators move to deeper areas. Within cypress sloughs and domes, they excavate mounds of peat and mud down to the limestone, creating a deep pool of water rimmed with fertile soil, where saplings start to take root. When the surrounding areas start to dry up, they are left with a bounty of fish and enough water to sustain them until the rains return in the summer. Wading birds flock to these areas for foraging and nesting, relying on the alligators below for protection against raccoons and snakes.

One particular winter, water levels were declining at a rapid rate and extending late into the dry season, more so than in previous years. I had heard rumors of refuges deep in the Everglades, where alligators were known to congregate by the hundreds when water levels reached a critical low. Poring over aerial maps and checking daily water stations in early April, I noted the conditions seemed perfect and hoped to find more than one gator this time.

Heading out before dawn, I arrived in Big Cypress National Preserve as the sun was peeking over the tree line. A thin layer of fog crept through the cypress domes, and I fought the urge to photograph the morning light. I was on a mission. Accompanied by a few friends, I set off into the woods at a fast pace. Following the dry creek bed, we spotted several cottonmouths coiled at the gnarled buttresses of pond apples, flaring their fangs as we passed. Orchids adorned every furrowed limb and panther tracks appeared, then disappeared along our path. The swamp was still and quiet, pleasant even. It was immediately clear we were in the heart of the Everglades, in a place very few have been.

Eventually our path opened up to a large basin and we stood at the mouth of the desiccated spillover, our jaws agape

▲ Alligator casualty along the Tamiami Trail. Big Cypress National Preserve.

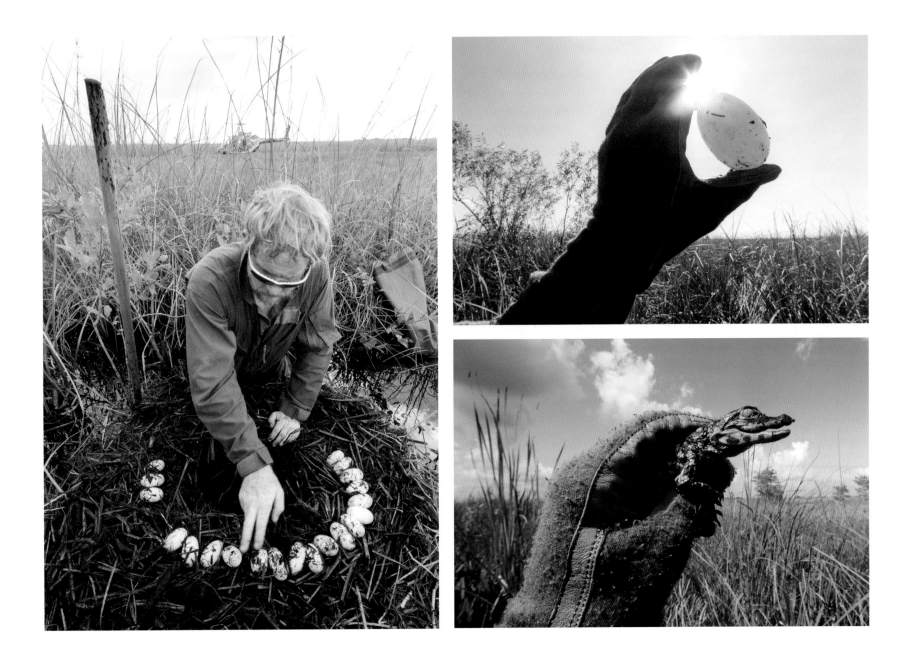

▲ Wildlife biologist Mark Parry conducts American alligator research by monitoring nesting success. Everglades National Park.

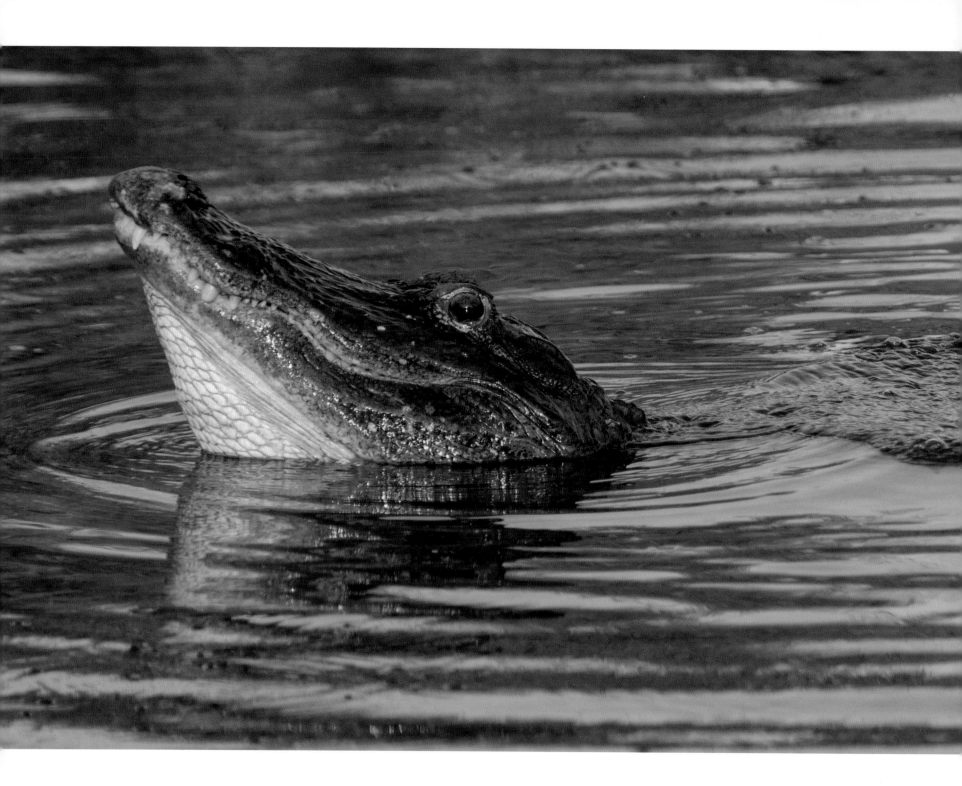

▲ An alligator bellows, using low frequency sound, to attract mates and lay claim to his water hole. Big Cypress National Preserve.

with amazement. Before me, a bowl of cypress trees about the length of a soccer field framed the stark blue sky and an explosion of night herons took off in a raucous flurry. The stagnant broth that filled the pond was a thick coffee, gurgling and dancing, as if an invisible downpour rained from above. Millions of mosquitofish filled the hypoxic puddle, their upturned mouths fervently tonguing the oxygen at the water's surface. They were locked in a death trap.

In the middle of the dark crater, hundreds of serrated ridges broke the rippling water. Countless alligators groaned and languidly moved through the muddy soup, pushing their way to the deepest point. I had found my gator hole. At the far end we noticed a rustling in the vegetation and a dark form emerged, trampling and chewing at the hearts of alligator flag that rimmed the pond. I was too late with my camera, for as soon as I saw the black bear, it looked up and lumbered off, disappearing into the swamp. Then, something incredible happened.

Suddenly, as if by cue, alligators started leaping out of the water and crashing down with a muddy splash. At first I laughed because it seemed so uncharacteristic; reptiles don't have fun. It appeared as though the gators had gone mad. Then I fumbled for my camera and began firing. Looking closely through my telephoto lens, I noticed as their large bodies slammed the surface, hundreds of fishes catapulted into the air. Thrashing violently in the mud, the alligators would rise victoriously with catfish in their jaws. Millennia of environmental engineering and behavioral adaptation revealed its purpose in this very moment. It was as though I stumbled upon an ancient Eden of prehistoric ritual. I imagined this is how Hiram Bingham felt as he emerged from the jungle to find Machu Picchu.

I bore witness to an incredible spectacle, but I had an image in my head that I could not let go. Hoping to ride out the dry season a little longer, I returned home and stayed glued to the water indexes for the next three weeks. I calculated that there was about a foot and a half of water in that basin, and without rain it wouldn't be long until it evaporated. On the last day of the month, I set out once again to retrace my steps and chase an iconic photograph that would tell the Everglades story of water and reptile.

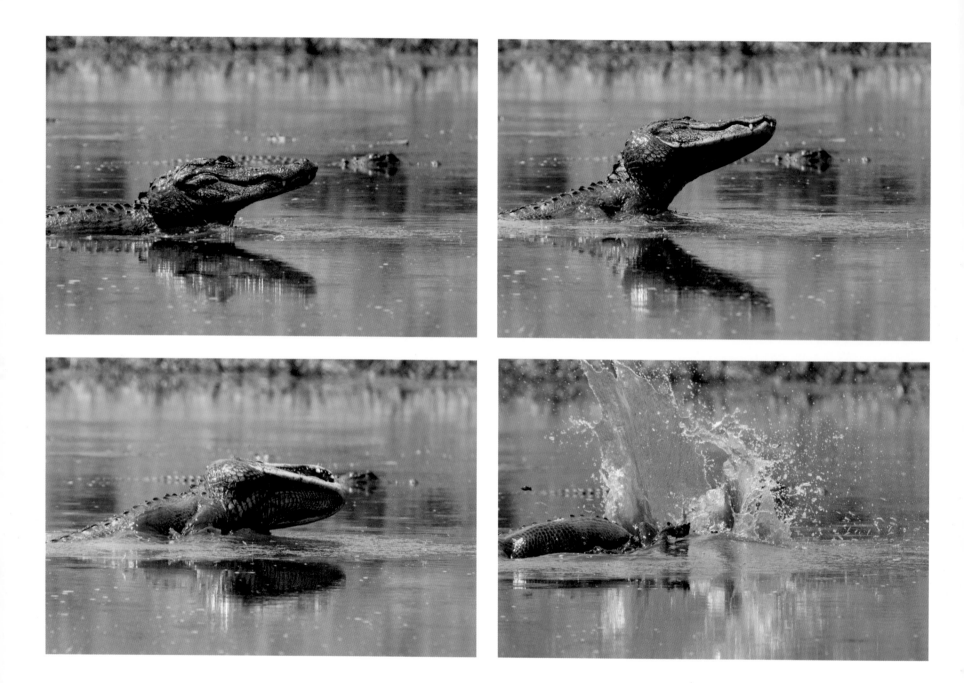

▲ In the dry season American alligators resort to a rarely documented behavior: launching out of the water and crashing down upon fishes. Big Cypress National Preserve.

▶ The method proves successful and an alligator enjoys a catfish meal. Big Cypress National Preserve.

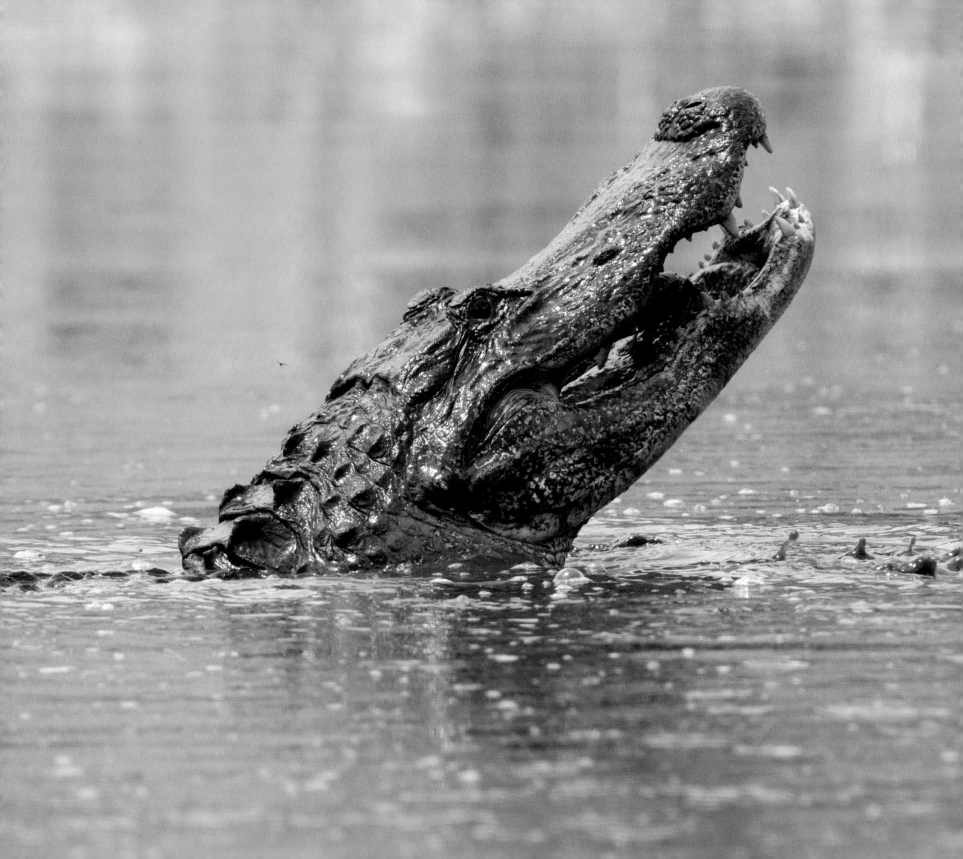

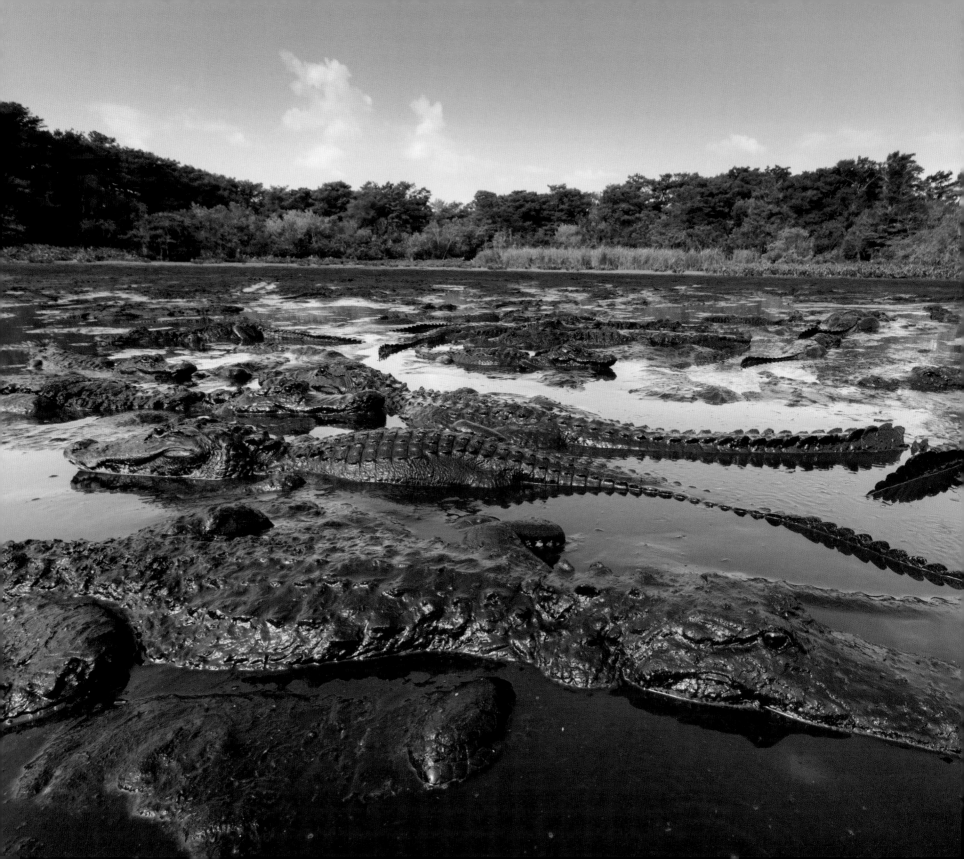

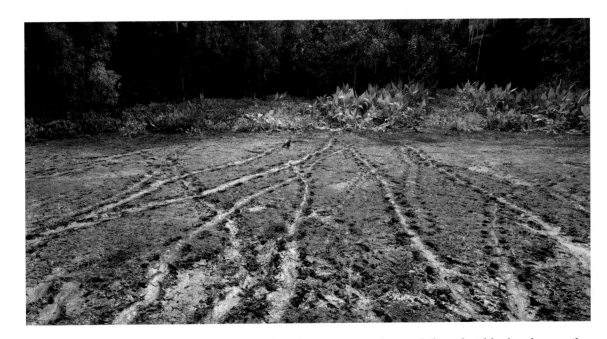

By this time, the ground was hardened, and I kept a good pace, hiking briskly for three miles through prairie and slough. In tow, a few eager friends came to see this backwoods oasis for themselves. When we came to the basin, there was no bear, and there was no water. Plants had begun to take root in the cracked earth and hundreds of alligator trails radiated from the muddy nucleus. Looking closely, my eyes needed a second to adjust to the dark morass, and then I began counting.

The closer I inspected, the more alligators appeared. Their eyes, barely poking out of the mud, and the disconnected tails of half-submerged gators kept me guessing. There must have been close to a hundred and twenty. I was reeling. Rolling up my sleeves and dropping my backpack, I looked at my friend Mark Parry, a wildlife biologist who tags crocodiles and alligators for the park, and said, "I'm going in, are you coming with me?"

With just a camera and a wide-angle lens, I knew exactly what I wanted. Mark stayed close, gripping his "chomp stick" tight to nudge away any brave alligators, assuring me that the mud was too thick and they were too tired to move. As I slogged into the wet mud, I began to sink. It was terribly unnerving. The smell of rotting fish and uric cesspit filled my nostrils. I could feel alligators wiggling beneath my feet, but I kept moving, focused on the largest one another few yards ahead. My heart was pounding and I kept glancing at Mark for reassurance. Crouching low and avoiding any sudden movements, I made it to the center of the pile. Hunkering down, I composed the shot and clicked two frames. In my viewfinder, a 9-foot alligator dominated the foreground while forty-four others languished in the distance, clinging desperately to life in the hope that water would soon be delivered.

▲ Gator trails. Big Cypress National Preserve.

◄ American alligators in the last remaining water hole. Big Cypress National Preserve.

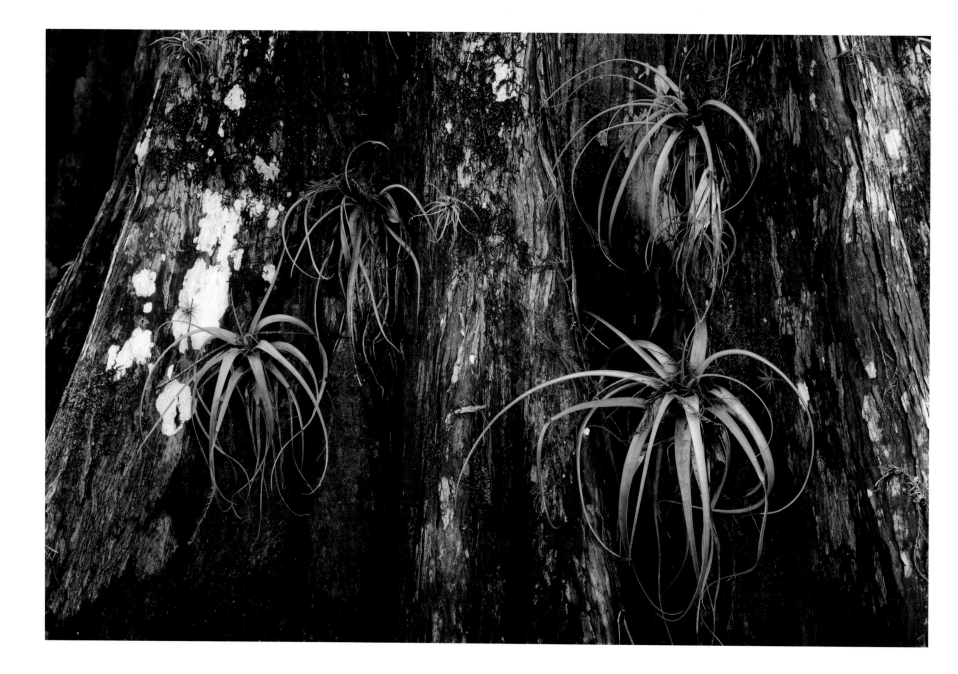

▲ Tillandsia grows on the furrowed bark of a bald cypress. Big Cypress National Preserve.

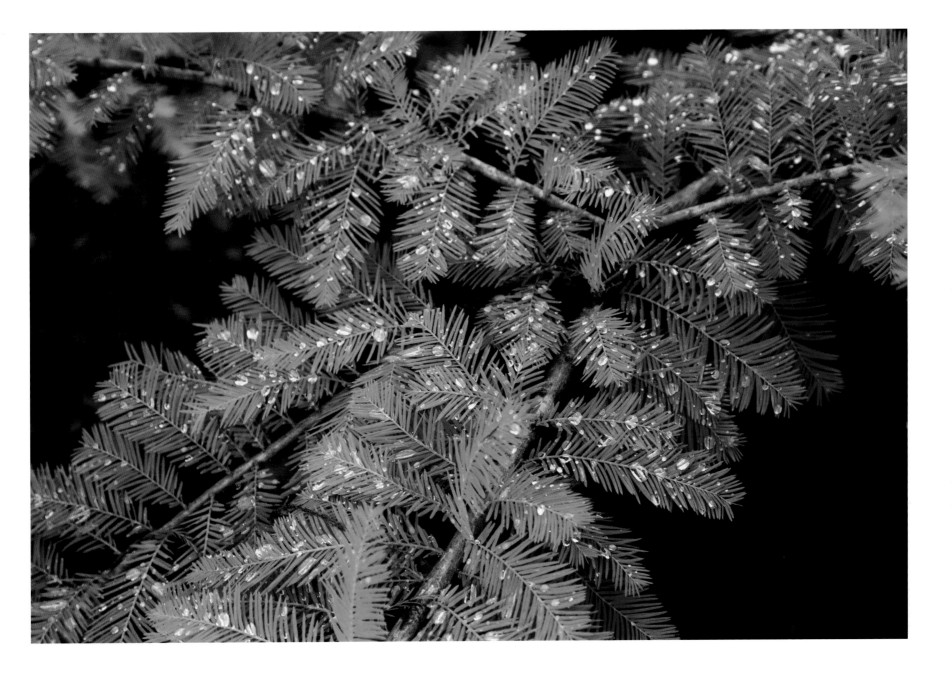

▲ Rain on a bald cypress limb. Big Cypress National Preserve.

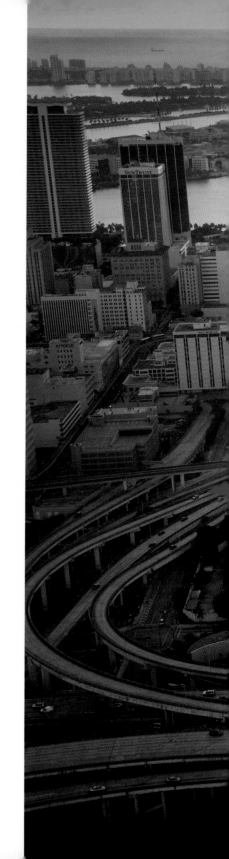

The Miami River delta has been the cradle of Everglades civilization for thousands of years. Before concrete and high rises and even before the arrival of Spanish explorers, the bounties of the Atlantic coastal ridge supported the Tequesta tribe for nearly two millennia. Once a wild stream complete with stunning rapids and freshwater springs, the Miami River delivered pulses of freshwater from the interior Everglades to form the rich estuary of Biscayne Bay. Miles of seagrass beds and coral heads supported an incredible array of fishes while springs in the bay provided drinking water to Native Americans and early settlers. At the turn of the twentieth century, just after Julia Tuttle convinced Henry Flagler to bring his railroad southward, the river was forever changed. Dammed, dredged, and developed, the gateway to the Everglades became the burgeoning city's sewer for the first half of the twentieth century. Consequently, the springs dried up, aquatic diversity declined, and the iconic rapids were cut off from their source. Today, visitors to the area can still see remnants of the ancient architect's civilization in the shadow of modern Miami.

▶ Miami River as it flows into Biscayne Bay. Miami.

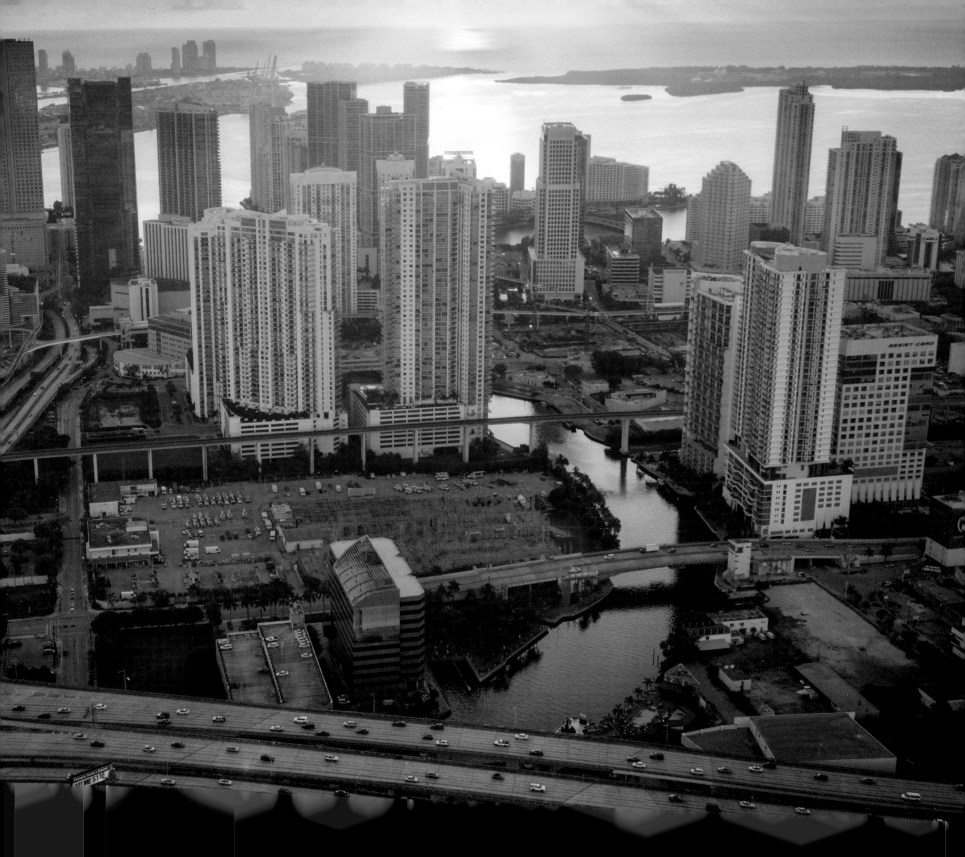

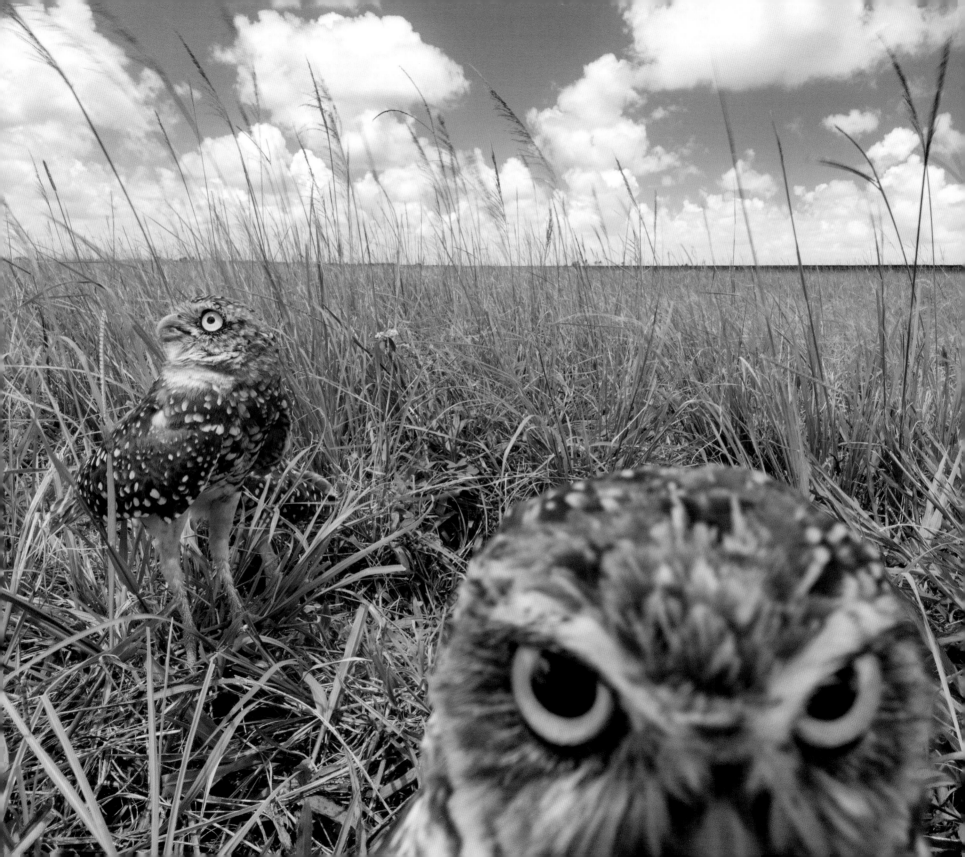

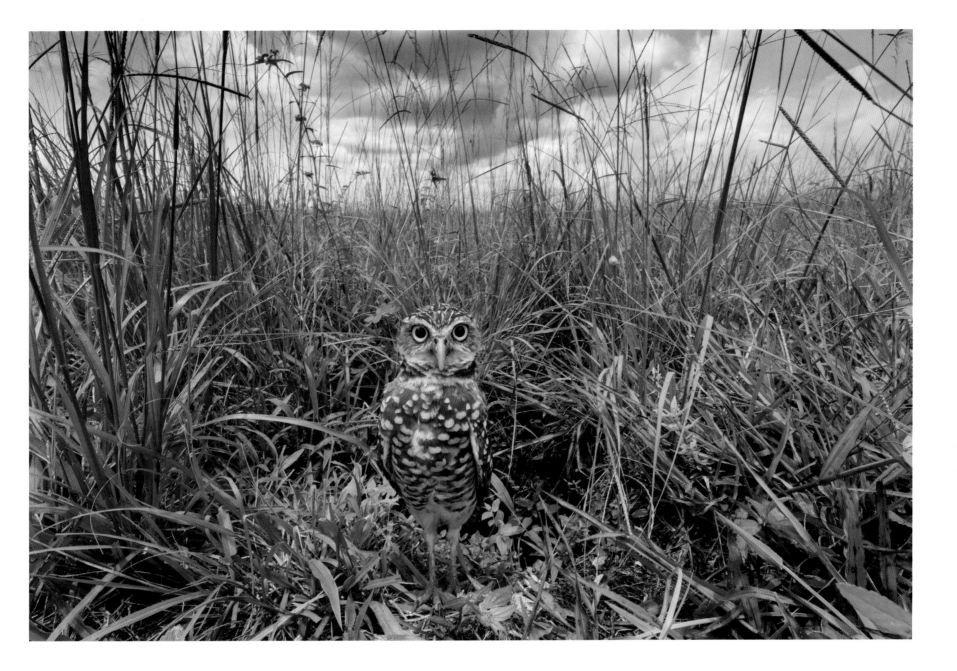

◂▴ Burrowing owls investigate a remote-triggered camera. Homestead.

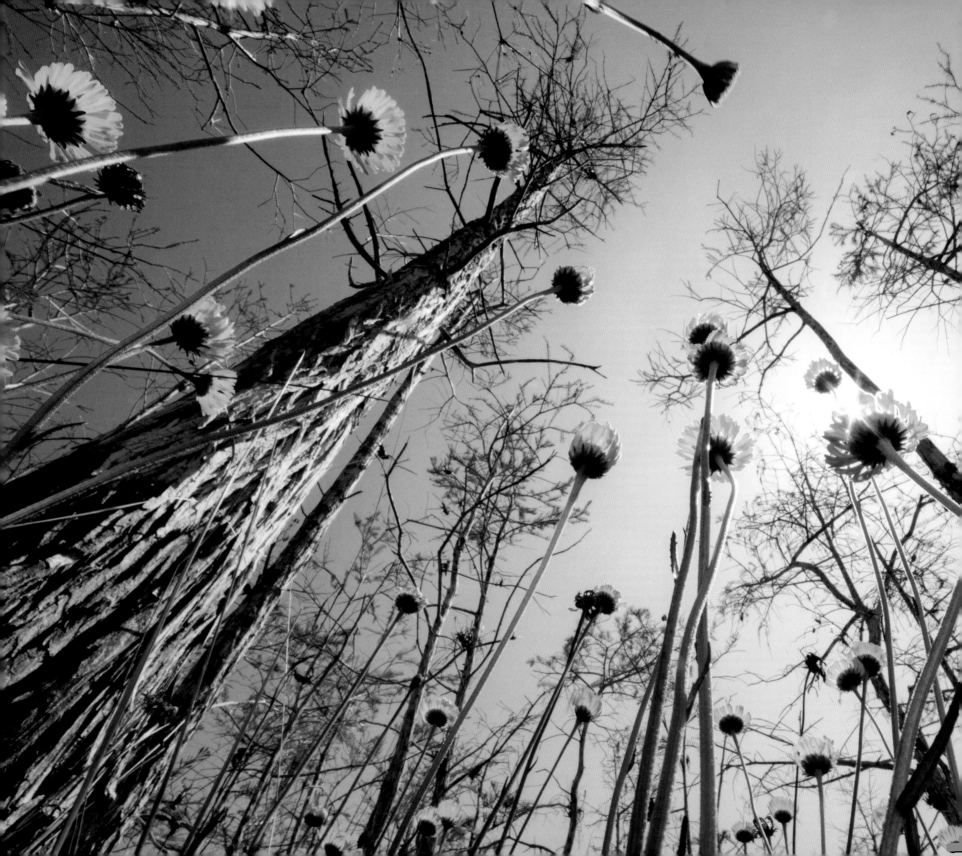

◄ Everglades daisies. Everglades National Park.

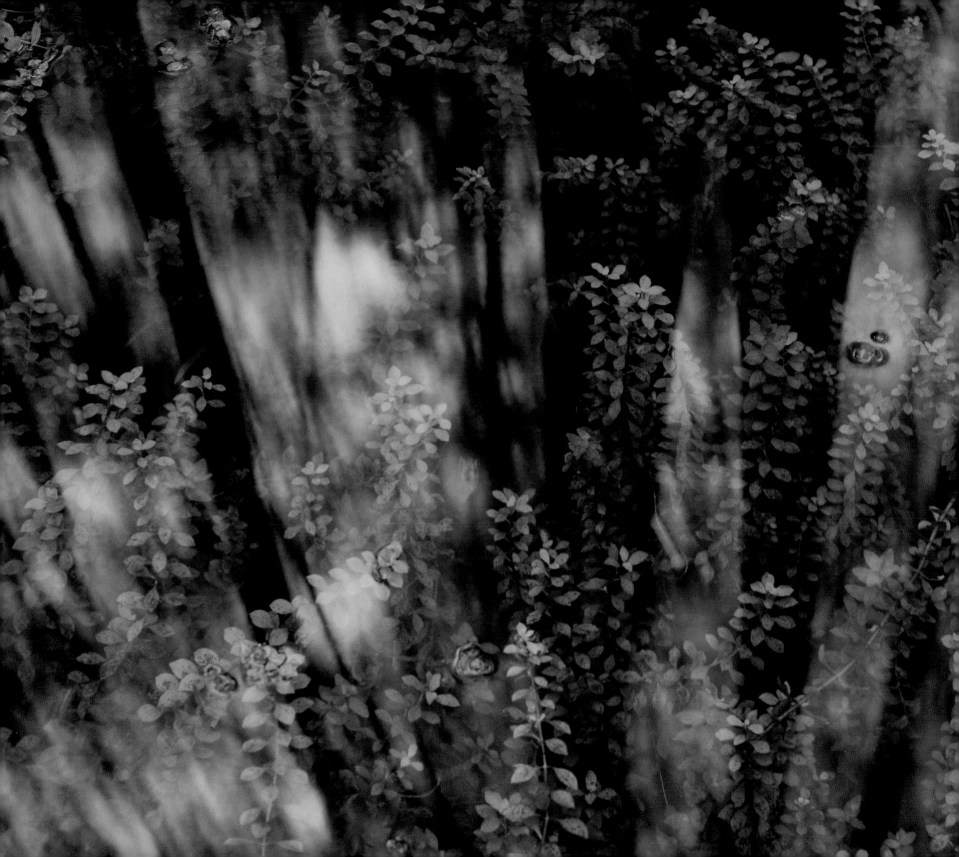

◄ Bacopa plants beneath a cypress dome. Everglades National Park.

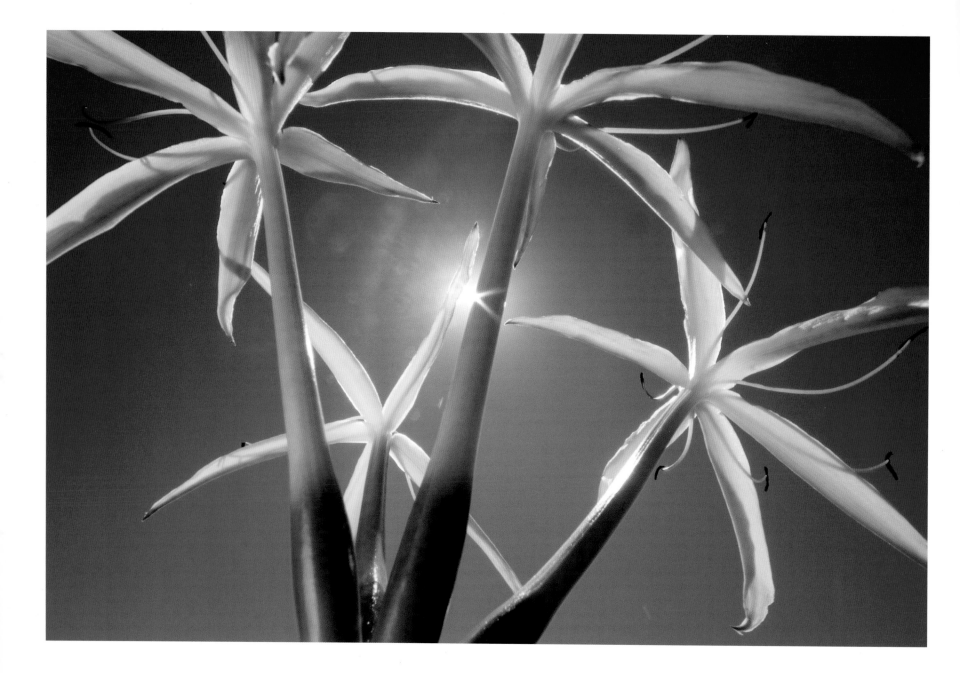

▲ **Everglades swamplily.** Everglades National Park.

▶ **Woodstork at dawn.** Everglades National Park.

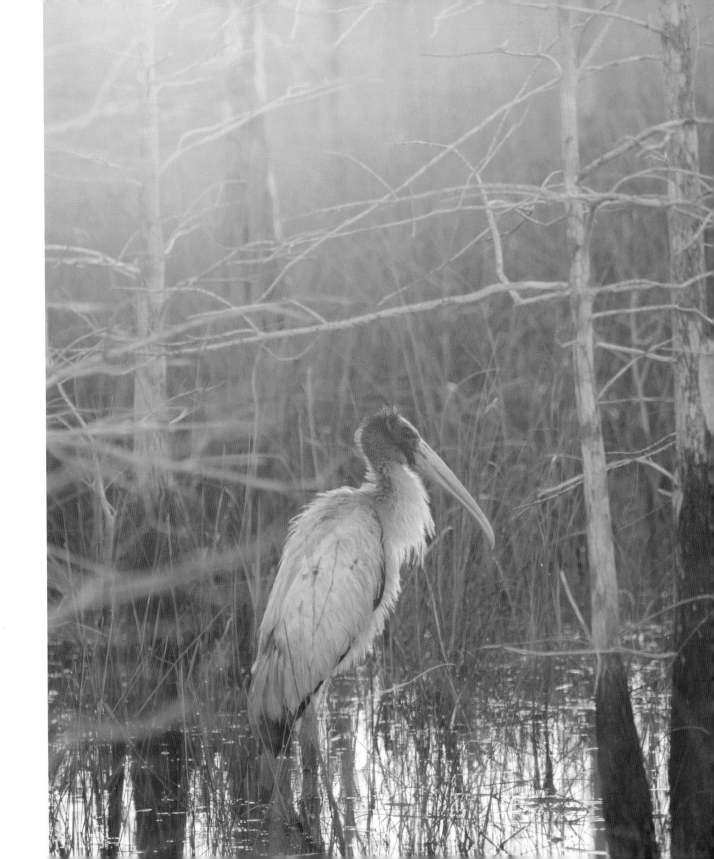

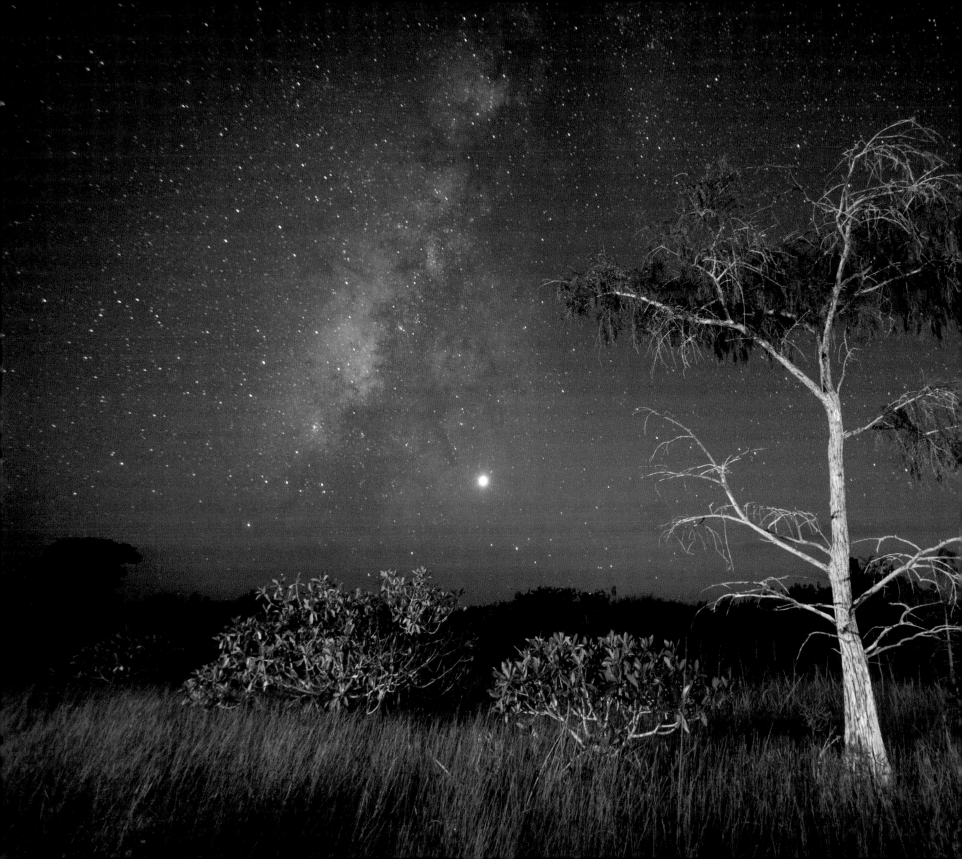

◄ Dwarf cypress under the Milky Way and Venus. Everglades National Park.

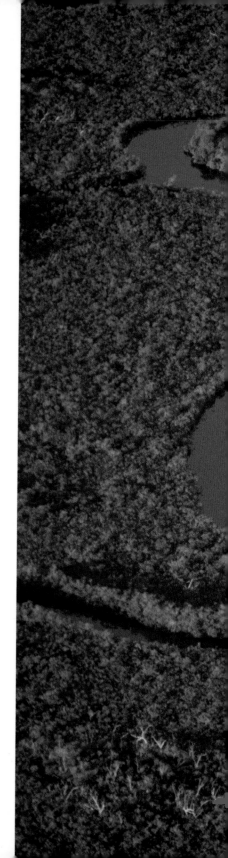

It is commonly believed that with the federal designation of Everglades National Park in 1947 came the assurance that at least the southern portion of the ecosystem would be protected in perpetuity. However, as with all components of this vast watershed, each habitat is entirely defined by external factors that govern its success. No manner of political or metaphorical boundaries can prevent contaminated water from flowing into the park or at the very least guarantee that there will even be enough freshwater to flow.

▶ Morning light on creeks flowing into Whitewater Bay. Everglades National Park.

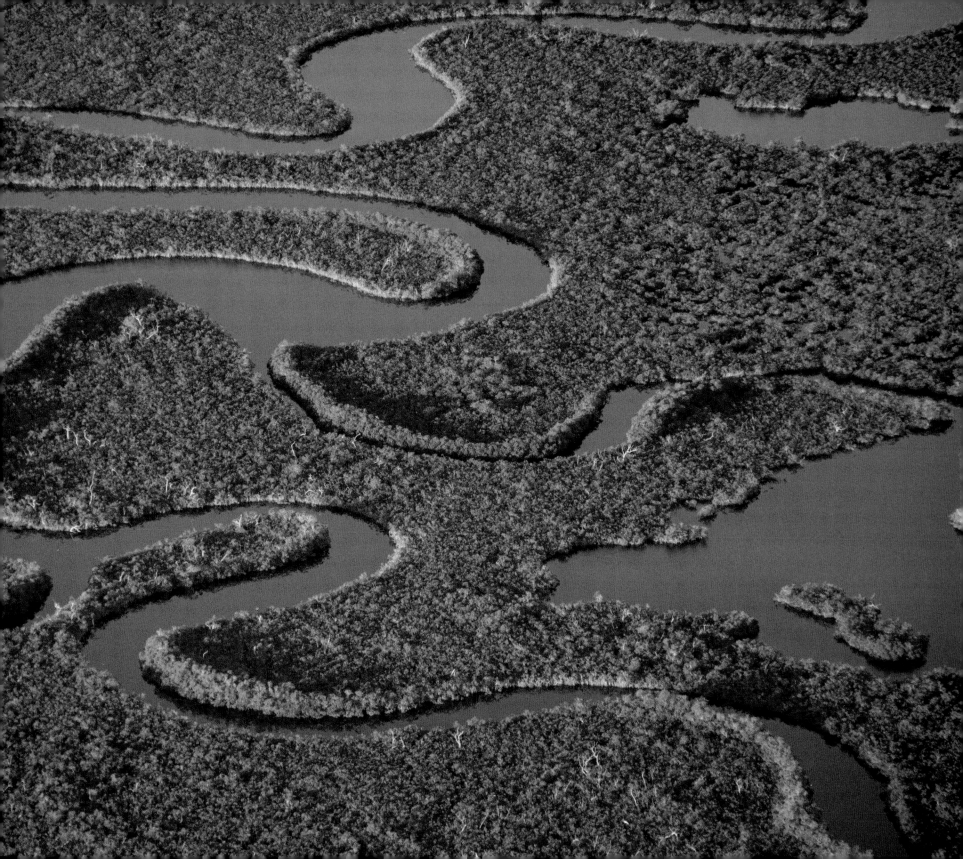

▶ White ibis aerial. Everglades National Park.

▶▶ Pond cypress and epiphytes. Everglades National Park.

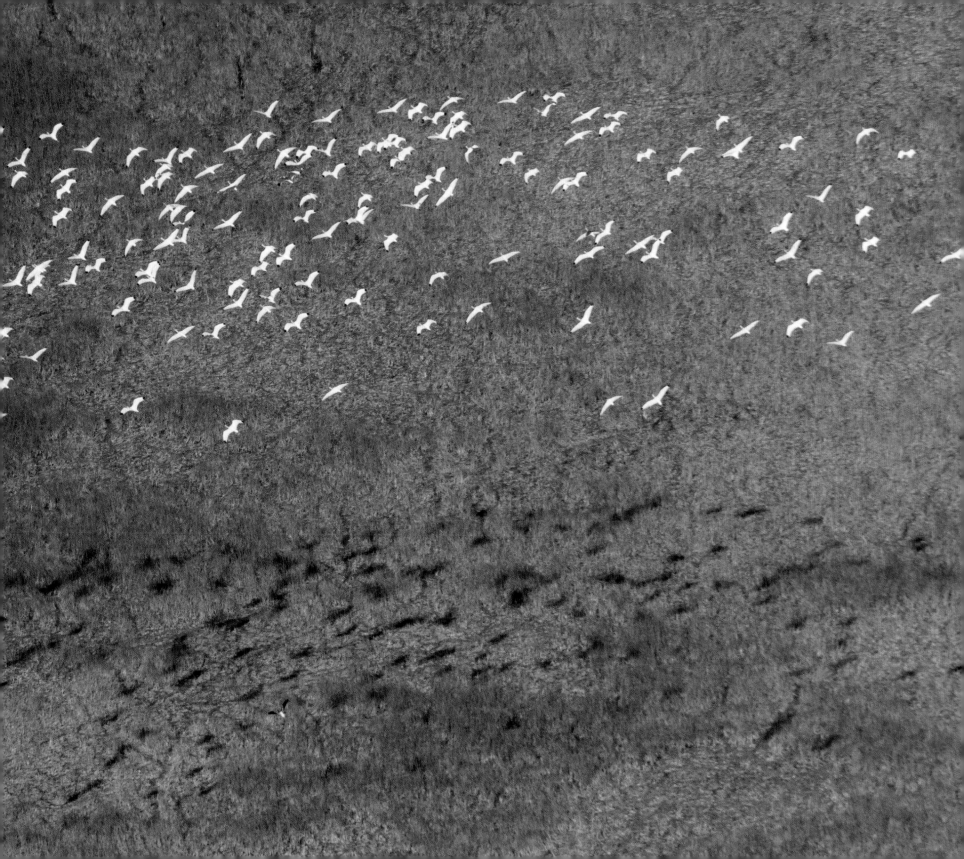

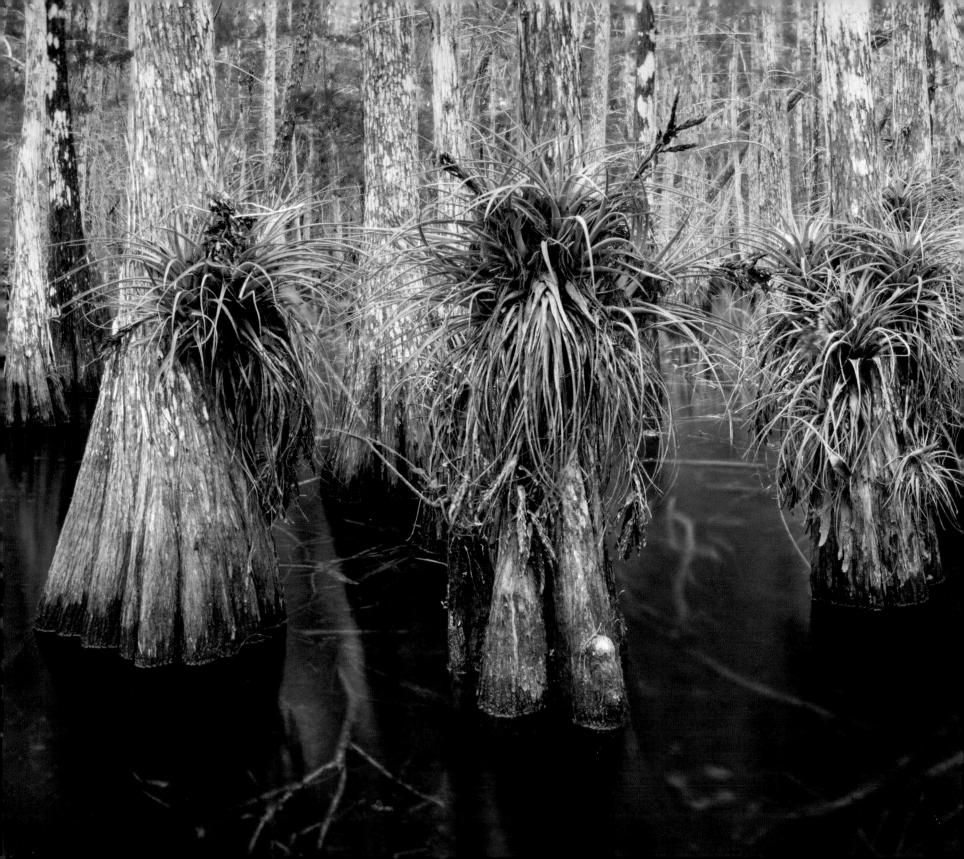

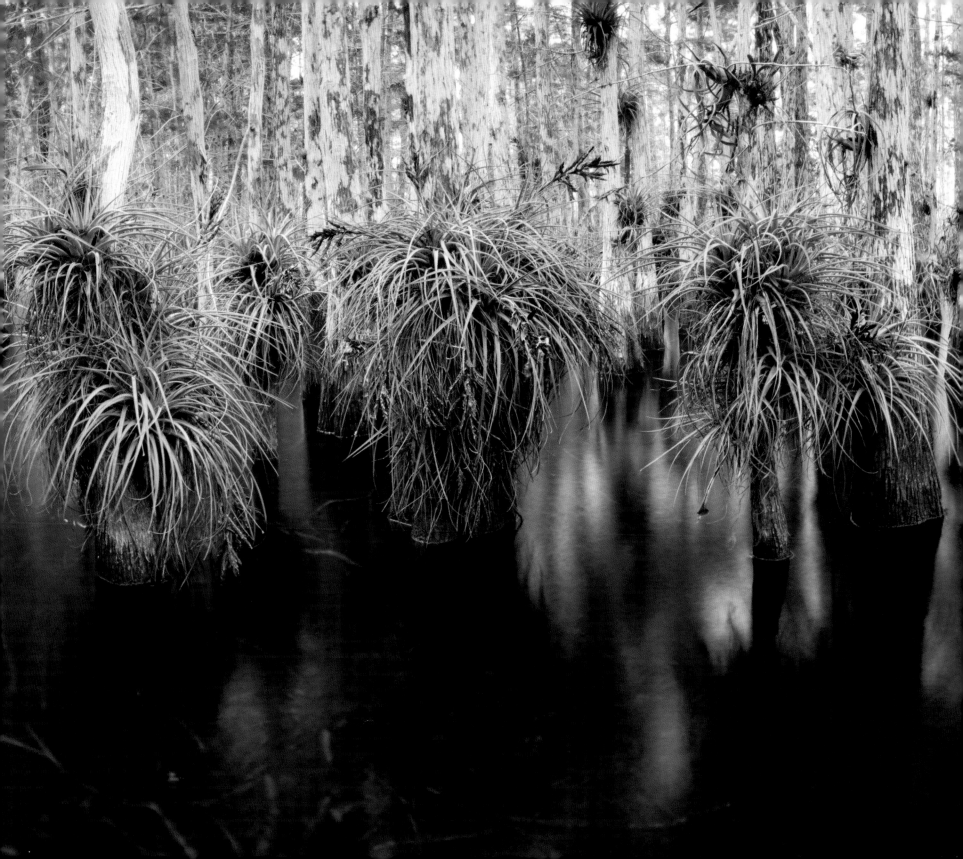

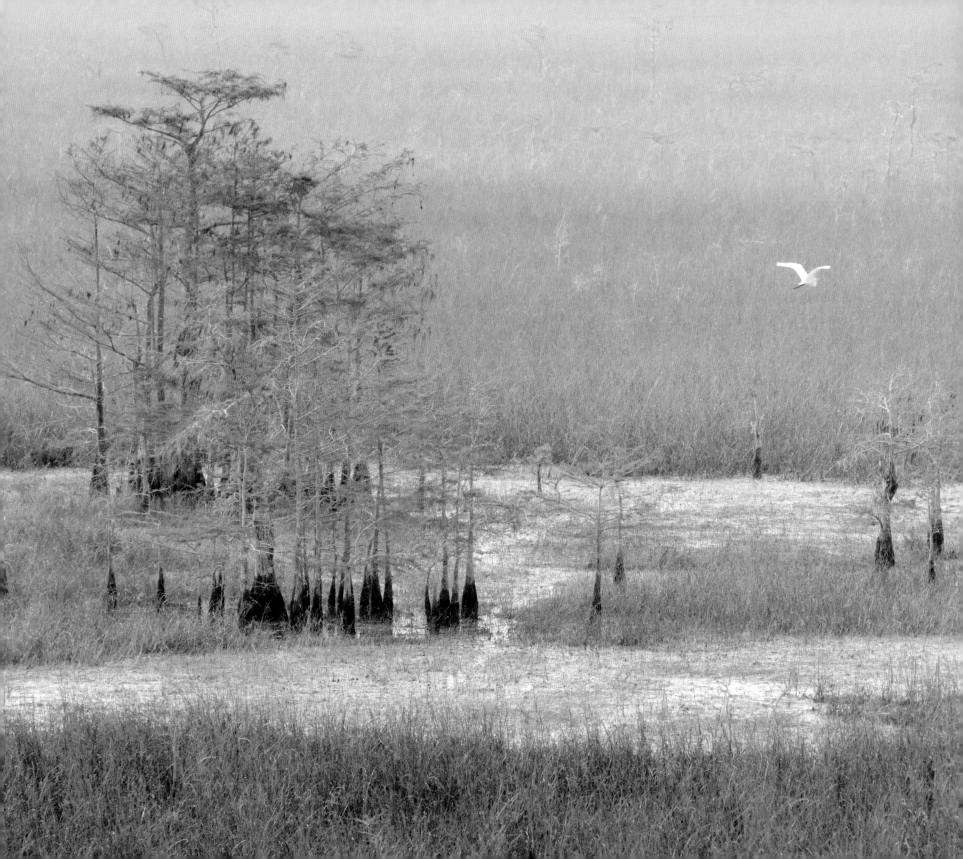

◄ Aerial of a great egret and cypress slough. Everglades National Park.

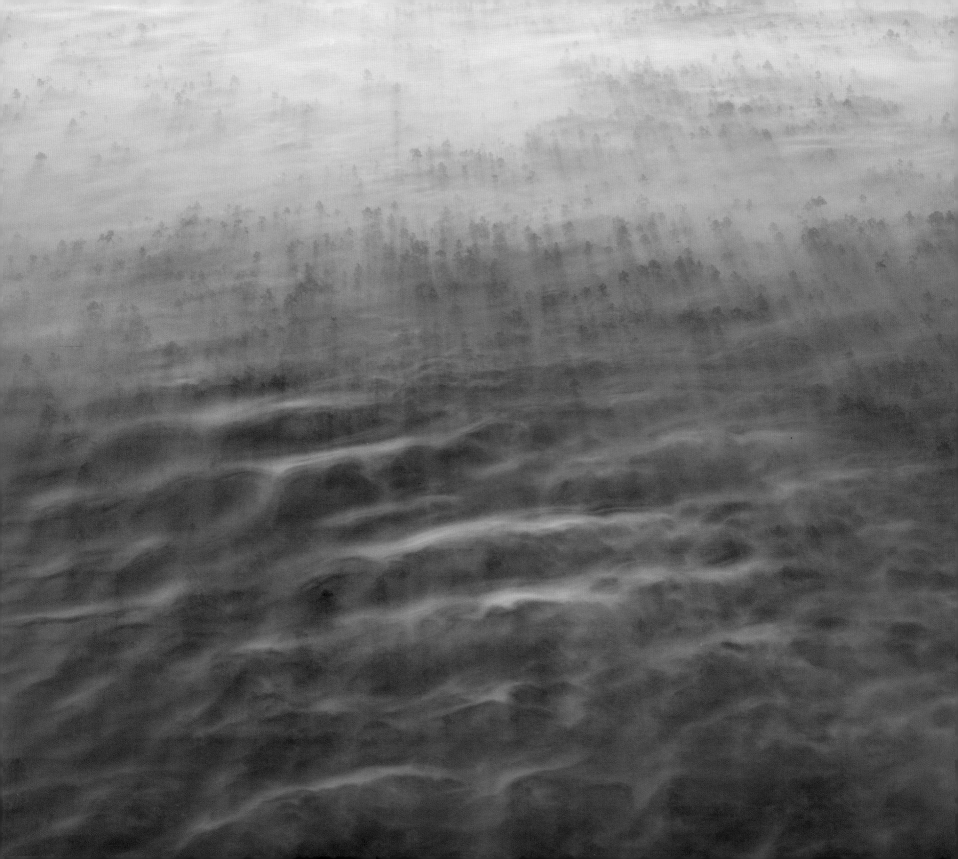

▶▶ Nine Mile Pond. Everglades National Park.

◀ Aerial view of fog rippling through a slash pine forest. Everglades National Park.

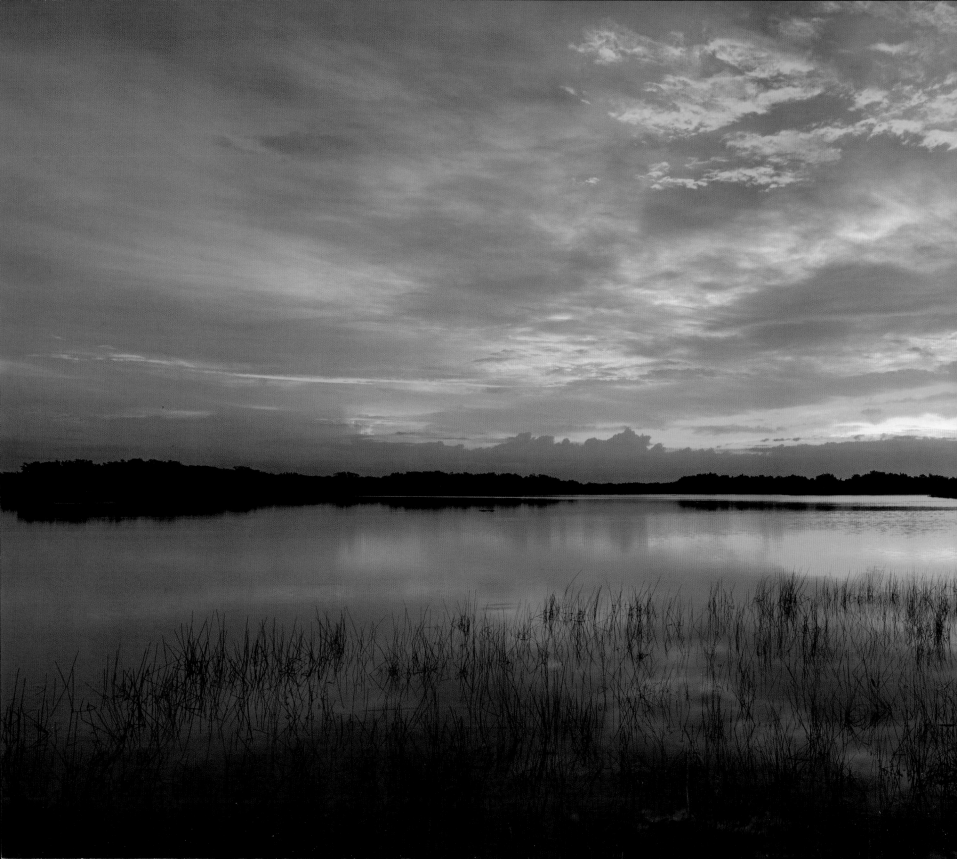

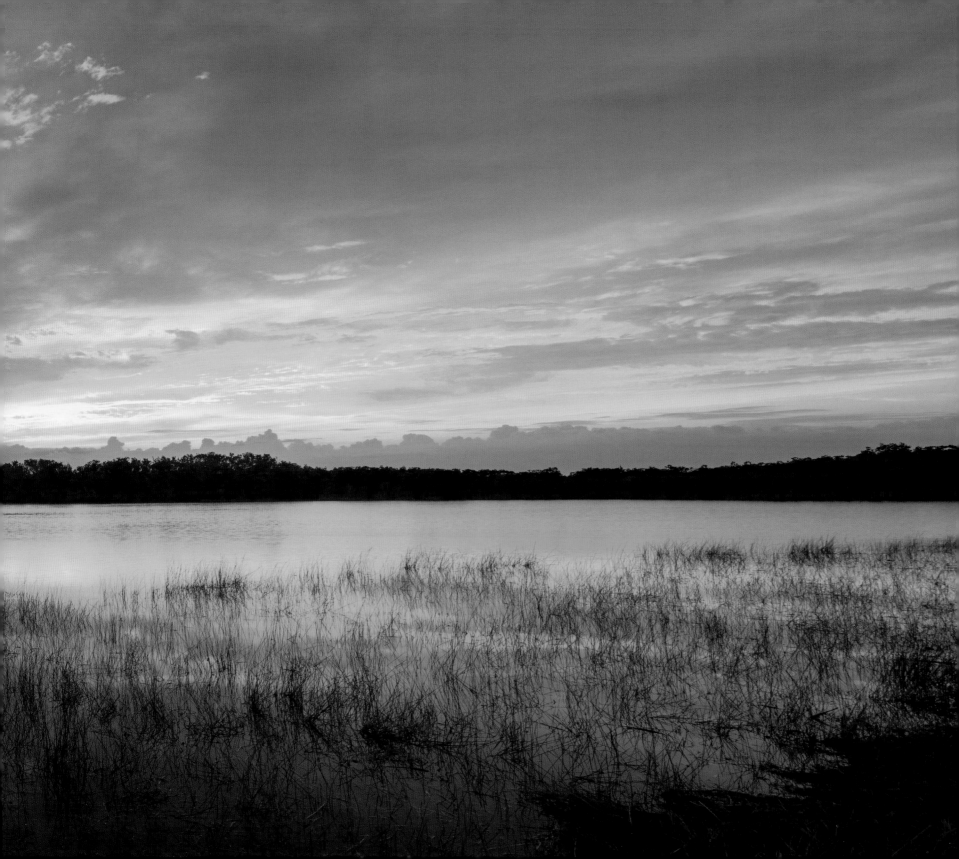

The New Pangaea

Mac Stone

When the supercontinent Pangaea started to break apart some 200 million years ago, leagues of oceans, mountains, and valleys disconnected plants and animals, leaving them to evolve or perish within their new surroundings. Eons of physiological adaptations responded to geographical isolation, reshaping global biodiversity. Each organism rediscovered its place within the new ecological hierarchy. Small-scale colonization occurred as mammals unknowingly carried hitchhiking seeds on their fur and wading birds transported bacteria from one pond to another while they foraged for fish. Humans evolved concurrently, and over time local tribes morphed into empires. Vast seas became blue highways connecting countries, cultures, and wildlife, and soon enough, the world became a much smaller place.

It wasn't long before entire civilizations were displaced or eradicated as the front lines between the old and new worlds raged at all levels. The Everglades saw its first extinction when its last native inhabitants, the Calusa, were decimated by plague and disease from Spanish conquistadors and pioneering Europeans. The few survivors eventually fled to Cuba after more modern, neighboring tribes threatened to scatter and enslave the remaining natives. The Calusa inhabited South Florida for thousands of years, became masters of the Everglades complex, and then, they were gone. If man could so easily disown and replace his own species, then what hope did the native flora and fauna stand as settlers moved in?

At the onset of the campaigns to the drain the Everglades, it appeared that every scheme and proposal to relieve its citizens of the ceaseless water was tested. When canals and levees proved too expensive, melaleuca trees were imported and dispersed throughout the region to help soak up the remaining water. It seemed no one was prepared for how fast and how far the trees would spread or for how difficult they would be to remove. Now, there are over half a million acres of melaleuca within South Florida.

But not all foreign plants are as dominant or invasive as the Australian trees. In fact, pioneers flocked to Florida because its warm climate offered the potential to grow oranges, sugarcane, bananas, and tomatoes, none of which is native to the United States. In essence, Florida became the nation's tropical connection, the one state in the Union that could support the agricultural fruits and riches of its Caribbean counterparts. But this open-border policy did not come without consequences.

Today, exotic species from all corners of the globe are arriving on Florida's shores, pushing out the natives, changing the ecology of the landscape, and quickly becoming the mod-

◀ Burmese python. Homestead.

▲ Oustalet chameleon. Homestead.

ern conquerors of the new Pangaea. Combined with bustling ports and South Florida's subtropical climate, the Everglades proves the ideal home for many species of plants, reptiles, fishes, and invertebrates from other equatorial regions of the world.

Now, some of these species are so ubiquitous that while walking through a park in South Florida one could easily pass dozens of exotics without ever knowing. The brown anoles, Cuban tree frogs, and fire ants, which seem to inhabit every nook and cranny, comprise only a small fraction of the more than 500 non-native species that call the Sunshine State home. Today, one can venture out and find crocodiles from Africa, catfish from Thailand, and chameleons from Madagascar. As I write this, the unmistakable chirps of a Tokay gecko pair echo through my home. One hundred years ago I would have had to travel to Indonesia to hear their evening ritual. For now, they keep the insects at bay and I'm happy to allow them to squat; but not all of the foreign visitors are the kind you want sitting in the corner of your room calling out to their mates.

Perhaps the most infamous of these invaders in recent years is the Burmese python. Reaching lengths up to 19 feet, they are prolific hunters and nearly impossible to find. Devouring alligators, raccoons, deer, birds, and fish, they are given an endless smorgasbord in the Everglades. Released by pet owners, they have found an arguably permanent residence in the Everglades, and their population is now estimated between 5,000 and 250,000 individuals. I wondered why the numbers were so inexact until I went out in the field with park biologists.

Native apple snail

Invasive island apple snail

We used radio telemetry to locate what they called "Judas Snakes," the individuals that were previously tagged with GPS chips hopefully to reveal the locations of other breeding pythons. Even with the aid of a beeping locator we spent hours hiking deep into sawgrass prairies and through pine uplands. As we crouched low beneath a canopy of cocoplum and poisonwood the tracking device held a solid tone indicating that the 9-foot python was within a few feet of our position. I could not see the snake until the biologist pointed it out to me, an arm's length away, camouflaged against the leaf litter. This is the problem: they are perfectly adapted to survive and thrive in these conditions.

The state is spending millions of dollars on invasive species removal, but not all cases are as cut and dried as the Burmese python. Take for instance the native apple snail and the island apple snail from South America. With smaller, more abundant eggs, the island apple snail drastically out-produces the native species. They are also significantly bigger, growing to the size of baseballs. In nearly every way, they appear as invasive as the maleleuca tree, conquering wetlands and eclipsing the native species. But one of the heralded icons of the Everglades, the critically endangered snail kite, feeds solely on these types of mollusks. When native apple snail populations declined as wetlands were drained and polluted, the raptors'

populations plummeted to near extinction. Today, snail kites appear to be rebounding, and below their nests are piles of hollowed out island apple snails.

What we know is that the ecology of South Florida, as with all natural systems, is one that flexes and bends, to a point. We cannot assume to fully grasp the biological complexities that govern interspecies relationships, and our track record of playing God in the Everglades is discouraging at best. The one thing that is certain, however, is that change is inevitable when given enough time. Cultures clash, species evolve, and at some point we were all invasive, disrupting the order of the old and replacing it with the new.

Perhaps the lionfish, pythons, maleleuca trees, and island apple snails are here to stay; and two hundred years from now they might be considered the norm. Maybe we can't remove them, but the risks, those foreseen and those not yet apparent, are too great not to try. At the very least we can focus our efforts on preventing new species from coming in. The most important thing in this globalized society is that we realize our actions can have lasting and unpredictable consequences, and we must capitalize on every opportunity to lessen our footprint on the landscape.

▲ Cuban tree frog maturation sequence. Key Largo.

◄ Native apple snail eggs (*left*) and invasive island apple snail eggs (*right*). Lake Okeechobee.

Around the World

Invasive species from all over the globe now find their home in the Everglades. Whether released from the pet trade or hitchhikers aboard merchant ships, these individuals are making their mark on the local ecology and competing with native species. Starting at the top left and running counter-clockwise: Cuban Tree Frog, Knight Anole, Mayan Cichlid, Pike Killifish, Brazilian Pepper, Island Apple Snail, Argentine Tegu, Veiled Chameleon, Oustalet Chameleon, Australian Pine, Maleleuca, Lionfish, Burmese Python, Tokay Gecko, Walking Catfish.

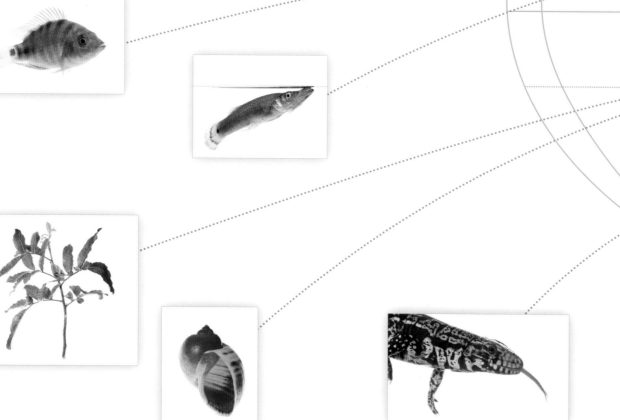

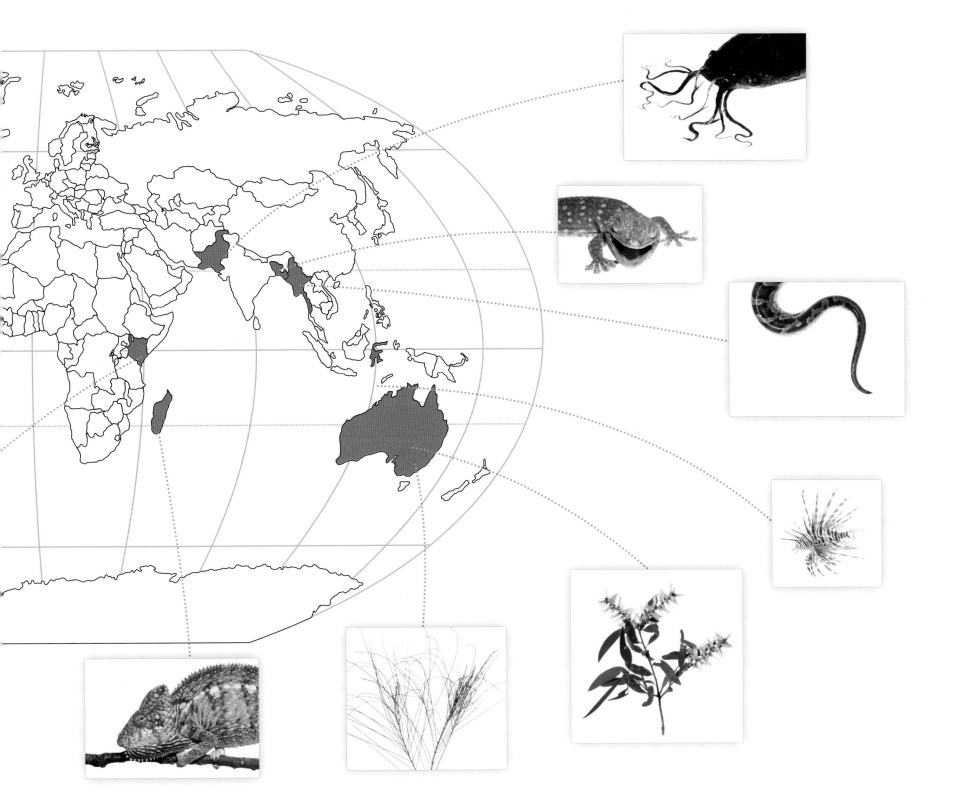

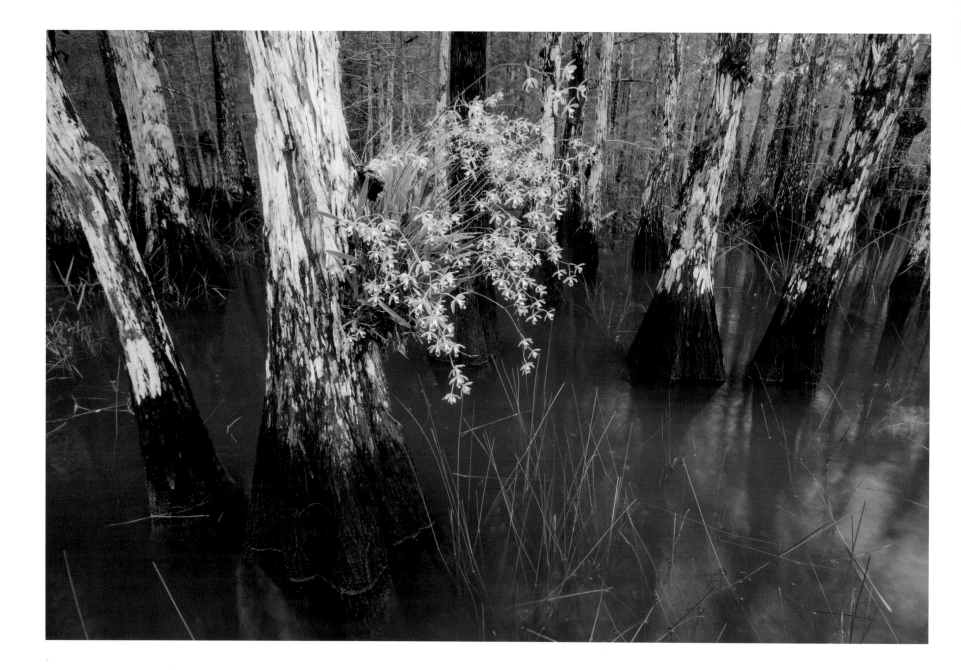

▲ Butterfly orchids bloom en masse in a cypress dome. Everglades National Park.

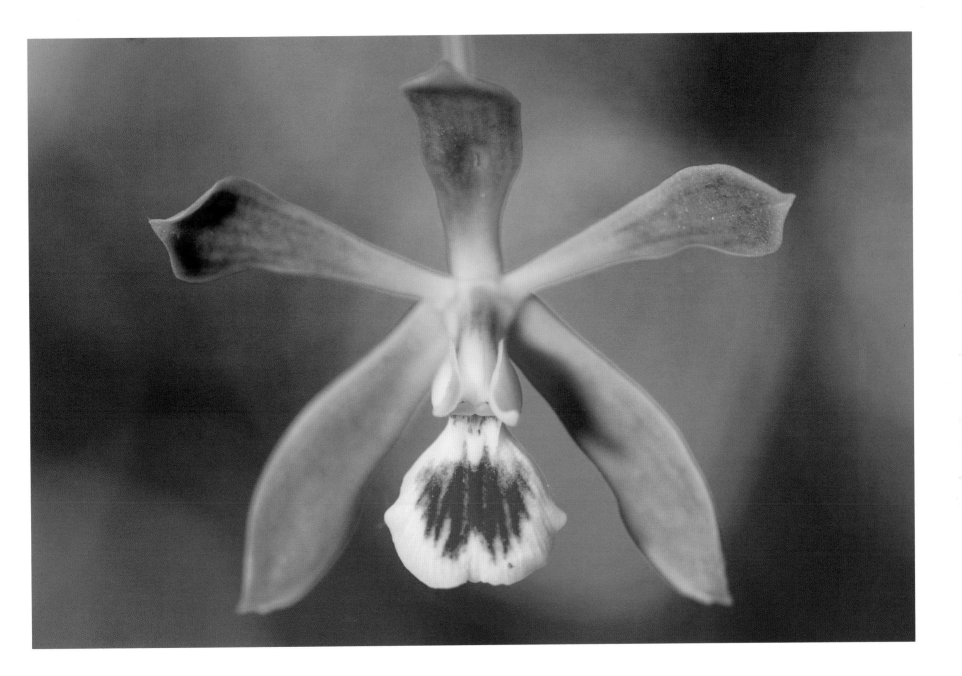

▲ **Butterfly orchid detail.** Everglades National Park.

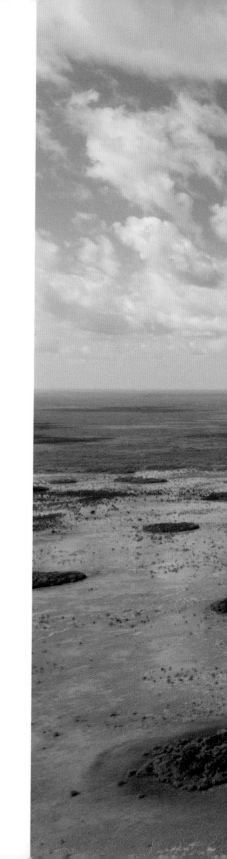

Thousands of teardrop-shaped islands pepper the ridge and slough habitats within the Everglades watershed. Formed by millennia of slow freshwater flow and sediment deposits, the inland archipelagos are comprised of dense shrubs and tropical hardwoods found nowhere else in North America. Protected from fire and flooding by deep moats and limestone outcroppings, trees like the gumbo limbo, mahogany, cocoplum, and over 100 other plant species thrive in these ecosystems. The broadleaf canopies of tree islands also create a tropical microclimate providing refuge for myriad wildlife and rare orchids.

▶ Tree islands in Taylor Slough. Everglades National Park.

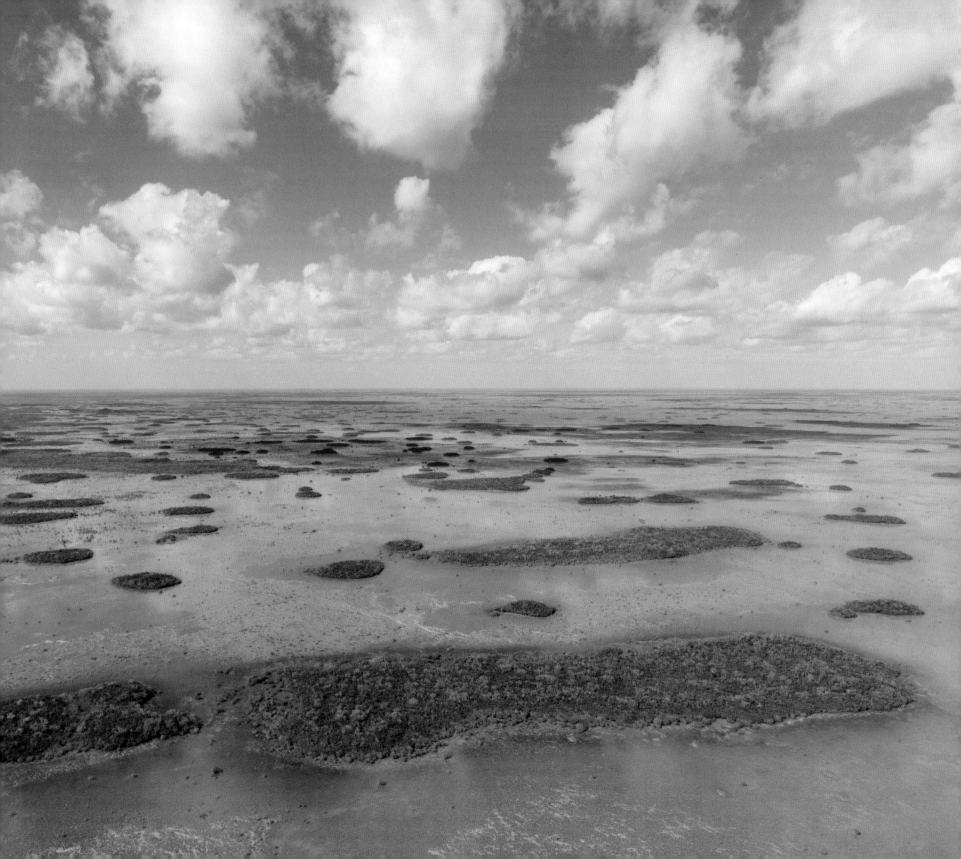

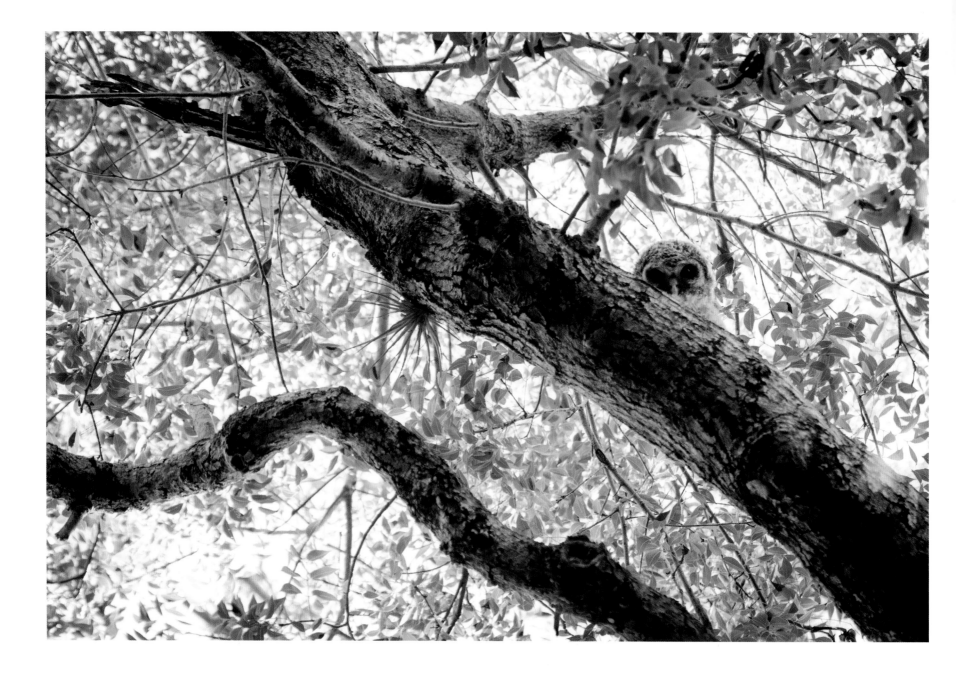

▲ Barred owl chick in Mahogany Hammock. Everglades National Park.

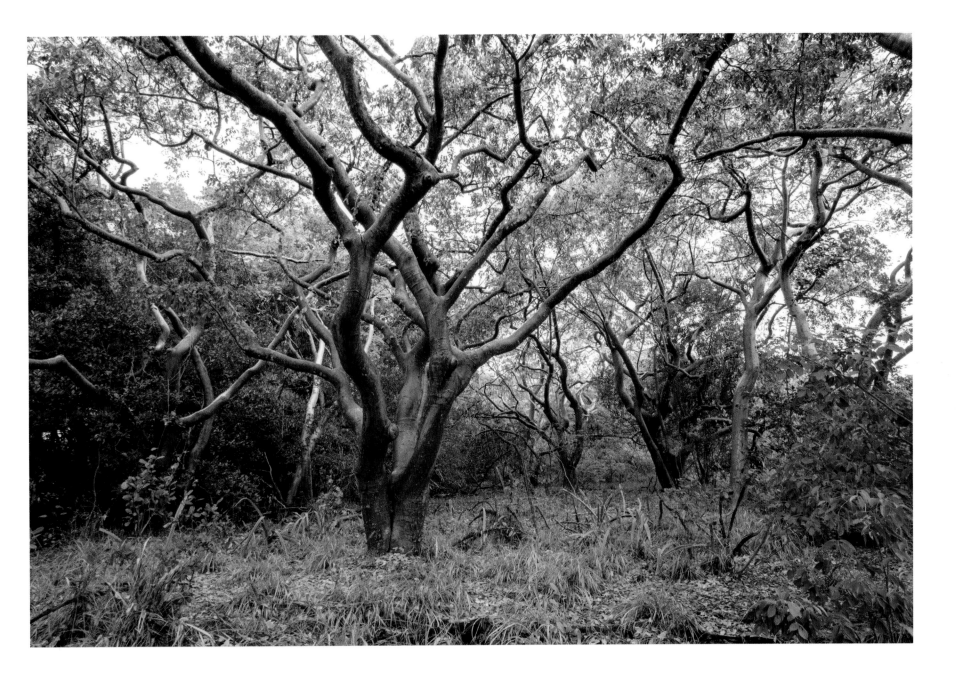

▲ Gumbo limbo trees. Everglades National Park.

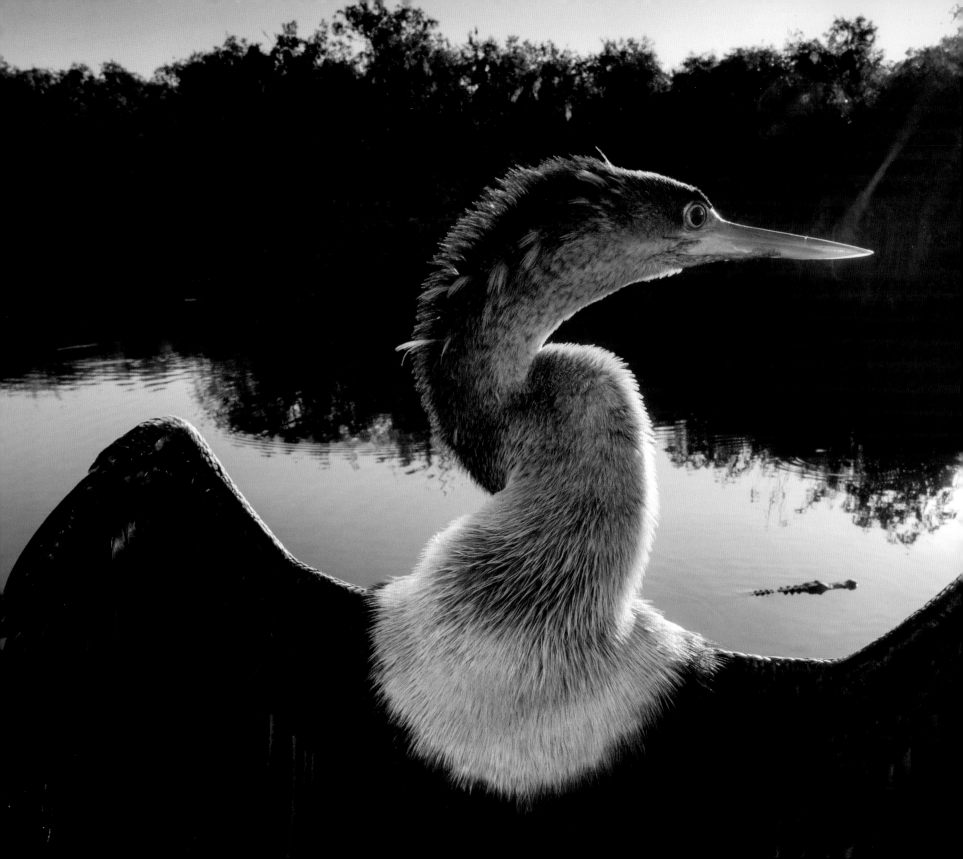

◄ Anhinga and alligator. Everglades National Park.

►► Slash pine forest. Everglades National Park.

143

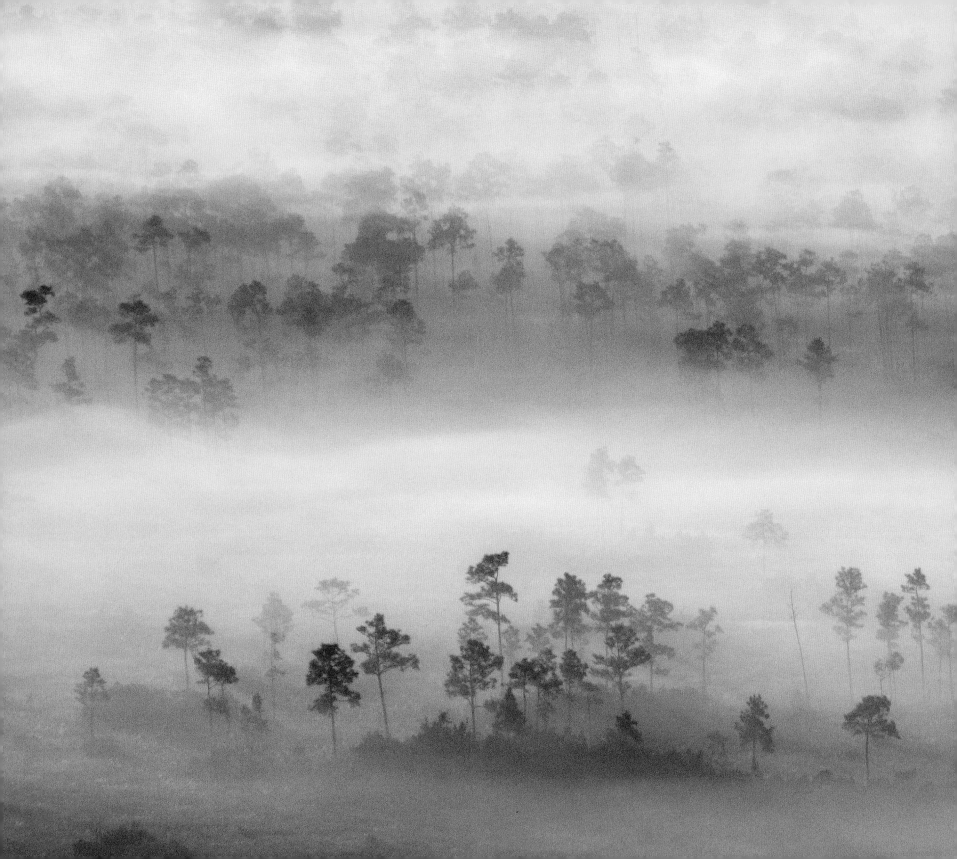

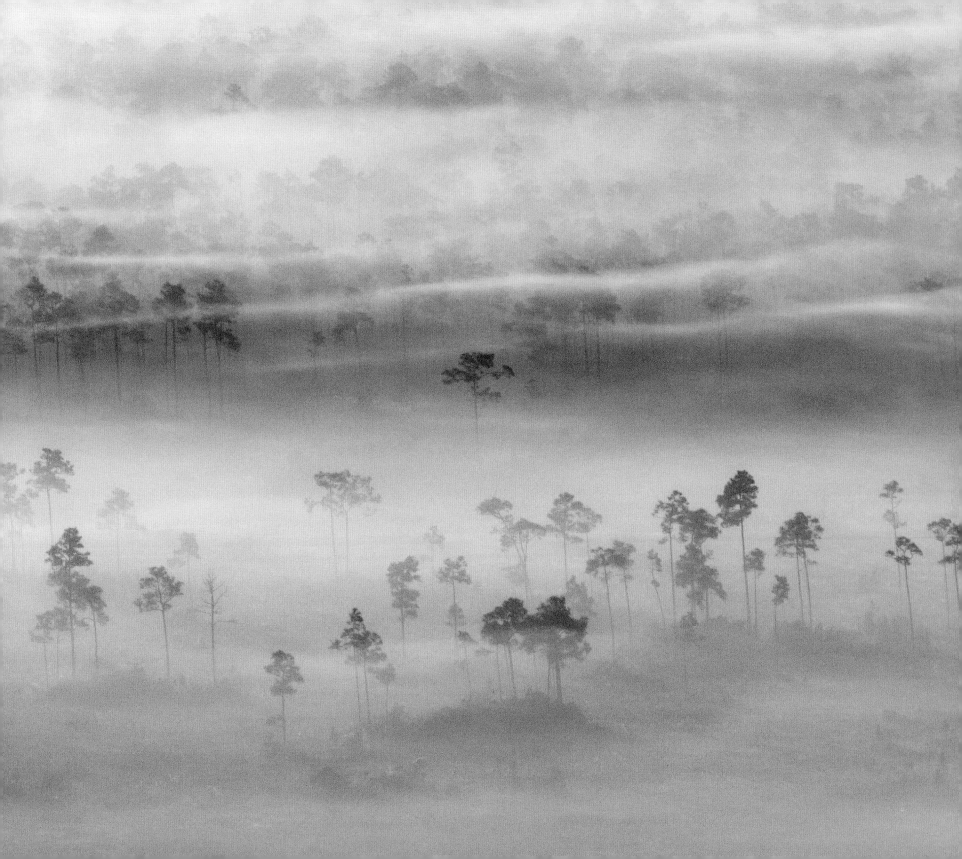

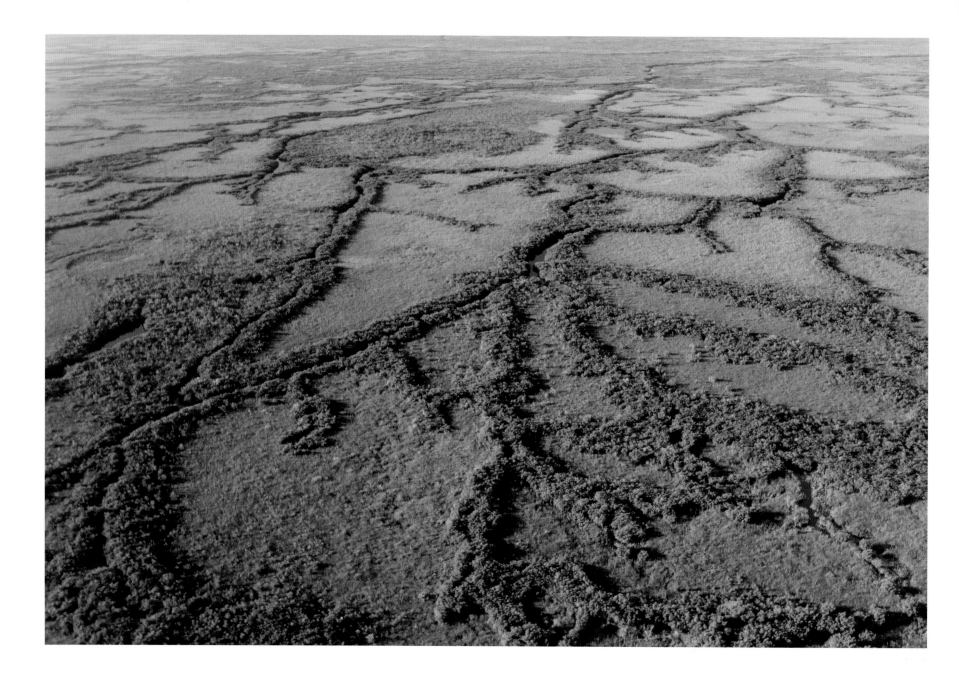

▲ Creeks and tributaries of Rookery Branch. Everglades National Park.

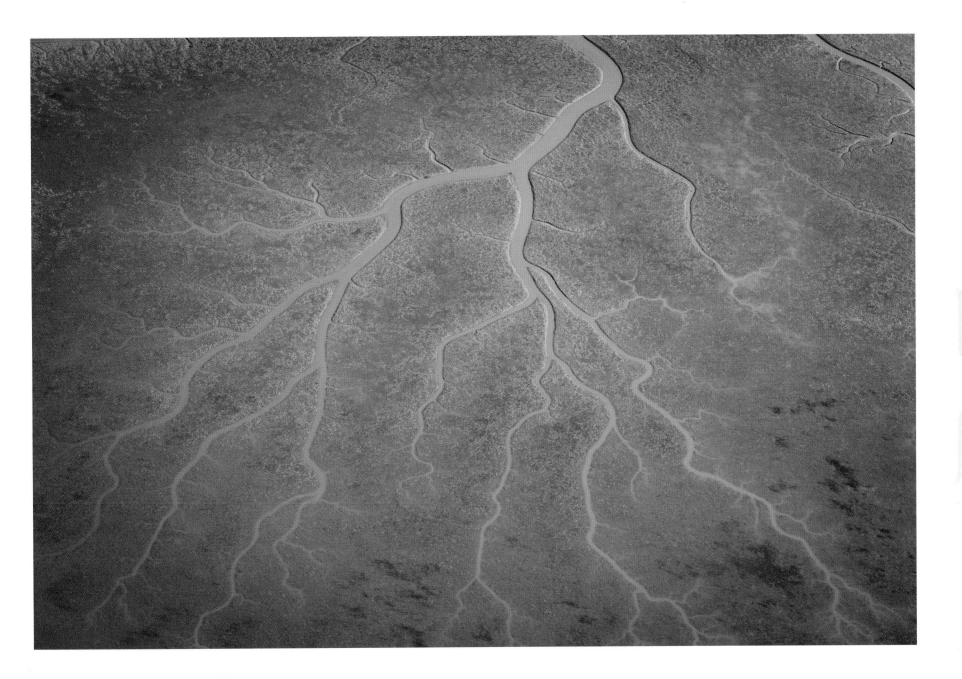

▲ **Tidal creeks.** Lake Ingraham.

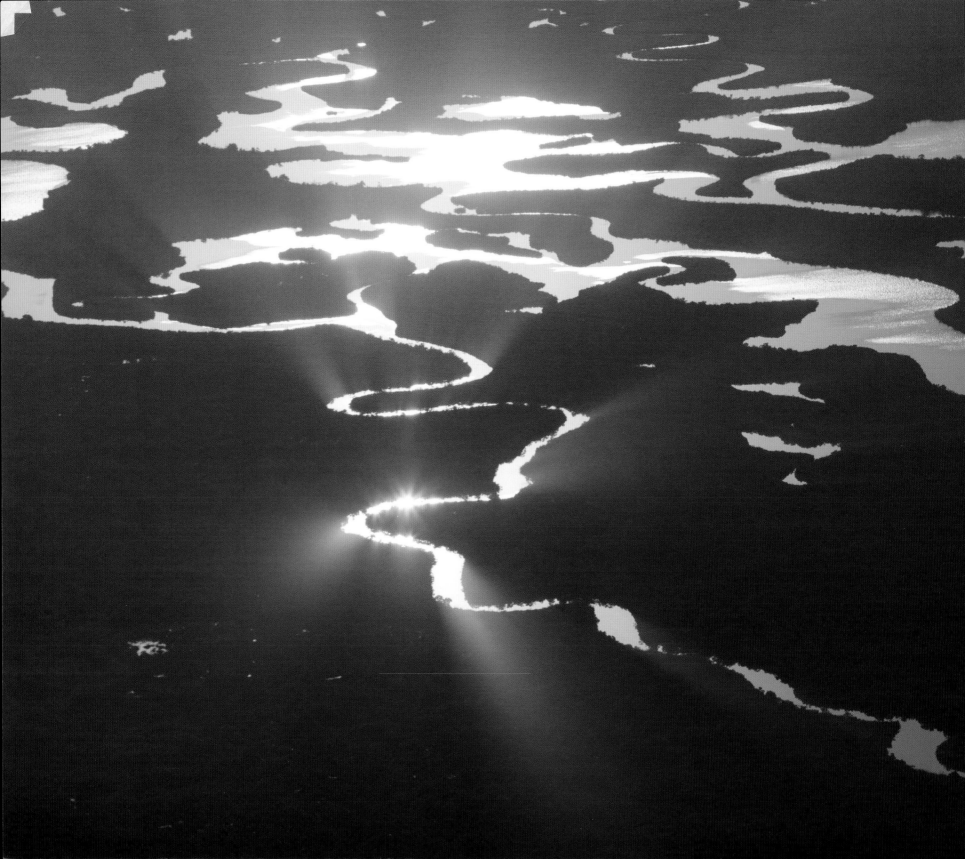

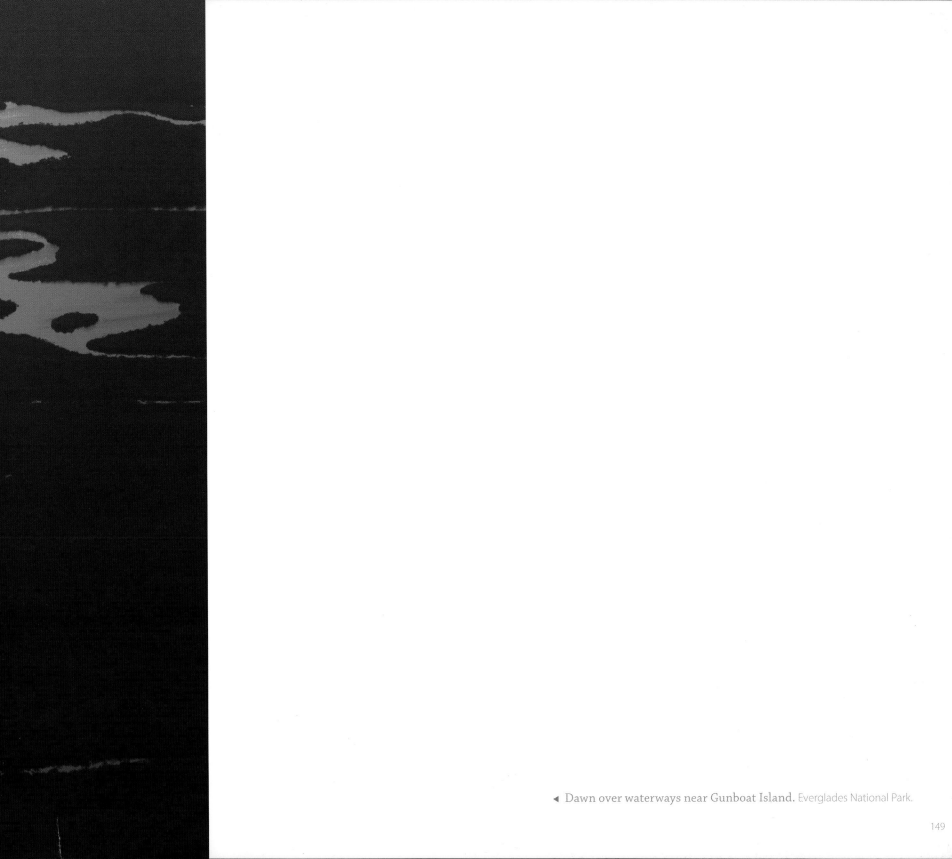

◄ Dawn over waterways near Gunboat Island. Everglades National Park.

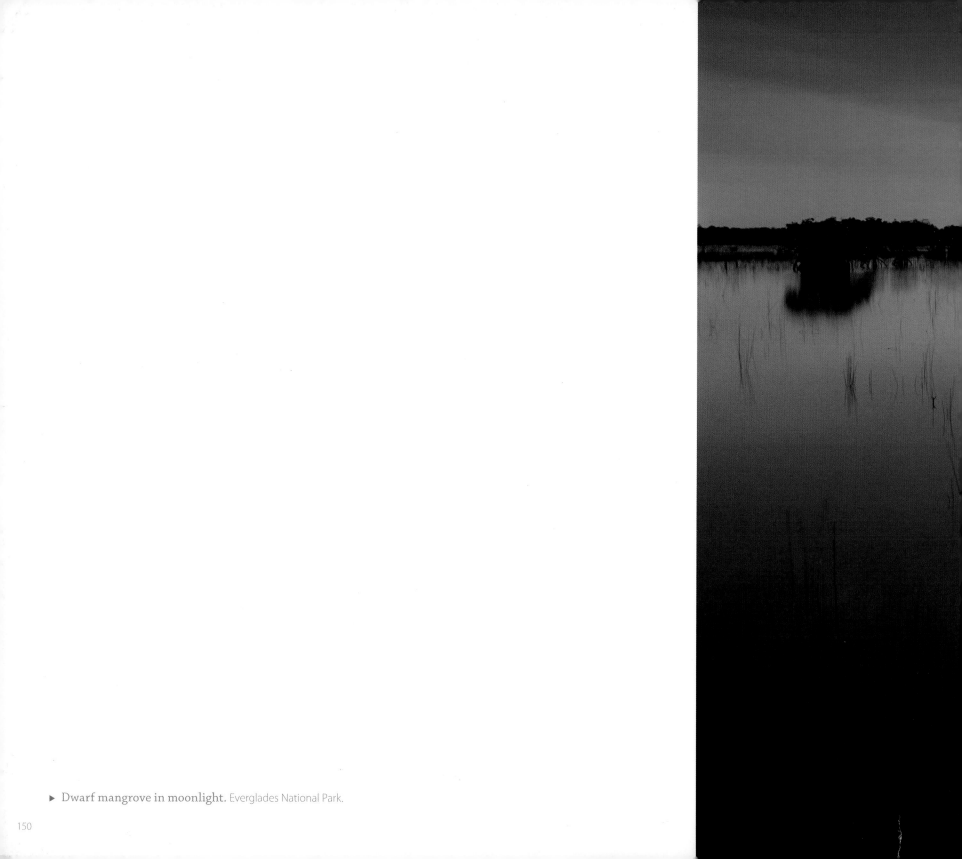

► Dwarf mangrove in moonlight. Everglades National Park.

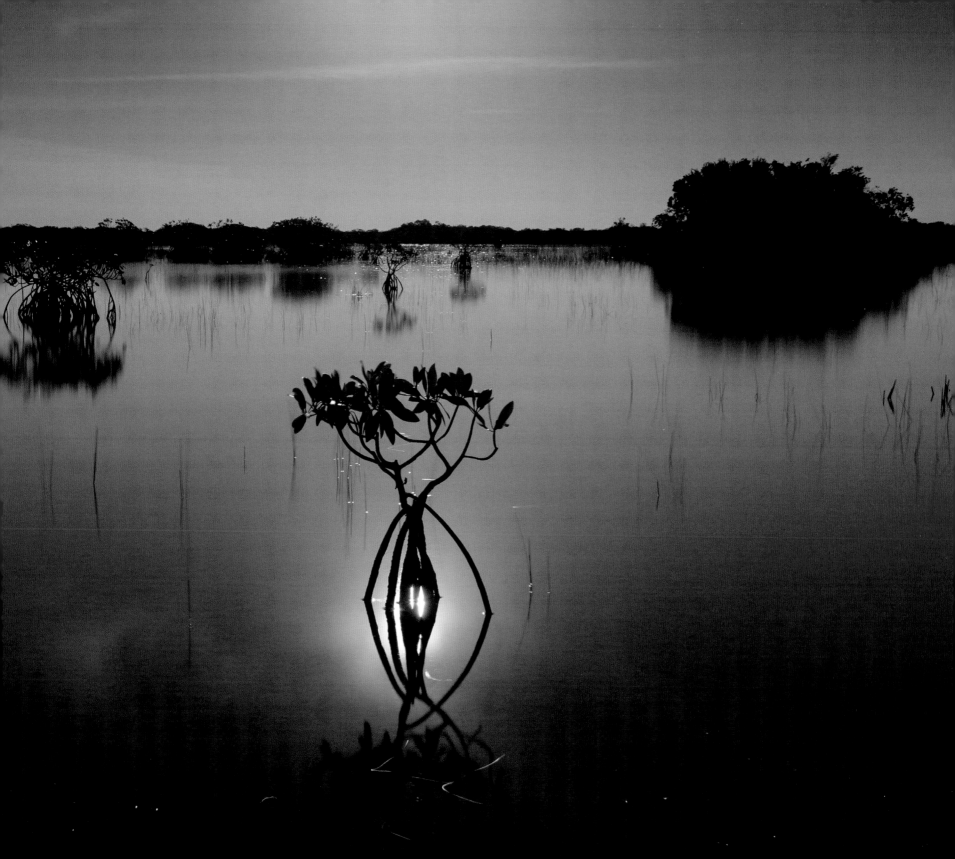

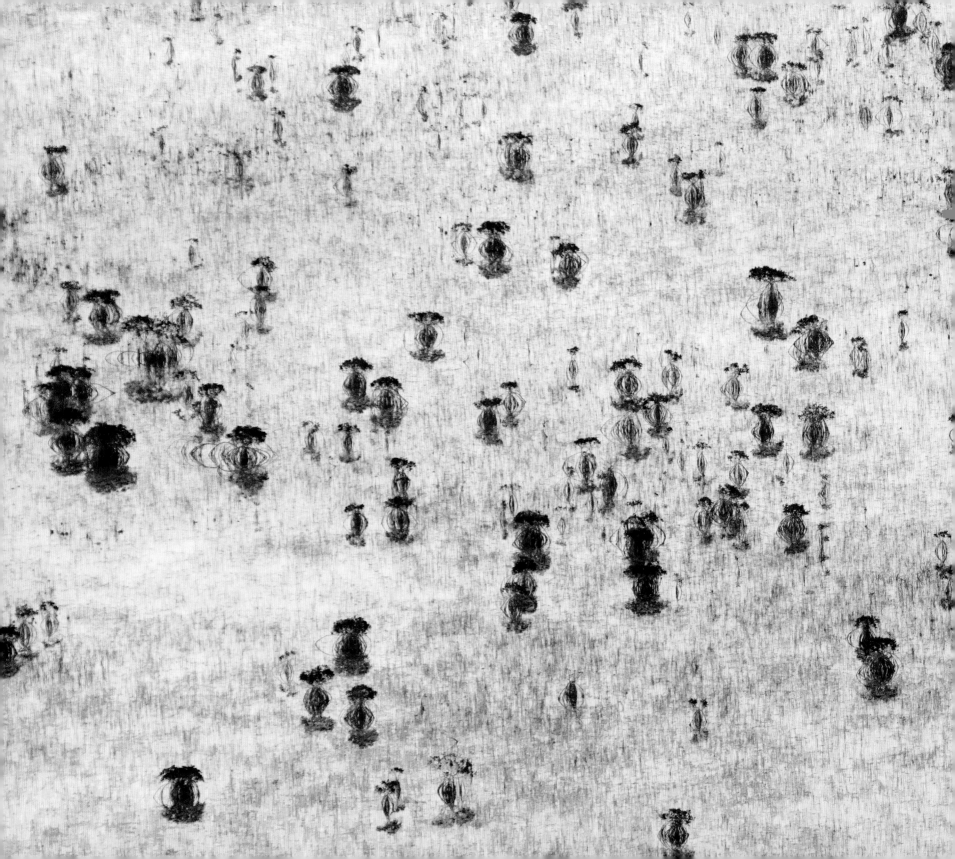

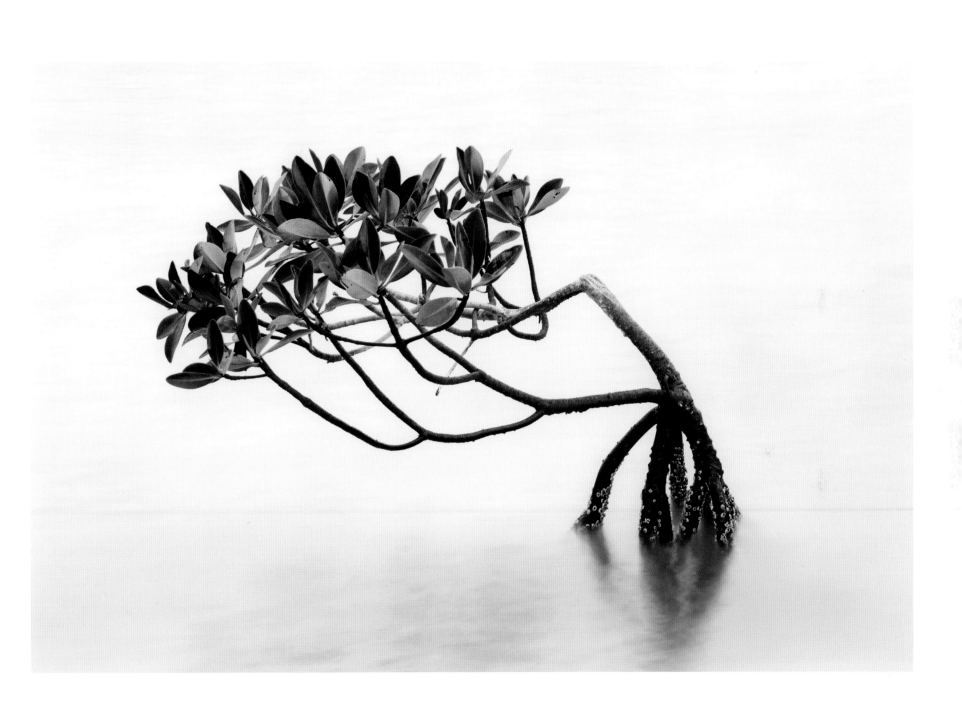

◄ Aerial view of freshwater dwarf mangrove and spikerush habitat. Everglades National Park.

▲ Red mangrove shaped by wind. Park Key.

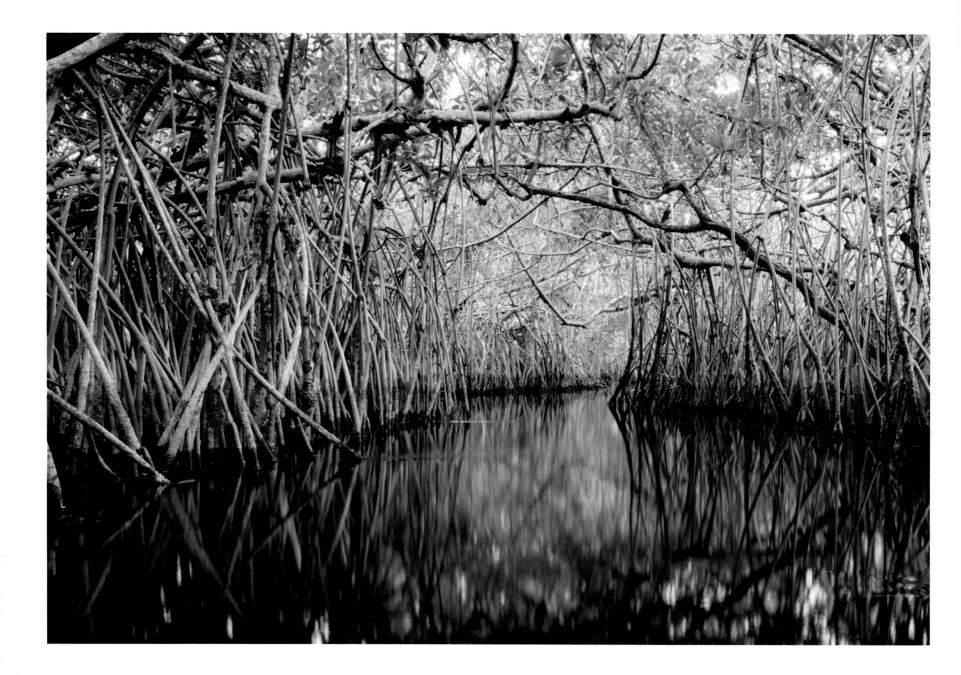

▲ **Taylor River.** Everglades National Park.

▶ **Aerial of mangrove creek.** Everglades National Park.

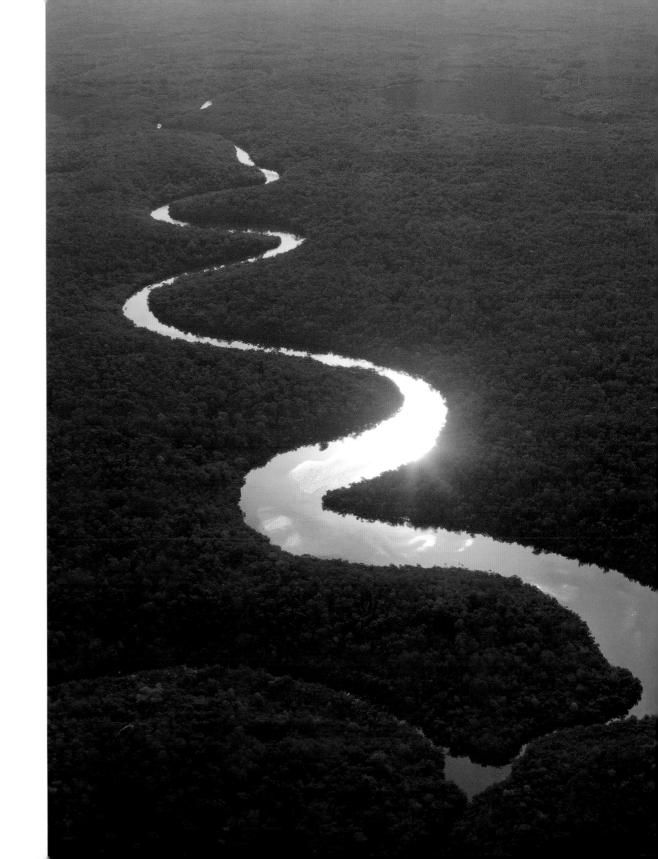

► Aerial of Broad River at dawn. Everglades National Park.

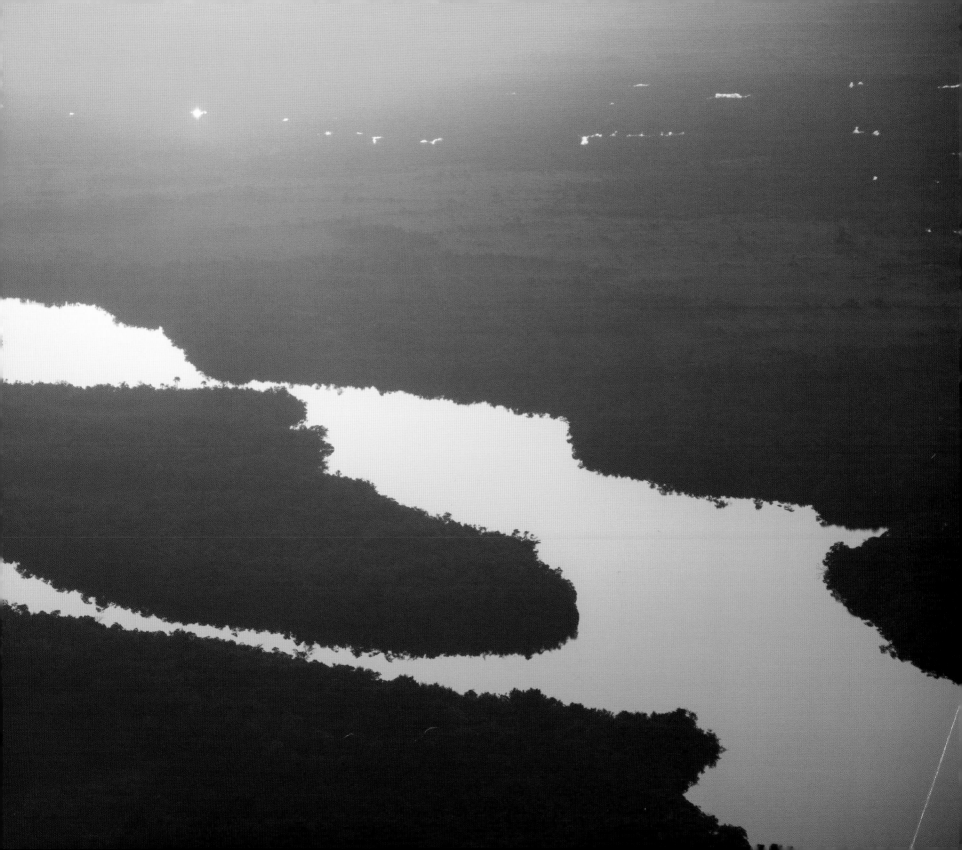

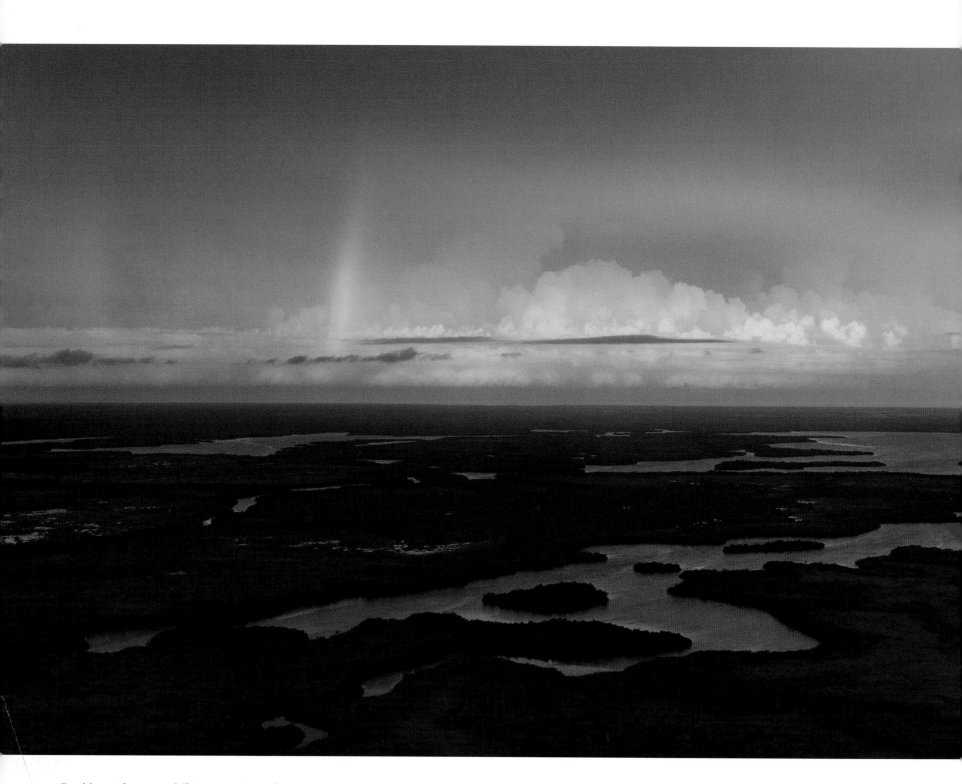

▲ Double rainbow over Whitewater Bay tributaries. Everglades National Park.

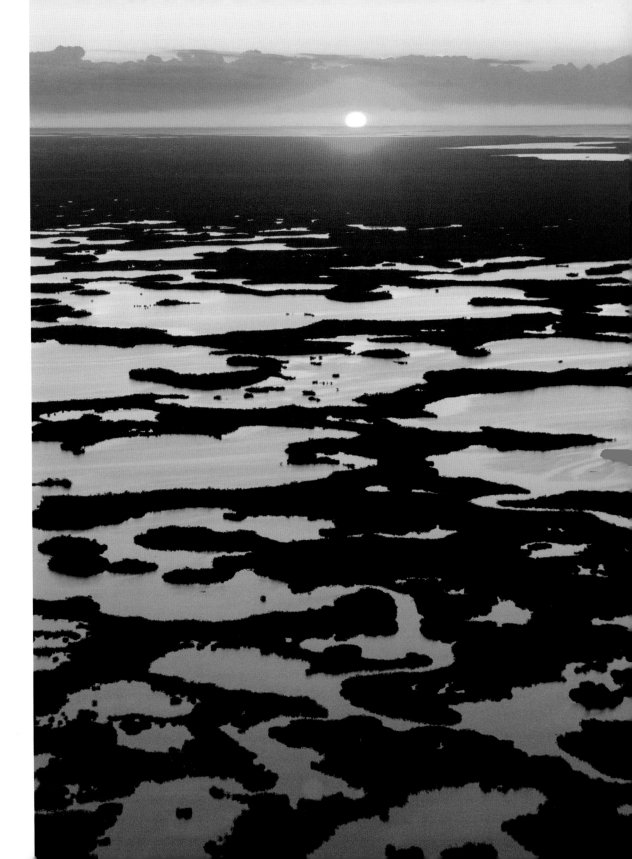

▶ Hell's Bay. Everglades National Park.

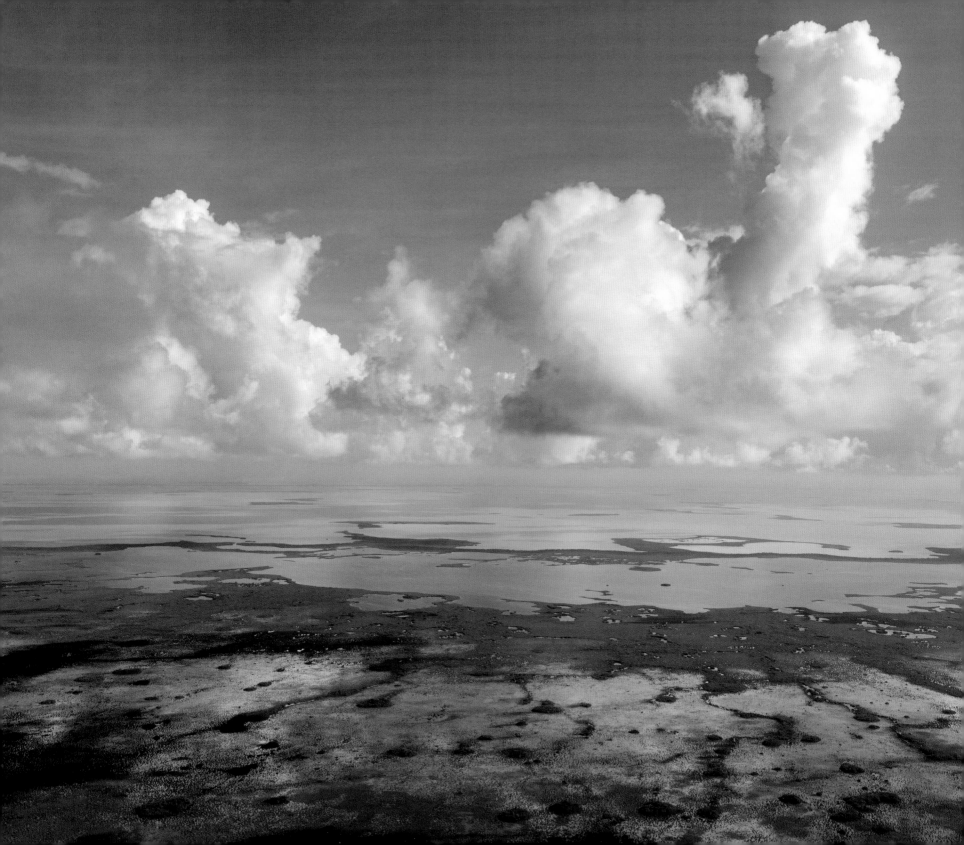

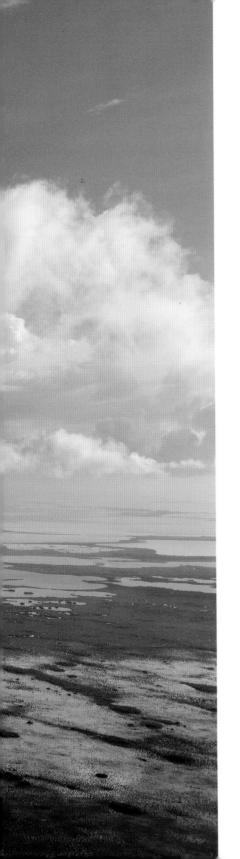

◄ Taylor Slough emptying into Florida Bay. Everglades National Park.

Florida Bay

Jerry Lorenz

At the transition of the Pleistocene and Holocene eras nearly 11,000 years ago, sea levels fluctuated exposing millennia of accumulated coral reefs forming the islands we now know as the Florida Keys. Over the next 7,000 years, the Everglades slowly formed and the vast watershed nearly 100 miles long delivered sheet flow of freshwater to Florida Bay, now contained within the boundaries of the Gulf of Mexico and the coral islands. The shallow basin fueled by freshwater inputs and a mixing of nutrient-rich saltwater from the Gulf and Atlantic created a vast and unique subtropical estuary.

As the first inhabitants of Florida were fishing oysters out of the tidal deltas, mangrove propagules floated around in the emerald waters until finding purchase along shallow sediment deposits. Over time, these singular trees would lurch forward, metastasizing to form large islands along the ever-changing banks and flats of Florida Bay. Meanwhile, continual sunlight through crystalline water enabled endless prairies of submerged grasses to blanket the shallows, and a profusion of fishes and wading birds exploded in Florida Bay.

By all accounts, it was a veritable wildlife Eden. The subtropical climate and continual freshwater input brought rare fauna like the West Indian manatee and the American crocodile. The isolated islands provided safe breeding grounds for thousands of colorful roseate spoonbills and other wading birds while the mangrove fringe supported nurseries for sharks and large gamefish. The rich water flowed out of Florida Bay and replenished the kaleidoscope coral reefs with mature fishes and healthy levels of nutrients. It continued on in this fashion, relatively undisturbed for another six thousand years, until we arrived.

In the short one hundred years of Florida's occupation by modern settlers, we managed to overfish the waters, drain the wetlands, and decimate bird populations to near extinction. The effects of South Florida's development schemes are nowhere more evident than in Florida Bay, the Everglades' last stop for freshwater. By the time I landed in Islamorada in 1989, Florida Bay was a land remembered and the early accounts I read from my predecessors of a thriving estuary seemed dated.

At the time, I was a graduate student working with National Audubon Society's Tavernier Science Center on an 18-month project. I was green and inexperienced, and after the first day, enduring the blazing sun and swarms of mosquitoes, I wanted to turn tail and head back to my home in Kentucky. It is now closing on 25 years that I have studied this emerald of the National Park Service, fighting for her protection and restoration, rendered completely powerless against the enslaving beauty that is Florida Bay.

It was the clear waters, neon grasses, and wind-bent trees that captured me, the diversity of life, the stunning creatures both large and small. But as soon as I arrived, I heard the rumblings from my scientific colleagues that large swaths of seagrasses were dying at alarming rates. What followed was years of ecological upheaval.

▶ Deer Key, shaped like the state of Florida, in northeastern Florida Bay. Everglades National Park.

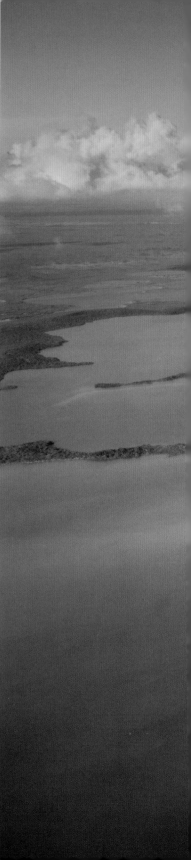

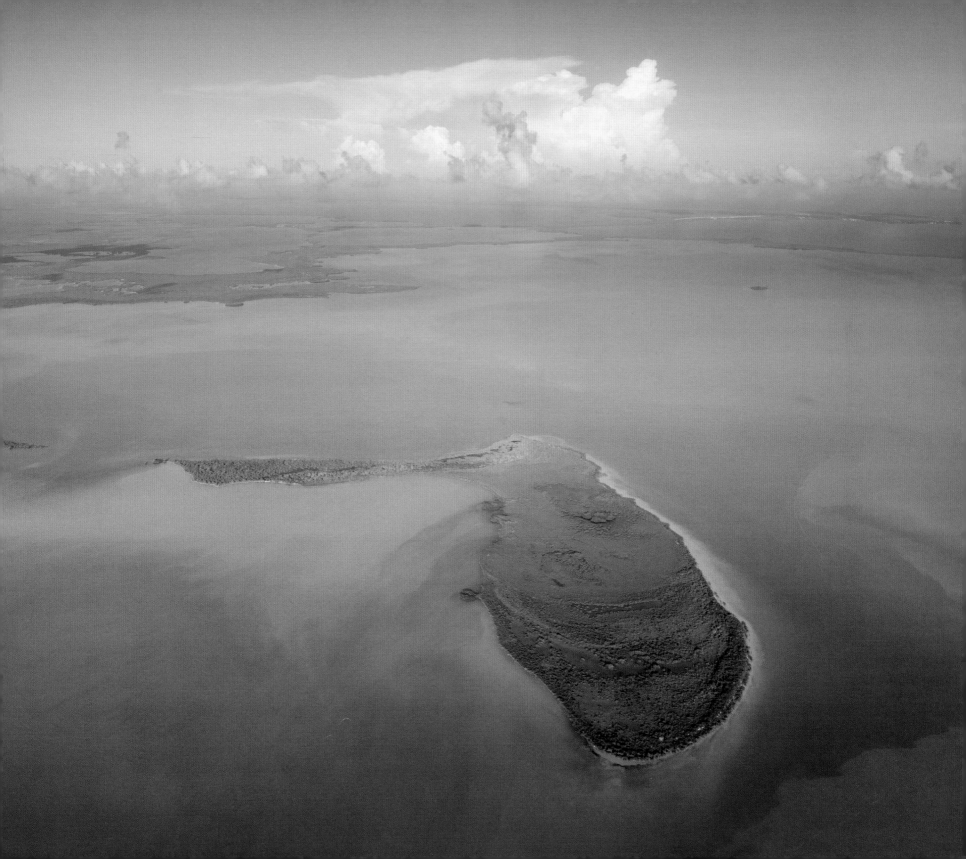

Massive algal blooms ensued, turning the gin-clear water into pea soup resulting in devastating fish kills. Fishing guides echoed that there were no fish to catch and that they could no longer earn a living from the once vital bay. Soon, other wildlife began to disappear. Thriving colonies of thousands of wading birds simply failed to form. Vast schools of feeding mullet the size of a city block all but disappeared and along with it many other fish eating birds, crocodiles, and bottlenose dolphin. Additionally, the hot salty water was flowing out of the bay and smothering the adjacent coral reefs.

Not only was the ecology of South Florida threatened, but with it, the complex economy built around tourism and fishing hung in the balance. We scientists held annual conferences to see if we could find a solution or at least an answer as to what was happening. After much debate the conclusion was that Florida Bay was dying of thirst. The life-giving freshwater that flowed from the Everglades had been diverted and drained, and what little was entering the bay was coming in at the wrong places, at the wrong time. The massive canal system that now governed all water flows through the southern Everglades was essentially strangling Florida Bay.

The scientists were heard and the government agencies reacted. The U.S. Army Corps of Engineers and the South Florida Water Management District became much more sensitive to environmental concerns. Many other federal, state, and local agencies also began to play a more active role in helping solve the problem. Changes were made in the water management practices and infrastructure, dramatically improving the situation. The ultimate gesture of solidarity came when the U.S. Congress approved the Comprehensive Everglades Restoration Plan in 2000. Granted, we are still far from achieving true restoration and the bay endures more than its share of ecological problems, but it is undoubtedly in better shape than it was twenty years ago.

Such a stunning place is certainly worthy of our collective love, admiration, and protection. If not simply for the preservation of biodiversity and natural beauty, we also need a healthy Everglades to provide potable water to the burgeoning human population that lives and vacations here. Additionally, a healthy Florida Bay is an economic engine that directly and indirectly creates jobs. From fishing and wildlife guides, to boat manufacturers, to hotels and dive shops, the residents and visitors of South Florida spend billions of dollars annually on industries founded upon the fruits of the famous watershed. We simply cannot afford to ignore restoring the Everglades and Florida Bay.

Jerry Lorenz is the state director of research for Audubon Florida and has spent over twenty-five years dedicating his research to Everglades restoration efforts in Florida Bay and the southern Everglades.

▶ Nurse shark on seagrass flats. Islamorada.

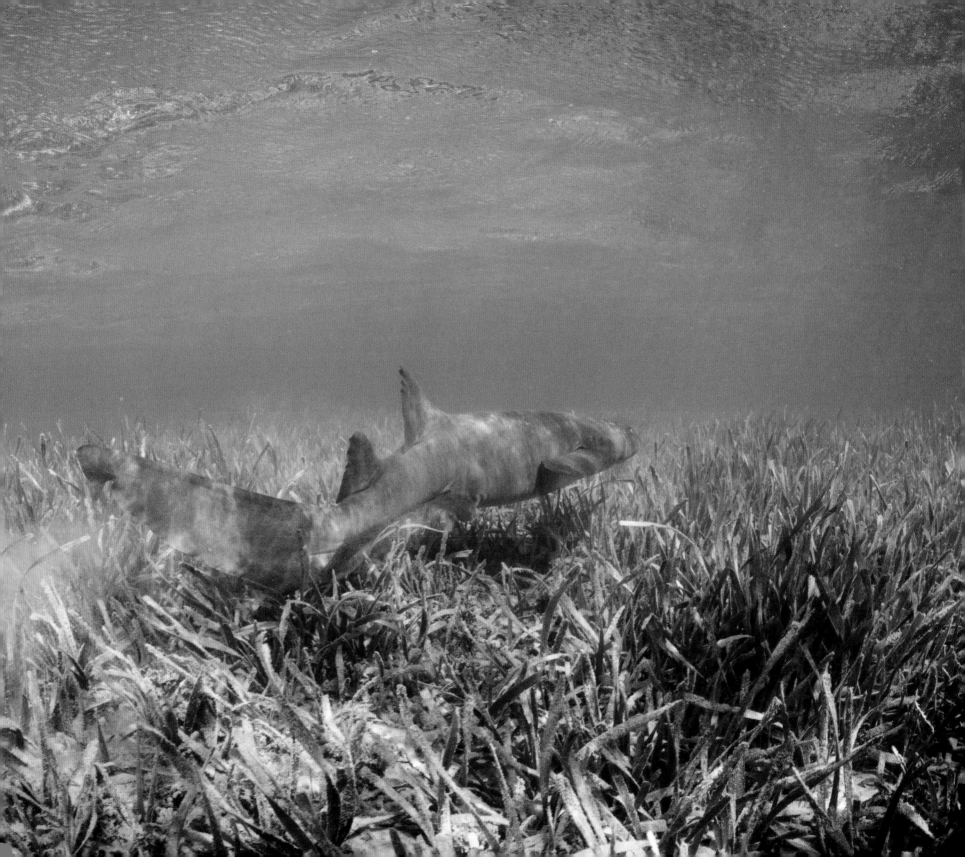

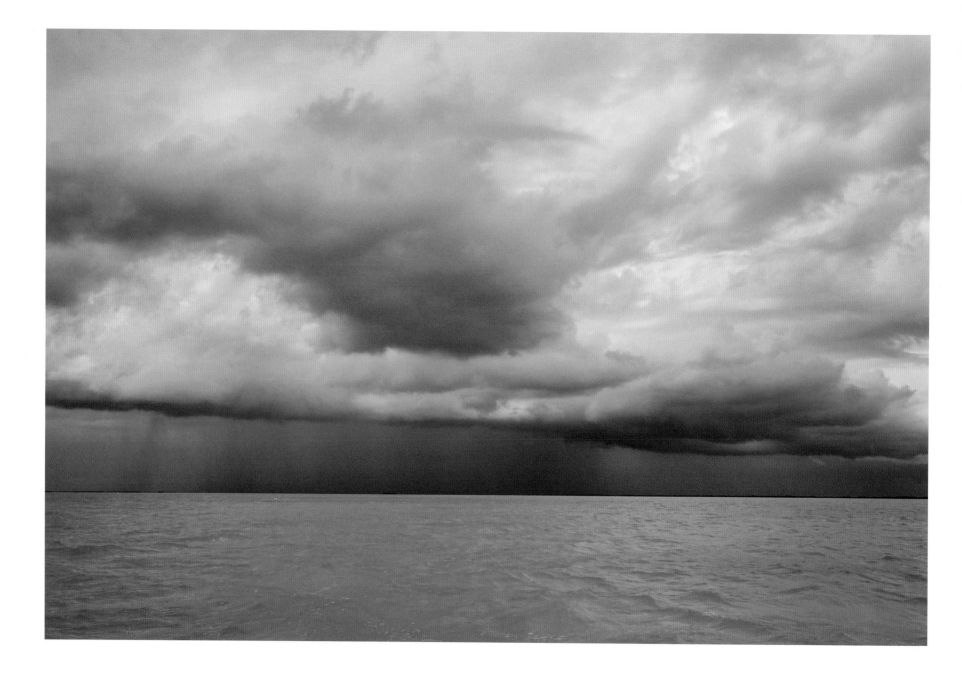

▲ **Summer storm clouds.** Florida Bay.

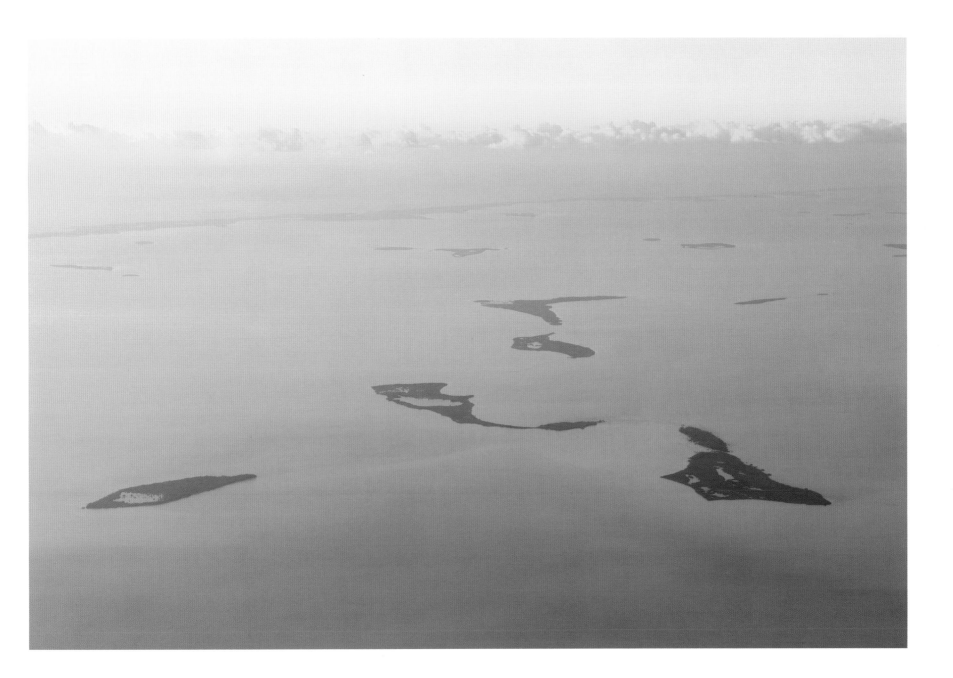

▲ Northeastern Florida Bay mangrove islands with Key Largo and the Gulf Stream in the background. Florida Bay.

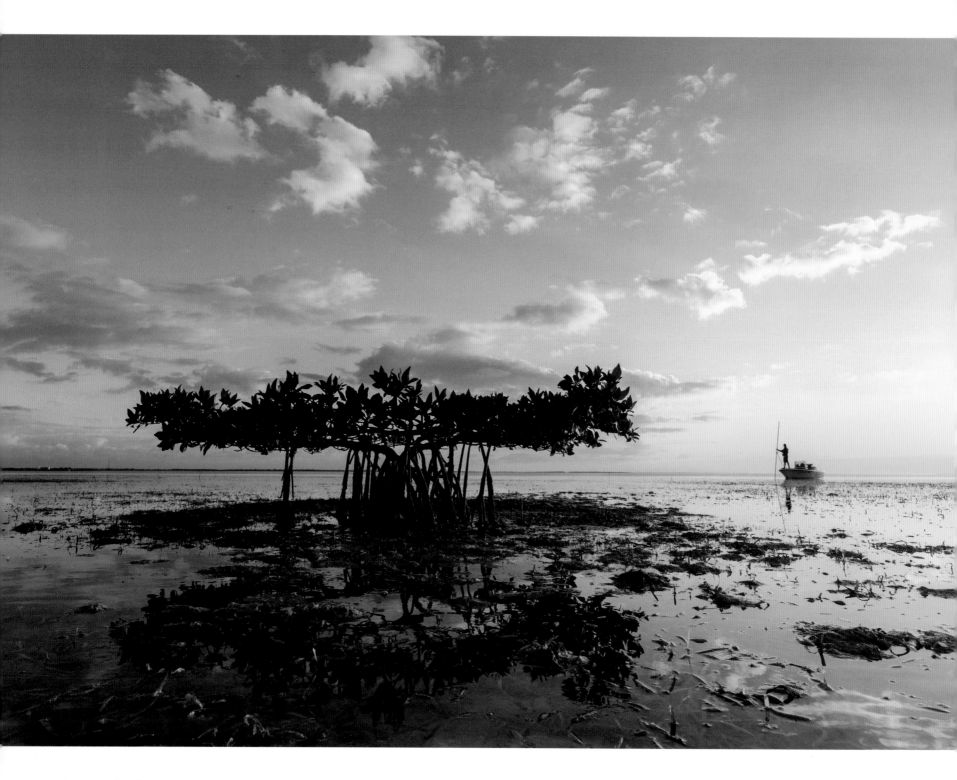

▲ Boater and red mangrove. Bottle Key.

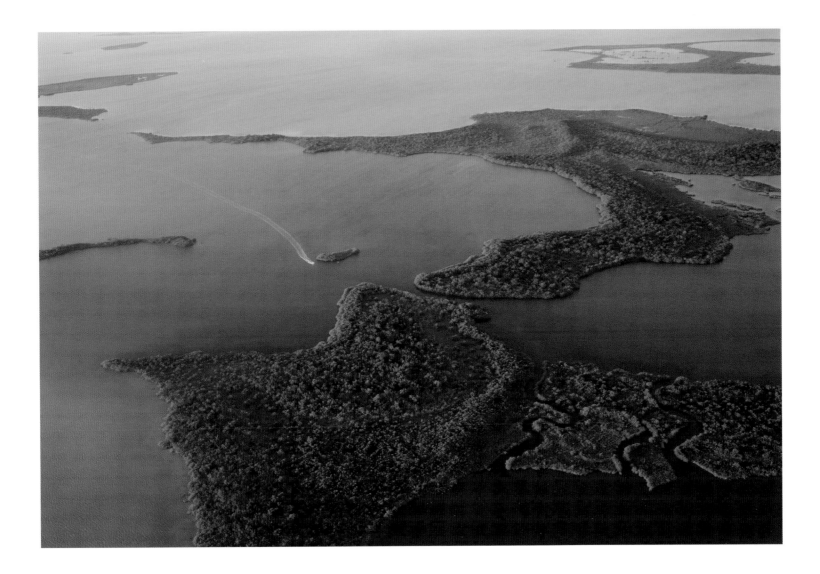

▲ Audubon biologists boat into the backcountry of Joe Bay. Florida Bay.

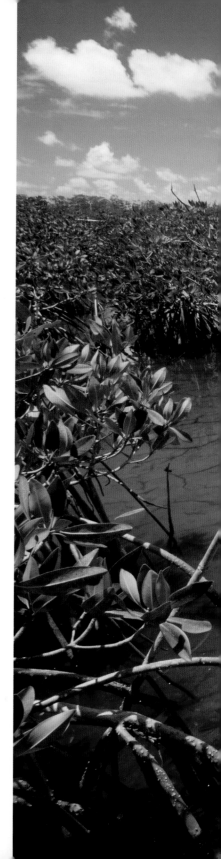

▶ New rains quench the parched and cracked mangrove flats. Taylor River.

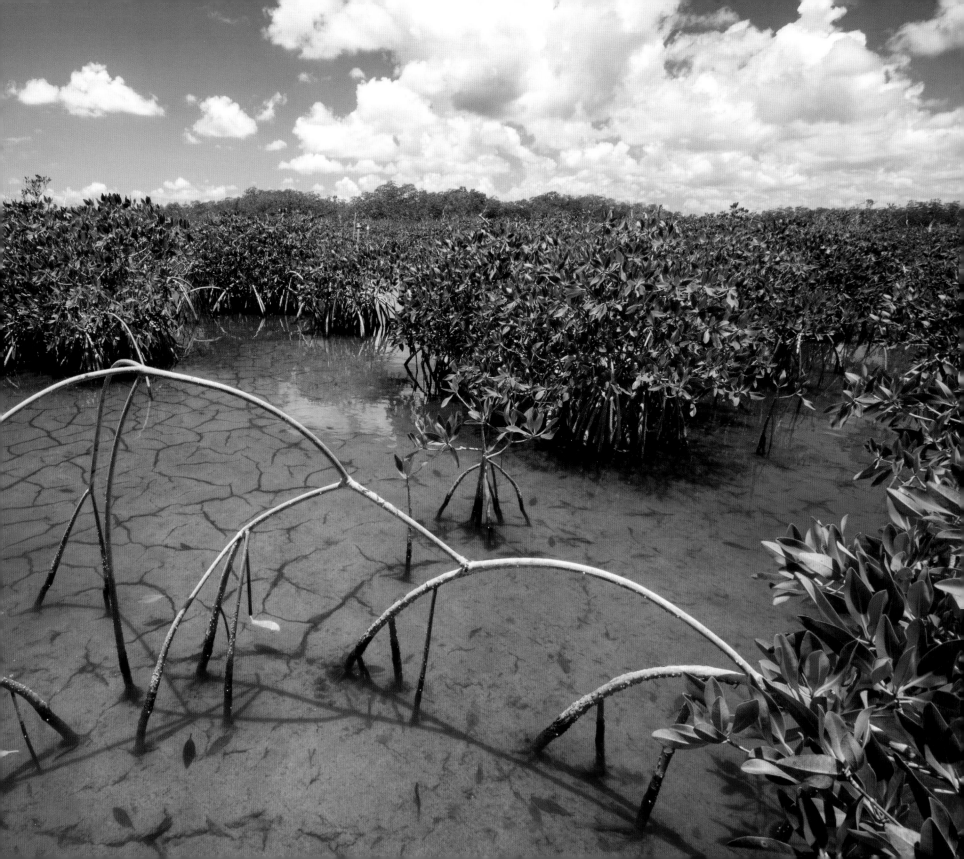

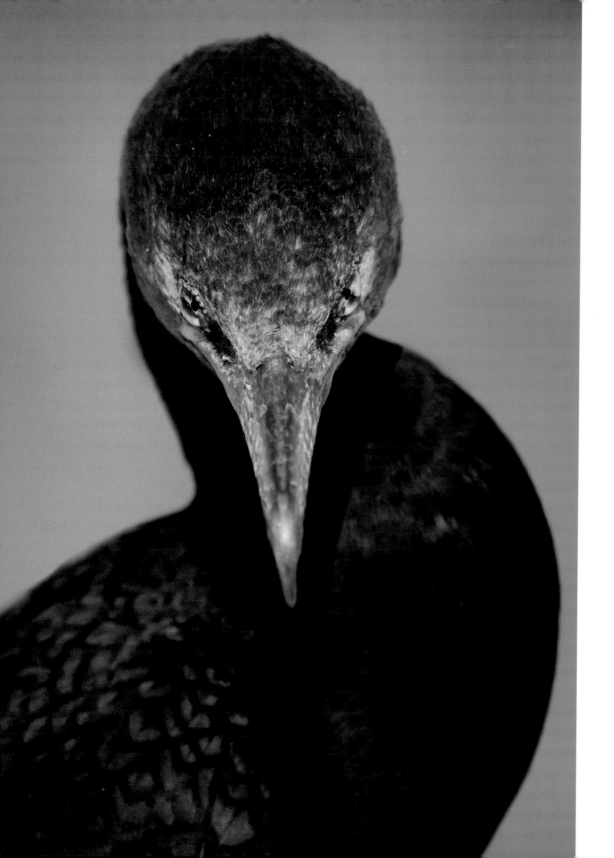

◄ Double crested cormorant. Everglades National Park.

► Aerial view of Black Betsy Key. Florida Bay.

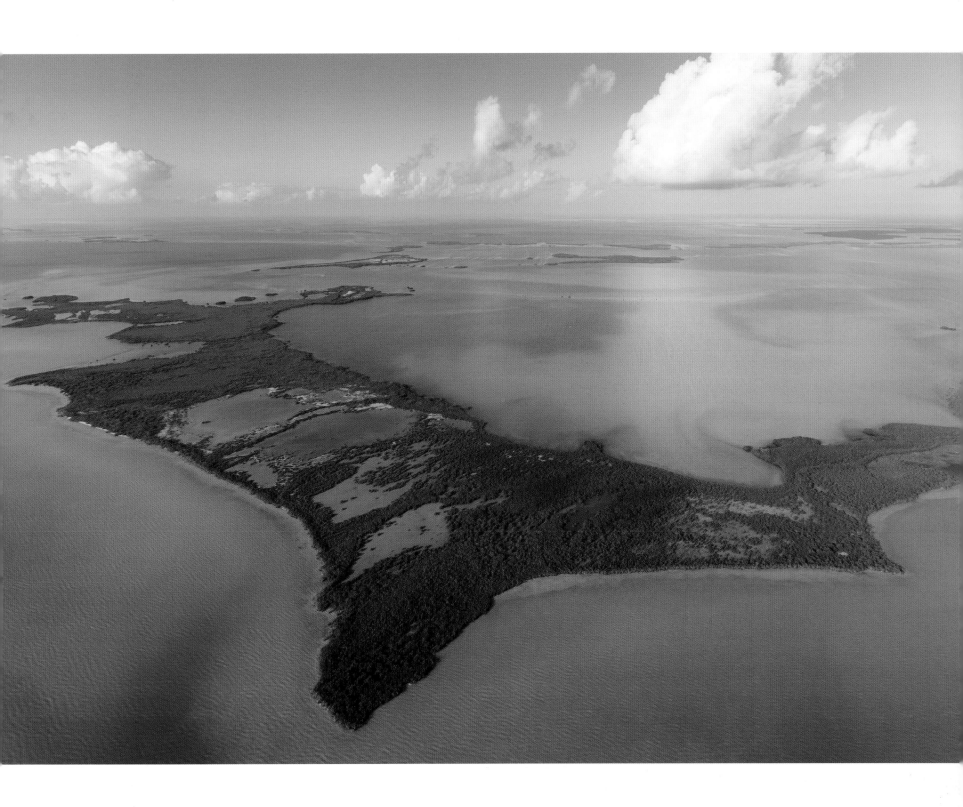

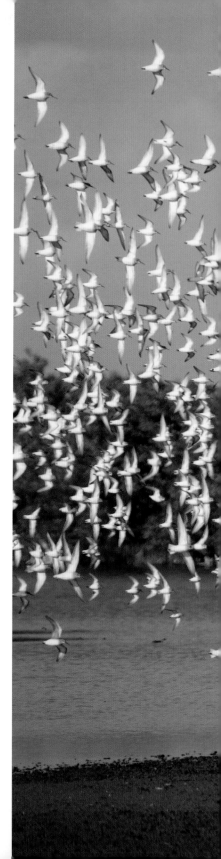

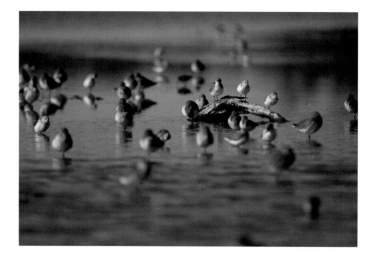

During the winter months, Florida Bay and the southern Everglades provide the most important wintering grounds and migration stopovers for shorebirds in North America. Within the ephemeral ponds of mangrove islands and along the tidal flats of the coastal wetland, hundreds of thousands winged bodies forage the shallows storing up energy before a long flight back to their breeding grounds.

▲▶ Shorebirds congregate by the thousands on interior ponds of mangrove islands. Florida Bay.

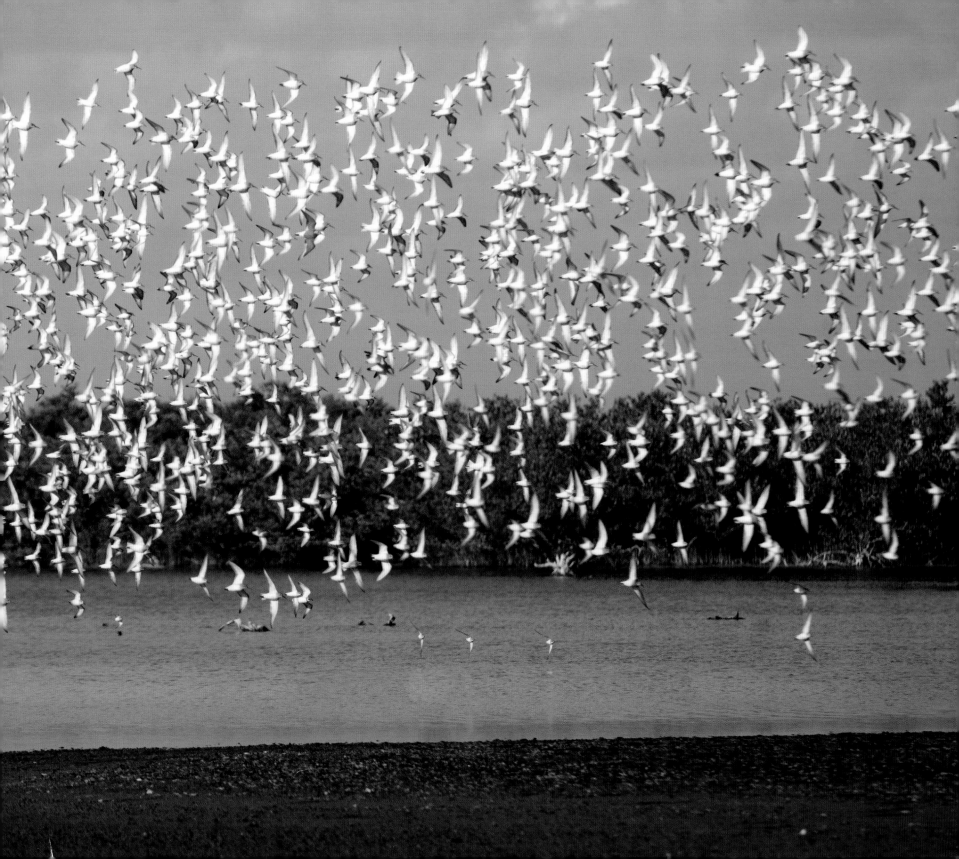

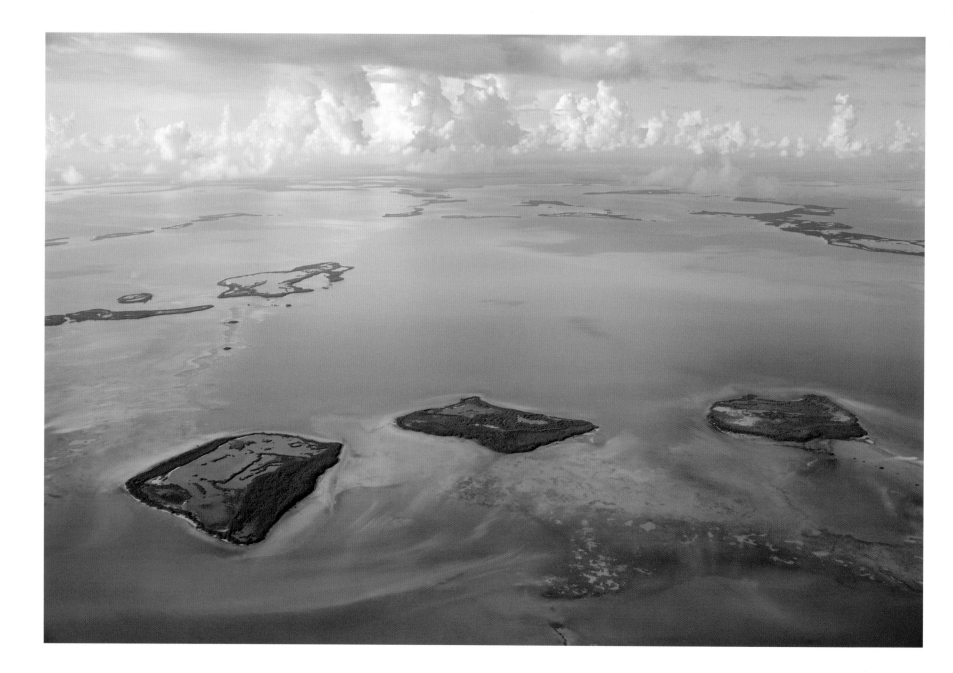

▲ Bob Allen Keys and seagrass beds. Florida Bay.

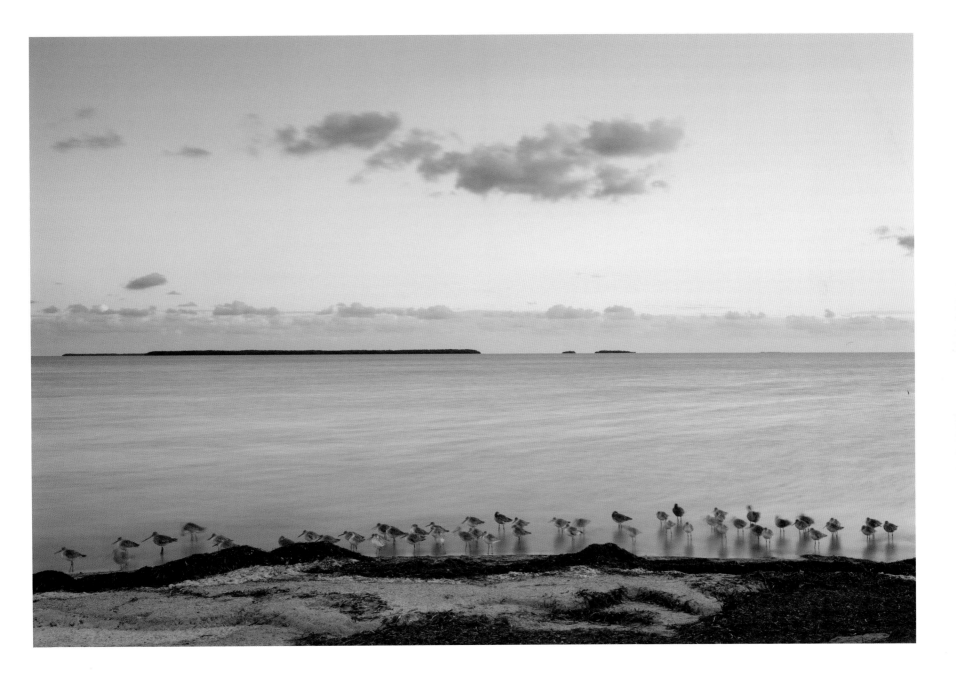

▲ Shorebirds at low tide. Flamingo.

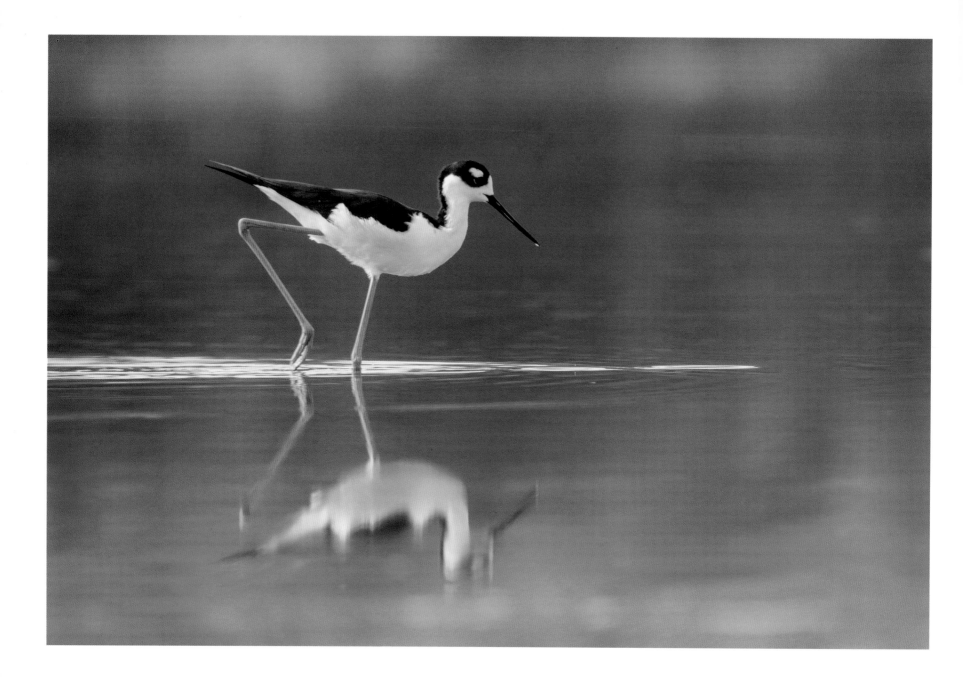

▲ **Black-necked stilt.** Everglades National Park.

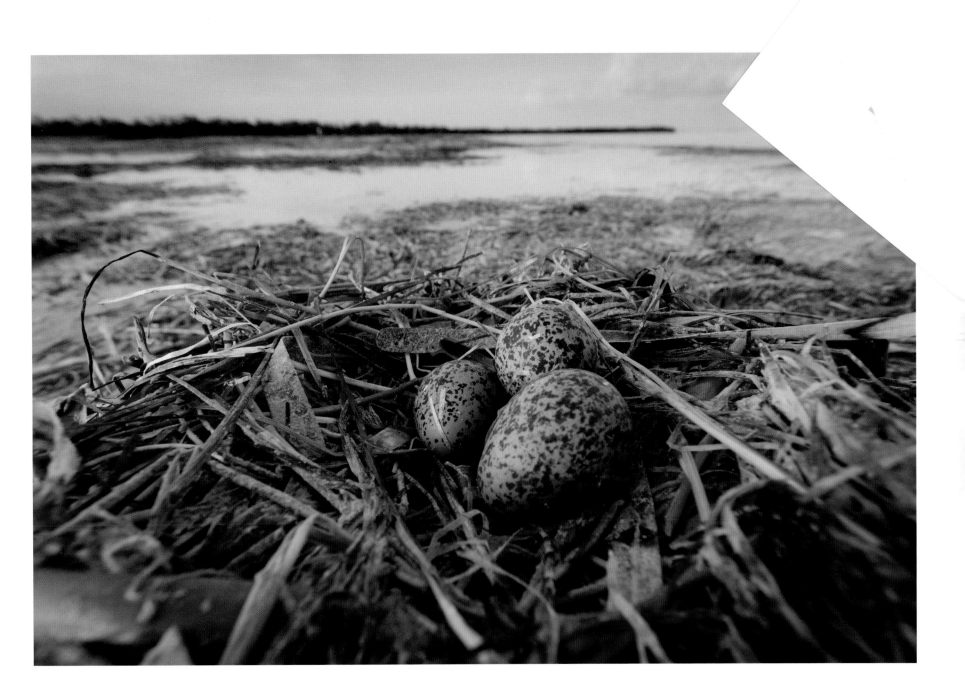

▲ Black-necked stilt eggs on tidal flat. Snake Bight.

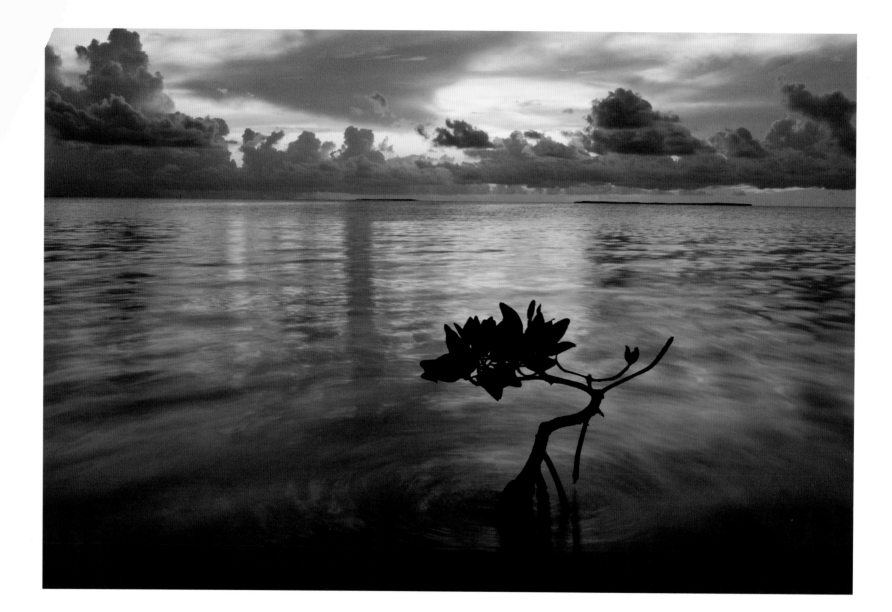

▲ Red mangrove dusk. Florida Bay.

▶ Water abstract. Florida Bay.

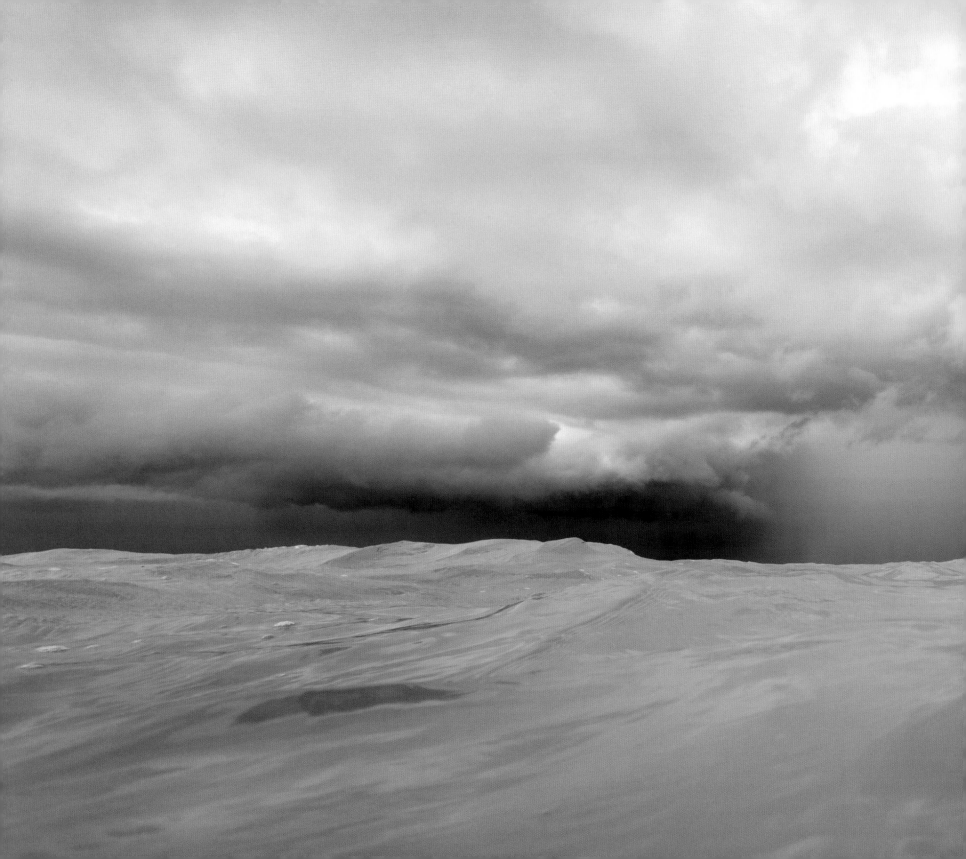

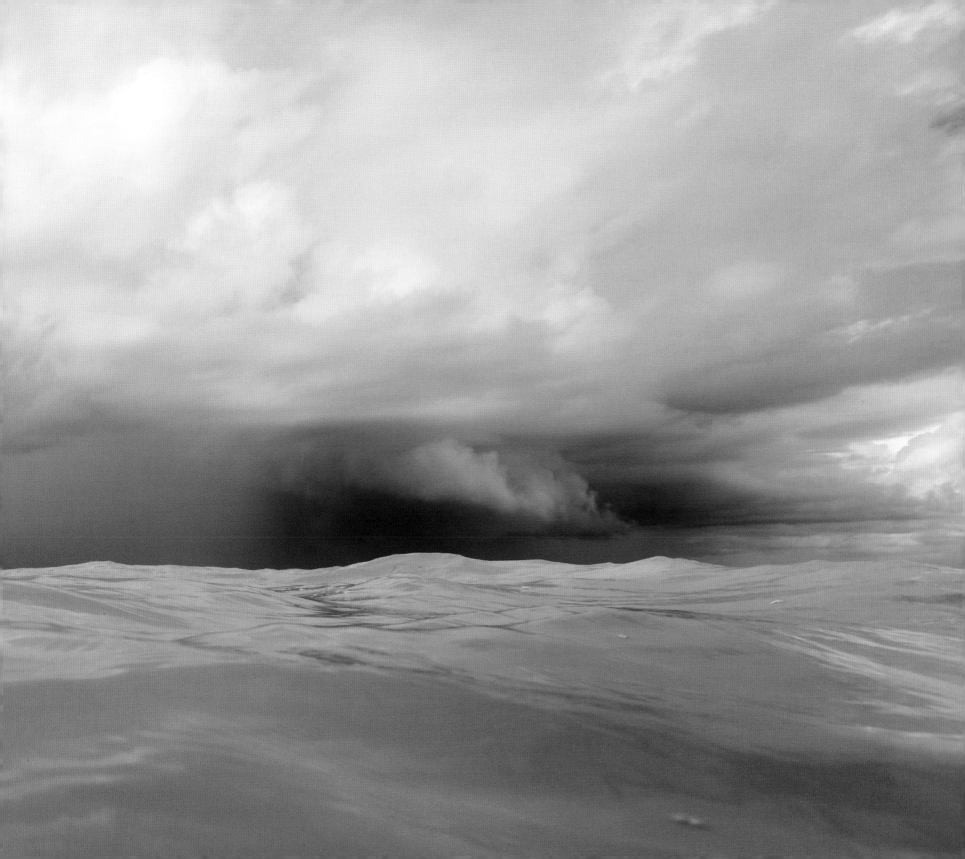

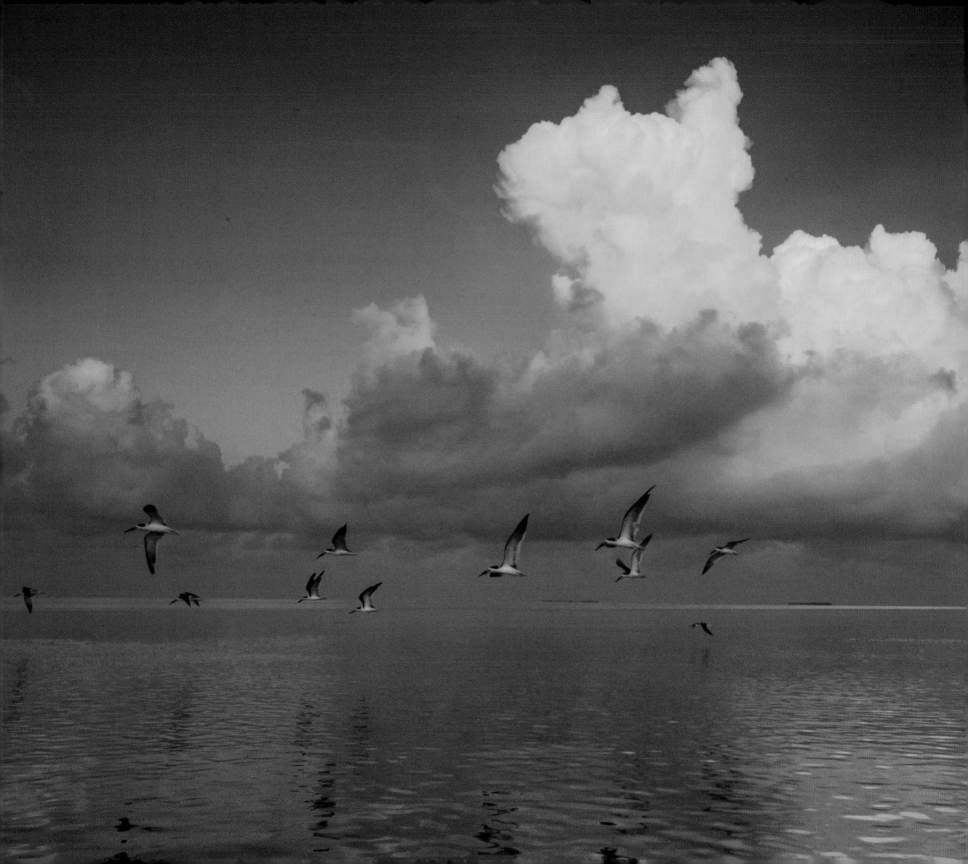

◄◄ Hurricane season downpour. Black Betsy Key.

◄ Black skimmers at sunset. Snake Bight.

Mangroves

The southern tip of Florida, within Everglades National Park, boasts the largest contiguous stand of protected mangrove habitat in the Western Hemisphere. Mangroves are essential to the ecology of Florida Bay and the coastal areas of South Florida. Comprising three species of mangrove—red, white, and black—the islands' and coastline's first line of defense against storm surges and ripping winds are these unique trees. Mangrove habitats offer nesting grounds for colonies of wading birds, and below the water's surface they provide nurseries for various species of fish, colorful sponges, and invertebrates.

▶ Cirrus clouds and red mangrove. Park Key.

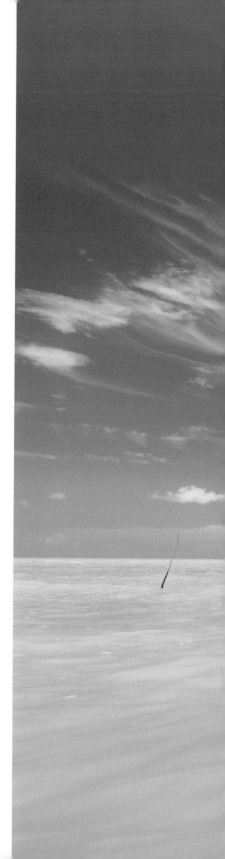

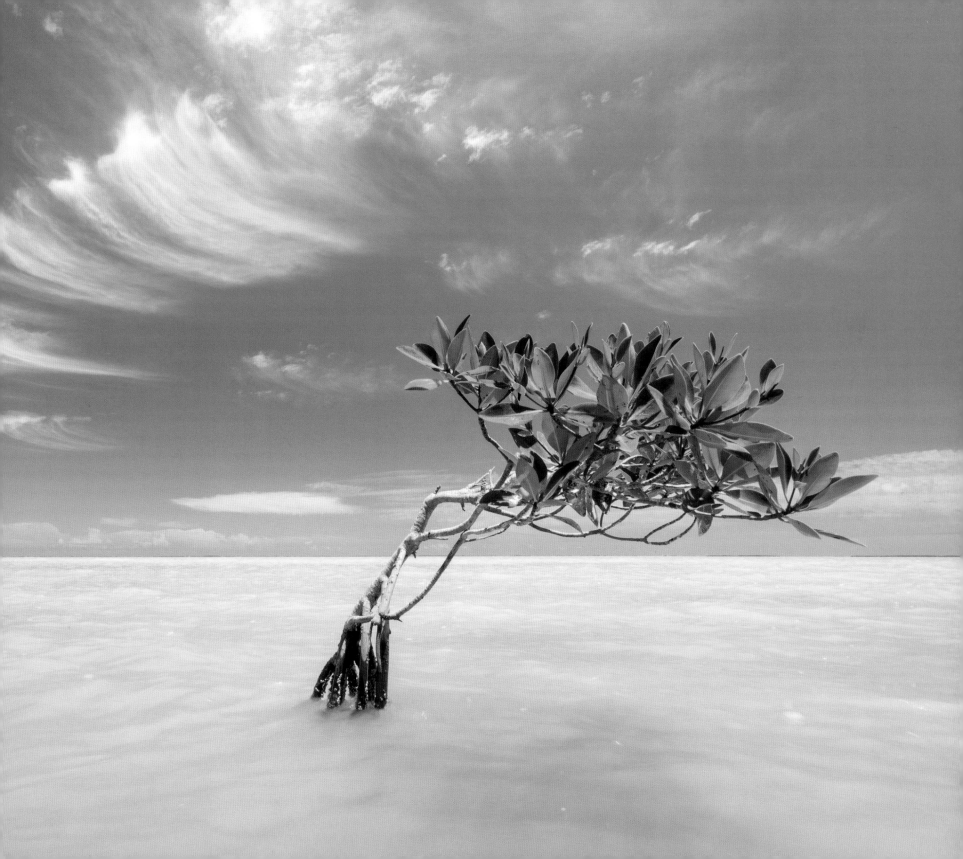

▶ Red and black mangrove maze. Tern Key.

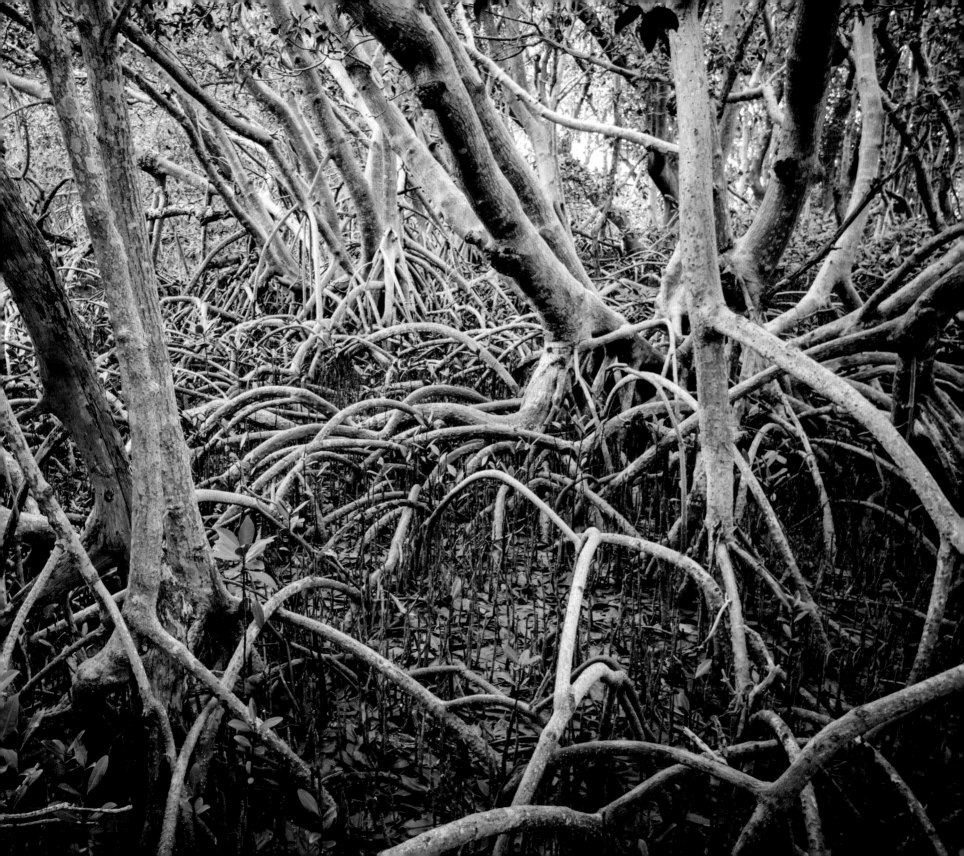

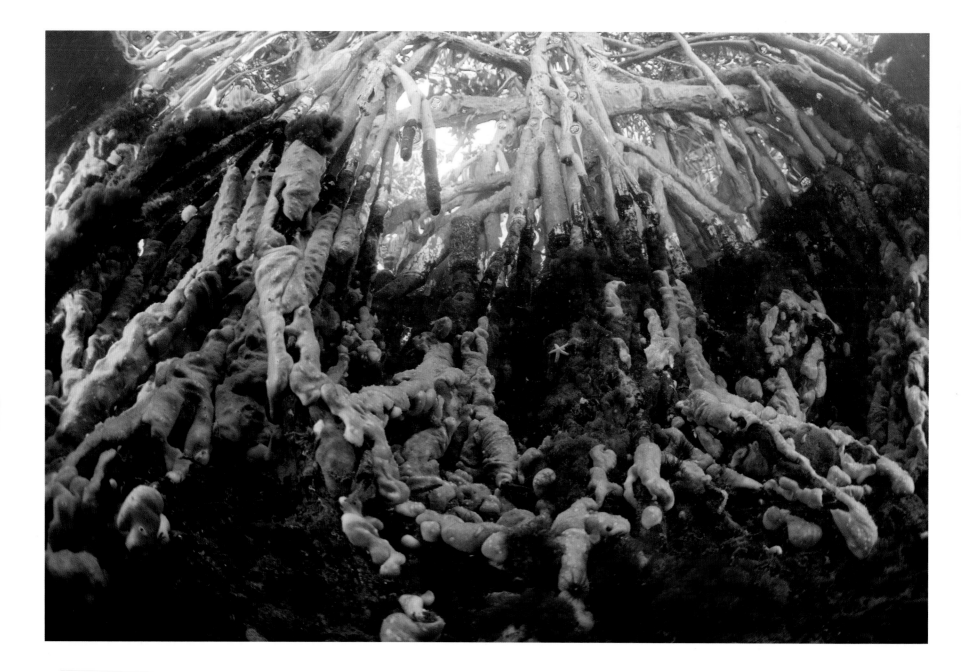

▲ Colorful sponges and algae cling to red mangrove prop roots. Florida Bay.

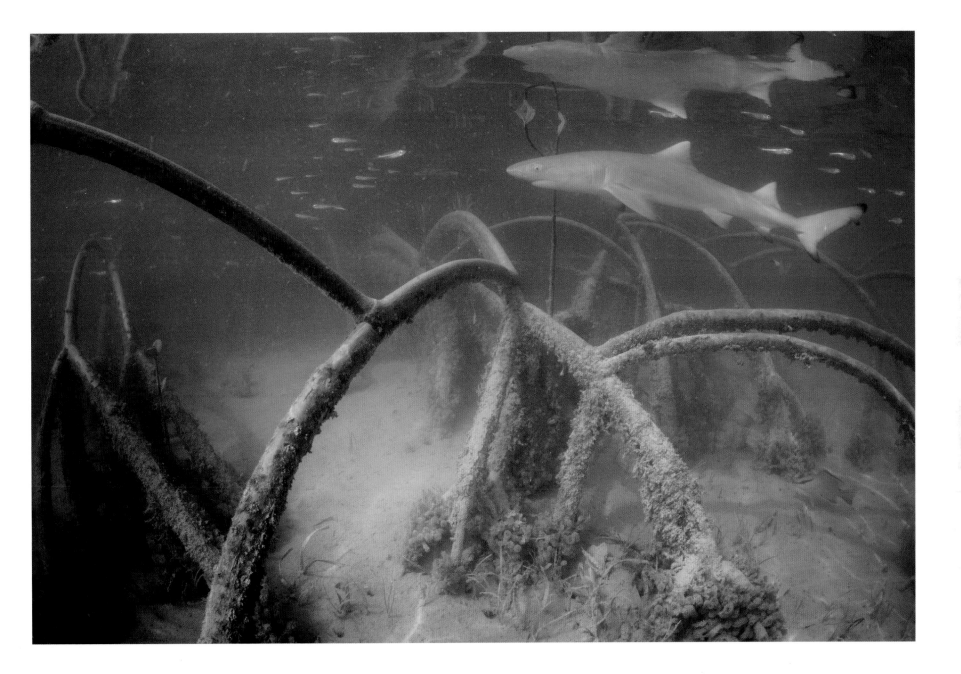

▲ A juvenile lemon shark prowls the mangroves for food. Lower Keys.

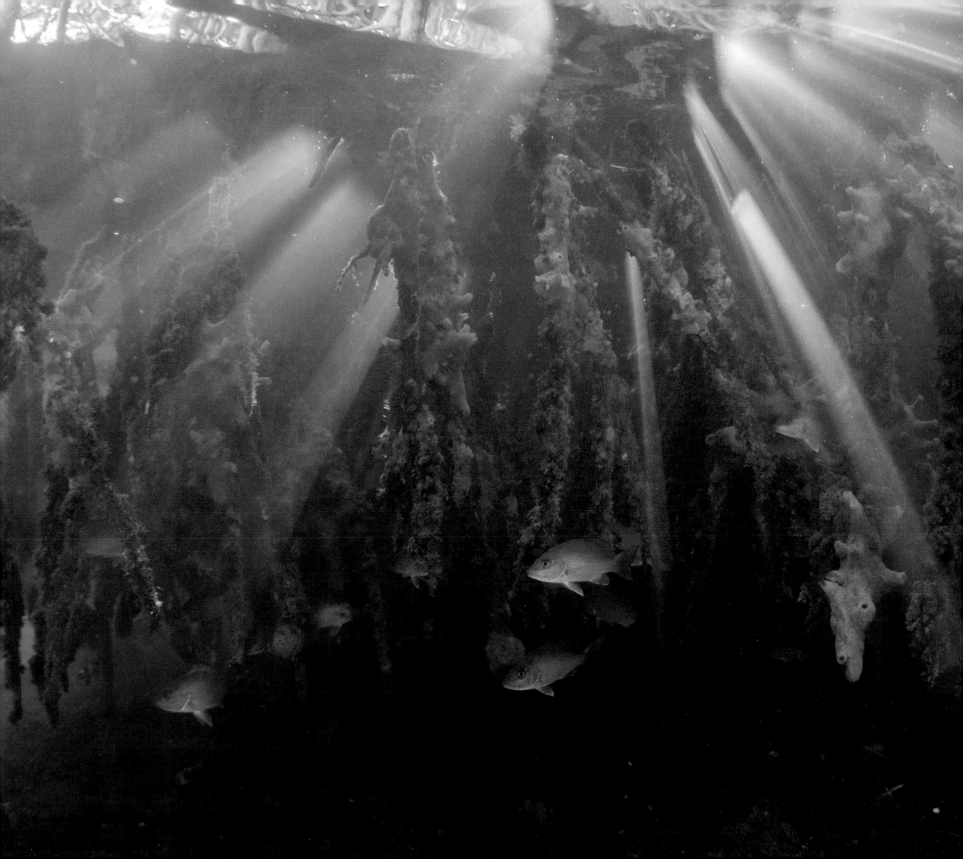

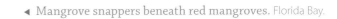

◄ Mangrove snappers beneath red mangroves. Florida Bay.

▲ Mangrove terrapin hatchling. Florida Bay.

▲ Mud crab portrait. Florida Bay.

▲ Lettuce sea slug. Florida Bay.

▲ Starfish. Florida Bay.

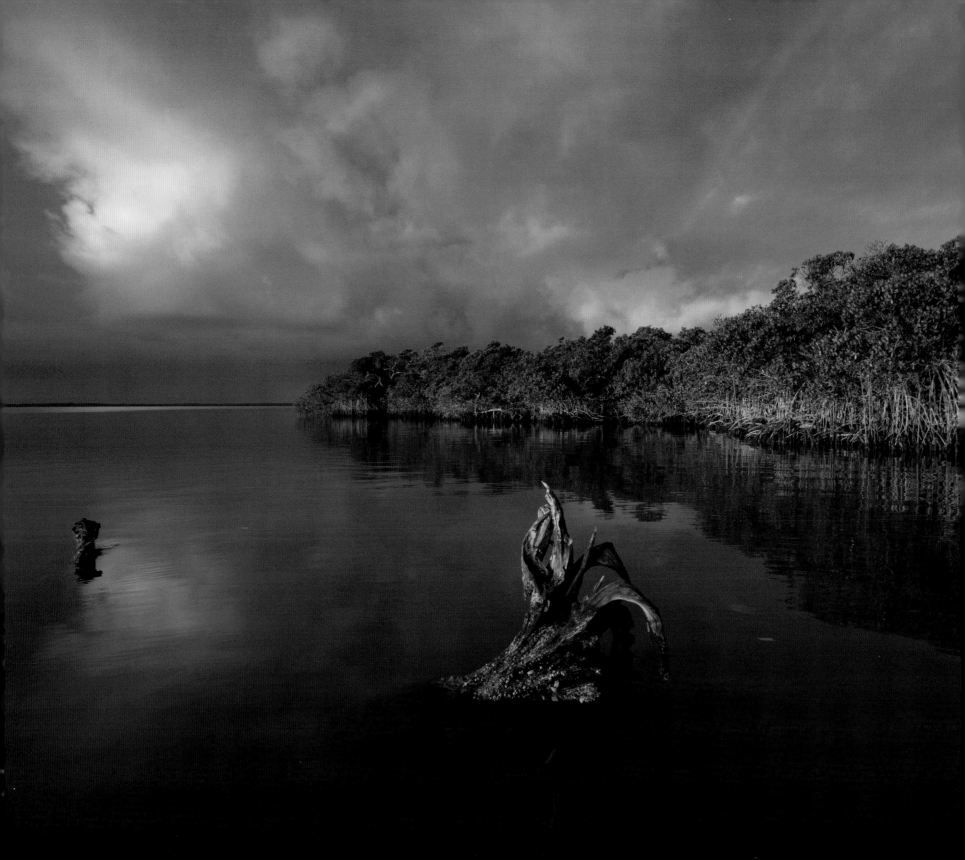

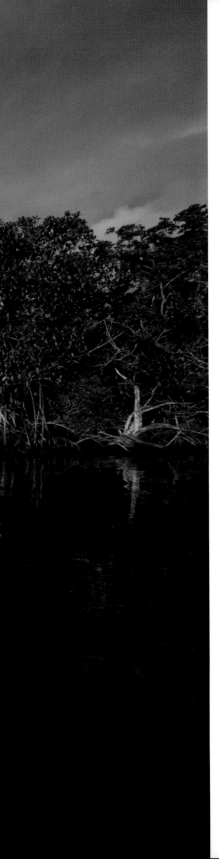

◄ Morning light and rain shower. Madeira Bay.

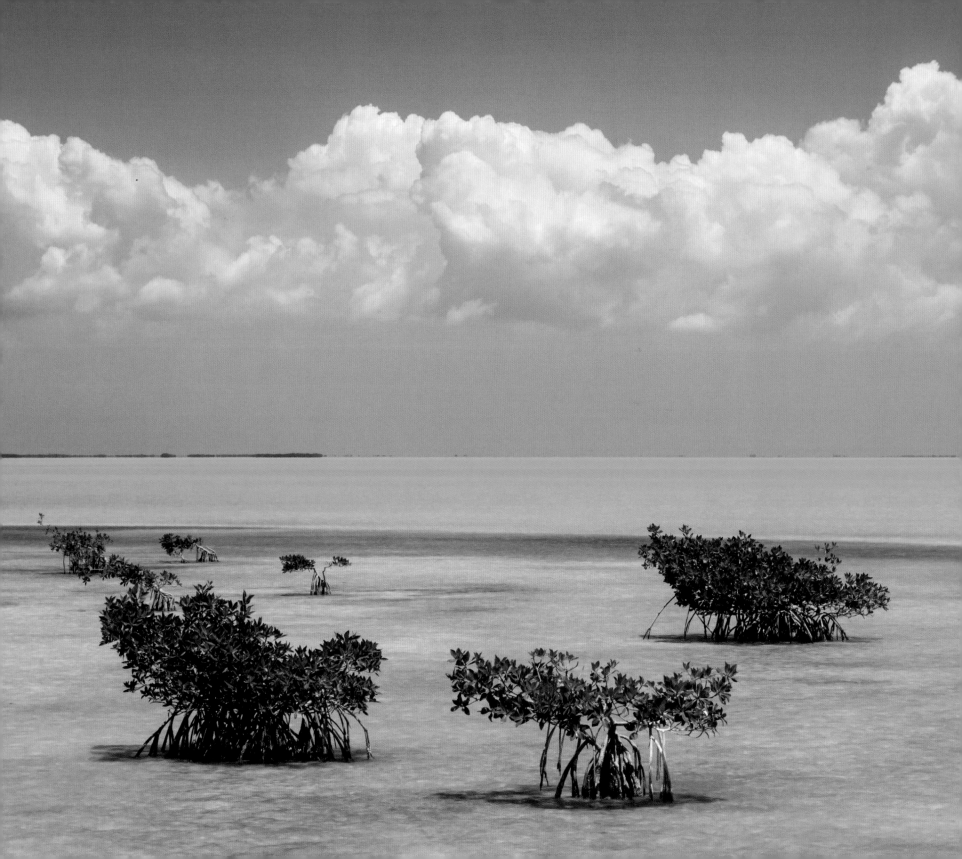

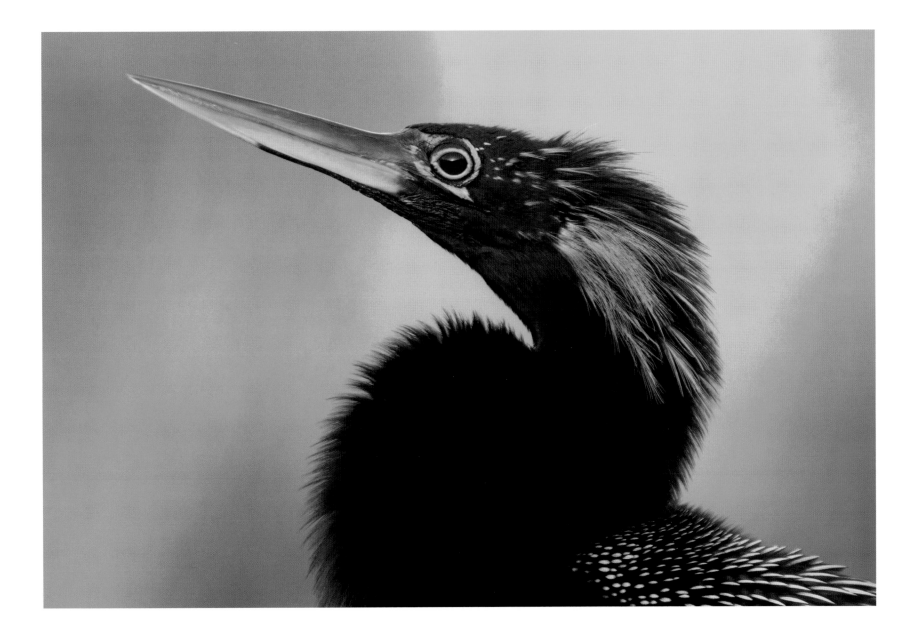

▲ Anhinga in breeding plumage. Everglades National Park.

◄ Mangrove flat. Park Key.

Shifting Baselines
Mac Stone and Peter Frezza

The now-worldwide sport of shallow-water sight fishing was founded in Florida Bay. By the 1950s an entire industry had formed around a specific shallow-water seagrass habitat and fishery dominated by tarpon, redfish, snook, and the iconic bonefish. Nowhere else in the world did anglers have the opportunity to target such an abundant variety of species only miles from a boat ramp. To many, it seemed like Florida Bay was an infinite resource, an indomitable gem of estuarine angling paradise. What Floridians failed to realize or had overlooked, however, was that the productive waters of Florida Bay owed much of its fame to a slow-moving watershed. A free flowing Everglades had been the main driver for the development of this globally unique fishery.

For many, shallow-water flats fishing became the purest form of backcountry angling, demanding quiet precision while chasing shadows across an aquatic prairie. It didn't take long for the Florida Keys to earn their reputation as the sportsfishing capital of the world. Accelerated drainage and development of the Everglades watershed within the latter half of the twentieth century, however, led to diminished freshwater inputs to Florida Bay as water tables dropped and water was diverted to the coasts through canals. Florida Bay was losing its estuarine engine and was slowly transforming into a saltwater lagoon.

From 1970 to 2000, Florida's population more than doubled, and it was during this time period that local anglers began to notice a declining trend in bonefish abundance within Florida Bay. By the mid-2000s, the grass flats once teeming with stingrays, bonnethead sharks, and bonefish were gradually being vacated by these symbolic species. Professional guides who made their living poling the neritic banks of Islamorada and the Upper Keys were finding fewer fish in historically productive areas. Some anglers targeting bonefish began focusing their attention south to the lower Keys, where populations appear more stable and the habitat is less influenced by freshwater inputs.

A topic gaining considerable attention in fisheries conservation is habitat protection. For estuaries like Florida Bay, if the inputs to the system are askew, then the entire machine fails to work productively.

Floridians are concerned with this issue not only from a biological standpoint but from an economic point of view as well. Florida boasts the largest recreational and commercial fisheries economy in the United States. Flats fishing is what is considered a low volume but high dollar industry, leaving a very small footprint on the habitat while being extremely beneficial to the economy of the state. By the latest accounts, the Florida Keys flats fishery alone contributes about $500 million to Florida's annual economy. The expenditures associated directly with the Keys bonefish prove that it is of the most economically valuable fishes in the world.

The fishing community stands at a difficult crossroads. For the newest generation of anglers and guides to Florida Bay, the current population of game fish within the bay may be adequate to fulfill their fishing needs. However, to the anglers and guides with decades of experience, the current fishing pales in comparison to the days of the past. When a new generation of anglers and guides replaces an older one, the perception of what is "natural" or "good" is redefined. This "shifting baseline syndrome," as it is referred to by ecologists, has plagued and divided fisheries management and the science community for years. Accepting a fishery decline is bad for business, especially one as popular as bonefish, but without identifying a problem, it's impossible to find a solution. Fortunately a few privately funded organizations are dedicating their resources to understanding the science behind the Florida Bay bonefish in hopes of reviving their populations.

With Everglades restoration underway and projects aligned to bring clean freshwater back through its historic path, scientists are hopeful to see a positive change for the ecosystem. Bonefish stand an excellent chance of returning in numbers to their favorite foraging grounds, and anglers may once again find the iconic boney fins slicing through the shallow flats of Florida Bay as in years past.

Peter Frezza is a senior scientist at the Everglades Science Center and one of the foremost backcountry fishing guides and naturalists in Florida Bay and Everglades National Park.

▶ Anglers searching for tailing bonefish on Buchanan Bank. Florida Bay.

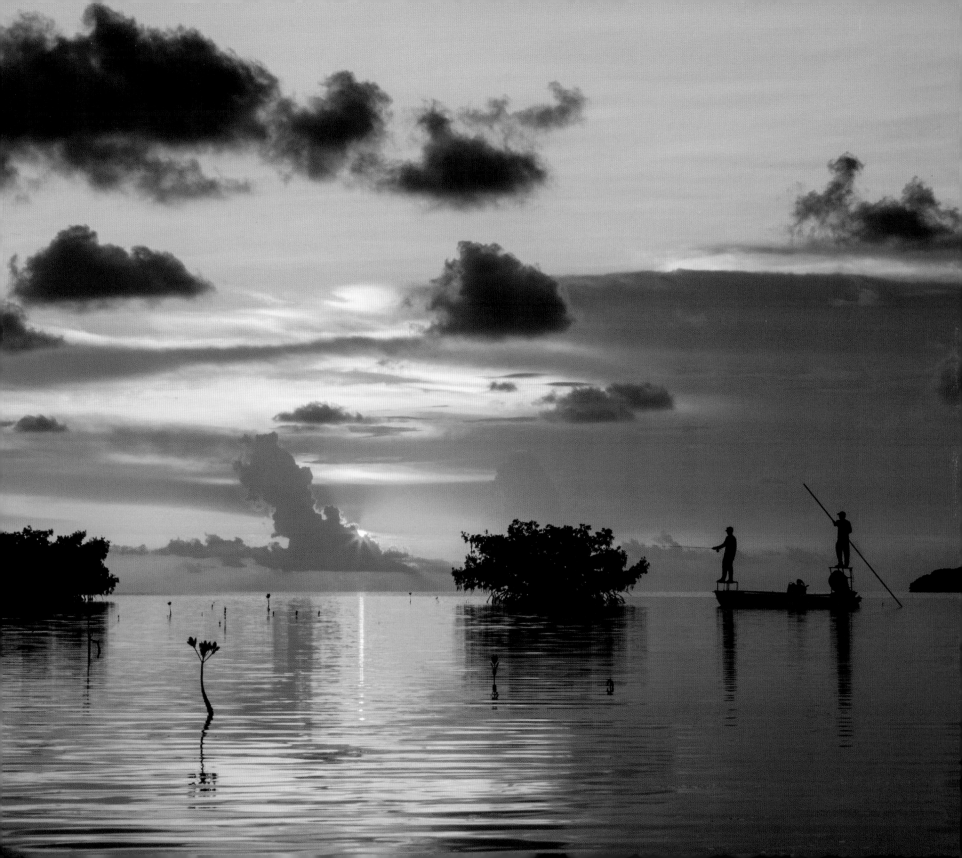

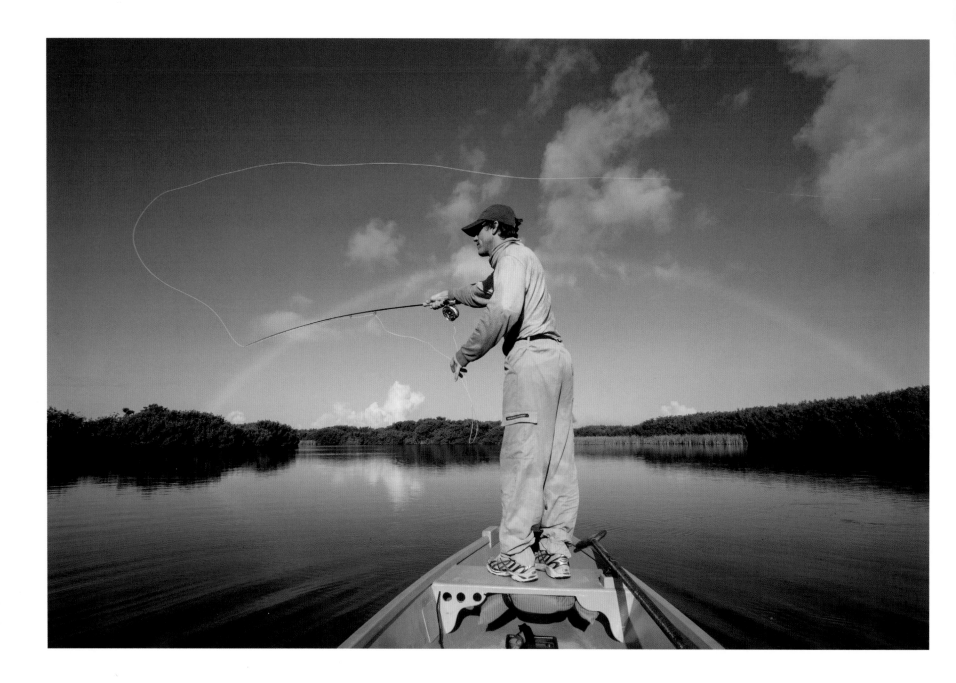

▲ An angler casts to rolling tarpon on a calm morning in a backcountry lake. Everglades National Park.

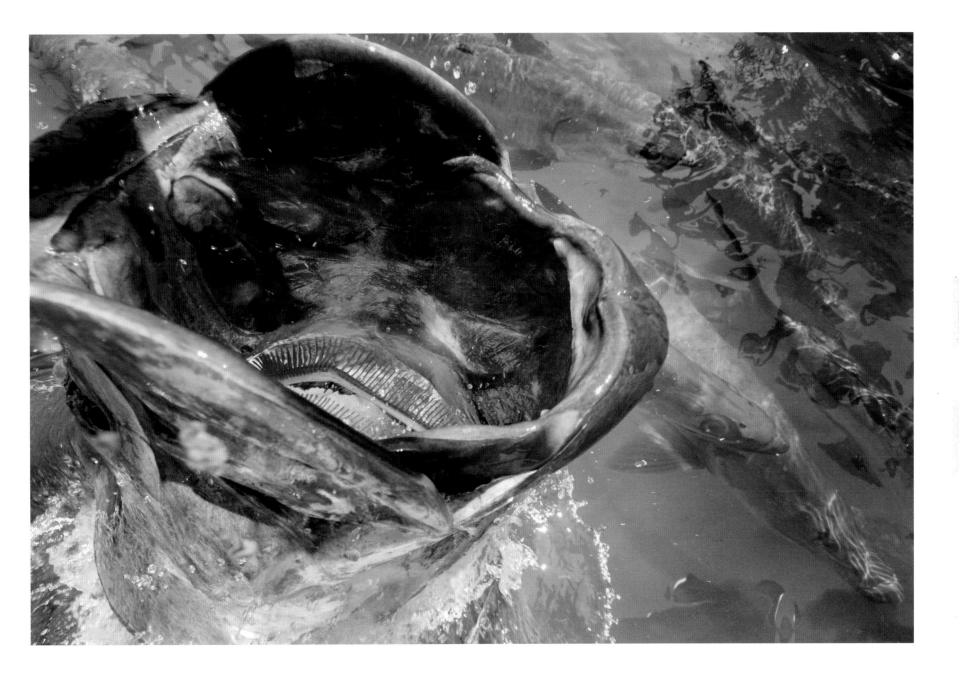

▲ A tarpon leaps out of the water. Florida Bay.

▶ Boaters at sunrise. Florida Bay.

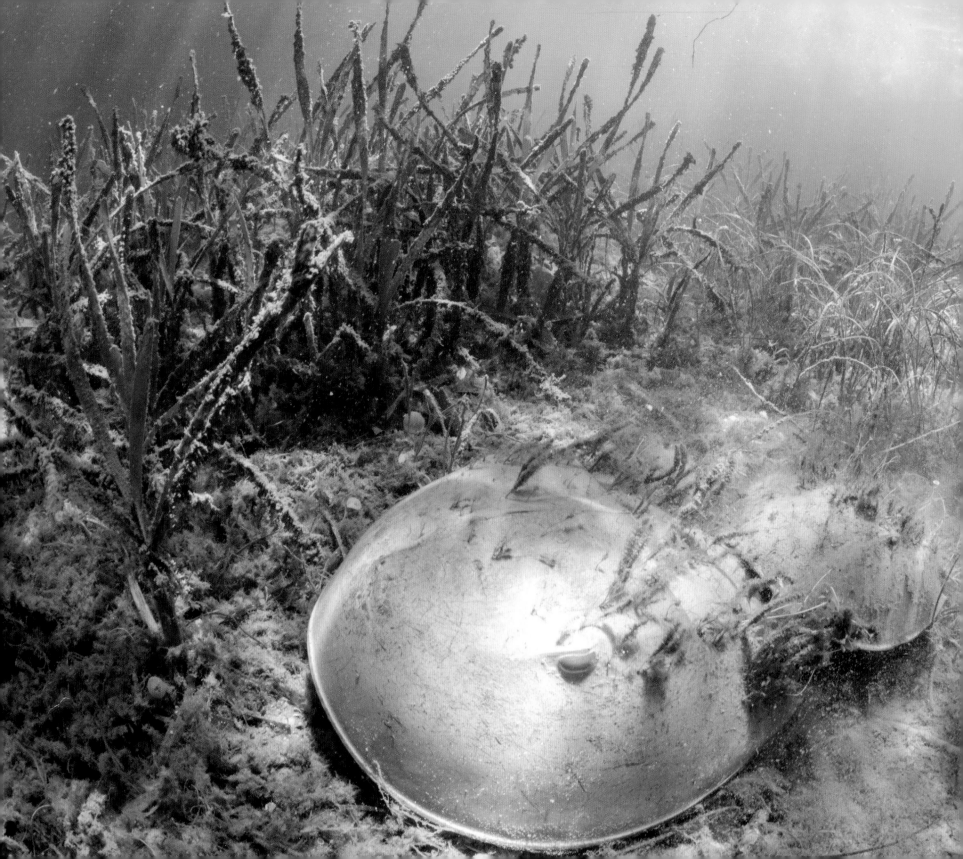

South Florida's extensive seagrass beds are the largest continuous submerged prairies in the world and can be seen from space. In Florida Bay alone, there are over 1,250,000 acres of seagrass. As one of the most productive plant communities on the planet, the various species of submerged grasses provide habitat and food for a diverse assemblage of invertebrates and vertebrates, forming the backbone of the commercial and recreational fishing industries. Vital to the Florida economy, seagrass beds are heavily protected. Within these dense communities small fishes, crustaceans, and several aquatic algae thrive to provide the prey base for larger predatorial fishes.

◄ Mating horseshoe crabs travel through seagrass prairie. Florida Bay.

► Florida spiny lobster start their migration at dusk on the grass flats. Florida Bay.

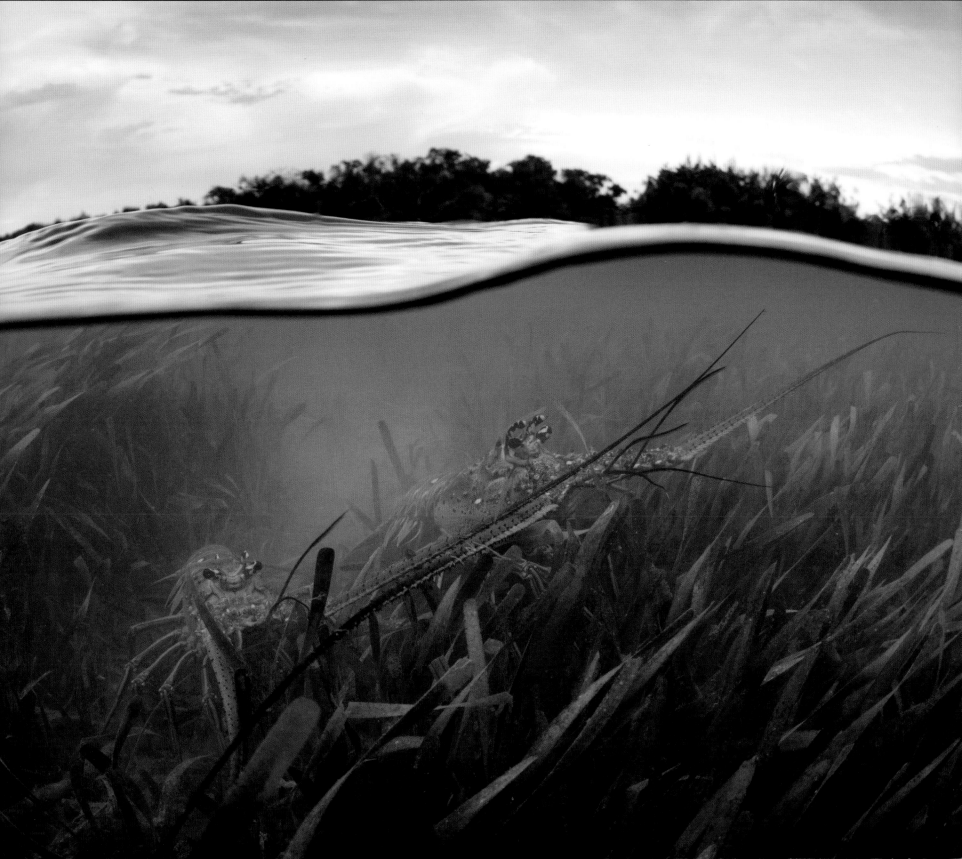

▶ Biomass collected from a 1-meter-square sample of seagrass; essential food for gamefish like redfish and bonefish. Florida Bay.

◂ Mermaid's wine glass algae. Florida Bay.

▸ Green feather algae detail. Florida Bay.

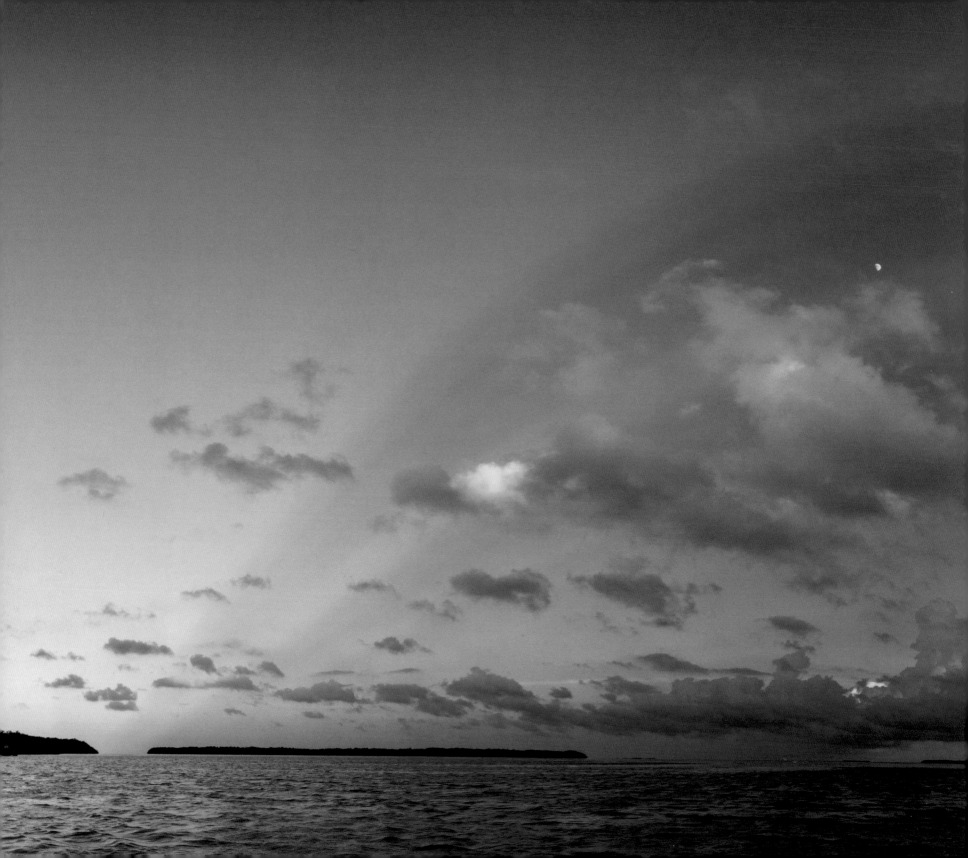

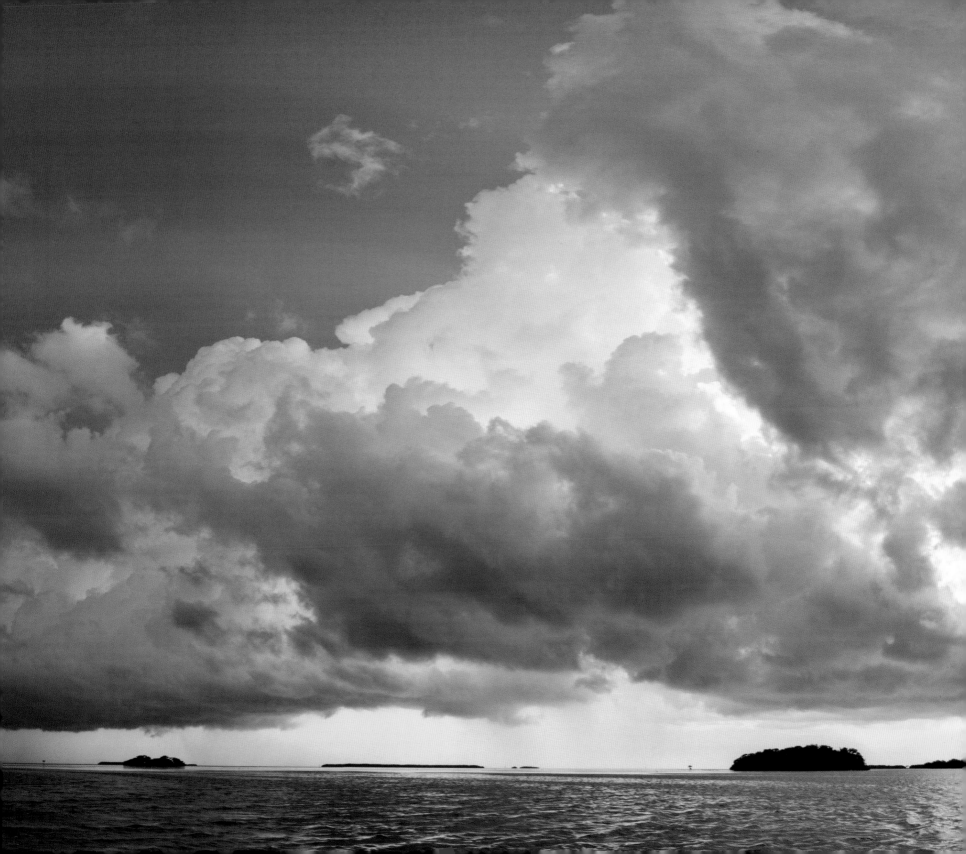

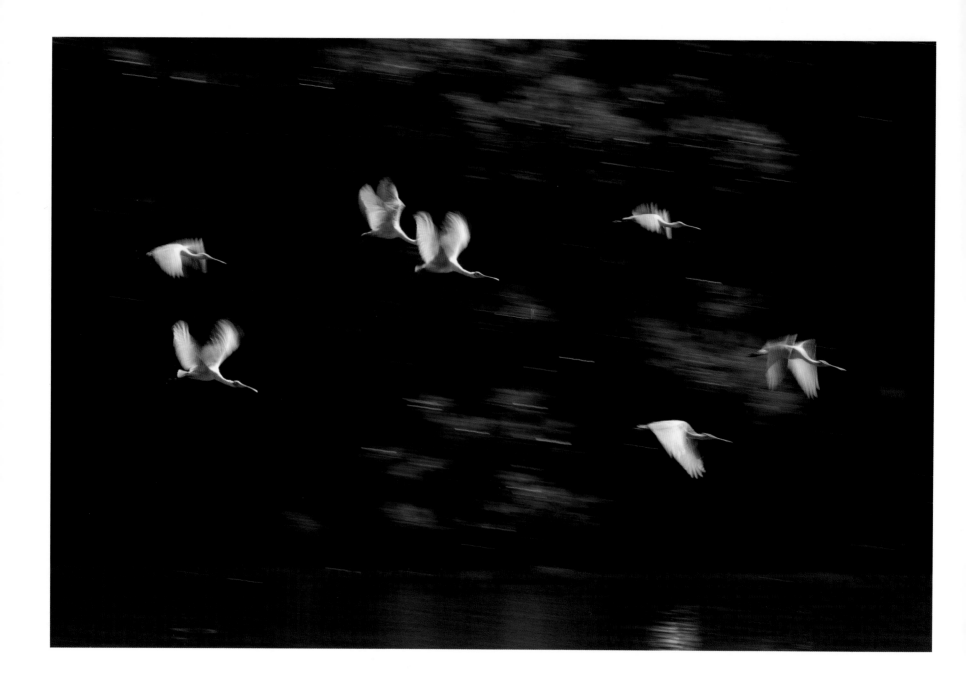

◄◄ Anticrepuscular rays stretch across Florida Bay at dusk. Flamingo.

▲ Roseate spoonbills fly out to roost. Snake Bight.

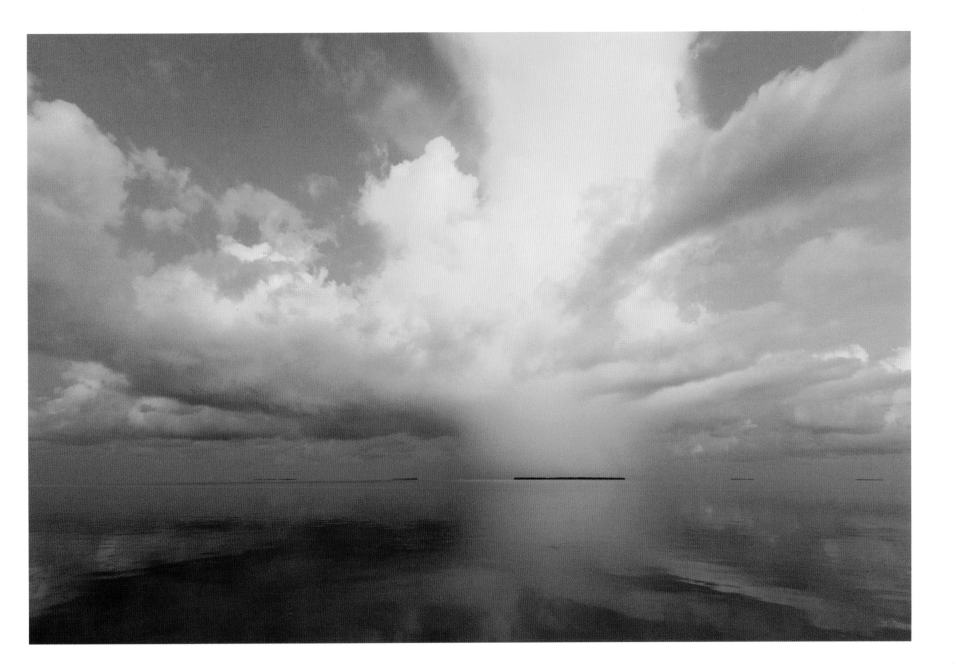

▲ Summer rainstorm at sunset. Snake Bight.

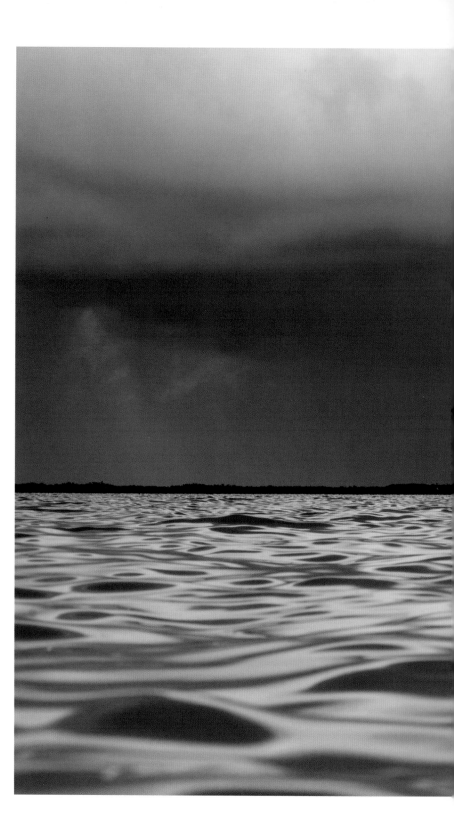

▶ Storm reflections and great white heron. Black Betsy Key.

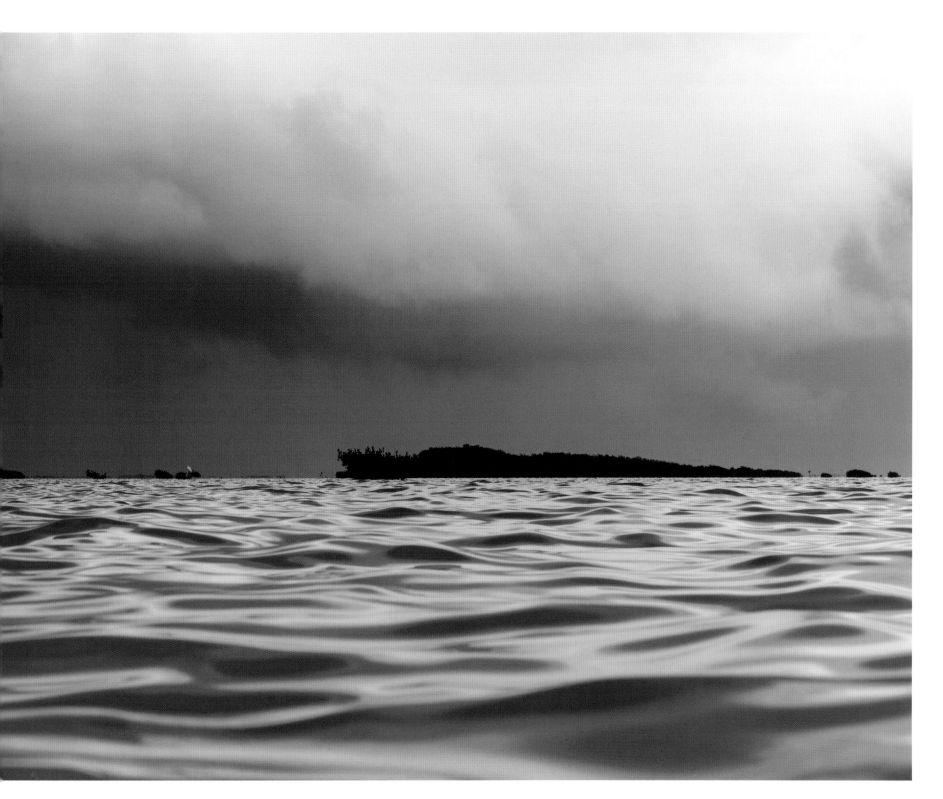

Sultans of the Sky

Mac Stone

It's nearly dawn in late February, and I've been awake since 3:00 boating cautiously through the darkness to arrive at a remote key in Florida Bay. I'm lying chest-down in the boggy mire beneath a black mangrove. Pneumatophores are poking at my stomach, viscous sediment is oozing into my pants, and mosquitoes are gnawing at my neck. Peering through the dense foliage, my tired eyes are glued to the binoculars, my trigger finger poised to fire a wireless signal to my camera. In my viewfinder, the largest osprey nest I've ever seen rests on the ground in the middle of a seasonal pond, towering three feet above the water's surface.

While monitoring wading bird colonies in Florida Bay, I had come across the scattered remains of many former osprey nests, long since abandoned by their architects. Traversing the desolate interiors, I longed to find one still intact, low enough to photograph at eye level. In conversations with other park biologists, I learned there were only a few cases where raptors have been documented nesting on the ground. Unique to remote island ecosystems, this learned behavior is born of extreme isolation.

Separated from the mainland by miles of saline water in every direction, Florida Bay's mangrove islands are surrounded by shallow feeding grounds and devoid of mammalian predators, offering the perfect refuge for ospreys. Many will build their nests on short mangroves or buttonwoods to evade the ripping winds at higher altitudes. Over time, however, the smaller trees often weaken and collapse beneath the weight of collected wood, sometimes exceeding 1,000 pounds: arduous work for a four-pound bird. Instead of abandoning years of effort, in rare cases the osprey will reconstitute the remains where they lie, and continue to use the nest.

One December morning while exploring a new colony in the central bay I heard the whistling shrieks of a female osprey. Peering through the tangled mangroves I saw what looked like a beaver lodge in the middle of the Everglades. Swooping down, an osprey landed atop the mound of intricately woven wood, and I knew I had found a treasure far exceeding my expectations. Two months later, I'm back in the dark of dawn, crawling on my elbows through the thick sediment until I have a clear view of the nest, some fifty yards away.

Beneath a dense canopy I remain still and silent with bated breath in order to not remind the ospreys of my presence. My camera sits mounted atop a tripod decorated with sun-bleached sticks for camouflage a few feet from the nest. The mother stands at the edge, calling out to her mate who watches from the skeletal remains of a dead mangrove. At her feet, a lone chick nearly full-grown hunkers in the bowl of the nest. Surviving its two siblings—whose lifeless bodies rest in the water—the juvenile raptor likely won the lottery of first born.

Hours crawl by and finally when the sun climbs high enough, the male takes to the wing making a slow pass over the surrounding pond. He flies out of sight, and my heart begins to pound with excitement. Several minutes pass and I see his shadow streaking across the wetland. Swooping low he returns victoriously with a shimmering emerald parrotfish tightly grasped in his talons. Heading straight to the nest

▸ A female osprey returns to her three camouflaged chicks. Florida Bay.

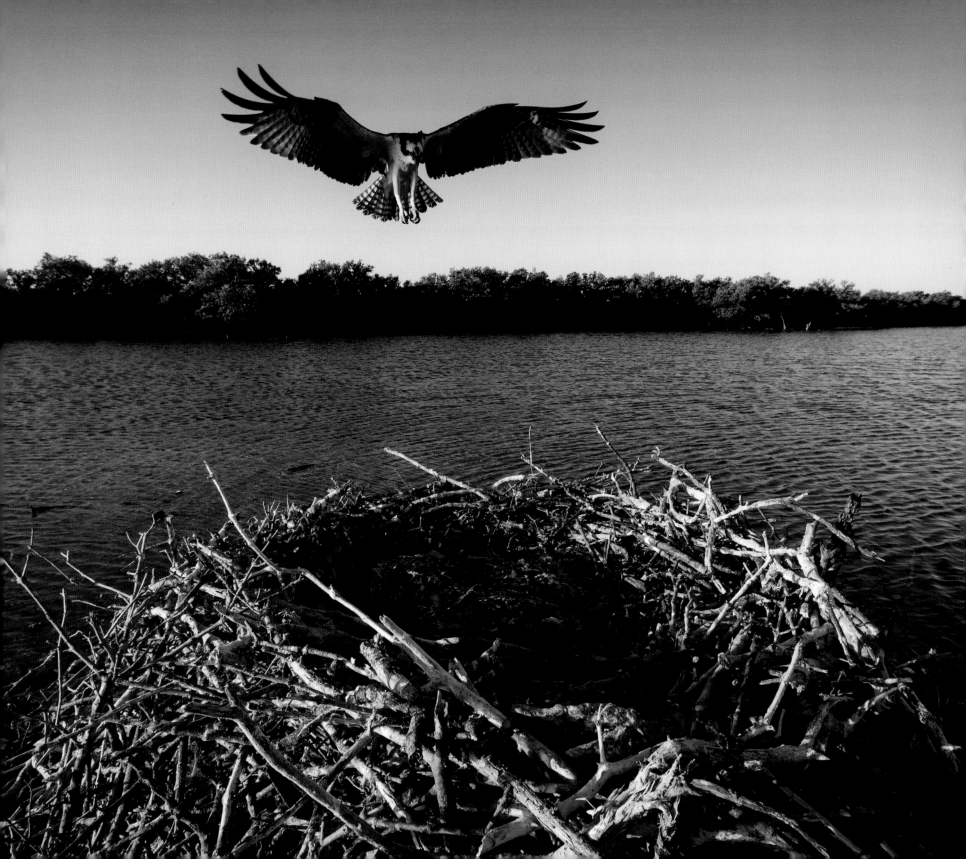

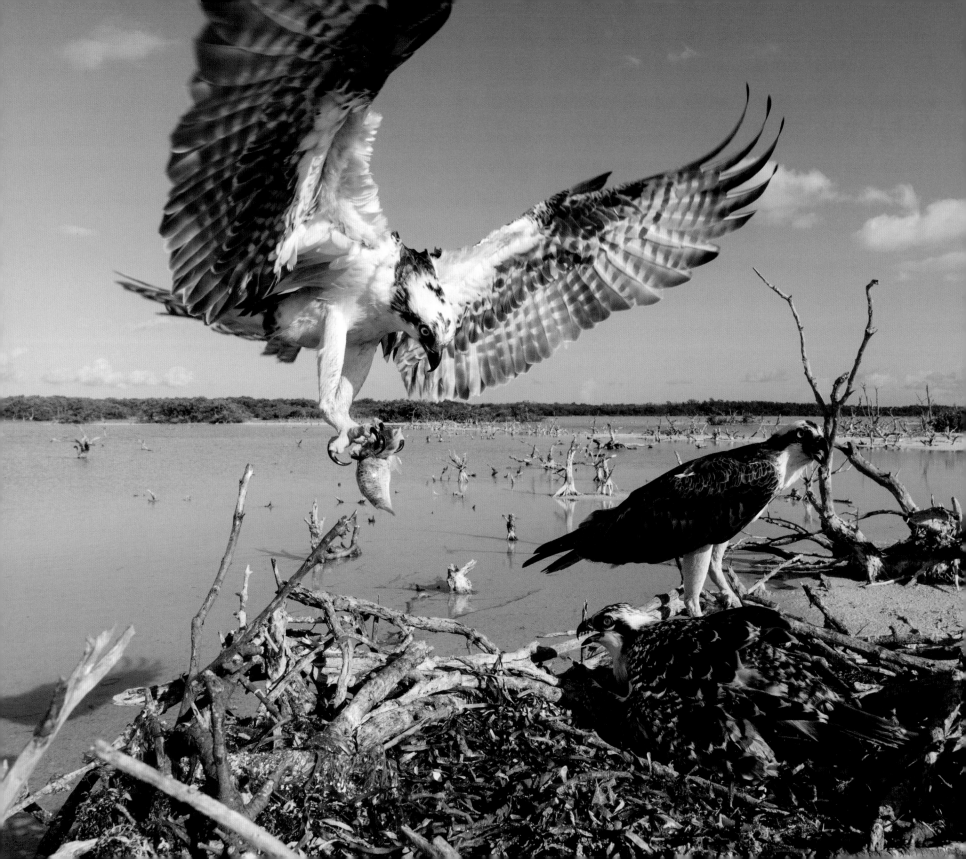

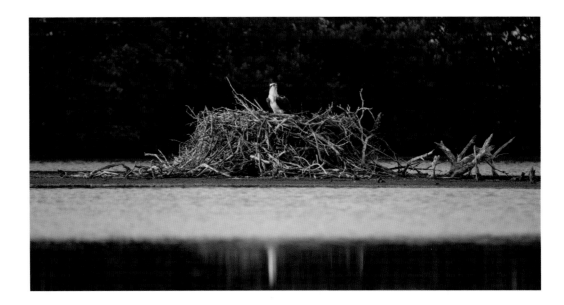

he gives me fractions of a second before he drops the prize. The purpose in my trigger finger ignites, and my breath is devoured by the moment.

From my mangrove hideout, I watch as the mother picks apart the fish selflessly giving each mouthful to her young. The chick draws essential calories from the scaly meat as well as its only source of freshwater. It will have to wait another few hours before its next feeding. Satiated, I rest my heavy head in the crotch of the tree, close my eyes, and exhale a long and thankful sigh for the shot of a lifetime. It's only 9:00 a.m. in the Everglades, I have six more islands to explore, and my day has just begun.

▲ Female osprey and ground nest. Florida Bay.

◄ A male osprey delivers an emerald parrotfish to his chick crouched in the nest. Florida Bay.

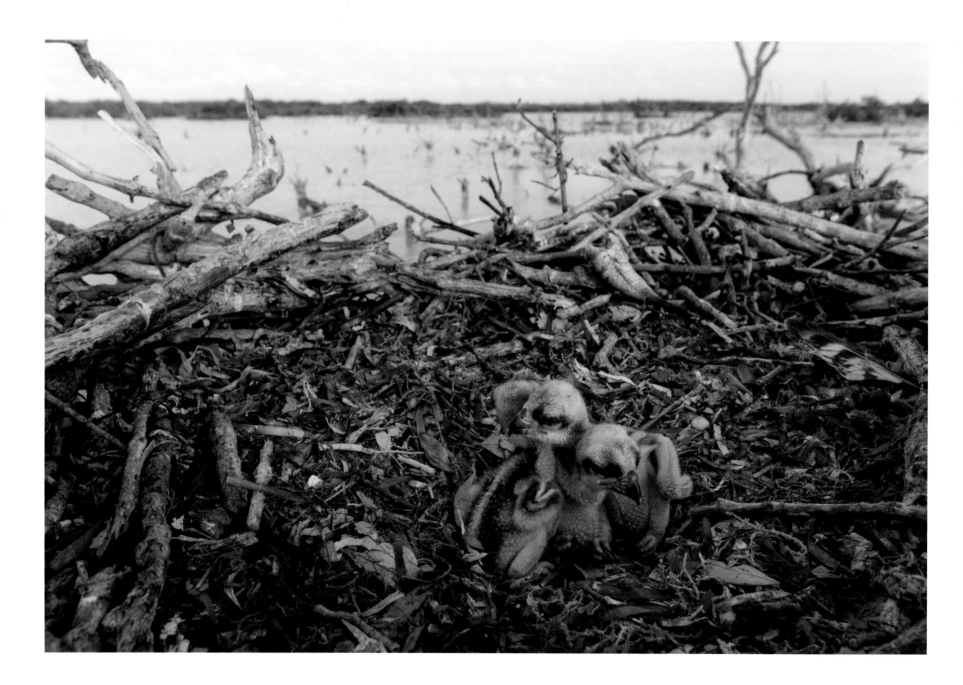

▲ Osprey chicks, a few days old. Florida Bay.

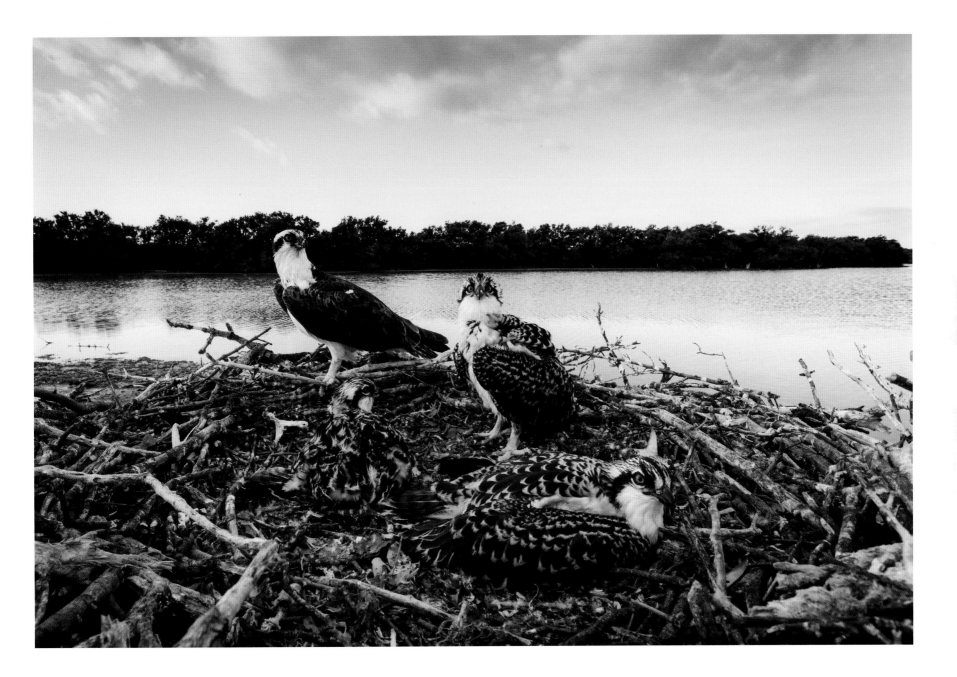

▲ At six weeks of age, three osprey chicks sit with their mother. Florida Bay.

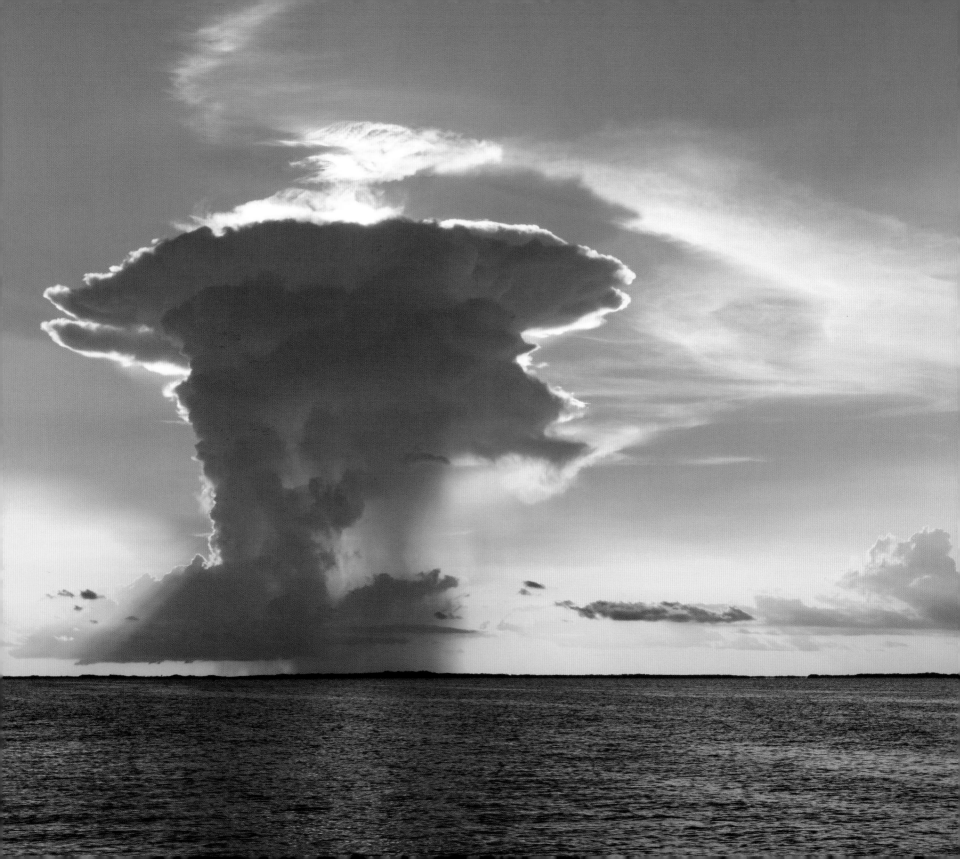

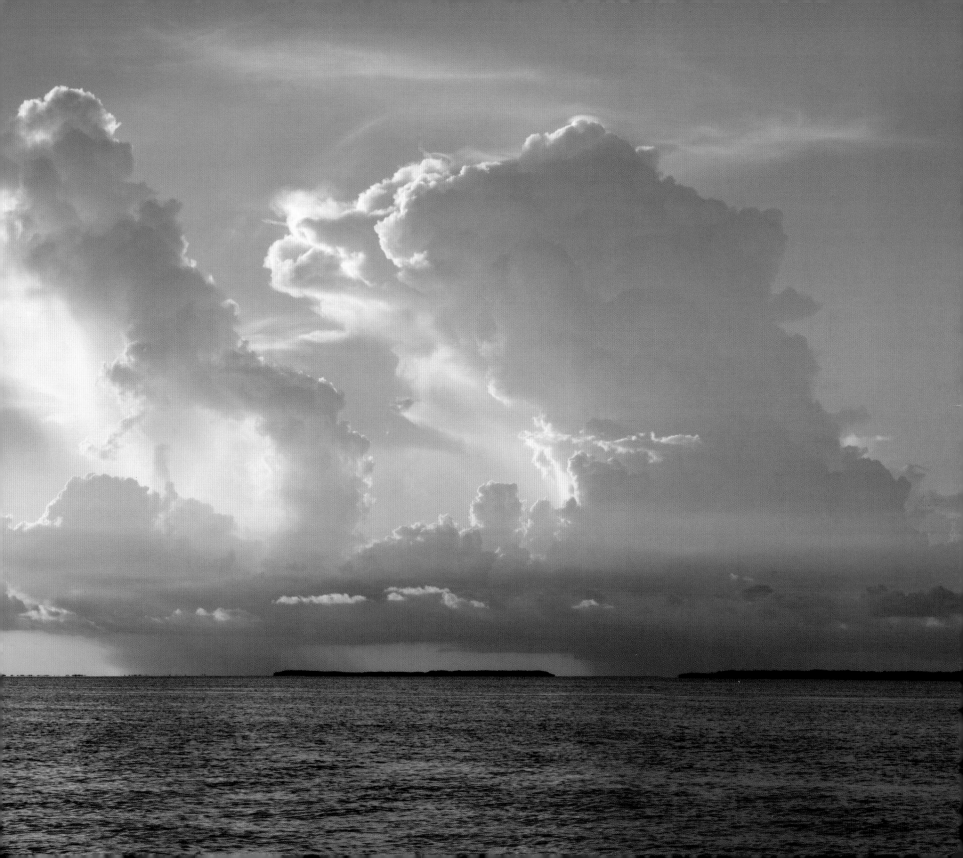

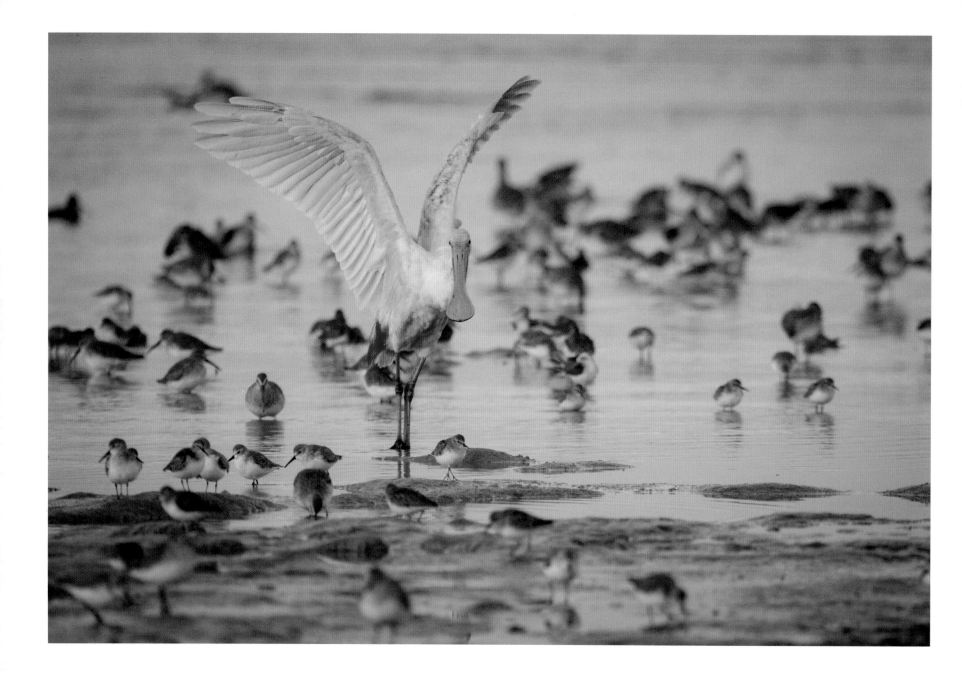

◂◂ Summer clouds on Florida Bay. Key Largo..

▲ An adult roseatte spoonbill and shorebirds. Lake Ingraham.

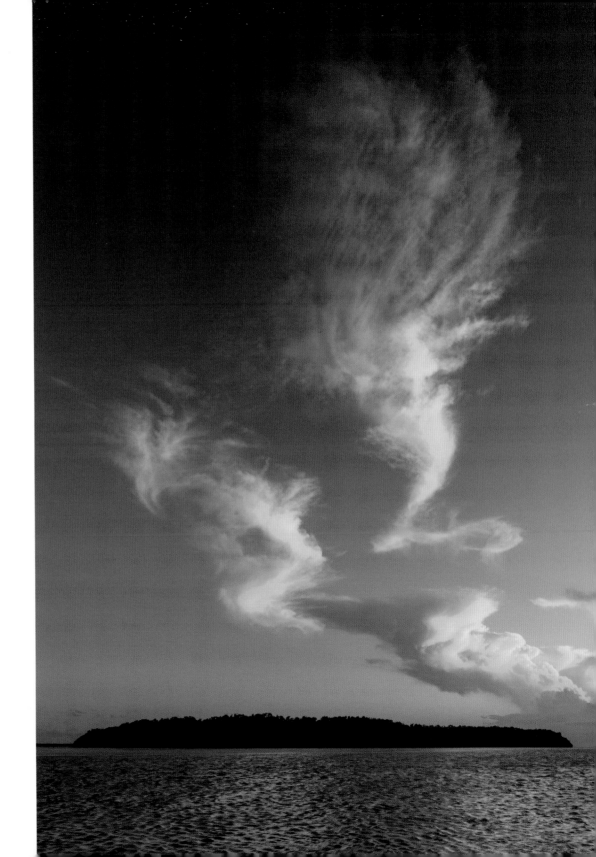

▶ Dusk clouds. Joe Kemp Key.

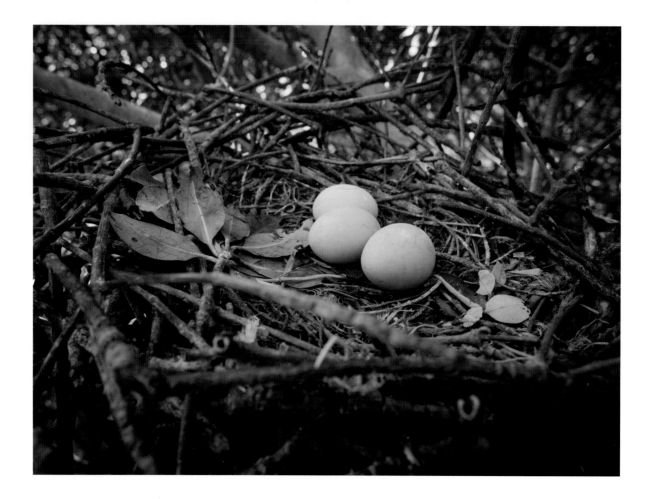

▲ Reddish egret eggs. Florida Bay.

▶ Reddish egret chicks fight for food from their mother. Butternut Key.

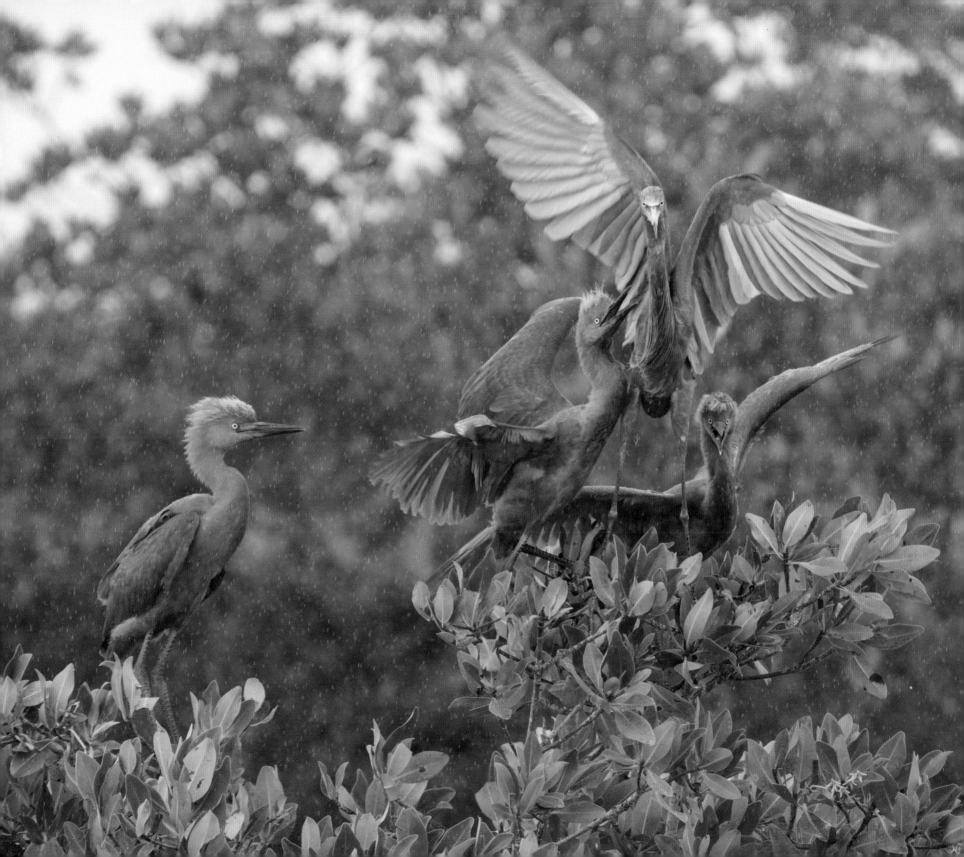

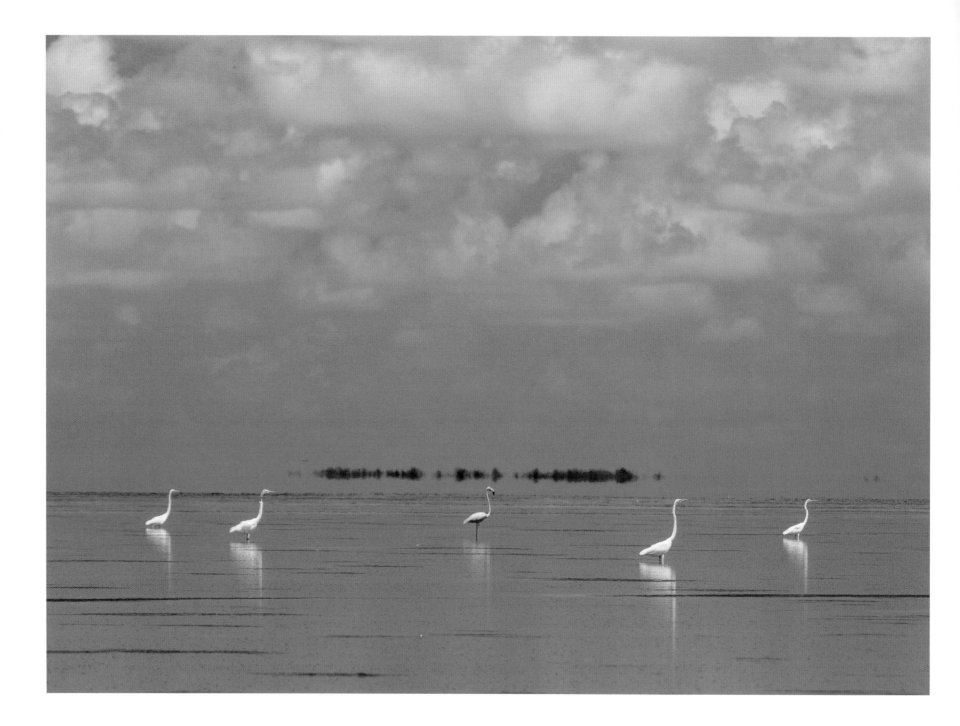

▲ Flamingo and great egrets on grass flats. Snake Bight.

▲ Great white heron tracks. Florida Bay.

▶ Great white heron nestlings. Florida Bay.

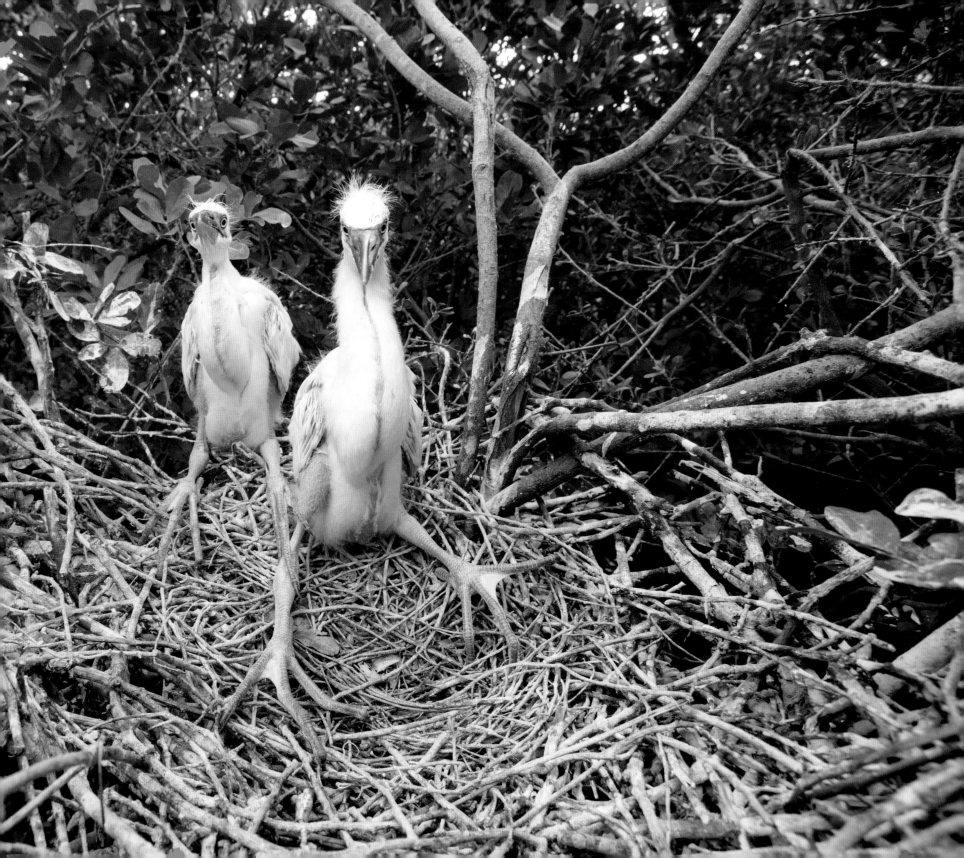

▶ Campfire and stargazing. Ten Thousand Islands.

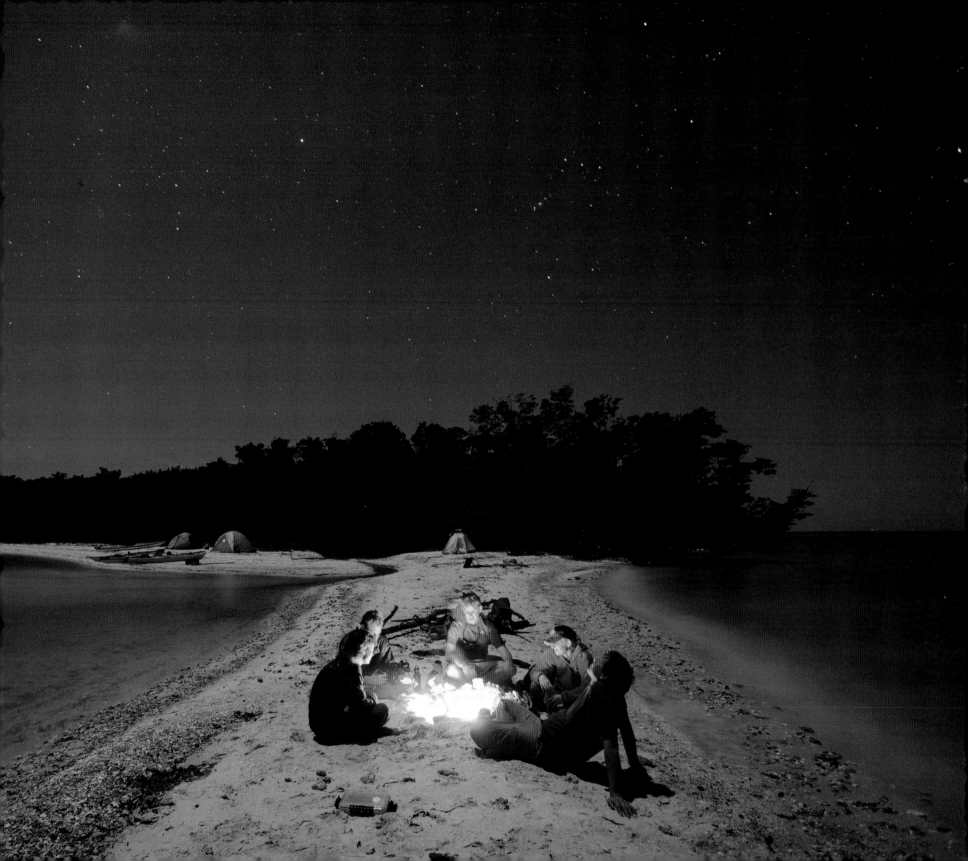

American Crocodiles

The Everglades is the only place in the world where alligators and crocodiles cohabitate. Although both crocodilians, crocodiles can be distinguished by their narrow triangular snout and lighter skin tones. Unlike their counterparts, American crocodiles also have salt glands to handle saline environments, making them a top predator of the Florida Bay estuary. Restricted to such a narrow range in South Florida, the success of their species is almost entirely dependent on the health of the Everglades watershed. From rampant habitat loss and uncontrolled hunting, American crocodiles nearly went extinct, until being placed on the endangered species list. Their numbers are slowly rebounding and on cold sunny days around Cape Sable you can often see them basking on mud flats.

▲ Crocodile hatchling detail. Turkey Point.

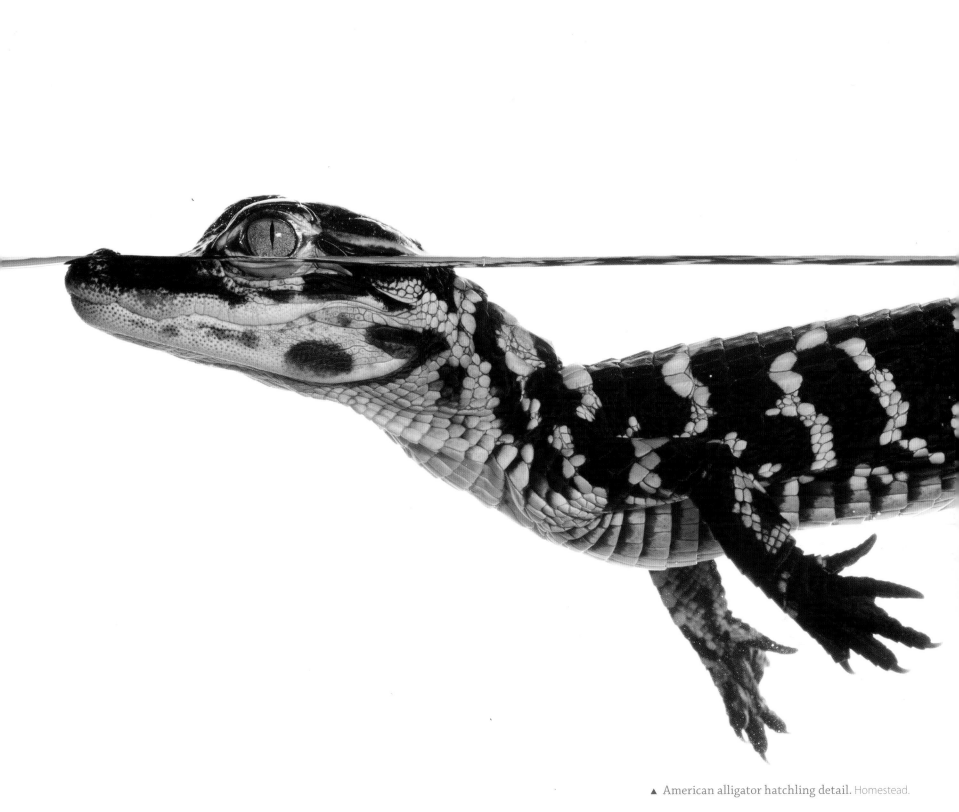

▲ American alligator hatchling detail. Homestead.

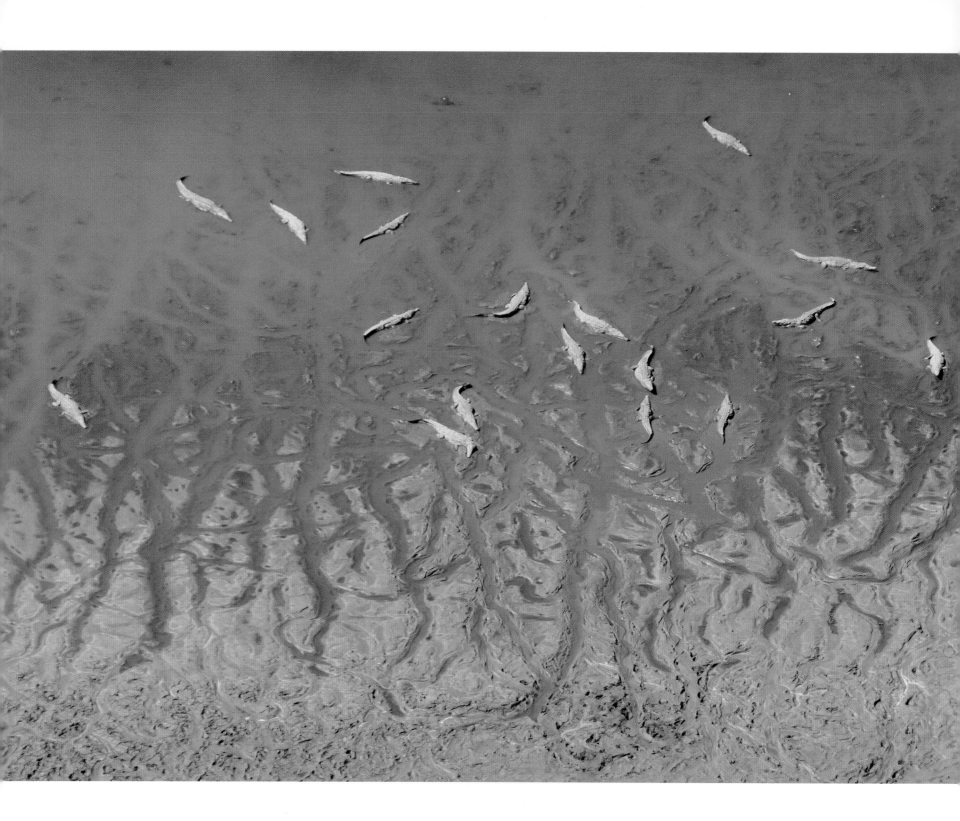

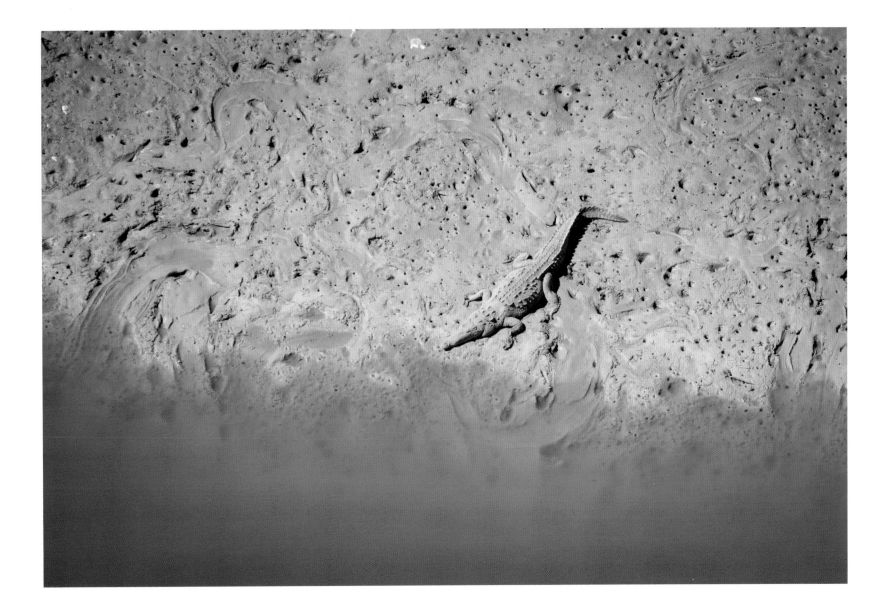

▲ American crocodile aerial detail. Cape Sable.

◄ American crocodiles bask on a mud flat during a cold snap. Everglades National Park.

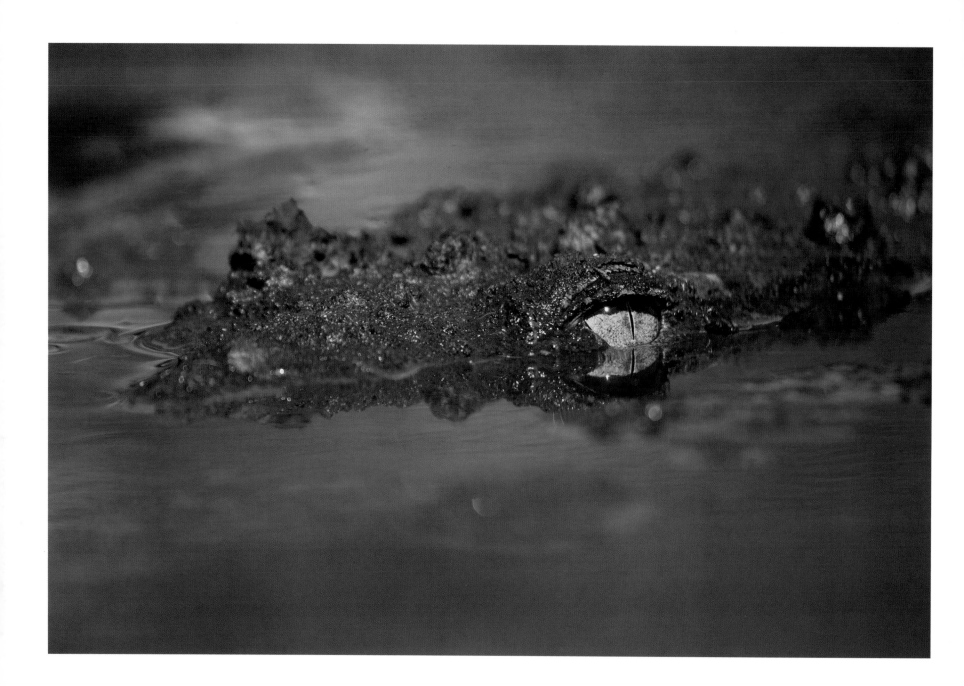

▲ American crocodile eye detail. Everglades National Park.

▶ American crocodile emerges from the mud. Everglades National Park.

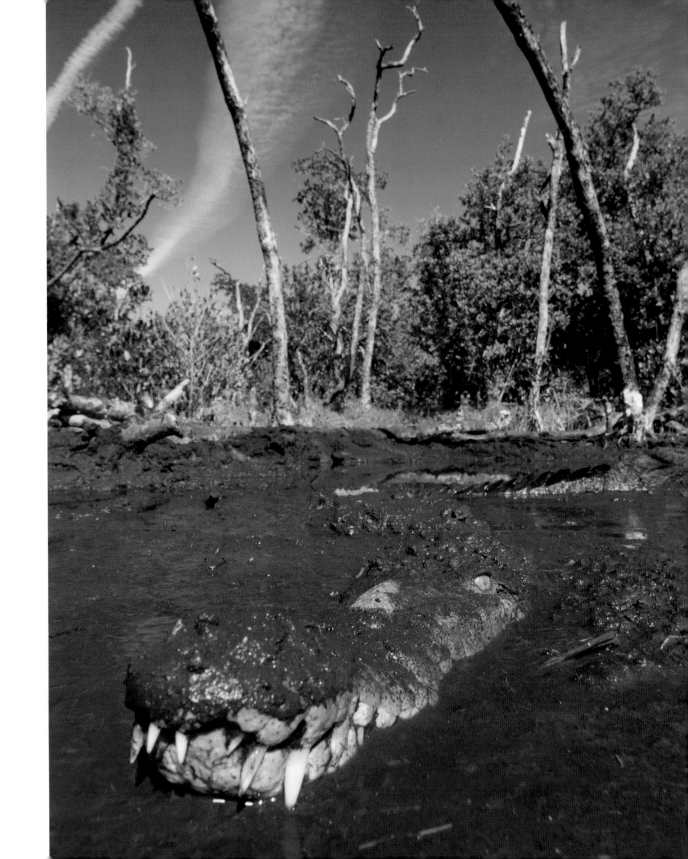

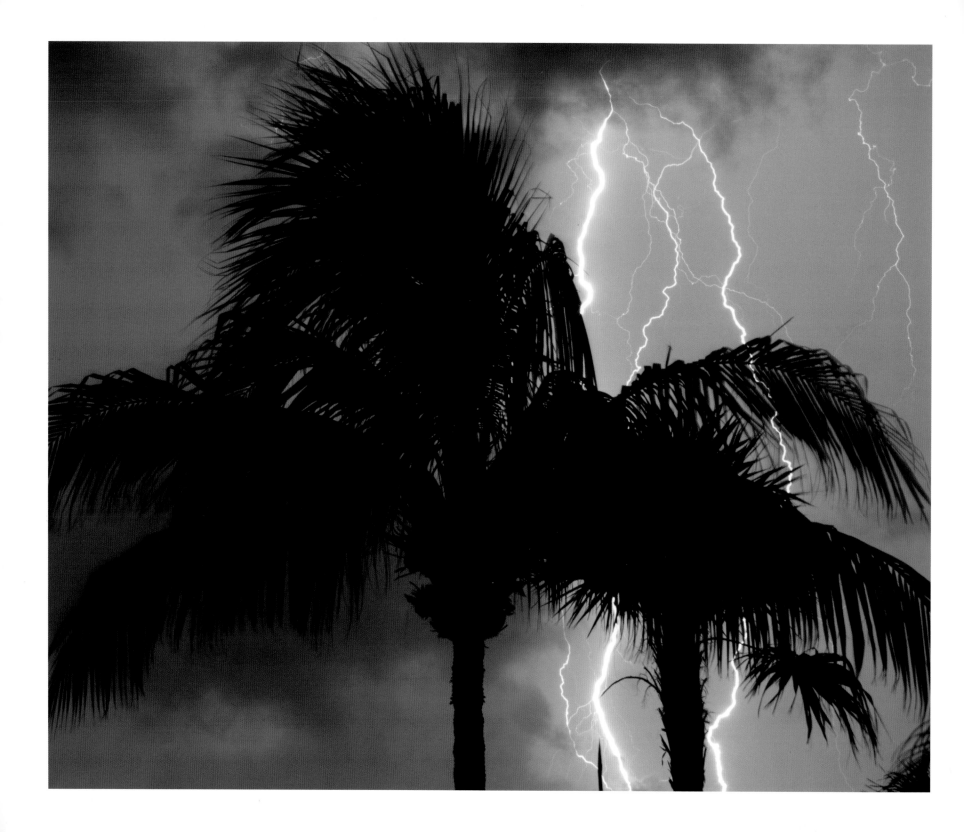

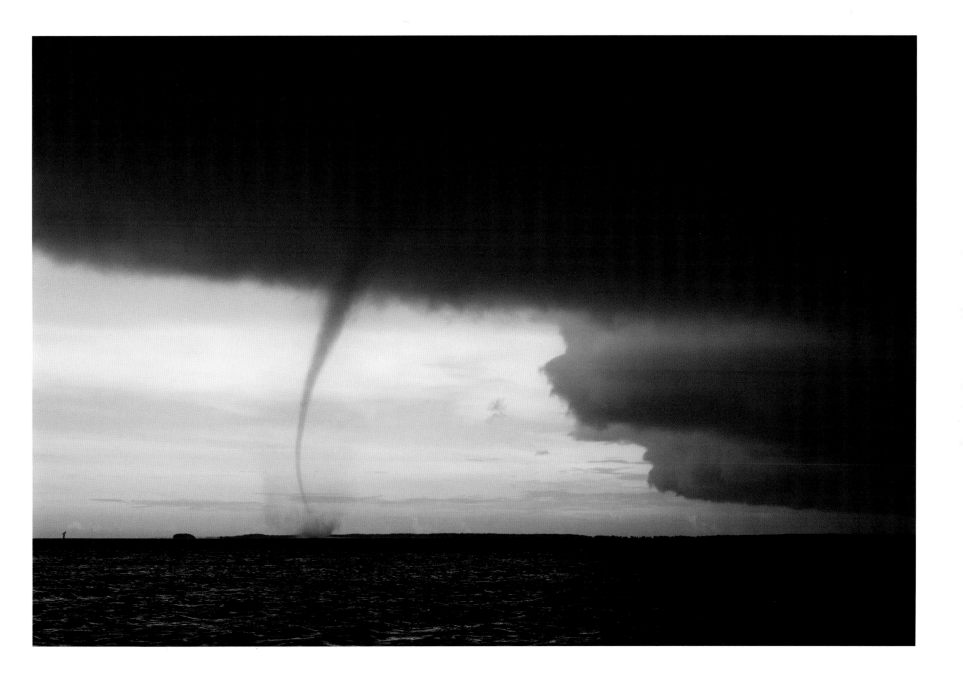

◄ Lightning storm and coconut palm. Florida Bay.

▲ A waterspout touches down at the edge of a squall. Bottle Key.

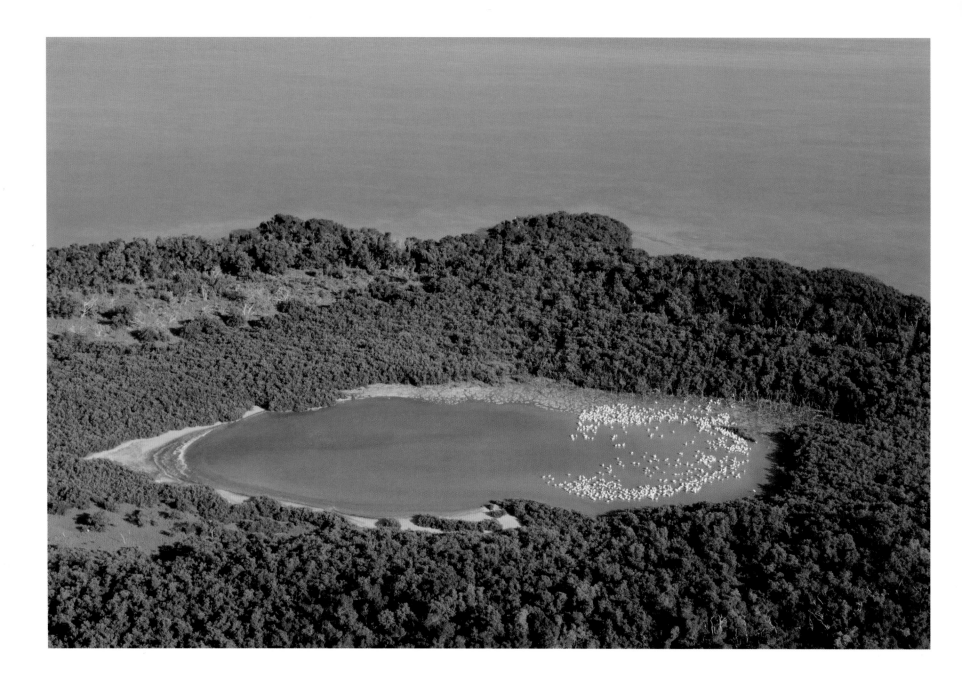

▲ White pelicans find refuge from the wind on a seasonal pond inside Murray Key. Florida Bay.

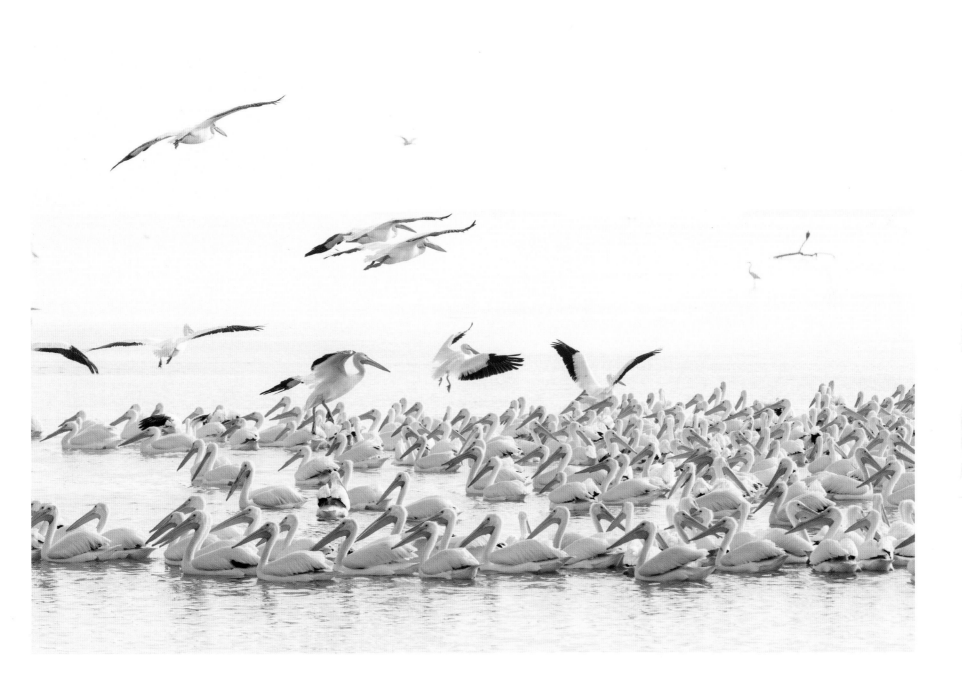

▲ White pelicans are the second largest bird in the United States; unlike brown pelicans they catch fish by corralling them in large groups. Sandy Key.

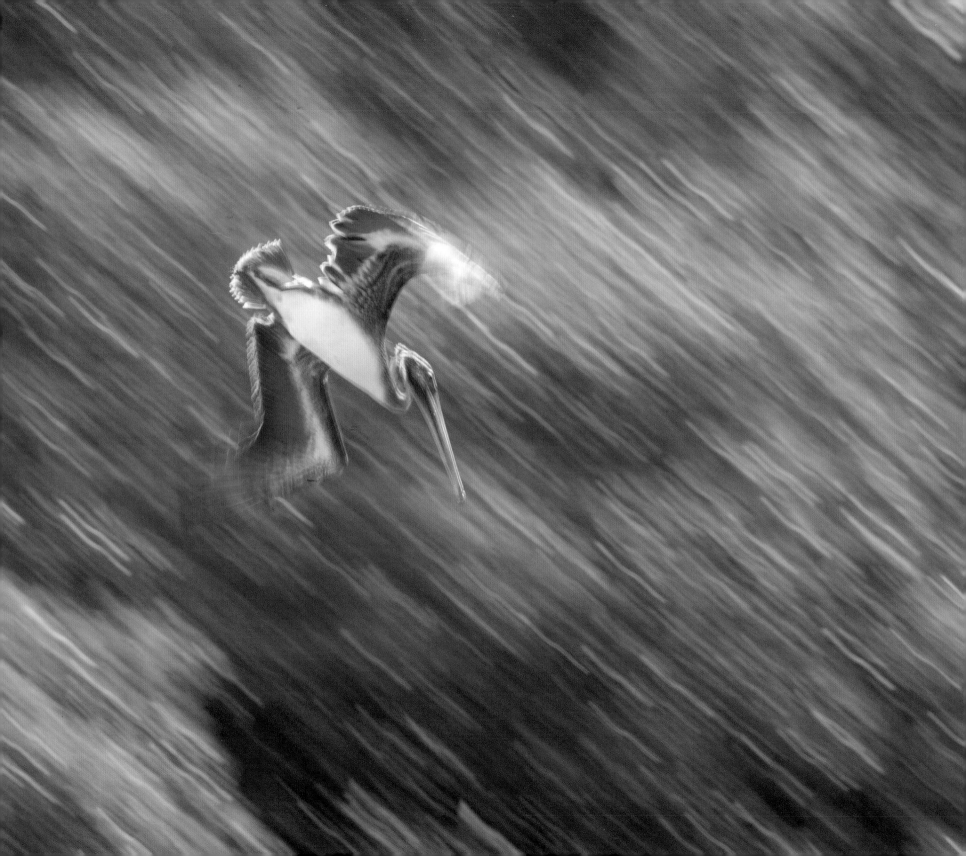

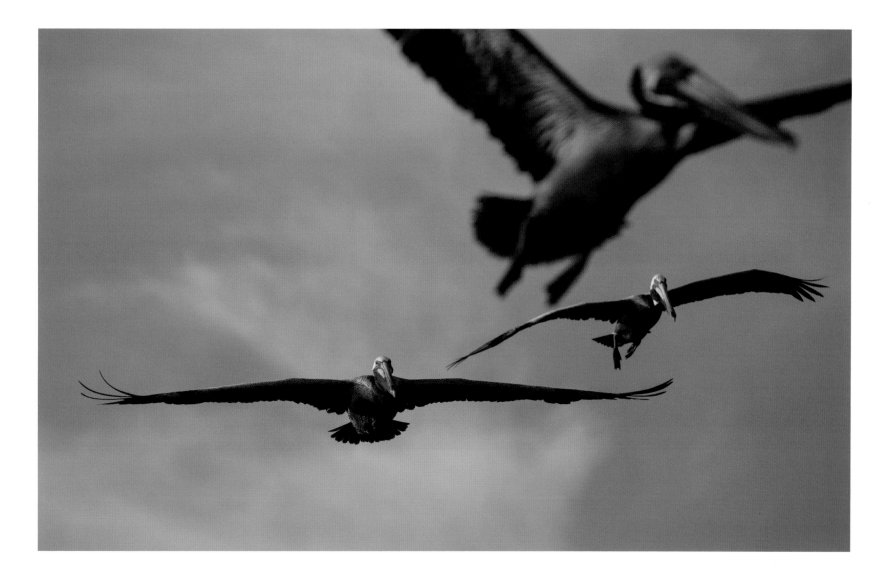

▲ Brown pelicans in flight. Buchanan Key.

◄ A brown pelican dives at speeds up to 45 mph to catch fish. Flamingo.

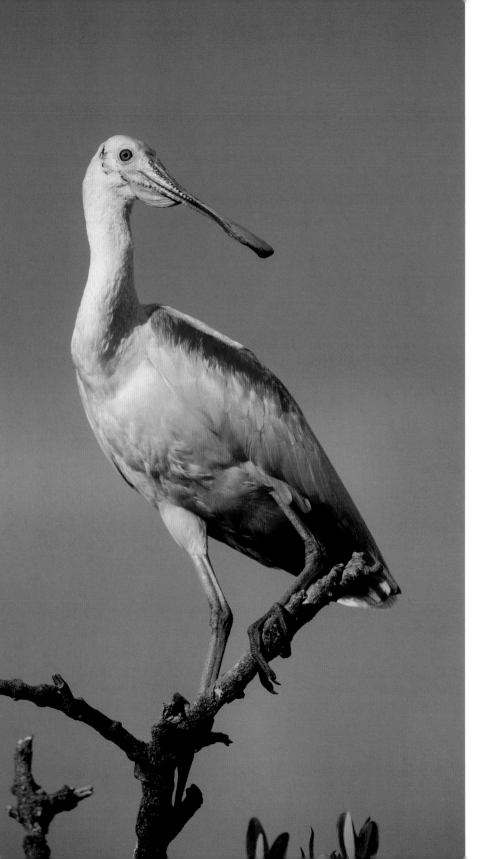

The Pink Canary in the Coal Mine
Mac Stone

Three months have passed since I started tracking the movements and nesting activity of spoonbills in Florida Bay for National Audubon's Everglades Science Center. It's January, and water levels throughout the watershed are on the decline. A brisk northern wind rips across the bay and scours the wetlands, driving freshwater out of the shallows and into deep creeks. Fishes are amassing into more concentrated pools. All the conditions seem perfect for the pink birds to begin their nesting, but in the central islands I've come up empty handed. I have one more island to check before calling it a day and waiting another three weeks to return.

The boat putts to a stop and I drive my push-pole into the sediment, tying off the bowline. I wait a few minutes, rocking with the boat in the heavy chop to make sure my anchor point holds so I don't have to swim after a runaway vessel, again. I paddle out and the frigid winter water slams into my kayak, filling the hull. I'm soaked, cold, and discouraged. Spoonbills have not nested here in years, and I don't expect to find anything, but I must be thorough.

Reaching the mangrove shore, I secure the kayak and contort my body to squeeze through the prop root mangrove maze. After the dense fringe, the island opens up to a black mangrove forest interspersed with mats of saltwort. As tired and uncomfortable as I am, the scene is arrestingly beautiful. Spongy pneumatophores rise from the ground like a giant pincushion, and vibrant orange ponds stained by colorful algae dot the landscape. I stop for a minute to listen, and then I hear them.

A chorus of reddish egrets and great white herons erupts from canopy. Then, the tenor trills of spoonbill hatchlings echo

◄ Adult roseate spoonbill in breeding plumage. Florida Bay.

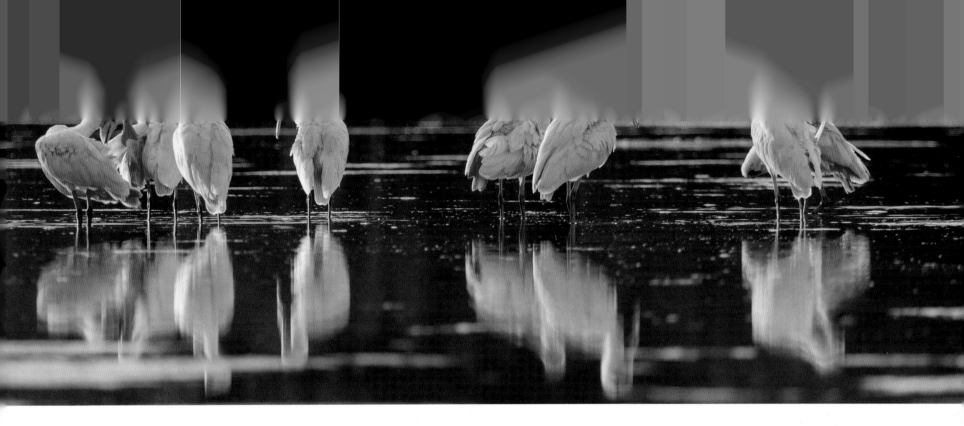

clear as day through the forest, accompanied by the distinct nasal bark of their parents. Excited, I trudge on toward the south end of the island until reaching the colony. The sound is deafening, and the subtropical landscape appears oddly cloaked in a thin layer of snow, but my nose betrays my eyes. Spackled guano marks the active nests, which dangle over a deep pond. I have to move fast to make a count and age the chicks while the parents have taken to the wing.

At eye level, I can make quick work. Spoonbills of all ages occupy the nests. When I come to the last one, I peer in and a mound of pink fuzz starts to move. Still blind, the day-old chick arches its neck and opens its mouth as if to be fed. Underneath its featherless wing a speckled egg appears and starts to shift. A hairline crack runs down the façade and then a supple spoon-shaped beak pokes through the shell. Before my eyes, the manifestation of a century's worth of research and conservation comes to fruition.

Albeit beautiful, it's hard not to look at the roseate spoonbill in the Everglades and think, "What happened here?" Amid the otherwise muted tones of herons and cormorants, the spoonbill seems like an evolutionary hiccup, a failed experiment.

Here's a bird that looks like it's fresh off a float from the Mardi Gras parade—dainty pink in color—dropped in the middle of a harsh environment where violent storms are common and predators lurk at every corner. And as if it didn't have a hard enough time dodging eagles, alligators, hurricanes, and poachers, it's forced to enter this world by breaking out of its eggshell prison with—of all utensils—a soft blunt spoon. However unfortunate, as with all species, its unique characteristics are merely the result of biological fine-tuning through the evolutionary epochs.

Unlike herons and egrets, spoonbills cannot pierce their prey with their beaks. Instead, they use their bill to create small whirlpools in the

▲ Spoonbills preen themselves on a tidal flat. Snake Bight.

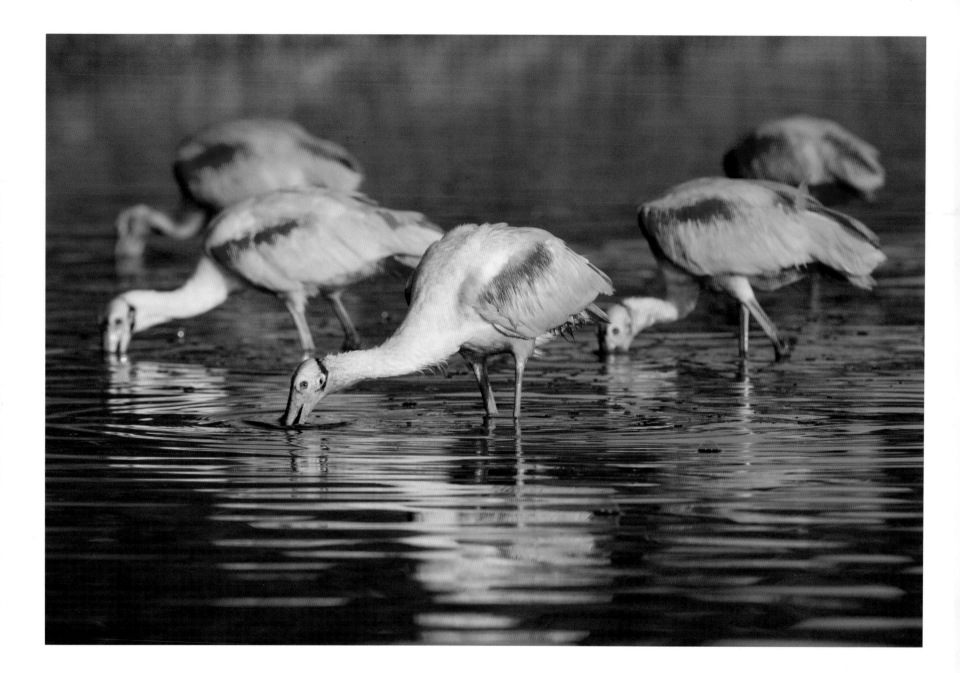

▲ Adult roseate spoonbills foraging by tactilocation. Eco Pond.

▶ Roseate spoonbill adult with two-week old chick. Florida Bay.

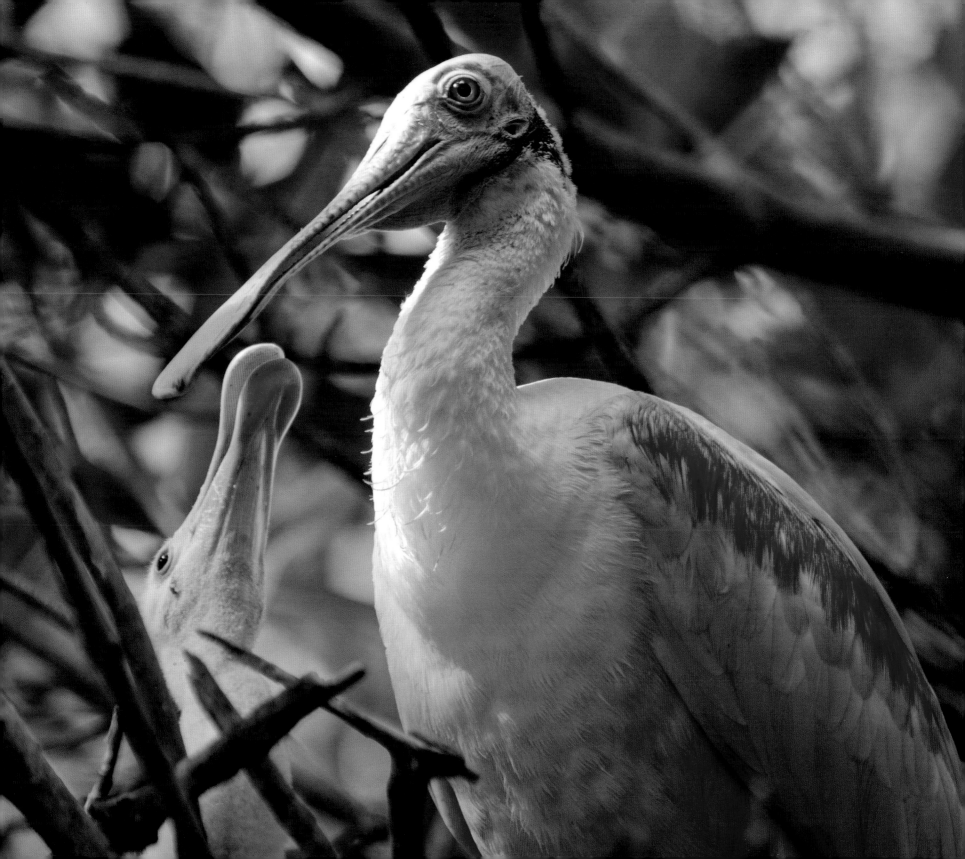

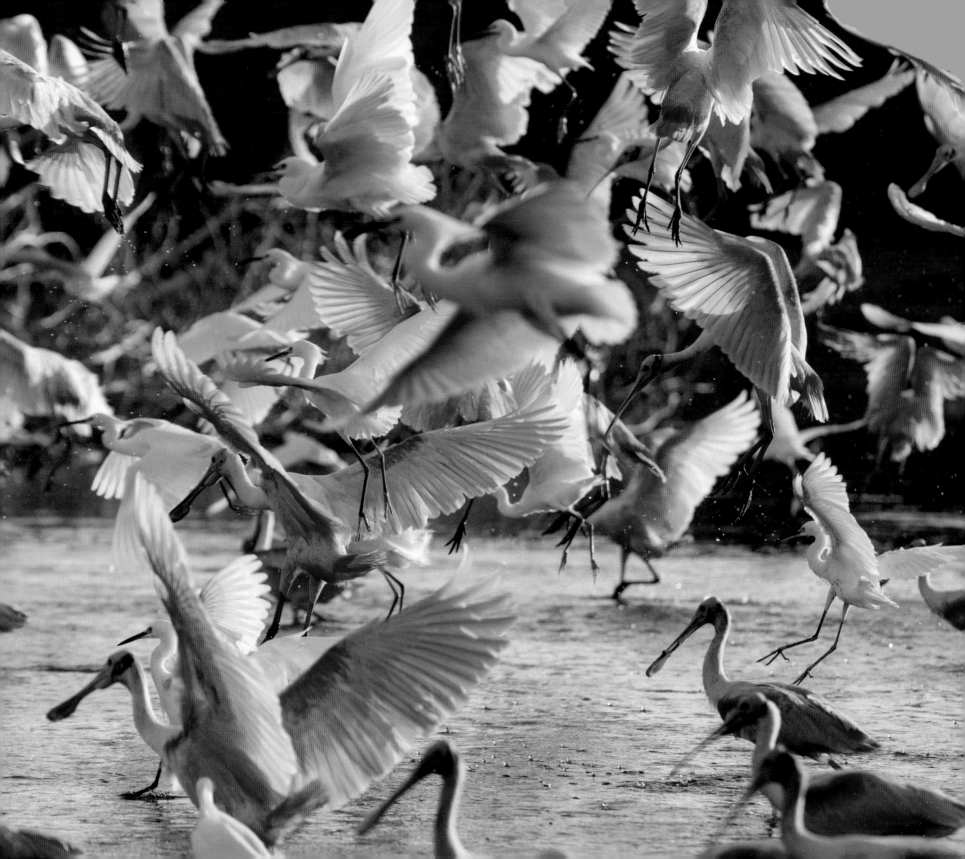

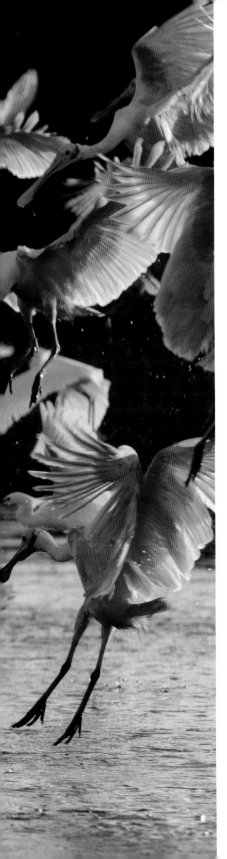

water column. A back-and-forth motion causes small fishes and crustaceans to be swept to the birds' beaks, which close with lightning speed the instant they touch prey. The feeding method is called tactilocation and requires the bird to expend a significant amount of energy.

During the nesting season, November to March, adults must be able to find enough food to satisfy the high energetic demands of their rapidly growing chicks. Tidal timetables shift throughout the month, and since they reach appropriate levels only during small windows of the day, they do not prove sustainable sources of food for a nest of hungry chicks. Thus, spoonbills, along with many other wading birds, have historically timed their nesting with the dry season. In doing so, they personify the quintessential relationship between seasonal water flow and available prey.

The earliest accounts of spoonbills in the southern Everglades cite populations in the thousands. At a time when the water in Lake Okeechobee spilled over its southern ridge in the summers and flowed freely for one hundred miles toward the estuary, pioneers of Florida stood in awe as radiant pink birds blotted out the sun. At the turn of the twentieth century, however, these sightings turned into faded memories due to the crushing demand of an opulent few.

A high-fashion trend created a market for feathers that were used to adorn women's hats; the more extravagant and bright the plumes, the higher the price. The spoonbill fetched top dollar: $5 per pelt. For some poachers in the Everglades, this proved a much more lucrative business than farming or fishing—the mainstays of South Florida life. The seemingly endless populations of wading birds offered an irresistible revenue source. Without regulation or proper enforcement, plume hunters nearly extirpated the roseate spoonbill in Florida Bay, leaving only five nesting pairs by the 1930s.

With populations at the brink of total collapse, legislation finally passed, banning the plume trade. With new laws in place and the founding of Everglades National Park in 1947, proper safeguards allowed spoonbills and other wading birds to begin rebuilding their populations. Over the next 30 years, Audubon's Everglades Science Center tracked their movements and watched as the birds' numbers steadily climbed. When they peaked at 1,260 nesting pairs in 1979, it seemed that the resilient pink birds had staged their comeback.

Meanwhile, Florida was joining the ranks of the country's fastest growing states, particularly in Fort Myers, Naples, Miami, and West Palm Beach. Campaigns focused on draining the Everglades to make way for agriculture and development thickened the political atmosphere. Elected officials begged engineers and developers to bring Florida into the new industrial economy by relieving its citizens of the swamp and mire of the Everglades.

Just when spoonbills in Florida Bay were

◄ Roseate spoonbills and snowy egrets startle as a bald eagle passes overhead. Eco Pond.

believed to have reached the tipping point of recovery, a major development project sent the birds spiraling back into decline.

In 1984, the completion of the South Dade Conveyance System—a series of canals constructed to meet agricultural water-supply needs and facilitate the shipment of rocket engines—dealt a final blow to the estuary, starving Florida Bay of nearly two-thirds of its freshwater. Wild fluctuations in salinity soon followed, and the seasonal ebb and flow of water, which had defined the estuary for millennia, became an afterthought.

Combined with rampant habitat loss in the upper Florida Keys, the bay's spoonbill population went into freefall; in 1984, just five years after it had peaked, biologists counted only 400 nesting pairs. When I took over monitoring in 2011, the bay-wide count had fallen to 87.

Slogging into an old spoonbill colony on Tern Key, I'm saddened by the silence. Ponds, interconnected by slim creeks lined with red mangrove, provide the ideal habitat for nesting birds. Besides the absence of avian life, everything seems perfect on the surface. But everything is far from perfect. Abandoned nests—some of them decades old—sit in disrepair like the moai statues of Easter Island. Only thirty years prior, this colony alone hosted more than 1,200 spoonbills. Waist deep in the middle of the main pond I pause, imagining the cacophonous trills of hungry hatchlings from years past, but the dream is soon replaced by the buzz of mosquitoes. Begrudgingly, I pack up my gear and head off to explore more islands.

By early February, nesting is in full swing, and I have found more than a dozen islands with spoonbills. Many colonies are starting to fledge their young, and I sit from my kayak and watch as the vibrant adults teach their six-week-old chicks to fly. I can't help but yell out in excitement when the black-tipped wings of a juvenile take to the sky. My numbers are optimistic, pointing to a dramatic increase from the previous year's nesting attempts.

As the season wages on, I run the gauntlet of emotions. From the lifeless bodies of emaciated chicks to the vigorous efforts of their dedicated parents, it's hard not to feel a deep connection and personal responsibility for the survival of these magnificent birds. Watching a hatchling struggle to emerge from its egg and, only 40 days later, witnessing its first flight at the heels of its mother, I am filled with an almost paternal pride.

Eighty years of research prove that these fiery birds are far more than seasonal ornaments on mangroves; they are the flying barometers for the entire River of Grass ecosystem. In other words, spoonbills are the pink canaries in the Everglades coal mine. As the Everglades shifts with the tides of

▲ Spoonbill egg eaten by a crow. Florida Bay.

▶ Spoonbill branchling dies from starvation after a rain event. Florida Bay.

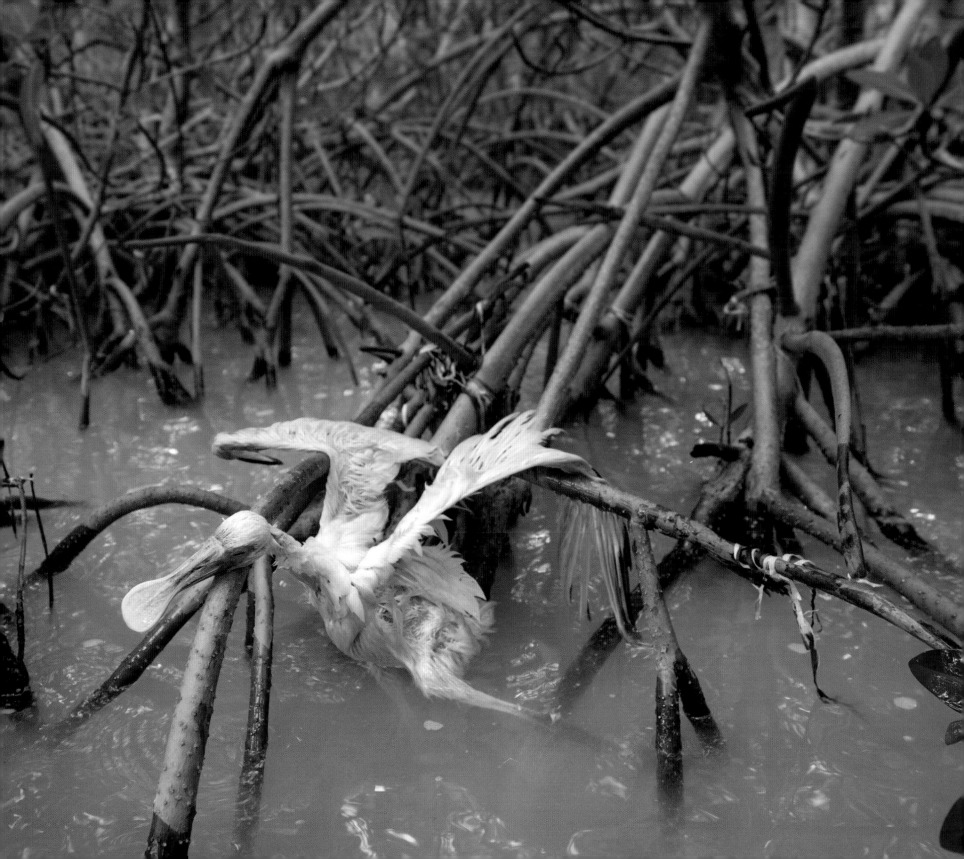

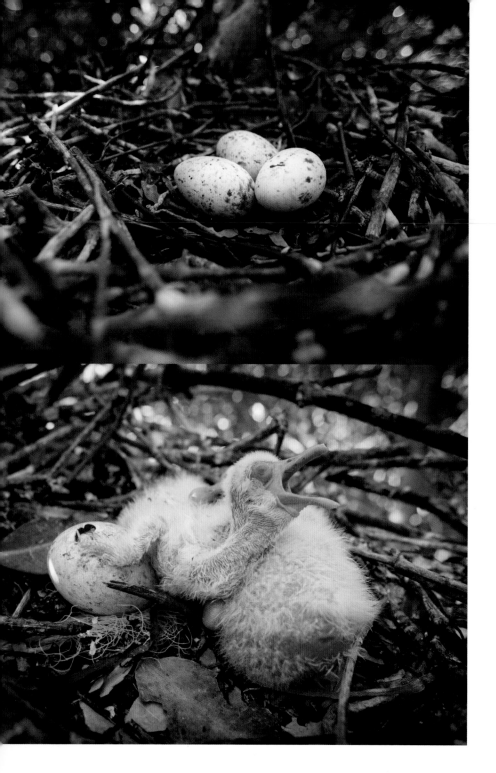

water management, so does the spoonbill. It's nothing short of a miracle that this icon of South Florida has overcome the slings and arrows of evolution and human expansion to weave its way into the complex fabric of the Everglades tapestry.

The future looks bright, though. State and federal agencies are spending billions of dollars to undo the mistakes of Florida's younger years, essentially rewriting the Everglades narrative. As I pen this, the Comprehensive Everglades Restoration Plan is underway, and the canal that has taken so much life from Florida Bay will soon be filled and rerouted to let the River of Grass continue southward. With the return of freshwater through Taylor Slough, we may witness yet another comeback of a seemingly indomitable species.

Wrapping up the season, I was proud to have documented an increase in nesting throughout the bay, adding my numbers to the eighty-year research tradition. Still, I couldn't help but feel jealous knowing that my esteemed predecessors had witnessed the mountainous peaks of a vibrant population. Then, at the tail end of the season, I explored a brand new colony. Just as in the reports from previous years, I sat outside and watched the steady stream of pink-feathered traffic coming in and out of the island. Wading into the waist-deep water, I was surrounded by hundreds of spoonbills, anhingas, and herons—the last outpost of wading birds. I counted 166 spoonbill nests, bringing the total of the 2012 nesting cycle to 350, more than quadruple the previous year's number.

After a century of overwhelming misfortune and in the face of near extirpation, the roseate spoonbills have proven time and again that they belong in the Everglades. In an essence, they are the Everglades.

▲▲ Spoonbill eggs. Florida Bay.

▲ Day-old hatchling. Florida Bay.

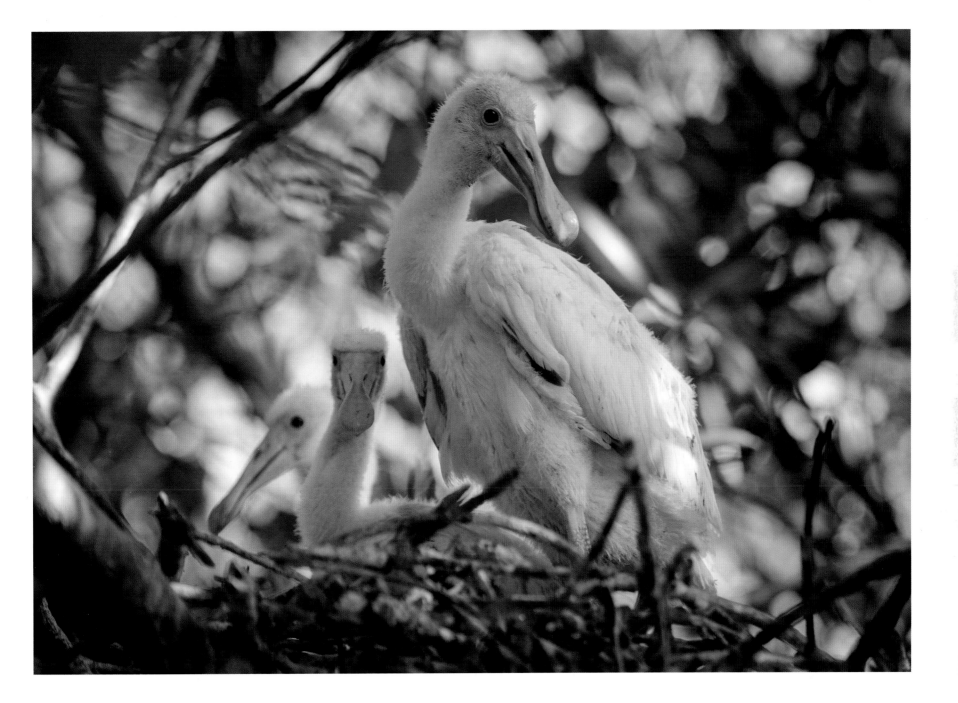

▲ Twenty-day-old chicks, about two weeks from fledging. Florida Bay.

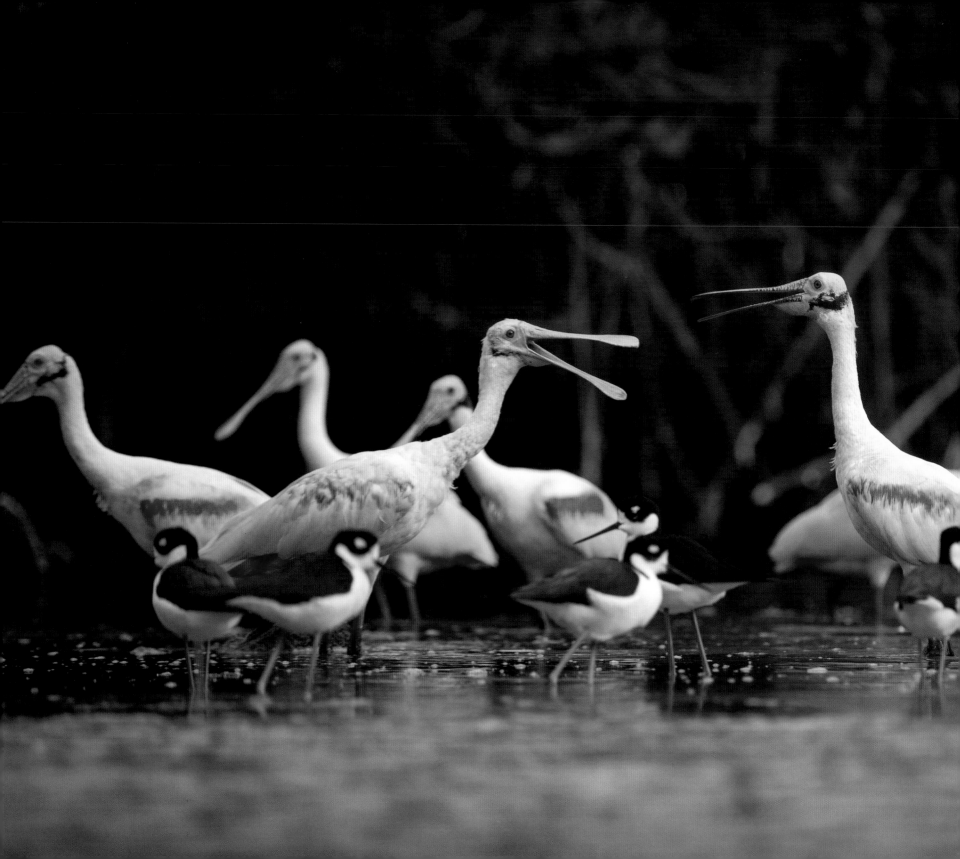

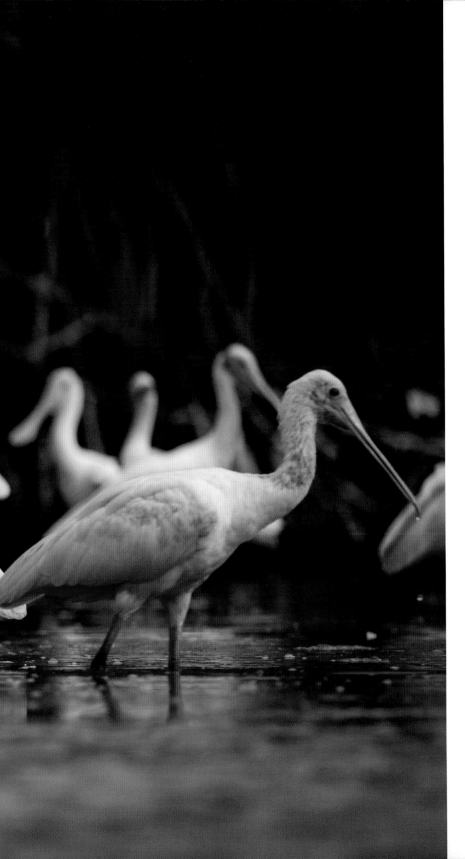

◄ Spoonbills and black-necked stilts in a seasonal pond. Florida Bay.

◄ White pelicans and shorebirds at low tide. Sandy Key.

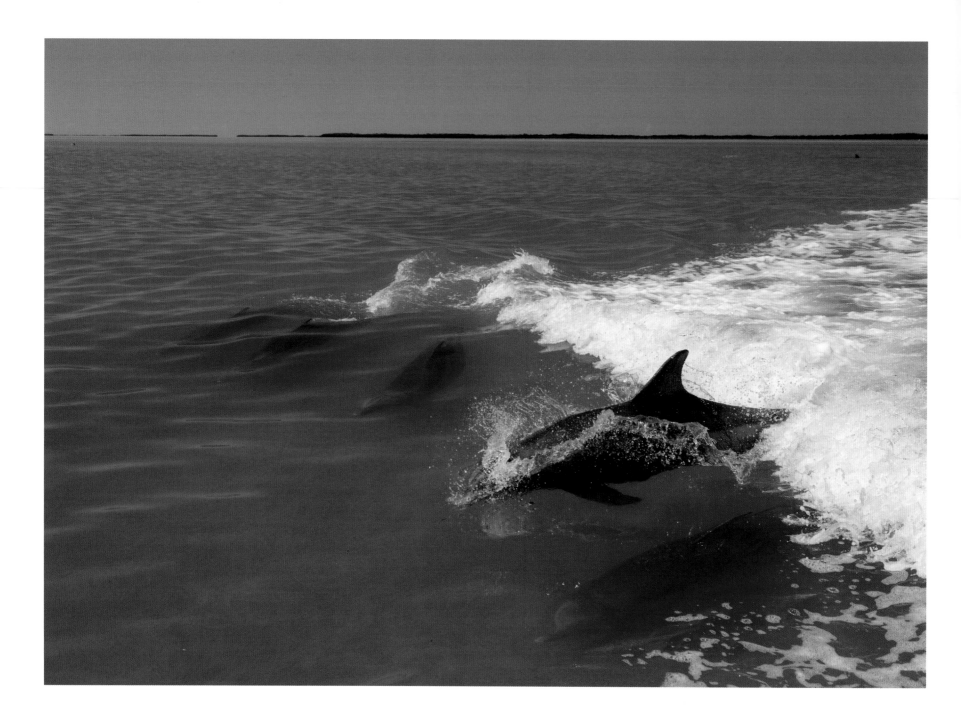

▲ Atlantic bottlenose dolphins play in the wake of a boat. Captain Key.

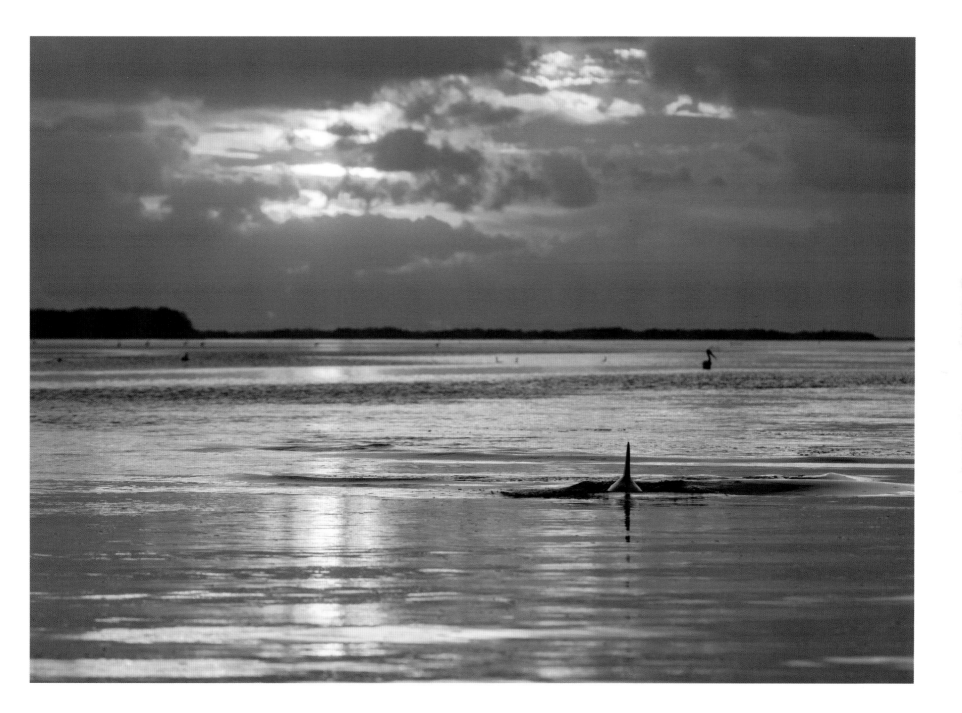

▲ Dolphin at sunrise. Palm Key.

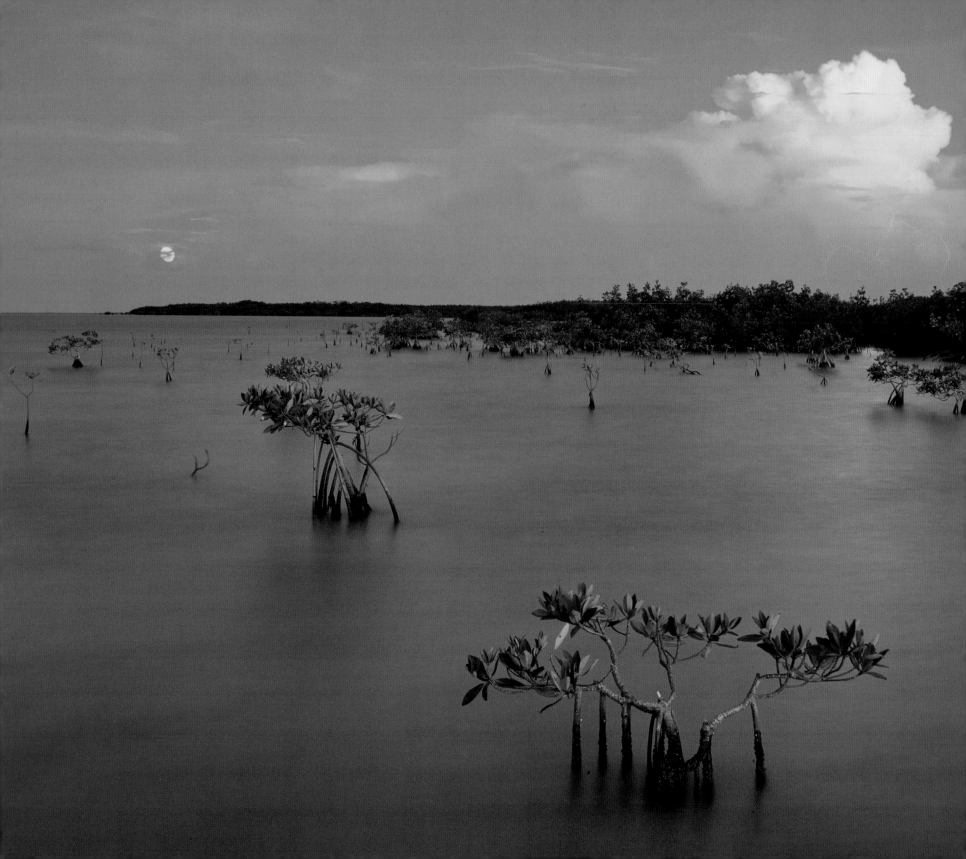

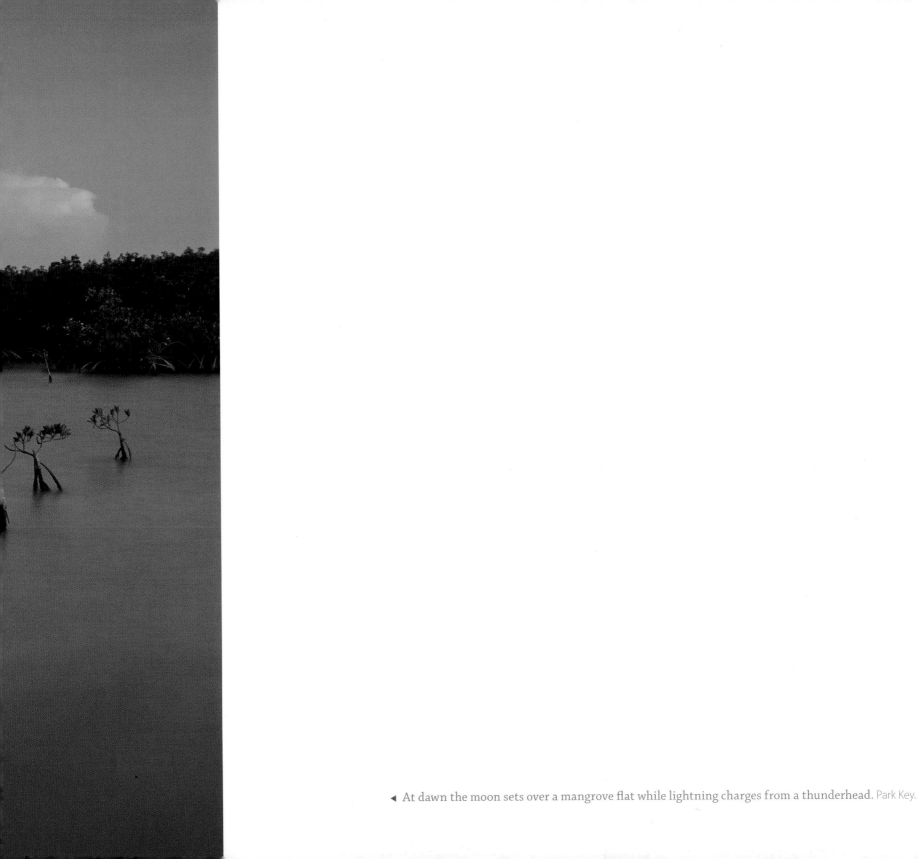

◄ At dawn the moon sets over a mangrove flat while lightning charges from a thunderhead. Park Key.

Afterword

Eric Draper

On a trip to Shark Valley in Everglades National Park, I looked across the sawgrass prairie as the sun sank low in the sky, wading birds returned to their roosts, and oxygen rich air filled my lungs. The park was closing but I could not will myself to move from that enchanted spot. Now the place has a hold on me, pulling me back for another exquisite experience, sticking to my heart as much as its marl clings to my boots. Yet I know that the Everglades marsh I saw is a compromised version of what it should be.

I came to Everglades advocacy reluctantly. As a Florida native growing up with accessible beaches and spring-fed lakes and rivers, the Everglades seemed more hassle than fun. The bizarre stories coming from South Florida and the glades were always tinged with negativity—floods, fires, drug wars, mosquitos, and garment-shredding sawgrass. I couldn't imagine a more uncomfortable place.

For more than a hundred years, however, from the time the earliest Audubon wardens poled boats through the swamps to confront the plumage hunters, people showed up to defend this enigmatic and wild part of Florida. Over the years I came to know the incredibly diverse birds and beautiful habitats that make up this amazing system, and it invariably grew on me. Once the Everglades ceased to be an abstraction, it became a passionate cause. Eventually, I put my pole in the water and began pushing the same slow restoration boat as Marjorie Stoneman Douglas, Nathaniel Reed, and so many other legends.

From the grassy shallows of Lake Okeechobee to the mangrove islands of Florida Bay, the landscape has been ditched, drained, diked, dirtied, and developed to the point where the natural system is only fragments of what it once was. The idea of restoring this one-hundred-mile complex is based on ambition so grand, believers can be accused of hubris. As compounded and varied as the natural systems that drive this wetland are, so too is its political climate. Opposition abounds. Whether the sugar industry's arrogant insistence on the right to pollute and use vast amounts of freshwater to grow its subsidized crop, or the urban sprawl bordering the sawgrass prairies, the Everglades faces tremendous hurdles. Against the many challenges, restoration seems a daunting task.

▶ Restored area of Eagle Bay marsh. Okeechobee.

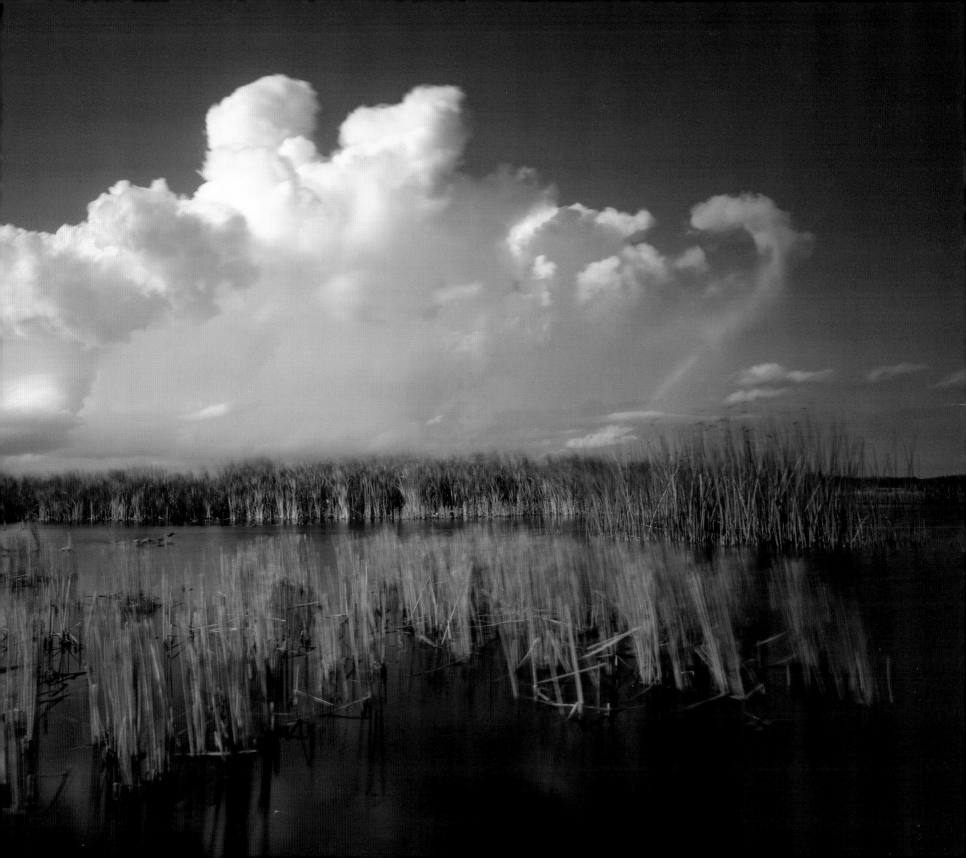

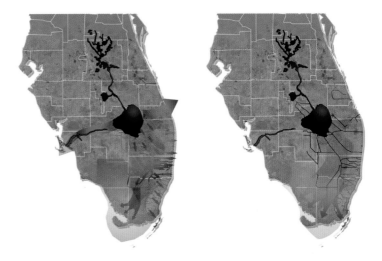

The good news is that there is widespread consensus on needs and goals. Government has now set enforceable water quality standards and is recommitted to expanding the publicly funded treatment projects that remove pollution. Once clean, water may flow naturally into parts of the historic Everglades in the right amounts at the right time.

This is the mission for the nation's—perhaps the world's—greatest wetland conservation challenge. We have put the job in the hands of state and federal agencies but our responsibility as citizens is to hold them to their commitment. Over the past three decades a series of successful projects and programs have demonstrated that government supported by an active grassroots constituency can make positive change.

What really gives hope is the knowledge that people who visit and learn about this wonderful place become committed to its salvation. The parks, wildlife refuges, and even Audubon Sanctuaries that make up so much of the Everglades are some of the most popular ecotourism destinations in Florida. As more people visit, learn about, and fall in love with the Everglades' special places, the constituency for conservation grows.

This book is a celebration of wonders of a special place. But it is also a call to duty. Nature needs friends and this is nowhere more evident than with the Everglades. With over 7 million souls living within the historic watershed and millions more visiting the region, we must enlist people to save America's heralded wetland.

Our challenges today are no less important than those whose paths through the sawgrass we follow—the brave and energetic people who stopped the plumage trade, created the parks, and passed the first laws to protect water and wildlife. Having read this book, you now have the pole in your hands. Get inspired and help us push Everglades restoration forward.

Eric Draper is the executive director of Audubon Florida, the state program of National Audubon Society. He was previously National Audubon's senior vice president for policy, staff director for the Florida House of Representatives Majority Office, and government relations director for the Nature Conservancy's Florida program, where he led efforts to fund Florida's $3 billion Preservation 2000 program and eleven local land conservation measures.

◄ An Audubon researcher releases a rehabilitated roseate spoonbill. Florida Bay.

▲ Current flow of Everglades watershed and proposed flow after restoration. Map courtesy of SFWMD.

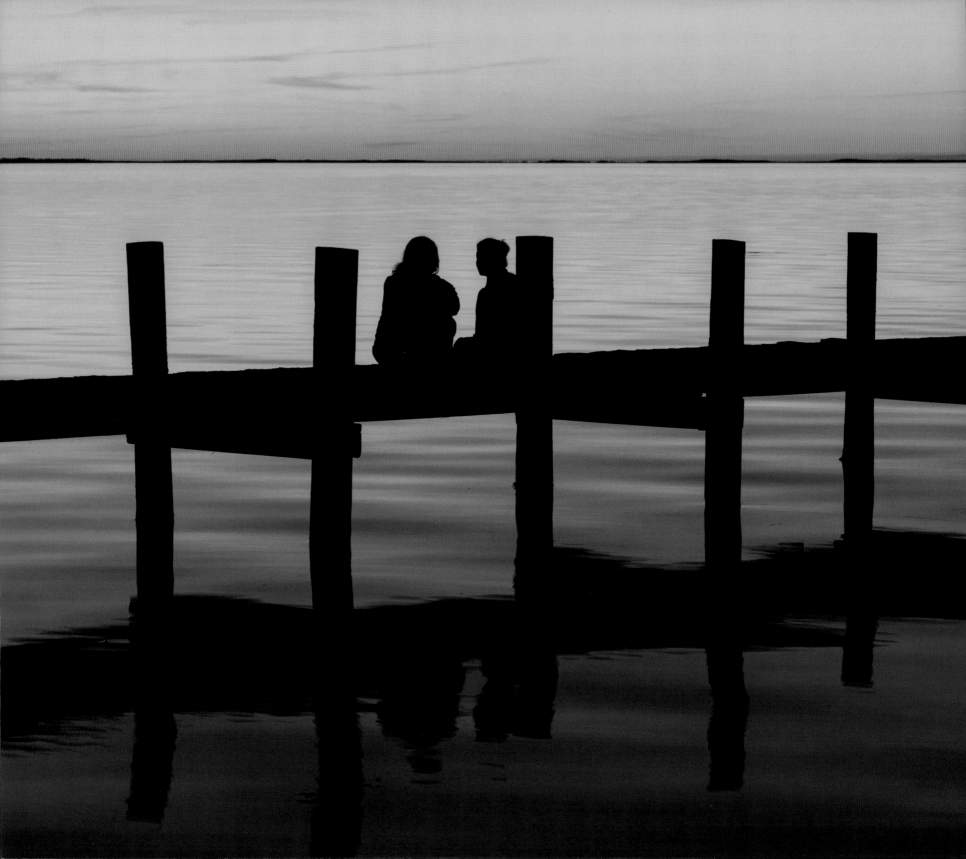

◂ Last light on Florida Bay. Key Largo.

275

Artist's Notes

Many of the images you see in this book are a result of the advances afforded by modern digital camera bodies. Being able to adjust various ISOs with the flick of a finger and employ integrated wireless technologies allows me to produce unique perspectives otherwise impossible with film cameras. At the same time, the limitless interpretation that digital processing affords leads viewers to often wonder what is real and what was contrived on the computer. I take pride in being a conservation and natural history photographer and thus hold myself to a certain journalistic standard. Readers can rest assured that each image in this book is a result of carefully balanced planning, serendipity, and reaction to actual events in the field. Although I use Adobe Photoshop and Lightroom to process and edit every image, I have not added or removed subjects, except for the dust spots that occasionally cling to my camera's sensor.

There are a few photographs that required manually blending multiple exposures of the same scene to counteract the camera's inability to process extreme light variations. This technique enables me to capture the scene that unfolds before my eyes more accurately than with split neutral density filters. Aside from minimal tweaks to contrast, white balance, and exposure, this is the extent of my advanced digital darkroom use.

Throughout the book I have added photographs of various flora and fauna against a stark white background. This look is achieved by using a small field studio with opaque acrylic boards illuminated by external strobes. I chose to use this method because it allows viewers to focus solely on the beauty and intricacy of the given species, removing it from its busy and distracting surroundings.

Many images in this publication reveal candid glimpses into the secretive lives of sensitive wildlife though I do not condone approaching these animals in the wild. I make sure to study my subjects intimately before using my camera, and I will either obtain special permits or work closely with qualified wildlife biologists to ensure that my images do not come at the detriment of the animals I'm photographing.

I strive for imagery that puts the viewer in the heart of the action because it provokes, even if just for a brief moment, a connection between the subject and the audience. My late friend, photographer, and mentor, Nancy Rotenberg, once urged her students to "go beyond the handshake," to create images that were more than a first impression, rather, images that exposed a deeper understanding of a certain subject. Now, I approach each potential photograph not as the fruit of good fortune but as a problem that needs to be solved.

When starting a story on the Everglades snail kite for this book, I asked myself how I would create an image that had not been attempted before. Putting pen to paper, I sketched out various scenes, storyboarding what I would like to see in my viewfinder. Settling on one particular frame, I sent the sketch to a biologist, Tyler Beck, in Lake Okeechobee and told him I wanted to make the drawing a reality.

In this bold idea, I envisioned a wide-angle close-up view of an endangered snail kite swooping in to pick up an apple snail off the

▲ Helicopter ride over agricultural areas. Photo by Adam Chasey.

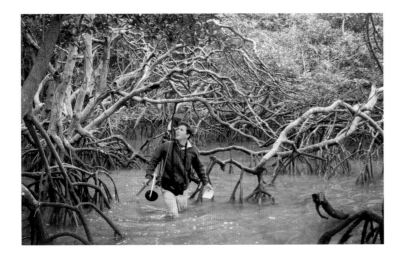

top of the water column a foot from the lens. To do this, I would need an ample supply of snails to attract a kite, a remotely triggered and camouflaged camera, and a submerged platform to ensure the snails were visible. I designed a PVC frame trap to hold the snails, and I constructed a camera hide out of a Tupperware container. With everything ready to go, I traveled to Lake Okeechobee and spent four days in nine-hour shifts with eight snails I scavenged from the marsh. After days of waiting, all the snails eventually escaped the trap, and I came up empty handed. Discouraged, but not defeated, I went back to the drawing board.

A month passed and I revamped the trap with zip tie spires to contain any renegade snails. Coordinating with FWC biologists, I collected thirty snails, and Tyler helped put out platforms weeks in advance for the kites to begin landing in a desired location. The night before my second shoot, I could not sleep because my heart was pounding with anticipation.

Leaving at 5:00 a.m., delirious and sleep deprived, I slogged out into the marsh pulling a canoe filled with gear and set up the new rig. Twelve hours later, without a single look from the kites,

I was sunburned and ready to give up. In the last hours of light, in a desperate effort, I moved the trap 30 yards within another flight line. To my surprise, after ten minutes a male kite swooped down and grabbed its first snail. Within 15 minutes, all six remaining snails in the trap were devoured. Words cannot express the excitement I felt in those moments. Over the next four days I made subtle adjustments until all the elements came together in a single frame. It was a labor of love and worth every sweaty minute.

This is one story of many, in my attempts to reveal a side of the Everglades that few seldom see. Half of the fun in creating these images is the laborious process involved and the new friendships I forge along the way. I could spend the next 50 years exploring and photographing the treasures offered by the River of Grass and still only scratch the surface. Hopefully, these vignettes will serve as a testament for all that remains to explore in the space between and inspire others to make that initial handshake with the Everglades so they too can start their own conversations.

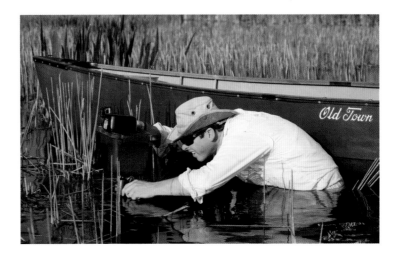

▲◄ Spoonbill nest monitoring. Photo by Adam Chasey.
▲ Setting up the snail kite camera trap. Photo by Carlton Ward Jr.

Five Ways to Support Everglades Restoration

1. Take the time to visit the Everglades, whether it's Big Cypress National Preserve, Loxahatchee Wildlife Refuge, or Everglades National Park. Every dollar spent within the Everglades economy increases the public need for maintaining this natural gem. Hire a fishing or kayaking guide to show you the heart of the Everglades and prove to the state that conserving the Everglades not only makes ecological but economical sense.

2. Write to your elected officials and tell them how important Everglades restoration is to you.

3. Buy organic foods, especially sugar. Produce that comes from South Florida is often treated with fertilizers and pesticides that infiltrate the ground water, negatively affecting the ecosystem. Something as simple as supporting organic farms and markets can influence agricultural practices to change to more ecologically sustainable methods.

4. Volunteer or donate to nonprofit organizations supporting Everglades restoration. The work these organizations do in research, outreach, and education is critical to the survival of this ecosystem.

5. Conserve your personal water use. Recycle rainwater and plant native flora around your house that don't require frequent watering.

▶ Dwarf cypress and Miami skyline glow. Everglades National Park.

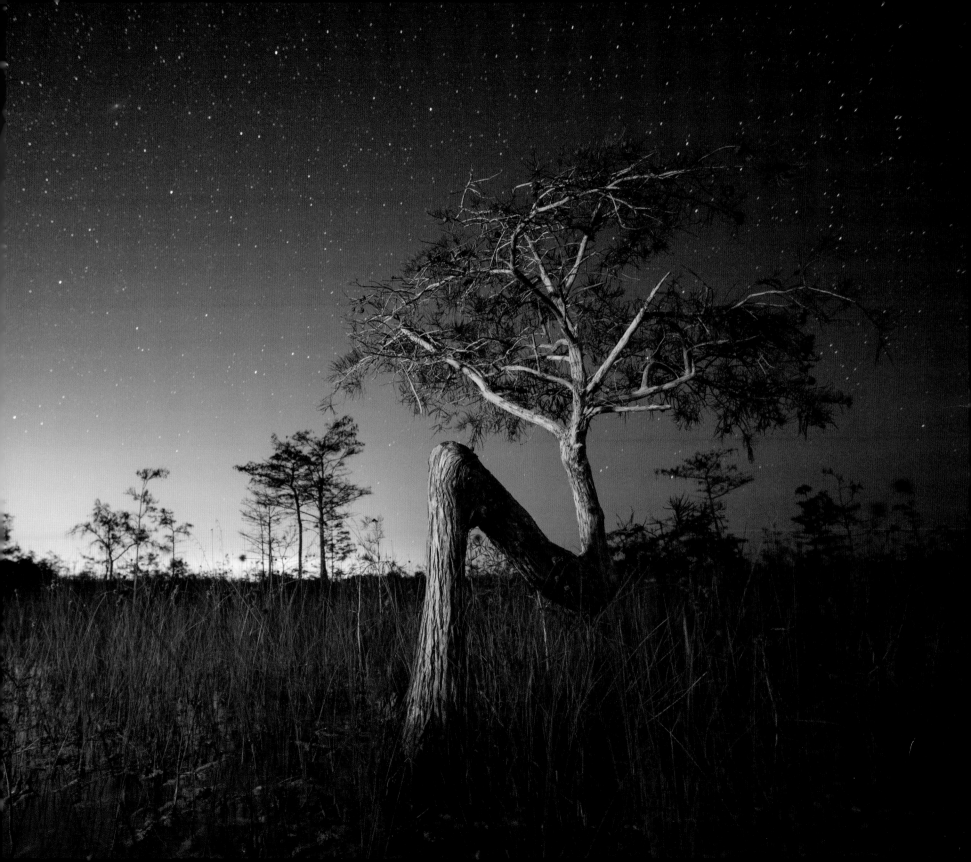

Acknowledgments

This book was born into the world by a community. It has been my greatest pleasure making and sharing these images and stories, none of which would have been possible without the direct help of dozens of individuals. I am so humbled by their selflessness and I could spend an entire lifetime repaying all the debts I accrued over the years in making this publication a reality.

I would first like to thank my family, Keith, Sarah, Greg, and Will Stone, for constantly encouraging my "Mactive" lifestyle despite the gray hairs I caused, and for giving me the most solid foundation anyone could ever ask for.

To my Audubon family in the Florida Keys: Jerry and Linda Lorenz, Pete Frezza, Michelle Robinson, Adam Chasey, Megan Tinsley, Lucille Canavan, Luis Canedo, Karen Dyer, Mike Kline, April Geisler, Erin Woods, and Heather Schorge, who dedicate their blood, sweat, and sometimes tears to preserving this heralded wetland. Thank you, Jerry, Pete, and Michelle, for running what I consider the Green Berets of Everglades conservation. Adam Chasey, who has been my Everglades co-pilot, weathering lightning storms, giant mosquitoes, and all manner of bad jokes just so I could take "one more photo." Flipping through the pages, there are only a handful of images where he wasn't present.

I owe many of my outings and photographic success to Garl Harrold from Garl's Coastal Kayaking for never passing up a single adventure and always putting his best, and least-paying customer first. To Mark Parry for being my backcountry guru and the only person I would trust slogging into a pit of alligators with. Also, Adam Vila for putting up with my late nights and early mornings while living in Tavernier.

To my greater Audubon family, Eric Draper, Margaret Spontak, Julie Hill-Gabriel, and Katie Carpenter for the endless support and helping to bring my various Everglades projects to fruition. Somehow they found time in the nooks and crannies of their busy schedules to mentor and guide me through the process of Everglades outreach. Also, to Norman Brunswig; without his sterling recommendation, I would not have made it to Audubon Florida.

A glimpse of the Everglades watershed would not be complete without aerial imagery, and I owe all of these photographs to a handful of wonderful pilots. Terry Jones, JK Wells, Ron Geisler, Robert Moehling Jr., and Gary Lickle, thank you for bringing me home safely despite my urgings to fly into thunderous squalls and fog banks at the crack of dawn.

Many of the images in this book were conceived months, even years in advance, and were executed on the backs of others. I'm sure my Okeechobee family, who made the snail kite images a reality, dreaded seeing my number appear on their phones, but they deserve applause for always answering: Christian Chauvin, Andrea Garcia, Tyler Beck, Don Fox, Paul Gray, and Dean Monette.

I would also like to thank Carlton Ward Jr., who inspired me to keep pushing my conservation efforts in Florida and who continually supported the production of this book through consult and peer review. Also, Joe Guthrie, for the late nights in bear country and his tireless efforts to get a Florida black bear to lick my camera.

To the essayists who have helped ground this book in the wisdom of experience: Michael Grunwald, Bob Graham, Bill Loftus, Nathaniel Reed, Susan Bullock Sylvester, and Pete Frezza. I am so humbled to have collaborated with these Everglades giants.

For the organizations that allowed me to channel my energy through their missions: National Audubon Society, Arthur R. Marshall Foundation, Everglades Foundation, the Legacy Institute of Nature and Culture, Meet Your Neighbours, and the North American Nature Photography Association.

Additionally, I would like to thank the handful of individuals who volunteered to slog out with me in the swamps to find slices of Everglades heaven: Steve Everett, Craig Britton, Jason Lauritson, Chris Evans, Mario Cisneros, Chris Gillette, Ashley Lawrence, Paul Marcellini, David Moynahan, and John Moran.

I had to step out of my comfort zone of publishing magazine articles to produce this book, and delving into the deep unknown required sage advice from many trusted colleagues. Top on this list is Ray Pfortner, whose input on book publishing proved invaluable and who continues to dole out instructional gems after more than ten years of my being his student. Thanks to Ian Shive, Ellen Anon, and Roger Hammer for the peer reviews and late night phone calls.

To my beautiful partner and graphic designer Hannah Dillard, for her unyielding patience and understanding when I would fall off the radar for weeks at a time, and for her artistic insight in the layout of this book.

Finally, thank you to the wonderful staff at University Press of Florida. Their books have adorned my coffee table for years, and I'm so proud to have collaborated with them on *Everglades: America's Wetland*. What a journey.

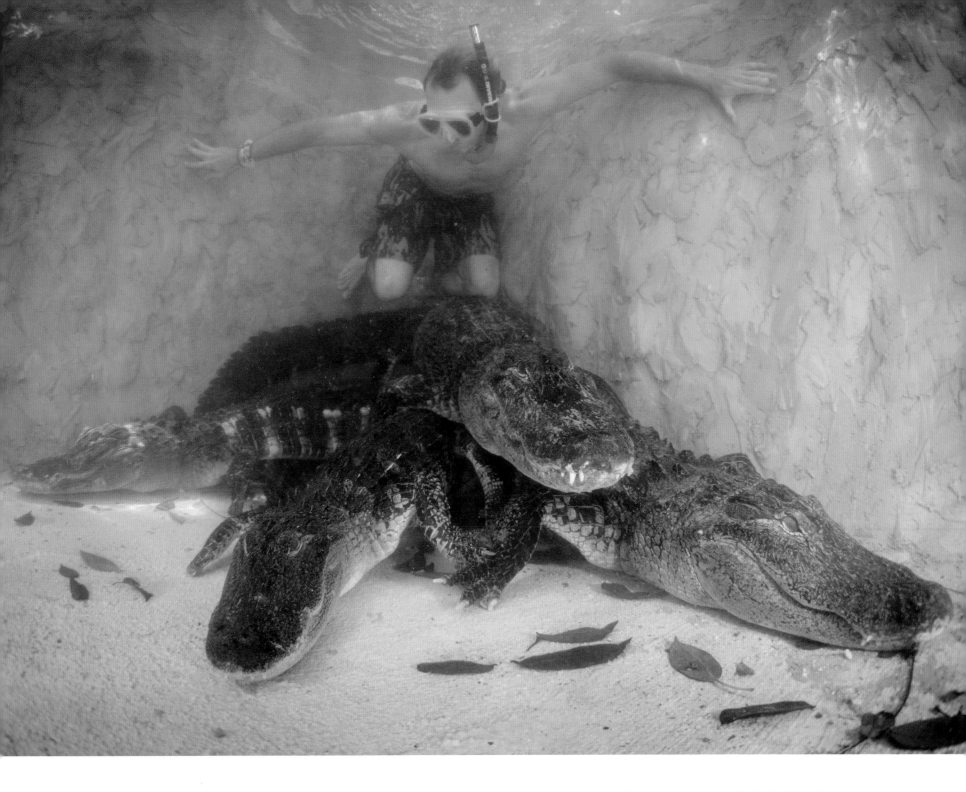

▲ Alligator wrestler Chris Gillette with relocated nuisance alligators at the Everglades Wildlife Outpost. Homestead.

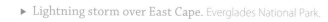

▶ Lightning storm over East Cape. Everglades National Park.

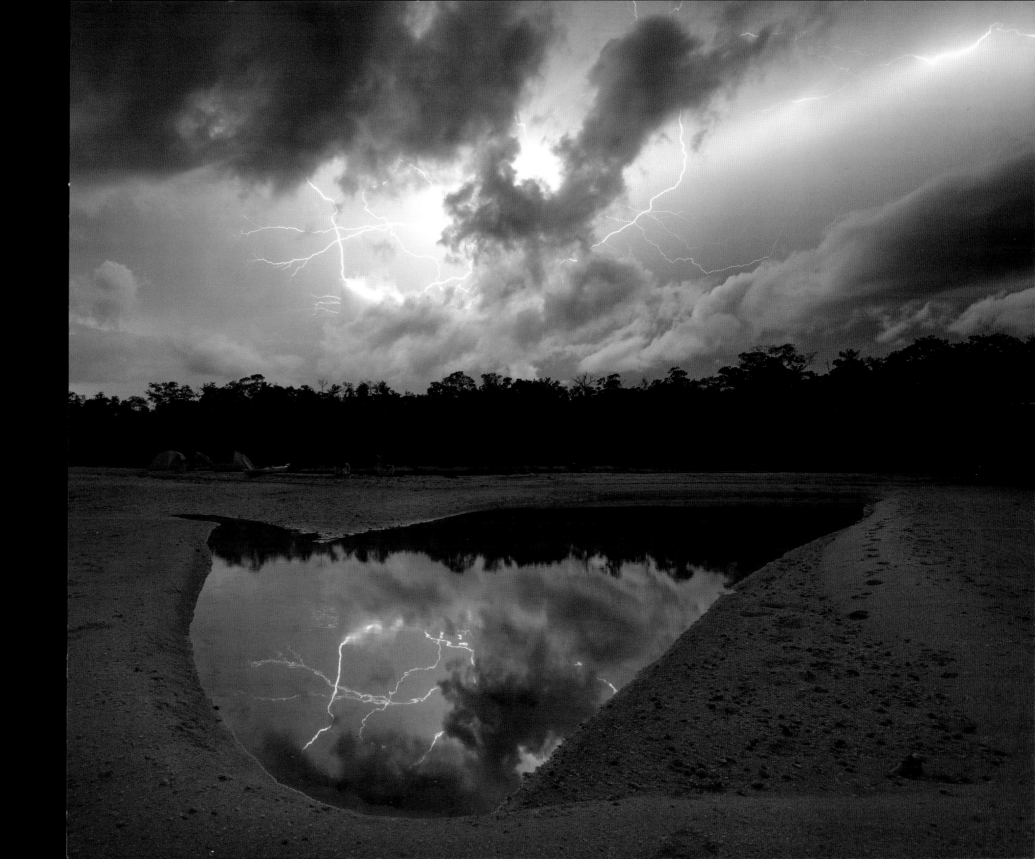

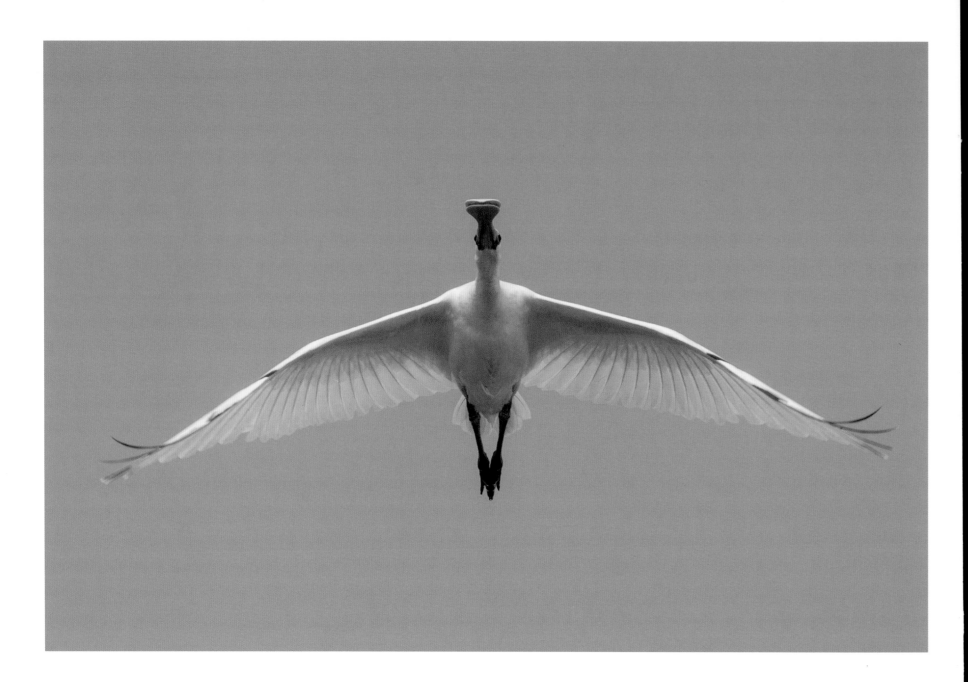

▲ Fledgling spoonbill. Florida Bay.